PLANTS ALSO HAVE POWER

KIM YUJUNG

CONTENTS

Red Air and Afterimage of Edge 2021

Pre- or Post-Human Landscapes

Lee Sunyoung, art critic

1. The logic of paradox branching in both directions

Artworks incorporating the exotic plant known as tillandsia dangle as though creeping downward, rich with a tactile surface that offers no hint at what lies inside. The plant-based installation work of Kim Yujung is, in a word, grotesque. The word "grotesque" is often used with a negative or comical connotation, but it provides a key concept in fully explaining the paradoxical aspects that are so apparent in her work. The dictionary definition of "grotesque" is a fresco or sculpture style in which hybrid human-animal forms are combined with swirling vines and flowers. In his book *The Grotesque in Art and Literature*, Wolfgang Kayser traces the origins of the word "grotesque" to the terms grottesco and la grottesca, which came from Italy's caves (known as "grotto"). The term, he explains, was used to refer to old ornamental art of a variety discovered in Rome and other parts of Italy during the late 15th century. This emphasis on the botanical origins of what is now a widely used term may aid in understanding the work of Kim Yujung.

Among all the different works of grotesque ornamentation, Kayser sees Raphael's grotesques on the columns of the Vatican (painted in 1515) as having had the largest impact. In these works, unknown shapes seem to grow out of the foliage, obliterating distinctions of species. After viewing these works, Goethe once said, "the chilling vitality of the seemingly inextricably tangled vines gives such a sense of the grotesque as to need no further exaggeration; they seem as though they are already somewhere in between the realms of plant and animal." Kim likewise makes use of the grotesque properties of plants, and the way that they can become anything—or destroy anything—through their creeping expansion in every direction. This is analogous to the ever-changing images created by drawings that began from aimless origins. The use of living plants in installations has enabled a three-dimensional approach to drawing. Appearing in numbers beyond those associated with ornamental plants, they make the gallery like a nameless tomb overgrown with weeds, shrouded in mysterious stillness like the landscape of an overnight snowfall.

To put it in terms of Kant's aesthetic distinctions, it is a shift from beauty to sublimity. Such landscapes are all the fresher for how much of nature has been dug away. Civilization tries to force nature and other unknown things into the circuits of capital. Previously opaque, nature is subjected to selection and strengthening to make it transparent. As an indirect and direct resource, it is introduced among the objects that occupy a particular era or moment. While its methods are quite different from those of science, technology, and capital, art also makes use of the opacity of nature. In Kim Yujung's case, opacity is underscored through transposition and the conversion of quantity into quality. The artist transforms the standards of use, proceeding in the opposite approach from excessive transparency (as in functionalism or the "production first" mentality). Hung over various objects, the plants cut across numerous boundaries that humans have drawn. Neither clearly alive nor clearly dead, these thick coats exist at the most important of all the different boundaries: the one between life and death. The damp air in a setting filled with plants calls to mind the small-scale activities of life, but any traces of human presence were erased long ago.

This nomadic way of being—made possible by the lack of roots—becomes a rich analogy that cuts across primeval times and the modern day. It alternates between the pre- and post-human landscapes, between the origins and the end. To some, origins are "underdeveloped"; to others, they are sacred. To some, endings are karmic retribution; to others, they are new beginnings. Paradox is an element within many of Kim Yujung's works. This is something latent within the tillandsia, but it is rendered real through the artwork. Boundaries do not exist in nature. They are artificial creations, and they have two sides to them. When boundaries operate as "limits," the crossing of one may be perceived as joyful; when they operate as "order," it may provoke anxiety. Anthropologists hold that the distinction between civilization and nature lies in the existence or absence of taboos. "Taboo" is another word for "boundary." As long as we remain within those

boundaries, change is impossible. Yet we cannot live our lives in security when we exist only outside the bounds. Artistic expression becomes impossible. While there are mythical images that have to do with madness and art, it is clear enough that art is a language so long as it is communication.

To be sure, various things that exist beyond boundaries furnish driving forces for expression and transform expressive limits—things considered to represent the "other," "madness," or "outside." This fact has been widely recognized since the discovery of the unconscious. A mode of existence that exists on either side of a boundary corresponds to art (the execution of an attempt to represent the unrepresentable) and the methods of the artist. Boundaries are quite important in human society, but their importance is not matched by definiteness. The structuralist anthropologist Claude Levi-Strauss noted that there are no predetermined truths in the principles of classification. As a result, systems assume ambiguity: internal unity and expansive potential. Another anthropologist, Mary Douglas, studied what might be called principles of categorization in terms of the religious ideas of cleanliness (godliness) and dirtiness (blasphemy). She maintained that the standards used to separate conflicting categories are completely relative. In *Purity and Danger*, she writes that sacredness is associated with the question of separating out what must be separated.
It is blasphemous to have objects from two different categories intermingling. But one anthropological argument that art would do well to refer to is Douglas's contention that all systems of categorization give rise to non-anomalous things, and all cultures confront events that rebel against their own conditions for being. According to this perspective, ambiguity is not an unpleasant experience, and the richness of art lies in its use of the ambiguous. Douglas predicts that the idea of "contamination" will eventually emerge in places

of uncertain boundaries, but she also equates existing on a boundary with being in contact with danger and existing at the origins of capability. Things that do not cleanly conform to categories seem uncanny. Like monsters, they are either worshiped or shunned; they do not conform to everyday life. Most of the objects and collected items that Kim Yujung incorporates into her work are products of everyday life. Even her exotic plants are ordinary by themselves, so long as they remain objects of admiration. As an artist, Kim favors things that are found in ordinary life.

But through a slight shift in its center, that ordinary quality gives rise to a feeling that is grotesque or uncanny. While the idea of the "grotesque" has its origins in cultural style, the idea of the "uncanny" is more psychological. It has often been remarked that the origins of the uncanny lies in the everyday rather than the transcendent. In *Fantasy: The Literature of Subversion*, Rosemary Jackson notes that as recently as 1785, the word "uncanny" was used to mean "dangerous and unsafe." The modern interpretation of the uncanny came courtesy of Sigmund Freud, who defined it as a frightening feeling associated with familiar things that we have known for a long time. Uncanniness does not exist by itself; it is a relational definition that exists only in its association with the familiar or "normal." According to Jackson, this definition based on relationality means that it subverts any representation based on a unified reality. She quotes Hélène Cixous's analysis of the uncanny as "a relational signifier . . . for the uncanny is in effect composite, it infiltrates itself in between things, in the interstices, it asserts a gap where one would like to be assured of unity."

Cixous describes the strangeness of the uncanny "not as merely displaced sexual anxiety, but as a rehearsal of an encounter with death, which is pure absence." "Death cannot be portrayed directly: it appears in literature either as figura (emblem) such as the medieval memento mori skeletons, or as mere space," Jackson explains. In addition to everyday life,

her analysis also applies to transcendent realms such as religion. She writes that the religious sense of wonder undergoes a process of secularization to emerge once again as a sense of the uncanny—but the two share the same psychological origin. The uncanny, she writes, refers to a realm that is subversive and empty. She quotes Heidegger's characterization of the uncanny as "that empty space produced by a loss of faith in divine images." "Indeed," Heidegger is quoted as saying, "in proportion with this impossibility of setting oneself in the place of God something far more uncanny may happen." Kim's approach in taking the most familiar and ordinary objects—things often found in our kitchens, our bathrooms, our bedrooms and living rooms—and flipping them into something entirely opposite cuts across an expansive network of interpretation that extends from psychology to aesthetic, from anthropology to religion.

This may explain why these randomly discovered plants are more than mere subject matter, continuing to expand as they occupy the foreground of the artwork. For a long time, Kim Yujung was engaged in fresco work, and her studio was constantly swirling with dust. To improve her environment, she adopted companion plants that have taken on an increasingly large role—leading up to today, when the artist is envisioning projects that could cover an entire building. Even after the exhibition ends, the plants continue growing in the artist's mind. To her, artwork and exhibitions may be boundaries that promise something that lies beyond; where there are no boundaries, there is nothing past the boundaries. This is why ritual is so essential to human life. But in contemporary society, ritual has been formalized, and it has consequently disappeared in a practical sense. Just as art has been the successor to religion since the modern era, ritual has been symbolically preserved in art. The disappearance of art in contemporary society, or its reduction to "culture," bears some relationship to the decline of ritual. In modern times, formalism—which is not much different from "coding"—has taken the place of the ritual that once presented the community with a symbolic universe.

Both taboos and their violation have lost their force. In Kim Yujung's work, plants have voraciously sought to expand their territory not only in installations, but in two-dimensional pieces as well. *Plants Also Have Power* (Sophis Gallery, 2018) was inspired by Alan Weisman's book *The World Without Us* and Kim Youngha's stories about the power of plants. This exhibition cleared away the notions of plants being inherently "passive" or "static." In addition to the role plants have played as the origin of vital energy, they have also been models of resurrection and renewal in the human imagination. In *The Green Mantle*, Michael Jordan cites the discovery of various forms of pollen alongside Neanderthal remains. This shows that the dead were surrounded in flowers, which the author interprets as having been meant to give the soul an opportunity for restoration. Plants do not have the activity of animals, but they have a spiritual side, an element of mystery. The endless transformations of resurrection and renewal are a dimension of mystery that transcends life and death. Jordan writes that to the primitive humans of the Ice Age, spring was a spiritual rebirth.

This mythology shows how ancient humankind accounted for the death of nature during periods of winter and sustained drought. According to Jordan, the ancient tradition of deities that die and come back to life survived into the era of Christianity. In Kim Yujung's case, this unusual plant was initially chosen for purposes of environmental purification, but soon transformed into a form of expression—into its own presence beyond meaning. Unlike objects, life remains within the realm of the unknown. This engenders feelings of both fascination and fear. The theatrical staging, which in most cases stays true to the locality of the exhibition settings, makes a participant of the viewer who has ventured inside. The plants presented here are not only meaningful in the way they appeal to the five senses; the viewer ends up participating in an act of caregiving to suit the ecology of the plants, which require moisture. At the summer 2020 exhibition *Submerged Vessel* (Jeongseojin Art Cube), visitors used spraying devices to water the plants that filled the gallery.

Over the course of the exhibition, the plants grow or wilt slightly. Kim Yujung's artwork speaks to how art, like life, is constantly changing. In a situation where it is impossible to step outside of linear thinking and precisely define what constitutes "development," change is as ambiguous as boundaries. Whether it is positive or not, change exists. Existence itself is change. Since Kim's first solo exhibition *Reading Walls and Shadows* (KwanHoon Gallery, 2003), the *tillandsia* that has been "submerging" the artist's work of late was first discovered in 2015 when she began a residency at the Incheon Art Platform. In terms of solo exhibitions, it was first seen at *Carving the Grove* (Incheon Art Platform, 2016). It appeared once again in 2021 in a special exhibition at the same venue. In Kim's recent work, the scale of her installations has become ever larger. The artist held solo and special exhibitions in succession while the COVID-19 pandemic was dealing a devastating blow to humankind: one in mid-2020, another in early 2021, and one in mid-2021. In the process, the plant "stages" that provided the artist with a source of healing and a way of breaking through have broadened to take on a different sense. In addition to large installations that "submerge" their entire surroundings, the plants are also connected to various narratives through photographs and frescos. Taking on different forms, the works supplement each other's meaning, linked in tenuous ways. A rootless plant lacks an essence and center, but that same absence permits it to become anything at all. The tillandsia does grow in its way—it is a foliage plant that bears white flowers—but there is something seemingly primitive about its shape, and the ambiguous relationship between part and whole. In modern philosophy, however, the analogy of the rhizome and the arboreal structure has gained some level of credence, with an emphasis on the affirmative aspects of a rhizomatic approach in which the relation between part and whole has been broken down. Owing to the analogy to the ability to live in conditions of extreme cold, this rootless entity also shares a vision of a post-human world. If we consider the hostile relationship between humanity and nature and how it has

become intensified, an image that appears apocalyptic in civilizational terms may signify for nature a return to an original state. The relationship between trauma and healing can depend on where one stands.

Kim Yujung does not speak unambiguously for any one position. Art does not take sides either, other than to insist that art must go on. The artist stages various scenarios from a neutral standpoint and leaves the rest to the viewer's imagination. Indeed, this southern plant is known to be a symbiotic species that covers entire large trees. Oddly well suited to concrete walls in the gray tones that predominate in cities, tillandsia is a form of nature that has penetrated deep into the human realm, like a botanical garden rendered in fresco form. A fresco is characteristically formed by scraping away at a surface, and the narrative of a plant covering over the scars alludes to the positive aspects of the return of nature from its peripheral status in civilizations. But as with humans in the past, the positive aspects of this returned nature may turn negative once a certain line is crossed. Using the unique ecological characteristics of this plant—which does not set down roots anywhere, but which can also travel anywhere—the artist presents something that is not represented, that cannot be represented, as a process of formation and extinction.

2. Empire of plants

Held in 2020 at Cheongseojin Art Cube in Incheon, the *Submerged Vessel* exhibition consisted of plant-based installation work that took advantage of the characteristics of its location at the starting point of the Ara Canal, an artificial waterway connecting to the sea. The venue had a view of the sea through a wide-open entrance, and the exhibition incorporated objects that had been used at ports and on old boats that had lived out their lives. Covered over in living plants that left them only partially exposed, the old objects seemed to be regenerated through some unexpected encounter: object and nature came together to make art. The things used by the artist—"unpowered boats, transportation crates from a warehouse, rescue equipment, floating tubes, steering devices, handle gear, navigation lights, fish traps, and such"— are already largely unfamiliar to ordinary viewers, but taken on even more of a sense of mystery in combination with the exotic plants. It's a case where the ideas of "grotesquerie" or "the uncanny" can be associated with ignorance. But the boats and plants also appear closely connected. After all, the gray Spanish moss used in the exhibition is not indigenous, but an imported plant that arrived on a boat.

Much of the exhibition setting is taken up by items related to sailing, installed in a variable way that makes use of the floor and walls alike. Capable of flexibly embracing any object, the plants leave behind shaggy silhouettes. The various faces and angles of functional objects are rounded off. It's an image that might appear chilling in its raw state, but ends up instead feeling warm, like a snowy landscape. *Common Land*, the inaugural exhibition held at the multipurpose cultural space L.A.D in Seoul's Seogyo neighborhood last January, echoes the port motif in the way that plants are invoked in connection with water. Repositioned in a location where a kitchen once stood, the kitchen and bathroom items relate to more ordinary settings. The plants create a sense of distance to evoke aesthetic effects. Here, too, they stand as symbols of metamorphosis and renewal. The

inherent ambiguity of Kim Yujung's work has parallels in the way that destruction and construction represent two sides of the same process. To distinguish it along Freudian lines, we might say that the underground exhibition venue—located underneath the everyday places where people gather—represents the realm of the unconscious.

As the viewer descends into the dim, cavernlike gallery, they are also venturing down below the level of consciousness. They see an unfamiliar version of themselves in an unfamiliar landscape. To this end, the artist has made a particular effort to empty out the mirror as an object. Places that were once outfitted as a family basement, a bathroom, or a kitchen are filled instead with different items/artworks. The things humans are capable of creating (civilization) and the things they cannot create (nature) meet and transform into unknown objects. Contemporary art has focused on the realm of objects that exist in between art and everyday life. There is art, oversaturated with meaning originating in the intentions of art history and individual artists, and there are objects in places that are not associated with the everyday—with clear functions, uses, and costs. Objects are all the more poetic when they are old, bearing the layers of time. Such objects are collected physically or indirectly, by means of photographs. In one interview, Kim explained, "I like to record fragments of memory and images that strike me as unfamiliar within familiar objects encountered in daily life."

While the photographs hanging or set down in the corners of the exhibition are not large in scale, they exist in a dialogic relationship with the main installation works. When photography first surfaced in art history as a rival to painting, it boasted a superb ability to gather images of every aspect of the world. If photography sought to emulate painting as an even older medium in the history of the visual arts, then painting makes use of photography's collection capabilities. Photographs were used as a means of

assisting memories as a source of inspiration, and they were employed in their own right. Kim Yujung places plants recorded in photographs among the installation works where she has presented her gathered objects together with plants. Located in the narrow spaces where the moisture briefly gathers beside the drains, the photographs represent a vitality of existence that protrudes even in the extreme time and space that civilization has pushed as far as they will go. In the context of an installation work, they may represent the early, struggling form of the plant—for the plants that we commonly refer to as "weeds" have ultimately pushed beyond the cracks to occupy the entire space.

Kim Yujung's favored materials are old items: visiting one of her exhibitions, we see many cases of abandoned things that have been gathered and reused. They vary in scale and type, from slippers to fishing boats. In the past, her work was predominantly two-dimensional, but the artist's chance encounter with tillandsia served as an impetus for her to introduce her existing work to actual settings. Images like ivy covering the wall in an old house had already been part of her previous work. The thin lines of the plants enabled the creation of images in space, whether in shape or shadow. The objects that make up the structure for her work *Semi-Shade Submergence_ Origin of Water* (2021), which visitors see upon entering the L.A.D gallery, are assorted kitchen items such as sinks, gas stoves, refrigerators, microwaves, rice cookers, and kettles, which integrate naturally with structures such as shelves and cords. These are things that the artist herself used or collected. If we consider the recent situation where an unforeseen disaster has led to many kitchen items being put up for sale, their presence cannot be seen as being simply poetic.

If the plants had been placed in pots, if they had not been growing over top of the kitchen items, the landscape might have appeared quite natural. But with everything either overstepping its appointed place or lying concealed, it takes on a strange quality. In contrast with other plants that face the sun, these plants respond to gravity, drooping in their semi-shaded conditions and

conveying a melancholy sense. Having overrun even the cords that dangle between the rooms, the plants offer proof of a long period of stasis. The sink that was once put to such busy use preparing provisions for the day and washing dishes appears instead as a sunken piece of terrain—human life overrun by a different kind of life. *Semi-Shade Submergence_Origin of Water 2* (2021) is another installation work that presumes a setting where water used to run, as with a kitchen. Placed in a setting low enough that the viewer might bump their head against it, we see a bathroom, toilet, shelves, a mirror, and a bathroom sink. Like the kitchen items, all of these objects were either used or collected by the artist. The sleek, functional surfaces of the sink, toilet, and bathtub are all concealed.

Between the bushy plants, a sharp light radiates from components made of stainless steel. The plants have overrun nearly all the objects in the bathroom, but we can see the surface of the mirror hanging slantwise overhead, as well as that of the mirror of the small storage closet. In the other bathroom items, the shiny surfaces were only revealed in tiny parts; here, they show themselves in full. It is worth emphasizing the importance of the mirror as a darling of the reproduction-based civilization. It also provides a small stage for imagining the self of the person facing it—a kind of stage-within-a-stage. The mineralogical sharpness contrasts with the bushy surface of the plants. Warming coating the skin of objects once stripped down for the sake of functionalism, the plants present us with a healing image. The dim lighting also accentuates the shadowy effect, with images "painted" on the walls and floors as particularly strong examples of objects and plants becoming integrated appear like spreading lines. Covering even the slippers, the plants emphasize absence; in Kim's work, absence is associated with the fantastic.

In *Fantasy*, Rosemary Jackson identifies the core of the fantastic in the separation between signifier and signified. Covering over unusual surfaces as though concealing something, the lines, planes, and masses separate the signifier from the signified. Beneath, there could be something, or there could be nothing. But it seems unbelievable that it would possess any continuity with respect to the surface. This process, in which the connection with the core is endlessly deferred, appears surrealistic. According to Jackson, fantasy incorporates a realm of non-meaning—death, in other words—as it replaces existence with absence. The uncanny, she observes, represents a collision that must be repressed for the same of cultural continuity. But what is repressed will always return eventually. Freud regarded all things that evoke the uncanny or death as cultural taboos. Citing the fantastical works of Edgar Allan Poe as an example, Jackson mentions how they incorporate a Gothic topography of sealed spaces, wastelands, basements, and other dark settings in order to represent psychological terror and primal desire.

But to artists of today, Gothic topography is seen less as something diabolical than as mere absence. Rather than being "Gothic," Kim Yujung's artwork merely alludes to what Jackson described as the fact "that the object of fear can have no adequate representation and is, therefore, all the more threatening." According to Jackson, this is something without name or form. Because it cannot be named, it cannot be easily banished either. It exists before what we refer to as "good" and "evil." To this category belong nameless presences, things without shape or form or name, fears that cannot be spoken. Kim's artwork alludes to situations in which the boundaries that make categorization and naming possible are constantly being broken down. *Still-Life as Landscape_Ornamental to Be Seen* (2021), an artwork positioned in a flower pot on a shelf on a central wall connecting the kitchen to the bathroom, is not confined to the pot like other plants. Without roots in the ground, its presence seems to move across

boundaries along the lines that connect various parts of the exhibition setting.

In contrast with the typical white cube, this space has many small partitions, loosely connecting the plants as they are incorporated into a wide range of genres such as photography, painting, and installation. The plant installation-based work seems more suited to the settings of everyday life than to the white cube, more fitting with settings bearing marks than those that are neutral. When an exhibition takes place in a white cube, it may be presented as a room unto itself. *Plant Kingdom* (2018), work from Kim's 2018 solo exhibition *Plants Also Have Power* (Sophis Gallery), has a space posited as a bedroom overrun by plants. It is a work where the conflicting feelings of warmth and absence coexist. The line of *tillandsia*—which Kim says she favors because of its linear elements—becomes a different sort of line that erases the lines that came before, a line that comes and goes itself without being fixed, an aesthetic element that lives (albeit slowly) amid changes. *Wild Garden*, which was shown at a 2021 special exhibition at the Incheon Art Platform, is a landscape that spans two stories of a building. Through an installation in an actual space, Kim realizes her wish to enter a landscape painting and stroll about inside.

The entire gallery setting comes to resemble the blank spaces of Eastern painting, with the thick lines of tillandsia folding and unfolding. "I refer to these as 'tillandsia landscapes' because they come across like paintings painted in plants, and they end up as wild landscapes," the artist has said. Her *Wild Garden* was also attempted at the 2016 exhibition *Carved Grove* at the Incheon Art Platform. While Kim's previous variable installation work *Tillandsia* (2016) placed plants over white walls like landscape art, her newer installation in the same setting from 2021 sees her increasing the scale even more as she attempts to transcend a merely "seen" landscape. The upper portion of the work has plants flowing along with the

silhouette of the minerals that make up the bones of a mountain—but underneath, they fall away. Rather than a utopian landscape, it gives the sense of flotsam washed in by a flood. It is an image created by things that are subject to the power of gravity, yet lack roots. There is no base, and there is no abyss either. In contrast with organismal installation art that lacks any framework beyond the limitations of the exhibition setting, the plants exist inside an artwork that makes use of a light box.

The fact that real plants are not used can make it easier to expand the scale in environmental terms. When I Encounter Your Green, a special exhibition at Artspace Gwanggyo in 2020, featured an artwork with a scale resembling a wall that seemed to just keep going the farther the visitor walked along it. The work was positioned at the very end of the visitor's course at L.A.D, encouraging viewers to lose themselves in contemplation of the relationship between nature and civilization. The work *Recycle_Breath* (2021) uses assembled bookcases as light boxes, using sensors inside as artificial plants respond to the viewers' movements. Situated in the light boxes opposite a corner in the low ceiling, the plants react as the viewer approaches, moving as though swaying in the breeze. The sounds of birds can also be heard, recorded personally by the artist in Uzbekistan. Kim has said that she intended this as a kind of "garden of healing, like an early morning forest thick with lyricism amid the light powerfully permeating from the space," where the "tones of shadow observed in differing levels of darkness create the experience of a seemingly living natural landscape, swaying in the wind amid the early morning fog."

Resembling plants reflected in weather strips, the three-dimensional installation work combines the form of a contemporary advertisement with the feeling of an Eastern garden. Light boxes are ordinarily used in advertising, and the fabric placed over the wood frame

is a kind often used for signs. The plants inside the light boxes are artificial, but they are so faintly visible that it is impossible to tell whether they are real or not. The greenness reflected against the shining white background lets the viewer know that it is not a shadow; it resembles an Eastern painting rendered over an empty white space. With advancements in productivity, humans began truly exploiting nature in the modern era, and nature has been subordinated to human needs ever since. The kind of nature that is meant for admiration is similarly "produced," as humans choose only what we wish to see. Plants would not seem nearly so docile if a human being were encountering them while lost in the jungle. In the modern city, plants make way for people. They are planted and uprooted according to human designs. They also get swept into trends, becoming objects to be periodically discarded. Since the work includes a layer of obscuring, a more typical form of plant foliage appears to have been chosen in place of the distinctively shaped tillandsia.

The tillandsia that the artist mainly uses comes from the southern regions. It has been developed for air purifying and admiration purposes, with other uses that have taken it out of its original habitat and placed it within a new circuit of consumption. In Kim's work, it is meant to restore the original ecosystem in which it lives over the surfaces of large trees. Nature is rumpled into something resembling how it was before humans intervened. It overruns the evidence of human lives—something that from nature's perspective is a recovery. When Kim Yujung sees the positive aspects of the grotesque within the plants that appear in her work, her attitude is made possible by her taking the side of nature over humankind. In *The Grotesque in Art and Literature*, Wolfgang Kayser traces the ambivalent meaning of the grotesque throughout history. In his analysis, the Italian word grottesco—referring to a particular style of decorative art inspired by ancient relics—did not only signify a kind of playful gaiety or free fantasy to the people of the Renaissance era; it also represented the tension and the uncanny feeling they experienced when confronted with a world where the practical order had collapsed.

Further absent here are precise divisions of the object, plant, animal, and human realms; the order of statics; the order of symmetry; and the order of natural scale. In Kim Yujung's case, the winding plant patterns do not transform into something else, yet they are capable of dramatic transformations simply through their covering of objects. Whatever form the change takes, the result is a world rendered unfamiliar. Kayser explains that the grotesque (the world rendered unfamiliar) occurs when things we once thought of as familiar and comfortable suddenly appear strange and uncanny. At the same time, we also sense that we cannot remain in this altered world. In a word, the heart of the grotesque is a terror not of death but of life. The unfamiliar world emerges from before the dreamer, from within illusion, or from a dusky fantasy that seems somewhere in between sleep and waking. Kayser defines the creation of the grotesque—also referred to as the "painter's dream"—as a matter of playing with the irrational.

The light box artwork using artificial plants also appears to blur the boundary between living and not. The rectangular frames used for the boxes come not only from bookcases but also from mother-of-pearl inlay cabinets and other antique objects; things that have passed through their short vogues (an ephemerality that admits no comparison with nature) and proceeded toward disposal are given new life through artwork. *Recycle_Breath* (2020), which appears in the Submerged Vessel exhibition, uses a mother-of-pearl inlay drawer. A discarded item has been revived as an artwork, evoking the symbolism of a plant's regeneration. Old fixtures once used to contain things have been aestheticized. But in Kim Yujung's artwork, the drawer still contains something. It contains it horizontally and vertically. It now holds nature, and it becomes nature itself. To be sure, the plant inside it is artificial, but it signals that the object has been contained in a different temporality through the artwork—in a time that is not fully suspended, but relatively slowed.

With *Breath* (2016), a work from a previous exhibition that increases the light boxes to architectural scale, the viewer seems to have entered inside the scene rather than merely viewing it. Whether the plants/images extend outside or are contained inside, the density of Kim's work is not diffused even when the scale increases. Another group of works by Kim are her fresco paintings, which similarly give the sense of breathing even in the inorganic medium of plaster walls. The metaphors of wounds and healing are likewise continued. When frescos are produced, a calcium surface is formed by applying water-based pigments before the plastered wall dries; in Kim's case, a sharp object is used to create "scars" before drying. The artist explains that with the "traumatic act of scraping before the plastered wall has dried," she has "metaphorically represented the lives of modern people, who long for healing of the basic wounds to our lives today." *Incubator* (2014), which was hung on the L.A.D walls, has a plant protruding from a window with a hole in it resembling the empty sockets of a modern building. Does anyone live inside? No signs of the warmth or vigor of life can be found in the Paju daycare center that attracted the artist's attention.

The feeling is accentuated by the dark space that seems to weigh down from above. This represents a critical attitude toward the educational process, with its infusions of dead knowledge into living beings. In terms of Kayser's distinction between the fantastical and satirical grotesque, this seems to represent the latter. Whether it is fantasy or satire, it emerges from a relationship with a particular center, namely reality. The engraved landscape alludes to similarities with the way education etches something onto the body as it continues over a person's life. The surface of the work is marked with scratches that seem to have been inflicted at different periods of time. In works from other periods that bear the same title, the buildings covered in scratches, with plants protruding from every window, come across as oppressive. *Warmth* (2016) offers the landscape of a botanical garden, but it comes across as something strange, rather than

an exotic setting frequented by many visitors. The organisms, which seem rather too big for an indoor setting, have been transplanted from somewhere else. The botanical garden is a space representative of nature that has been categorized and named.

Here, the order of nature is reduced to the order of human beings. Human rules are much more relative than the laws of nature. The artist omits the visitors from the garden. Like her installation work, the botanical garden images have the serenity or peace of a world without people. This pre- or post-human vision invokes an "other" that has existed outside of humanity. As Julian Pefanis notes in his *Heterology and the Postmodern*, reflection on otherness is both an old and a new phenomenon; it is pre-modern, yet also post-modern. Pefanis quotes the words of Michel

Foucault, the preeminent philosopher of heterology. As a philosopher, Foucault spoke of human death. In *The Order of Things*, he writes, "The unthought (whatever name we give it) is not lodged in man like a shrivelled-up nature or a stratified history; it is, in relation to man, the Other: the Other that is not only a brother but a twin, born, not of man, nor in man, but beside him and at the same time, in an identical newness, in an unavoidable duality."

Art is capable of playing an important role in the new movement to elicit others—for art itself is "otherlike." The frescos appear faded, like old black-and-white photographs, but are filled with the rich textures of nature. Inherently integrated with their wall surface, frescoes came away from the wall like oil paintings. In Kim Yujung's work, the properties of the

wall are emphasized—as though she has collected the walls. The technique of scratching is well suited to the rendering of old objects resembling ruins. It speaks to a naturalization of civilization. *Urban Kingdom* (2021), a photographic work found in the same space as the frescos, features plants managing to grow in a gray city that is like a fortress imposed on nature. If we consider them in light of the artist's proclivity for collecting old and discarded things, the plants that inhabit the cracks of civilization are also (photographic) collector's items. The presence of plant photographs alongside the installation works alludes to the possibility that plants may come to creep into the spaces, fill them up, and—when the time comes—submerge the whole.

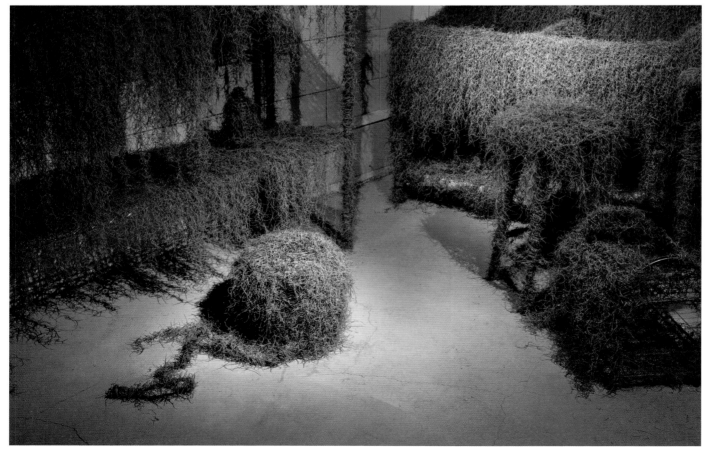

Half Shade Encroached Land
_Starting Point of Water I
반그늘 잠식지_물의 시원 I

2021
tillandsia, objects in the kitchen, net, wire
dimensions variable

인간 이전 혹은 이후의 풍경

이선영, 미술평론가

1. 양쪽으로 뻗어나가는 역설의 논리

틸란드시아(tillandsia)라는 이국적인 식물을 활용한 작품들은 스멀스멀 기어가는 듯하고 아래로 축축 늘어지며 그 내부에 무엇이 있는지 알 수 없는 촉각적 표면으로 풍부하다. 김유정의 식물설치 작품들은 그로테스크(grotesque)하다. 그로테스크는 부정적이거나 희극적으로 사용되곤 하지만, 그녀의 작품에 선명한 역설적 측면을 온전히 해석할 수 있는 중요한 개념이다. 그로테스크의 사전적 정의는 '인간과 동물의 잡종 형태와 소용돌이치는 덩굴과 꽃을 합쳐놓은 프레스코나 조각장식'을 가리켰다. 볼프강 카이저(Wolfgang Kaiser)는 『미술과 문학에 나타난 그로테스크』에서 그로테스크의 어원을 추적하면서, 그 용어가 이탈리아어 그로타(grotta, 동굴)에서 유래한 라 그로테스카(La grottesca)와 그로테스코(grottesco)에 두고 있다면서, 15세기 말 로마를 위시해 이탈리아 곳곳에서 발굴된 특정한 고대 장식미술을 지칭하는 용어라고 풀이한다. 지금은 널리 쓰이는 그로테스크라는 용어의 식물적 기원을 강조하는 것은 김유정의 작품을 이해하는데 도움을 줄 것이다.

볼프강 카이저는 그로테스크 장식화 중에서도 가장 커다란 성과와 영향력을 떨친 것은 라파엘로가 1515년에 그린 교황청의 기둥 장식화라고 평가한다. 이 작품에서 덩굴의 잎사귀에서 자라난 듯한 미지의 형상은 종의 구별을 사라지게 한다는 것이다. 이 장식화를 직접 감상한 괴테는 "도저히 풀어헤칠 수 없을 것처럼 얽힌 넝쿨의 섬뜩한 생명력은 그 자체로도 더이상 과장이 필요 없을 만큼 그로테스크하게 느껴지며, 이미 동물과 식물의 영역을 넘나들고 있는 것처럼 보인다."고 말한 바 있다. 전방위적으로 스멀스멀 확장하면서 무엇으로도 될 수 있고, 그 무엇도 무화시킬 수 있는 식물의 그로테스크한 속성을 김유정 또한 활용한다. 그것은 정처없이 시작된 드로잉이 그리는 변화무쌍한 이미지와 동형적이다. 살아있는 식물의 설치는 3차원 드로잉을 가능하게 했다. 관상용 식물을 넘어서 대량 등장하는 전시장은 잡초가 무성한 이름 없는 무덤같이, 밤새 소복이 내린 눈 풍경같이 신비로운 정적에 감싸여 있곤 한다.

칸트(Kant) 미학적 구별에 의하자면, 아름다움에서 숭고로의 이동이다. 자연이 많이 파헤쳐져 왔기에 이러한 풍경은 신선하다. 문명은 자연을 비롯한 미지의 것들을 자본의 회로에 진입시키려 한다. 불투명했던 자연은 선별과 강화를 거쳐 투명하게 변화한다. 한 시대, 또는 시기를 점령하는 대상의 대열에 자연 또한 직간접적인 자원으로 끼어든다. 예술 또한 과학기술이나 자본과는 사뭇 다른 방식이기는 해도 자연의 불투명성을 활용한다. 김유정은 위치전환, 양질전화를 통해 불투명성을 강조한다. 작가는 쓸모의 기준을 변화시키며, 지나친 투명성, 가령 가능주의나 생산지상주의와 역방향을 취한다. 여러 대상에 늘어뜨린 식물은 인간이 그어놓은 많은 경계를 가로지른다. 살아있는 것인지 죽은 것인지 모호한 이 두툼한 덮개는 수많은 경계 중에서 가장 중요한 삶/죽음 사이에 있다. 식물이 가득한 공간의 눅눅한 공기는 미시적인 생명의 활동을 떠올리지만, 인간의 흔적은 오래전에 지워진 모습이다.

뿌리를 내리지 않기에 가능한 이 유목적 존재는 원시와 현대를 넘나들며, 풍부한 비유로 거듭난다. 그것은 인간 이전, 혹은 이후의 풍경, 즉 원초와 종말을 오고 간다. 누군가에게는 원초가 미개발이고 누군가에게는 신성함일 것이다. 누군가에게는 종말이 인과응보이고 누군가에게는 새로운 시작일 것이다. 역설은 김유정의 여러 작품에 내재한다. 그것은 틸란드시아에 잠재한, 그렇지만 작품으로 현실화된 것이다. 자연에는 경계가 없다. 인위의 산물인 경계는 양면적이다. 경계가 한계로 작동할 때 경계의 위반은 희열로, 질서일 때는 불안으로 다가올 것이다. 인류학자들에 의하면 문명과 자연의 구별은 금기의 유무에 있다. 금기란 경계를 말한다. 경계 안에만 머물러 있을 때 변화는 불가능하다. 경계 밖에만 있다면 삶을 안전하게 영위할 수 없다. 예술적 표현도 불가능하다. 광기와 예술에 관한 신화적 이미지가 있지만, 예술이 소통인 한, 그것도 언어임은 분명하다.

물론 경계를 넘어서는 타자, 광기, 바깥 등등으로 분류되는 것들이 표현의 원동력을 제공해 주고 한정된 표현을 변화시킨다는 점은 무의식의 발견 이래로 널리 인정되는 바이다. 경계 안팎을 넘나드는 존재태는 표현 불가능할 것을 표현하려는 과제를 수행하는 예술 및 예술가의 방식과 조응한다. 경계는 인간사회에서 매우 중요하다. 하지만 그것이 중요한 만큼 확실한 것은 아니다. 구조주의 인류학자 레비 스트로스(Levi Strauss)는 분류의 원리에서 "미리 결정된 공리란 없다."고 말한다. 그에 의하면 체계는 양면성을 가진다. 내적 통일성과 확장성이 그것이다. 인류학자 메리 더글러스(Mary Douglas)는 깨끗함(성스러움)과 더러움(불경함)이라는 종교적 관념을 주제로 해서 분류의 원리라 할만한 것을 연구한다. 그에 의하면 상반되는 범주를 나누는 기준은 철저히 상대적이다. 메리 더글러스는 『순수와 위험』에서 성스러움은 분리해야 할 것을 분리하는 문제에 속한다고 말한다.

각기 다른 범주의 사물이 뒤섞이는 것은 불경하다. 하지만 인류학의 주장에서 예술이 참고할만한 사항은 "모든 분류체계는 반드시 이례적인 것을 낳기 마련이며, 모든 문화도 자신의 존재조건에 반항하는 사건들에 직면한다."(메리 더글라스)는 점이다. 이에 따르면 애매 모호함은 불쾌한 경험이 아니며, 예술의 풍요로움은 애매함을 이용하는데 있다. 메리 더글러스는 경계선이 불확실한 곳에서는 언제든지 오염의 관념이 출현한다고 보지만, 경계선 상에 존재한다는 것은 위험과 접촉하는 것이고 능력의 근원에 존재하는 것이라고 평가한다. 명확한 분류에 속하지 못하는 존재는 기괴하다. 그것은 괴물처럼 숭배되거나 배척될 뿐 일상적 삶과 조응하지 않는다. 김유정이 작품에 끌어들이는 대상이나 수집물 등은 대부분 일상적 삶의 산물이다. 이국적 식물도 그것이 관상의 대상으로 머무르는 한 그 자체로서는 평범하다. 작가는 평범한 삶에서 찾아지는 것들을 선호한다.

그렇지만 평범함은 약간의 중심이동을 거치고 그로테스크나 기괴한 분위기를 낳는다. 그로테스크가 문예사조적인 배경을 가진다면, 기괴함은 보다 심리학적이다. 기괴함의 근원이 초월이 아닌 일상에 있다는 점은 자주 지적되어 왔다. 로즈메리 잭슨(Rosemary Jackson)은 『환상성』에서 기괴한(uncanny)이란 단어는 1785년까지 '위험하고 불안전한'이란 의미로 쓰였다고 지적한다. 기괴함에 대한 현대적 분석은 프로이트에 의한 것인데, 프로이트에 의하면 기괴함은 '오랫동안 잘 알고 있고 친숙했던 것에 대한 섬뜩한 느낌'을 의미한다. 기괴한 것은 그 자체가 아니라 오직 친숙한 것, 정상적인 것과의 관계 속에서만 존재하는 관계적 규정이다. 로즈메리 잭슨에 의하면 관계성에 의해 규정된다함은 어떤 단일화된 리얼리티에 대한 모든 재현을 전복한다는 의미다. 로즈메리 잭슨은 엘렌 식수스(Hélène Cixous)의 분석을 인용한다. "기괴함은 관계적 기표이다. 왜냐하면 기괴한 것이란 합성물이기 때문이다. 즉 그것은 사물들 사이의 틈새에 스며들고 우리가 단일성을 보장받고 싶어하는 그 지점에서 하나의 간극을 강력히 주장한다."

식수스는 기괴한 것이 주는 낯설음을 '단순히 전치된 성적 불안이 아니라, 순수한 부재, 죽음과 대면하는 시연'으로 제시한다. 죽음은 직접적으로 묘사될 수 없다. 그것은 죽음을 상징하는(memento mori) 형상이라는 것이다. 로즈메리

잭슨의 해석은 일상뿐 아니라 종교같은 초월적인 영역도 해당된다. 그에 의하면 불가사의한 신비에 대한 종교적 감각은 세속화의 과정을 거치면서 기괴함의 감각으로 다시 나타난다. 그러나 그 둘의 심리적 기원은 동일하다. 로즈메리 잭슨은 기괴함이 불온하고 공허한 영역을 지칭한다고 말한다. 그는 기괴함을 "신성한 이미지에 대한 믿음을 상실함으로써 야기되는 텅 빈 공간"이라고 보는 하이데거를 인용한다. "진실로 자기 자신을 신의 공간 안에 위치시키는 것의 불가능성에 비례해서 기괴한 무언가가 발생할지도 모른다."(하이데거, Heidegger) 김유정이 부엌과 욕실, 침실, 거실 등에서 흔히 발견되는 가장 친숙하고 일상적인 사물을 정반대의 것으로 뒤집는 방식은 심리학부터 미학, 인류학부터 종교에 이르는 광범위한 해석의 그물망에 걸쳐 있다.

그것은 우연찮게 발견한 이 식물이 단순한 소재를 넘어서 작업 전면을 차지하며 확장되는 이유일 것이다. 오랫동안 해왔던 프레스코 작업으로 먼지가 많이 날리는 작업실 환경을 개선하기 위해 선택된 이 반려식물의 비중은 점차 커졌으며, 이제 작가는 건물 전체를 뒤덮을 프로젝트까지 상상한다. 전시가 끝나도 작가의 머릿속에서 이 식물은 계속 자라나고 있다. 작가에게 작품이나 전시는 그 너머를 기약하는 하나의 경계일 수 있다. 경계가 없다면 그 너머도 없다. 인간의 삶에 의식(儀式)이 필요한 이유이다. 그러나 현대사회에서 의식은 형식화되어 실질적으로는 사라지고 있다. 근대 이래로 예술이 종교의 계승자였던 것과 마찬가지로 의식 또한 예술에서 상징적으로 보존되어왔다. 현대사회에서 예술이 문화로 경량화되거나 사라지는 것은 의식의 쇠퇴와 무관하지 않다. 현대는 코드화와 크게 다르지 않은 형식주의가 공동체에게 상징적 우주를 제공해 주었던 의식을 대체한다.

금기도 위반도 그 힘을 잃었다. 김유정의 작품에서 식물은 설치는 물론, 평면 작품에서도 호시탐탐 제 영역을 넓히려 한다. 앨런 와이즈먼(Alan Weisman)의 저서 『인간 없는 세상』과 김영하의 식물 세력에 대한 이야기에 관심을 갖고 영감을 받은 ≪식물에도 세력이 있다≫(소피스갤러리, 2018)는 식물성에 내재한 수동성이나 정지의 관념을 걷어낸다. 식물이 생명에너지의 기원이 된다는 사실뿐 아니라, 인류의 상상력 속에서 식물 자체가 부활과 재생의 모델이 되어왔기 때문이다. 마이클 조던(Michael Jordan)은 『초록덮개』에서 네안데르탈인의 유골과 함께 발견된

수많은 꽃가루 유적의 예를 든다. 즉 그것은 시신이 꽃으로 둘러싸였었다는 것을 보여주는데, 그것은 그의 영혼에게 회복 기회를 주기 위한 것이라고 해석한다. 식물은 동물만큼의 활동성이 없는 대신에 정신적인 면, 즉 신비를 내포한다. 부활과 재생이라는 끝없는 변화는 생사를 초극하는 신비의 차원이다. 마이클 조던은 빙하기의 원시인들에게 봄은 정신적인 부활이었다고 말한다.

이러한 신화는 고대인들이 겨울과 긴 가뭄이 이어지는 시기에 일어나는 자연의 죽음을 어떻게 설명했는지를 보여준다. 마이클 조던은 죽었다가 소생하는 신이라는 고대의 전통은 기독교 시대에도 살아남았다고 기술한다. 김유정에게 이 특이한 식물은 처음에 환경 정화의 목적으로 선택되었지만, 곧 표현으로, 의미를 넘어 존재 그 자체로 변모했다. 대상이나 사물과 다르게 생명은 여전히 미지의 영역에 속한다. 그것은 매혹과 두려움을 동시에 낳는다. 대부분 전시되는 장소성에 충실한 연극적 연출은 그 내부로 들어온 관객을 참여시킨다. 여기저기 걸쳐 있는 식물이 오감에 호소한다는 의미뿐 아니라, 수분을 필요로 하는 식물의 생태에 맞춰 관객은 일종의 돌봄 행위에 참여하게 된다. 작년 여름에 있었던 ≪잠식 항(航)≫(정서진 아트큐브, 2020) 전에서 관객들은 비치된 분무기로 전시장에 가득한 식물에 물을 뿌려 주었다.

식물은 전시 기간 동안 조금씩 자라거나 시들 것이다. 김유정의 작품은 예술 또한 삶처럼 끊임없이 변화함을 말한다. 단선적 사고를 벗어나 무엇이 '발전'인지 정확하게 규정할 수 없는 상황에서 변화 또한 경계처럼 양면적이다. 변화는 좋은 것이든 아닌 것이든 일단 존재하는 것이다. 존재 자체가 변화이다. 첫 개인전 ≪Reading Walls and Shadows≫(관훈 갤러리, 2003)를 시작으로, 요즘 작업을 '잠식'하고 있는 틸란드시아는 2015년에 인천 아트플랫폼에 입주하면서 발견했고, 개인전에서는 ≪조각난 숲≫(인천아트플랫폼, 2016)에 처음 등장했다. 2021년 동일한 장소에서 진행된 기획전에서도 다시금 선보였다. 최근 작품에서 설치 규모는 점점 더 커지고 있다. 인류에게 치명적 상처를 안겨준 코로나 사태가 한창이던 2020년 중반기와 2021년 초, 그리고 올해 중반에 개인전과 주요 기획전을 연이어 열면서 자신에게 치유와 돌파구가 되었던 식물의 무대는 또다른 의미로 확장되고 있다.

식물은 공간 전체를 잠식하곤 하는 대규모 설치뿐

아니라 사진과 프레스코 등을 통해 다양한 서사로 연결된다. 서로 다른 형식의 작품들은 끊어질 듯 이어지면서 의미를 보충한다. 뿌리 없는 존재는 본질과 중심 또한 부재하지만, 바로 그렇기 때문에 무엇으로도 될 수 있다. 틸란드시아는 관엽식물로 하얗게 꽃도 피우는 등 나름대로 성장이라는 것을 하지만, 부분과 전체의 관계가 모호한 형태는 원시적으로 보인다. 하지만 현대 철학에서 리좀과 수목구조의 비유가 설득력을 얻은 이래, 부분과 전체의 관계가 해체된 리좀적 방식의 긍정성이 부각 되어왔다. 이 뿌리 없는 존재는 극한의 조건에서 살 수 있는 비유로 인해 인간 이후의 세계에 대한 비전을 보여주기도 한다. 어느 순간 강화된 인간과 자연의 적대적 관계를 생각할 때, 문명에게는 종말론적 이미지가 자연에게는 원래 상태로의 복귀가 될 수 있다. 상처와 치유의 관계 또한 어느 입장에 서는가에 따라 달라진다.

김유정은 명확히 어느 편을 주장하는 것은 아니다. 예술은 단지 예술이 지속되어야 한다는 것 외에 어떤 편도 들지 않는다. 작가는 중립적인 입장에서 여러 상황을 연출하고 관객의 상상에 맡긴다. 실제로 이 남국의 식물은 큰 나무를 뒤덮으며 공생하는 종으로 알려져 있다. 도시의 주조색인 회색빛 콘크리트 벽에 기묘하게 어울리는 틸란드시아는 프레스코화로 표현한 식물원처럼 인간의 영역에 깊이 들어와 있는 자연이다. 프레스코 작업의 특징인 표면을 긁어낸 상처를 식물이 덮는다는 서사는 문명의 주변부로 밀려난 자연 복귀를 긍정적 측면을 암시한다. 그러나 복귀된 자연이 과거에 인간이 그러했던 것처럼 선을 넘는다면 긍정은 부정으로도 전환될 수 있다. 작가는 어디에도 뿌리를 내리지 않는 대신에 어디에도 갈 수 있는 그 식물의 독특한 생태적 조건을 활용하여 재현되지 않는, 또는 재현될 수 없는 무엇을 생성과 소멸의 과정으로 제시한다.

2. 식물의 제국

2020년 인천 정서진 아트큐브에서 열린 ≪잠식 항(航)≫ 전은 바다에 인공적 물길을 낸 아라뱃길의 시작점이 있는 장소성을 살린 식물 설치작업이다. 활짝 열린 입구 밖으로 바다가 보이는 전시장에서 수명을 다한 오래된 배와 항구에서 쓰였던 물건들이 활용되었다. 살아있는 식물을 푹 뒤집어 쓴 채 일부를 노출한 오래된 사물들은 이 뜻밖의 만남에 의해 재생되는 듯하다. 사물과 자연이 만나 예술이 되었다. 작가가 활용했던 '무동력 배, 물류창고의 운반 상자들, 구명, 부환, 조타장치, 핸들 조타기, 향해등, 통발 어구' 등은 일반인들에게는 그 자체로도 낯선 물건들이며, 이국적 식물과의 만남으로 더욱 신기하다. 그로테스크나 기괴함이라는 관념이 무지와도 관련될 수 있는 대목이다. 그러나 배와 식물은 밀접해 보이기도 한다. 이 전시에 쓰인 회색빛 수염 틸란드시아 또한 자생이 아니라 수입 식물이니 배를 타고 오지 않았겠는가.

전시공간 대부분을 차지하는 항해와 관련 물건들은 바닥과 벽을 모두 활용하여 가변적으로 설치되었으며, 어떤 대상도 융통성 있게 감싸 안을 수 있는 식물은 복슬복슬한 실루엣을 남긴다. 기능을 가진 물건의 여러 면과 각은 둥글려 있다. 날것이었으면 을씨년스러울 수 있는 풍경이지만, 눈이 소복이 쌓인 풍경처럼 포근하다. 2021년 1월에 열린, 서교동에 위치한 복합 문화공간 L.A.D의 개관전 ≪공유지≫는 항구와 마찬가지로 물과 연결되어 식물이 호출된다. 원래 주방이

자리했던 장소에 다시 세팅된 주방과 욕실 물품은 보다 일상적인 공간과 관련된다. 식물은 심미적 효과를 자아낼 거리를 만들어낸다. 여기에서도 식물은 변모와 재생의 상징이다. 김유정의 작품에 내재된 양면성은 파괴와 건설이 동일한 과정의 양면인 것과 같다. 사람들이 모이는 일상공간 아래에 자리한 지하 전시장은 프로이트식으로 구별하자면 무의식의 영역에 해당된다.

관객은 동굴처럼 어둑한 전시장으로 내려가면서 의식(意識) 아래로도 내려가는 것이다. 낯선 풍경 속에서 자신의 낯선 모습을 보게 된다. 작가는 이를 위하여 거울이라는 대상을 특별히 비워놓기도했다. 이전에 가정집 지하실로, 욕실이나 주방도 갖춰져 있던 장소는 또 다른 사물/작품으로 채워진다. 인간이 만들 수 있는 것(문명)과 창조할 수 없는 것(자연)이 만나 미지의 대상으로 변모한다. 현대미술은 예술과 일상 사이에 존재하는 사물의 영역에 주목했다. 미술사나 작가의 의도로부터 출발한 의미로 과포화된 예술, 그리고 명확한 기능과 쓸모와 가격을 가진 일상이 아닌 곳에 사물이 있다. 특히 시간의 더께를 쓴 오래된 사물은 더 시적이다. 이러한 사물은 실제로 수집되거나 사진을 통해 간접적으로 수집된다. 작가는 한 인터뷰에서 "일상 속에서 발견된 익숙한 대상에서 낯설게 다가오는 기억의 편린이나 이미지들을 기록하는 것을 좋아한다"고 말한다.

이 전시에서 구석구석에 걸려있거나 놓인 사진들은 큰 규모는 아니어도 메인 설치 작품과 대화적 관계를 가진다. 사진이 회화의 경쟁자로 미술사에 처음 등장했을 때 세상의 구석구석을 이미지로 수집하는 사진의 능력은 탁월했다. 시각 예술의 역사에서 사진이 더 오래된 매체인 회화를 흉내내려 했다면 회화는 사진의 수집 능력을 활용했다. 사진은 영감의 근원으로 기억을 보조하는 수단으로 또는 그 자체로 활용되었다. 김유정은 수집된 사물을 식물과 함께 연출한 설치작품 사이사이에 사진으로 수집한 식물을 배치했다. 배수구 옆의 수분이 잠시 모이는 틈 사이에 자리한 식물 사진들은 문명이 밀어낼 때까지 밀어낸 극단적인 시공간 속에서도 비집고 나와 있는 존재의 생명력이다. 설치작품의 맥락에서 보자면, 식물이 고군분투하는 초창기 모습일 수 있다. 흔히 잡초라고 말해지는 식물들은 결국 이러한 틈새들을 넘어서 전체를 차지하기 때문이다.

김유정이 선호하는 소재는 오래된 물건으로 전시장에 가보면 버려진 물건을 수집해서 활용한 것들이 많다. 실내화부터 어선까지 그 규모와 종류도 다양하다. 원래 평면 작업을 주로 했지만, 우연한 기회에 만난 틸란드시아는 기존의 작품을 실제 공간에 끌어내는 견인차 역할을 했다. 오래된

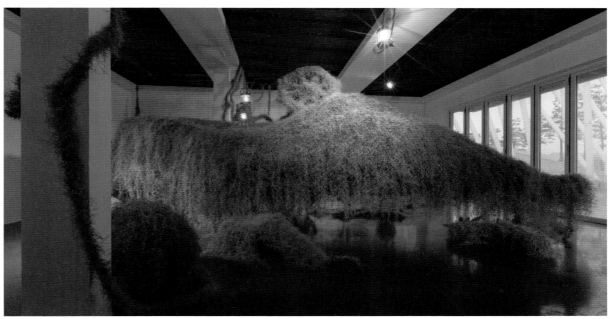

Submerged Vessel
잠식 항(航)

2020
tillandsia, ship, various objects in the port, net, wire
dimensions variable

집의 벽을 잠식하는 담쟁이 식물 같은 이미지는 이미 작가의 이전 그림 속에 있었던 것이다. 가는 선으로 이루어진 식물은 형태로든 그림자로든 공간에 그림을 그리게 했다. L.A.D의 전시장에 들어서면서 보이는 작품 <반그늘 잠식지_물의 시원1>(2021)의 골조를 이루는 사물은 씽크대, 가스렌지, 냉장고, 전자렌지, 밥통, 주전자 등 각종 주방 기기들이며, 선반이나 줄 같은 구조와 자연스럽게 어우러진다. 작가가 직접 사용했던 것이거나 수집한 것들이다. 요즘 예기치 못한 재난으로 주방 기기들이 매물로도 많이 나와있는 상황을 염두에 둔다면 시적이라고만은 볼 수 없을 것이다.

식물이 화분 안에 있었다면, 주방 기기들 위에 식물이 없었다면 극히 자연스러웠을 풍경이지만 모두 자기 자리를 벗어나 있거나 은폐되어있음으로 인해 낯설어진다. 태양의 방향을 향하는 대부분의 식물과 달리, 반그늘 속에서 아래로 축축 처지면서 중력에 반응하는 이 식물은 멜랑콜리한 느낌을 준다. 특히 방과 방사이로 늘어진 줄까지 잠식한 식물은 오래된 정지의 시간을 증거 한다. 매일 일용할 양식을 마련하고 설거지를 하느라 분주했을 개수대는 우묵한 지형처럼 드러난다. 인간적인 삶은 또다른 삶에 의해 잠식된다. 작품 <반그늘 잠식지_물의 시원2>(2021) 또한 부엌처럼 물이 있었던 공간을 전제로 한 설치물이다. 머리가 닿을 듯한 나지막한 공간에 자리 잡은 욕조, 변기, 선반, 거울, 세면대 등 또한 부엌과 마찬가지로 작가가 직접 사용하거나 수집한 물건들이다. 세면대와 변기, 욕조 등이 기능에 충실한 맨들맨들한 표면을 감추고 있다.

덥수룩한 식물 사이로 스테인레스 스틸 재질의 부속품 일부가 날카로운 빛을 발한다. 식물은 욕실의 거의 모든 사물을 덮었지만, 위로 비스듬하게 걸린 거울과 작은 수납장의 거울 표면은 그대로 드러나 있다. 다른 욕실 물건에서 조금씩만 드러나는 빛나는 표면은 여기서 온몸을 드러낸다. 거울은 복제에 근거한 문명의 총아로 그 중요성을 강조할만 하다. 또한 그것은 마주한 이의 자아를 상상하게 하는 작은 무대가 된다. 일종의 무대 속의 무대인 셈이다. 광물질적인 날카로움이 복슬복슬한 식물의 피막과 비교된다. 기능주의를 위해 벌거벗었던 사물의 피부를 따스하게 덮는 식물은 치유적 이미지로 다가온다. 어둑한 조명 때문에 그림자도 강조되는데, 사물과 식물의 일체화가 강한 경우에 번진 선 같은 느낌으로 벽과 바닥에 '그려진다'. 슬리퍼 위에도 덮여있는 식물은 부재감을 강조한다. 김유정의 작품은 부재감을 환상성과 연결시킨다.

로즈메리 잭슨은 『환상성』에서 환상적인 것의 핵심을 기표와 기의 간의 분리라고 말한다. 무엇인가 숨긴 듯 엉뚱한 외피를 걸치고 있는 선, 면, 그리고 덩어리들은 기표와 기의를 분리시킨다. 표면 아래에는 무엇인가 있을 수도 있고 없을 수도 있다. 하지만 그것이 표면과 연속성을 가질 것이라 믿어지지는 않는다. 핵심과의 연결이 끝없이 유예되는 과정은 초현실주의적이다. 로즈메리 잭슨은 환상은 현존을 부재로 대체시킴으로써 비의미의 영역, 즉 죽음을 끌어들인다고 말한다. 그에 의하면 기괴한 것은 문화적 연속성을 위해 억압되어야 하는 충동을 표현한다. 하지만 억압된 것은 귀환하기 마련이다. 프로이트(Freud)는 기괴하거나 죽음을 환기시키는 모든 것을 문화적 금기의 대상으로 간주한다. 로즈메리 잭슨은 애드가 앨런 포(Edgar Allan Poe)의 환상적인 작품들의 예를 들면서 심리적 공포와 원시적 욕망을 표현하기 위해 봉쇄된 곳, 황무지, 지하실, 어두운 장소라는 고딕 지형학을 도입한다고 본다.

하지만 현대의 작가에게 고딕적 지형학은 악마적인 것이라기 보다는 단순한 부재로 이해된다. 김유정의 작품은 고딕적이기 보다는 "적당한 재현물을 가질 수 없으며, 그리하여 모든 것이 좀 더 위협적인 것이 되었다는 사실"(로즈메리 잭슨)만을 암시할 따름이다. 로즈메리 잭슨에 의하면 그것은 이름과 형태가 없는 어떤 것이다. 이름이 붙여질 수 없기 때문에 그것은 쉽게 추방되지도 않는다. 그것은 선이나 악으로 명명되는 것에 앞서 존재한다. 익명의 존재, 형태 없고 형식 없고 이름이 없는 것, 말해질 수 없는 공포가 거기에 있는 것이다. 김유정의 작품은 분류와 명명이 가능하기 위한 경계가 끊임없이 해체되는 상황을 은유한다. 부엌과 욕실을 잇는 중앙 공간 벽에 설치된 선반 위의 화분이 있는 작품 <풍경이 된 정물_보여지기 위한 Ornamental>(2021)은 다른 식물처럼 화분 안에 갇혀있지 않는다. 뿌리를 내리지 않는 이 존재는 전시공간 여기저기를 연결하는 선을 따라 경계를 넘어 이동하는 듯하다.

화이트 큐브와 달리 작은 칸막이 공간이 많은 장소에서 식물은 끊어질 듯 이어지며 사진, 회화, 설치 등 여러 장르에 포진해 있다. 식물설치 작업은 화이트 큐브보다는 삶의 공간, 중성적이기보다는 흔적이 있는 공간과 잘 어울린다. 전시공간이 화이트 큐브라면 그 자체가 하나의 방처럼 연출될 수도 있다. 2018년 개인전 ≪식물에게도 세력이 있다≫(소피스 갤러리)의 작품 <세력도원>(2018)은

한 공간을 침실로 가정하고 식물로 뒤덮었다. 포근함과 부재감이라는 상반된 감성이 공존하는 작품이었다. 선적 요소 때문에 선호하게 되었다는 틸란드시아의 선은 이전의 선을 지우는 또다른 선, 그렇지만 고정됨 없이 생멸하는 선, 느릿하지만 변화의 와중에 있는 살아있는 조형적 요소가 된다. 2021년 인천아트플랫폼의 기획전에 출품된 <야생전도>는 건물 두 개 층을 횡단하는 풍경이다. 산수화를 볼 때 그 안으로 들어가서 소요하고 싶은 생각을 실제 공간에서의 설치작품으로 구현한다.

전시공간 전체는 틸란드시아의 촘촘한 선들이 펼쳐지고 접혀지는 동양화의 여백같은 모습이다. 작가는 이에 대해 "식물로 그림을 그린 듯해 틸란드시아 산수화로 부르기도 하며, 야생 풍경으로 완성된다"고 말한다. 작품 <야생전도>는 2016년 ≪조각난 숲≫(인천아트플랫폼)에서도 실험적으로 시도된 바 있다. 이전의 가변설치 작품 <틸란드시아>(2016)가 식물을 하얀 벽에 산수화처럼 걸쳐놓았다면, 2021년 같은 장소에서 다시 설치한 작품에서는 규모를 더욱 크게 하여 보여지는 산수를 넘어서고자 한다. 작품 상단부는 산의 뼈인 광물질의 실루엣을 따라 흐르는 식물이지만, 아래는 쑥 빠져버린 모습이다. 유토피아적인 산수화라기 보다는 홍수로 떠밀려 내려온 부유물같은 느낌도 있다. 중력의 작용은 받지만 뿌리 없는 존재가 만들어내는 풍경이다. 바닥은 없다. 심연도 없다. 전시공간이라는 한계 외에는 틀이 없는 생물 설치작업과 달리 라이트박스를 활용한 작품에서 식물은 내부에 들어가 있다.

진짜 식물이 사용되지 않아 규모를 환경적 차원으로도 확장하는데 더 용이할 수 있다. 2020년 광교아트스페이스의 기획전 ≪뜻밖의 초록을 만나다≫ 전에서는 한참을 걸어도 계속되는 벽같은 스케일의 작품을 선보인 바 있다. L.A.D에서는 관객 동선의 맨 마지막에 위치한 공간에 설치되어 자연과 문명의 관계에 대한 상념에 잠기게 한다. 작품 <재생_숨>(2021)은 수집된 책장을 라이트 박스로 삼고 그 내부에 센서를 통해 관객의 움직임에 반응하는 인조식물이 자리한다. 나지막한 천정 모서리에 마주 보고 설치한 라이트 박스 안의 식물은 관객이 다가가면 반응하여 바람에 흔들리는 듯한 모습이다. 작가가 직접 우즈베키스탄에서 녹음해 온 새소리도 들린다. 작가는 이에 대해 '음영의 농담으로 보여지는 그림자의 톤들이 새벽 안개 사이로 바람에 흔들리는 살아있는 듯한 자연풍경을 체험하게 하며'...'공간에서 강하게 투과되는 빛 사이로 서정성이 짙은 새벽 숲과도 같은 치유의 정원'을 의도했다고 밝힌다.

문풍지에 비친 식물같은 입체설치물은 현대 광고판의 형식과 동양적 정원의 느낌을 결합시킨다. 보통 라이트 박스는 광고판으로 많이 이용한다. 나무틀에 덧씌운 천도 간판에 많이 활용되는 천이다. 라이트 박스 안의 식물은 모조 식물이지만 흐릿해서 진짜인지 아닌지 가늠할 수 없다. 빛나는 하얀 바탕에 비치는 푸릇한 기운은 그것이 그림자는 아니라는 것을 알려준다. 하얀 여백 위에 그려진 동양화 같은 모습이다. 생산력의 발전을 통해 자연을 전면적으로 착취하기 시작한 근대 이후 자연은 인간의 필요에 종속되었다. 관상용 또한 자연에서 보고 싶은 것만 골라서 '생산'한다. 만약 인간이 정글 속에서 길을 잃었다면 결코 식물은 저렇게 얌전한 모습이지 않을 것이다. 현대 도시에서 식물은 인간에게 길을 비켜준다. 인간의 계획에 따라 심어지고 뽑힌다. 그것도 유행을 타서 주기적인 폐기의 대상이 되기도 한다. 작품은 한 겹 가려진 모습이기에 특이한 형태의 틸란드시아가 아니라 보다 전형적인 식물의 잎이 선택된 듯하다.

작가가 주로 활용하는 틸란드시아는 남쪽 지방의 식물로 공기정화나 관상용 등으로 개발, 또는 쓸모가 발견되어 원래의 서식지를 벗어나 또다른 소비의 회로에 진입한 것이다. 그것은 김유정의 작품에서 큰 나무를 뒤덮고 사는 원래의 생태를 복구하려는 방향성을 가진다. 자연은 인간이 건드리기 이전의 모습으로 흐트러진다. 그것은 인간적 삶의 흔적들을 잠식한다. 자연의 입장에서는 회복이다. 김유정이 자신의 작품 속 식물의 모습에서 그로테스크의 긍정적인 면을 보는 것은 인간보다는 자연의 편에 설 때 가능한 관점이다. 볼프강 카이저는 『미술과 문학에 나타난 그로테스크』에서 그로테스크의 양가적 의미를 역사적으로 추적한다. 그에 의하면, 고대유물로부터 영감을 받은 특정 양식의 장식미술을 가리키는 단어 '그로테스코grottesco'는 르네상스 시대의 사람들에게 유희적인 명랑함이나 자유로운 환상만을 뜻하는 것이 아니라, 현실의 질서가 파괴된 세계와 대면할 때의 긴장감과 섬뜩함 또한 의미했다.

여기서는 사물, 식물, 동물, 인간의 영역에 대한 정확한 구분, 정역학의 질서, 대칭의 질서, 자연스러운 크기의 질서도 사라지고 있다. 김유정의 경우 구불거리는 식물문양이 다른 것으로 변형되는 식은 아니지만, 대상을 덮는 것만으로도 극적인 변형이 가능하다. 어떤 형식의 변형이든 그 결과는 생경해진 세계이다. 볼프강 카이저에 의하면 그로테스크, 즉 생경해진 세계란 우리가 익숙하고 편안하게 느끼던 것이 별안간 낯설고 섬뜩하게 다가오는 것을 말한다. 동시에 우리는 이렇게 변해버린 세계에 머물 수 없음을 감지한다. 말하자면 그로테스크의 핵심은 죽음에 대한 공포가 아니라

삶에 대한 공포이다. 생경한 세계는 꿈꾸는 자의 눈 앞에서나 공상 속에서 혹은 잠과 깨어남의 중간쯤에 보이는 어스름한 환상으로부터 탄생한다. 볼프강 카이저는 '화가의 꿈'으로도 말해지는 그로테스크의 창작이란 곧 불합리한 것을 가지고 유희를 벌이는 것이라고 정리한다. 인조식물을 사용한 라이트 박스 작품 또한 그것이 살아있는 것인지 아닌지 그 경계가 모호하게 다가온다. 라이트 박스로 사용되는 사각 틀은 책장 뿐 아니라 보다 고풍스러운 사물인 자개장 등인데, 그 또한 자연과는 비교할 수도 없는 짧은 유행을 마치고 폐기 수순으로 돌아선 것들이 작품을 통해 재생된다. 《잠식 항(航)》 전에 출품된 <재생_숨 Recycle_Breath>(2020)은 자개장 서랍이 활용된다. 버려진 물건은 작품으로 되살려졌고, 이때 식물의 재생이라는 상징성을 환기시킨다. 무엇인가 담았던 오래된 가구는 이제 심미화된다. 그렇지만 김유정의 작품에서 서랍은 계속 무엇인가를 담고 있다. 가로로도 담고 세로로도 담는다. 이제 그것은 자연을 품고 그 스스로도 자연화 된다. 물론 그 안의 식물은 인조지만, 그것은 사물이 작품을 통해 또다른 시간성으로, 즉 완전한 정지는 아니지만 상대적으로 더딘 시간 안으로 봉인됨을 말한다.

라이트 박스를 건축적 규모로 키운 이전 전시 작품 <숨>(2016)에서 관객은 장면을 본다기 보다 그 내부에 들어가 있는 느낌을 받는다. 식물/이미지가 밖으로 나와 있든 안에 들어가 있든 김유정의 작품은 규모를 키워도 밀도가 흐려지지 않는다. 김유정의 또다른 작품군인 프레스코화는 석회벽이라는 무기물적 재질에도 불구하고 숨을 쉬는 듯한 재료라는 점은 비슷하다. 상처와 치유라는 은유 또한 연속적이다. 프레스코는 회벽이 마르기 전에 수성안료로 고착하여 칼슘막을 형성하는데, 김유정은 마르기 전에 뾰족한 것으로 표면에 상처를 내면서 진행하는 방식으로 제작한다. 작가는 이에 대해 '석회벽이 마르기 전에 긁기의 외상적 행위'를 통해 '현재 우리 삶의 기본적인 상처 치유를 갈망하는 현대인들의 삶을 은유적으로 표현해 왔다'고 말한다. L.A.D의 벽에 걸린 작품 <Incubator>(2014)는 신식 건물의 눈구멍처럼 뚫린 창문에서 식물이 삐져 나와 있다. 그 안에는 사람이 살고 있는가. 작가의 눈에 띄었던 파주의 어린이집은 삶의 온기나 생기라고는 찾아볼 수 없다. 위에서 억누르는 듯한 어두운 공간 또한 그런 느낌을 강조한다. 거기에는 살아있는 개체에 죽은 지식을 이식하는 교육과정에 대한 비판적 관점이 있다. 그것은 그로테스크를 환상적인 것과

풍자적인 것으로 나누는 볼프강 카이저의 구별에서 후자에 해당된다고 할 수 있다. 환상이든 풍자든 현실이라는 중심과의 관련 속에서 생겨난다. 새겨진 풍경은 평생 동안 계속될 교육이란 몸에 무엇인가를 새겨넣는 것과 같음을 암시한다. 작품 표면은 여러 시기에 새겨진 듯한 생채기들로 가득하다. 같은 제목의 시기가 다른 작품에서도 창문마다 식물이 삐져 나와 있는 스크래치로 뒤덮인 건물은 위압적으로 다가온다. 작품 <온기>(2016)는 식물원 풍경이지만, 구경하는 사람들이 많은 이국적 장소라기 보다는 낯선 모습이다. 실내에 있기에는 다소간 큰 개체들은 어디선가 이식되어온 존재들이다. 식물원은 분류하고 명명되는 자연을 대표하는 공간이다.

여기에서 자연의 질서는 인간의 질서로 환원된다. 인간의 규칙은 자연의 법칙에 비해 훨씬 상대적이다. 작가는 식물원의 구경꾼들을 삭제한다. 식물원 이미지 또한 설치작품에서처럼 인간 없는 세상의 고즈넉함, 또는 평화로움이 있다. 인간 이전 혹은 이후의 비전은 인간 바깥에 존재해온 타자를 호명한다. 줄리언 페파니스(Julian Pefanis)가 『이질성의 철학』에서 말하듯이, 타자성(Otherness)에 대한 성찰은 오래된 것이면서 동시에 새로운 현상이다. 그것은 전(前)현대적이면서 탈(脫)현대적이다. 줄리언 페파니스는 대표적인 '이질성의 철학자'인 미셸 푸코(Michel Foucault)를 인용한다. 푸코는 인간의 죽음을 말한 철학자이다. 그는 『사물의 질서』에서 "사유되지 않은 것은 오그라든 자연이나 계층화된 역사처럼 인간 속에 박혀있지 않는다. 인간과 관련하여 그것은 타자이다. 인간으로부터 태어나지 않고 인간 옆에서 동일한 새로움으로 똑같은 모습으로 태어난 타자이다"라고 말한다.

타자들을 끌어내리려는 새로운 움직임에 예술은 중요한 역할을 할 수 있다. 예술 자체가 타자적이기 때문이다. 프레스코화는 오래된 흑백사진처럼 퇴색된 모습이지만, 자연의 풍부한 질감이 가득하다. 원래 벽과 일체화된 회화인 프레스코는 유화처럼 벽으로부터 떨어져 나온다. 김유정의 작품에서는 벽의 속성이 강조된다. 마치 벽을 수집한 것처럼 말이다. 스크래치 기법은 유적지처럼 오래된 사물의 표현에 적합하다. 그것은 문명의 자연화를 말한다. 프레스코화들이 걸린 공간에 같이 있는 사진작품 <콘크리트 정글 Urban Kingdom>(2021)은 자연에 철벽을 친듯한 회색 도시에서 가까스로 자리한 풀들이 있다. 주로 버려진 것, 오래된 것을 수집하는 작가의 경향을 볼 때 문명의 빈틈에 서식하는 식물들 또한 (사진적)수집의 대상이다. 설치작품들과 함께 수집된 식물 사진을 보면 식물들은 틈새들을 벌리고 채우며 때가 되면 전체를 차지할 수 있음을 암시한다.

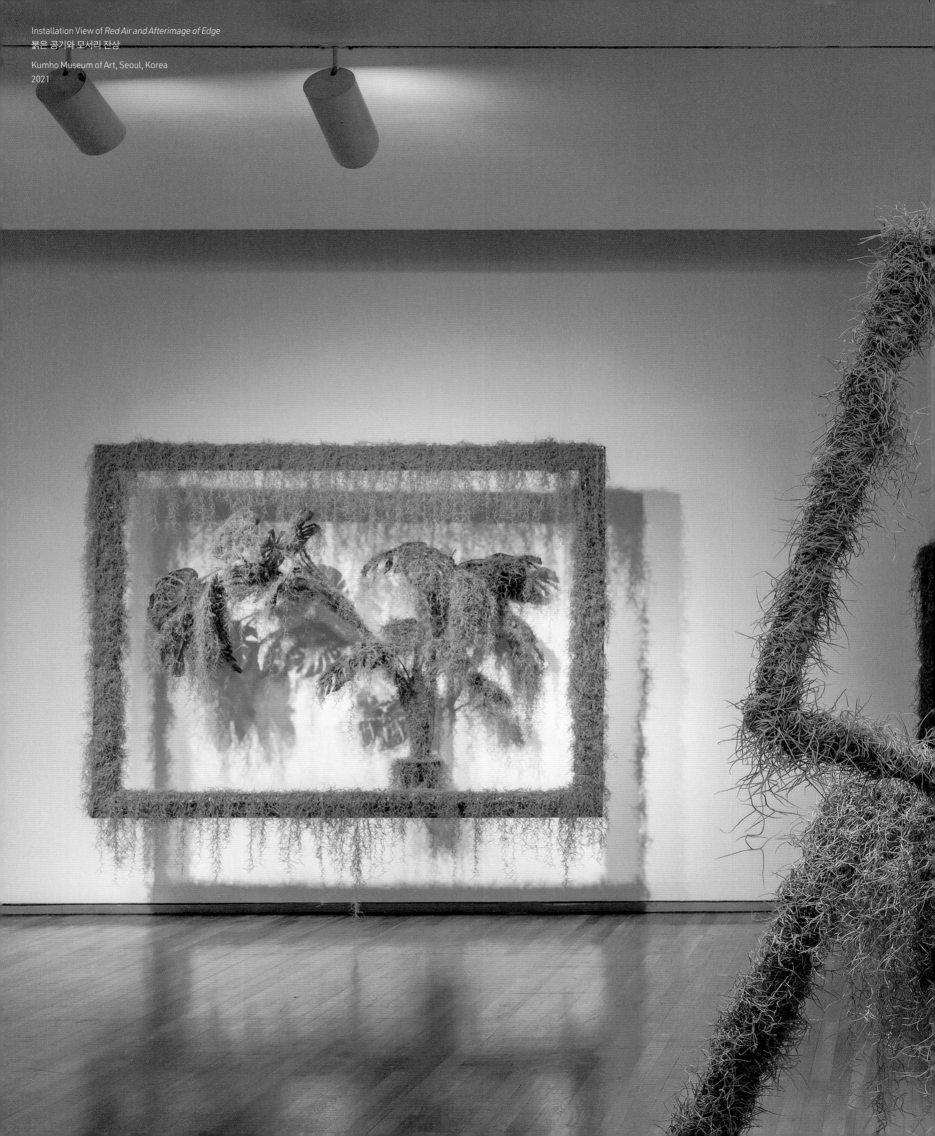

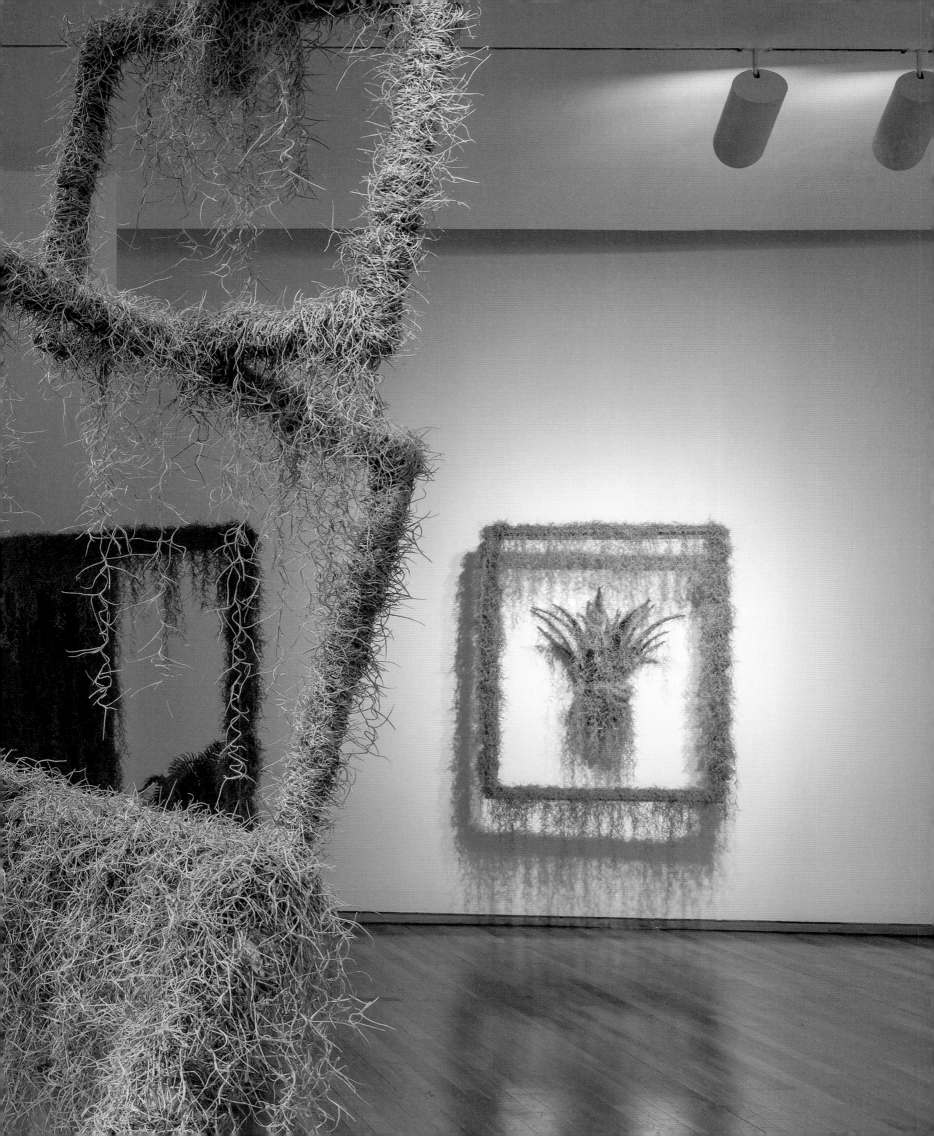

Flowing Tower
흐르는 탑

2021
tillandsia, collected frames, artificial flower pots, wire
dimensions variable

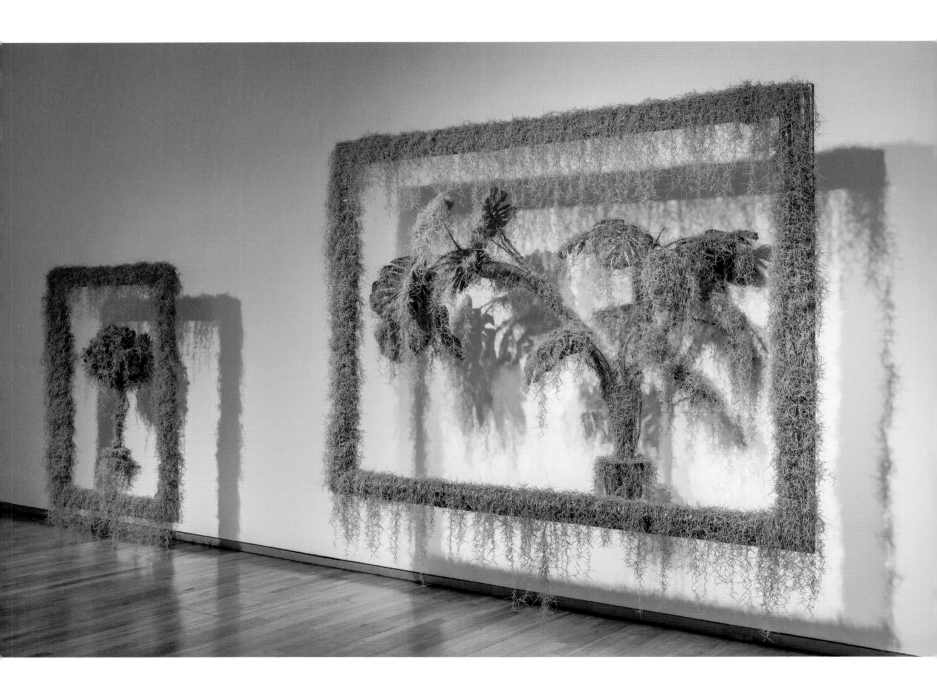

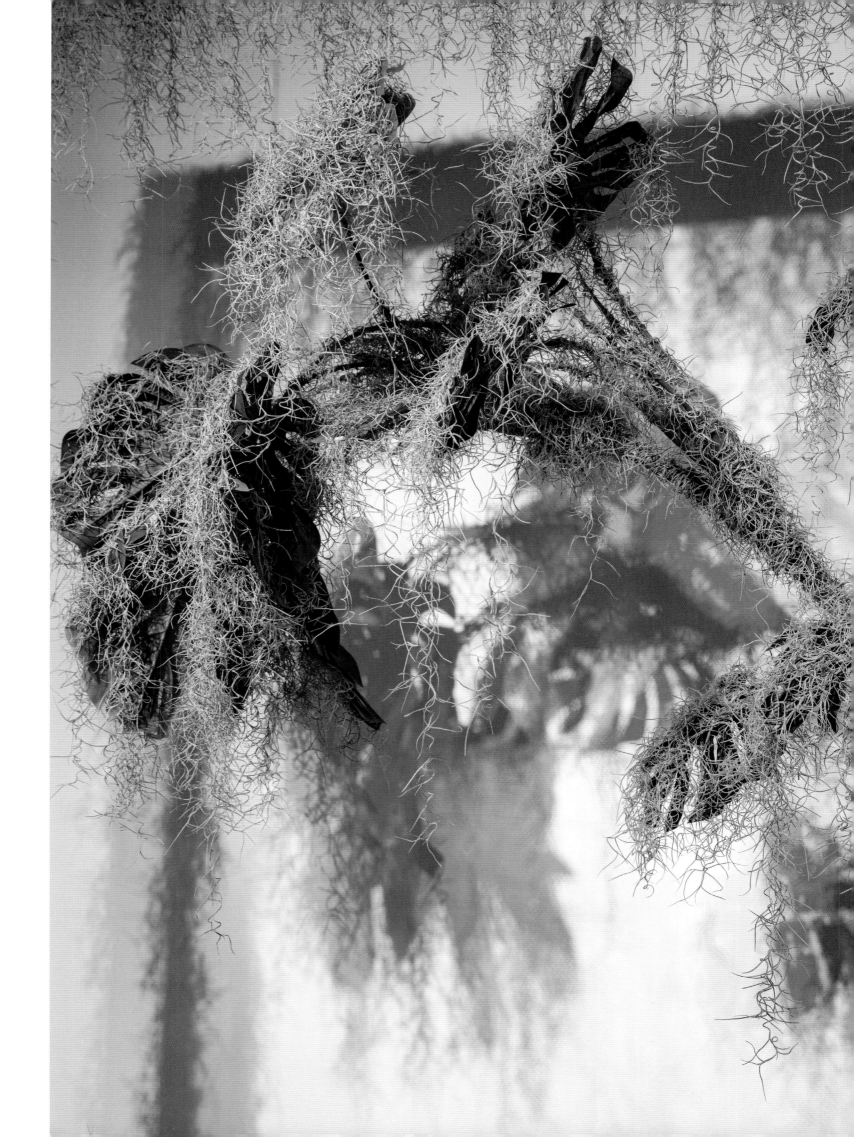

Edge of the Jungle
정글의 가장자리

President's Seat
높은 의자

2021
pigment print
162x130cm

The eyes rest on a plant growing in an unexpected place, or perhaps a form of life that has gone unnoticed. The object is consistently recorded, viewed with an affectionate gaze.

예기치 못한 뜻밖의 장소에서 나고 자라는 식물, 혹은 주목받지 못하는 생명에 머무는 눈길. 애정 어린 시선으로 바라본 대상을 지속적으로 기록한다.

President's Seat
높은 의자

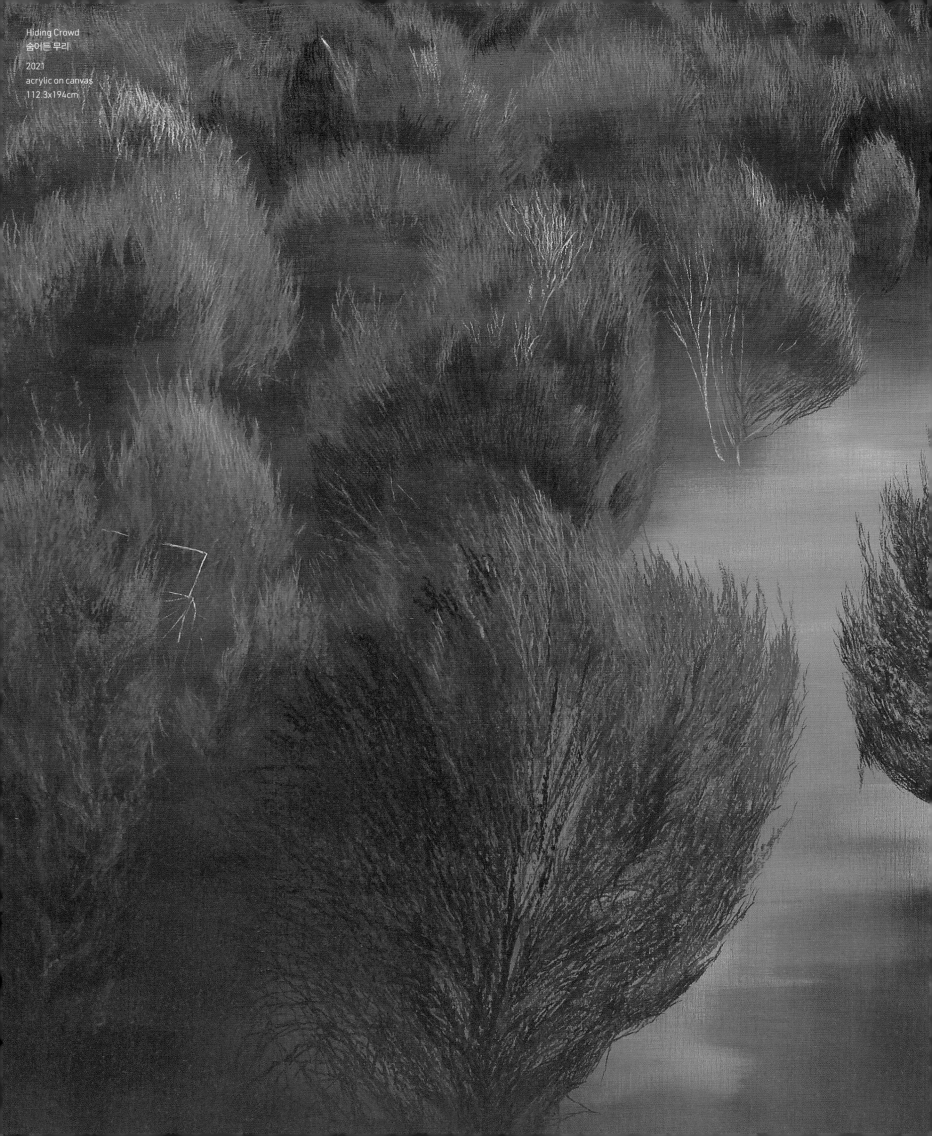

Hiding Crowd
숨어든 무리
2021
acrylic on canvas
112.3x194cm

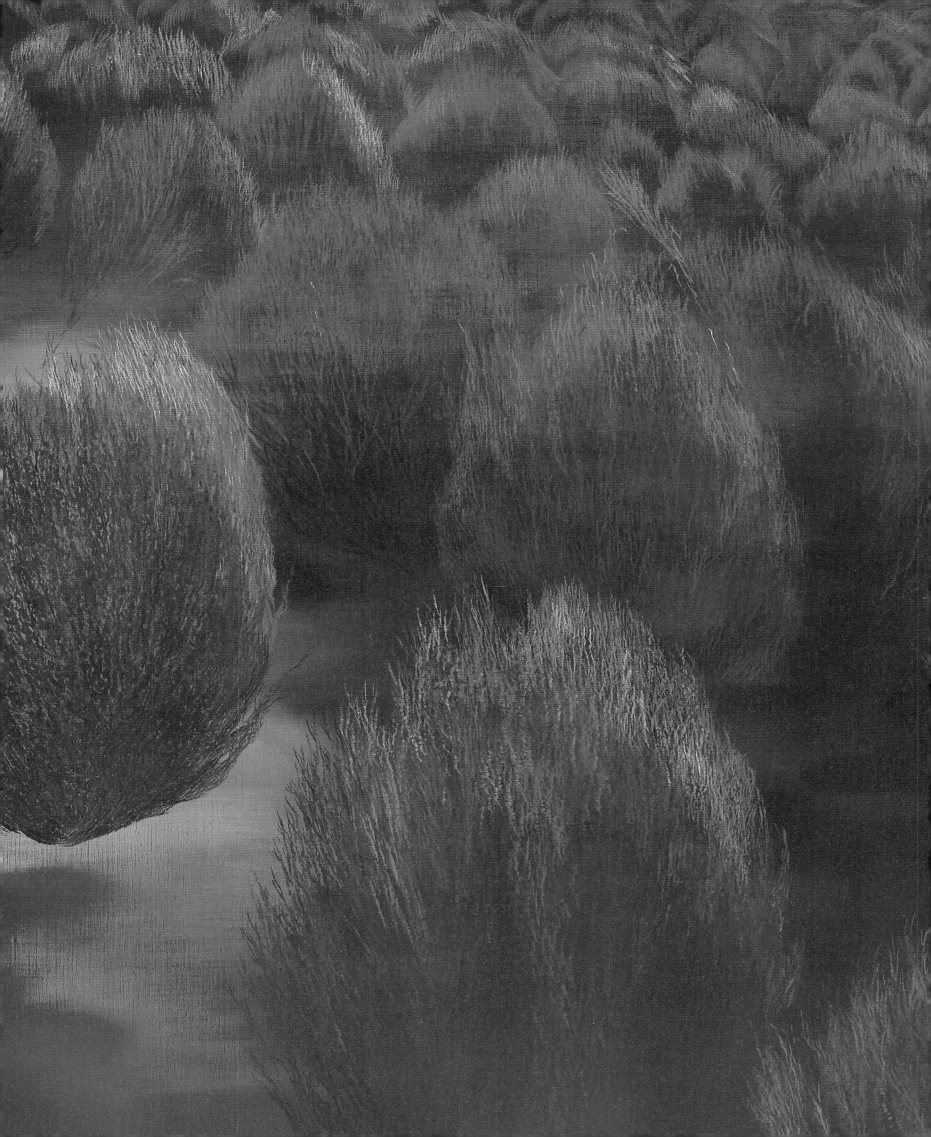

The strange and profound atmosphere possesses a red energy. The red reed stimulates the eye, while drawing people in this tourist destination and capturing the gaze with its strangeness. People sense the power of that red energy, but go on their way rather than linger where the energy swirls. Amid this scattering that floats and flows like a gas, the red reed acts as something that fixes the gaze. In this, it calls to mind the virus created amid the current pandemic.

낯설고 오묘한 분위기의 붉은 기운. 붉은 갈대는 시선을 자극하는 동시에 그 생경함으로 관광지의 사람들을 모으고 시선을 잡아 끈다. 사람들은 붉은 기운의 강렬함을 체감하지만, 그 기운이 감도는 곳에 머물기보다는 각자의 길로 향한다. 마치 기체처럼 유동하고, 부유하는 이런 흩어짐 속에서 붉은 갈대는 시선을 고정시키는 존재로서 기능한다. 현재 팬데믹 상황에서 만들어진 바이러스를 상기시킨다.

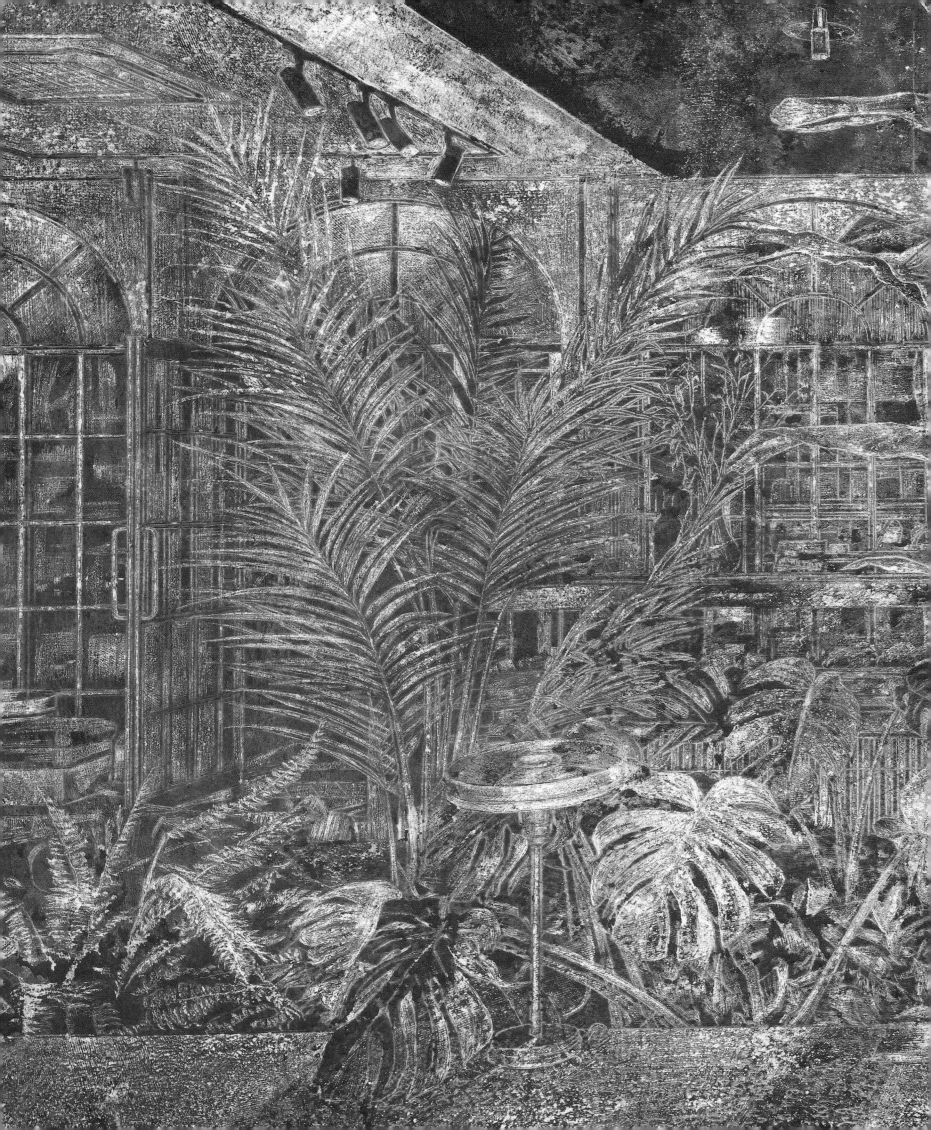

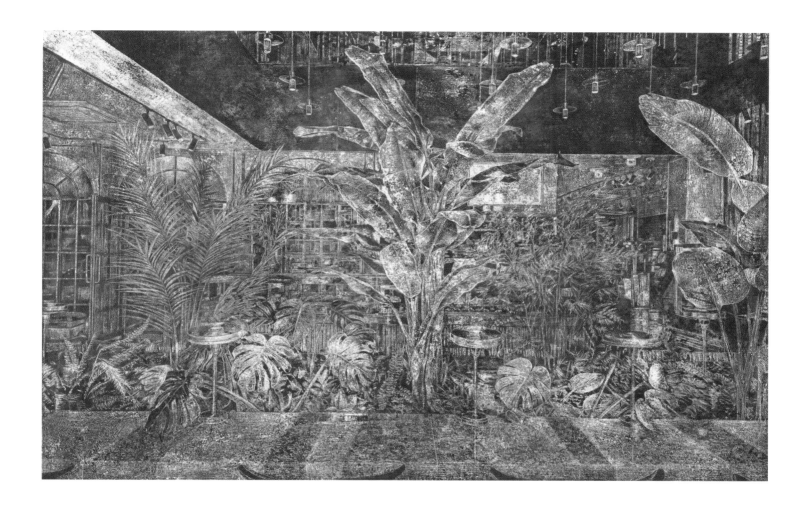

Landscaped plants—a form of "nature" imposed from a purely human-centered perspective—create environments and offer solace to people in the city. At times precariously slender, they possess at the same time a hidden force as they expand their territory.

철저히 인간 중심적인 관점과 시각에서 '자연스러움'을 강요받으며 조경된 식물은 도시에서 인간에게 위안을 주거나 환경을 구성한다.
때로는 위태로울 정도로 가녀리지만, 동시에 숨은 힘을 간직한 존재로 그 세력을 뻗어 나간다.

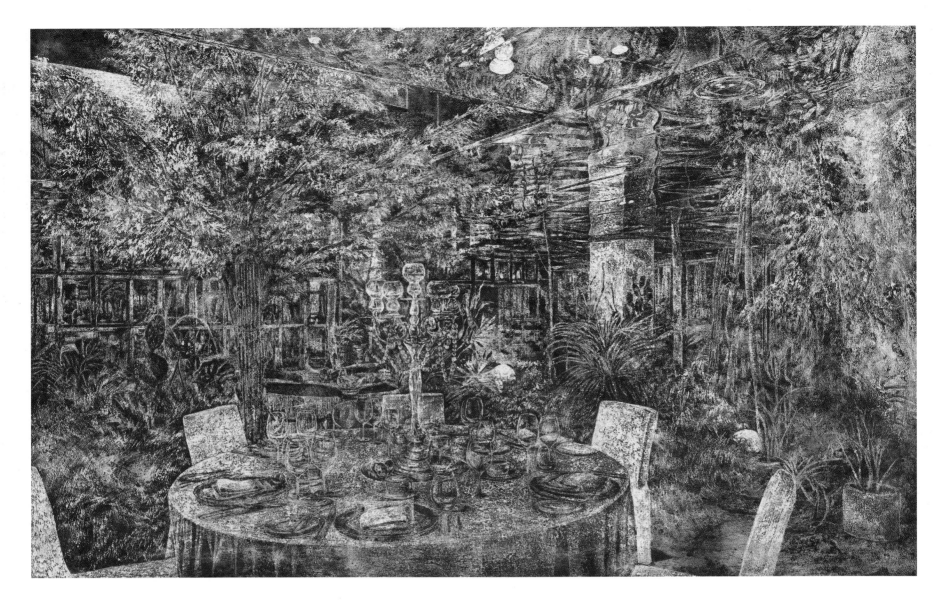

In certain settings, there are plants that draw people's attention, causing them to gather in a single place. Plants may be heedlessly left in setting as little more than a planterior decoration, but they may also exert an unexpected power of presence. As we see plants continuing to grow in the radius of human-made spaces—in the conditions of an artificially formed habitat, in other words—we are reminded once again of the relationship between humans and plants.

어떤 장소에서 식물은 인간의 이목을 끌어 이들이 한자리에 모이게 한다. 식물은 플랜테리어 도구로 전락한 공간에 무심하게 놓이기도 하지만, 동시에 예기치 못한 존재감을 발휘하기도 한다. 인간이 만든 공간의 반경 속에서, 즉 인공적으로 조성된 서식지의 조건 속에서 생장을 지속하는 식물의 모습을 통해 인간과 식물의 관계를 다시금 환기한다.

Middle Habitat of Life
중간 서식지

2021
fresco, scratch on lime wall
90x140cm

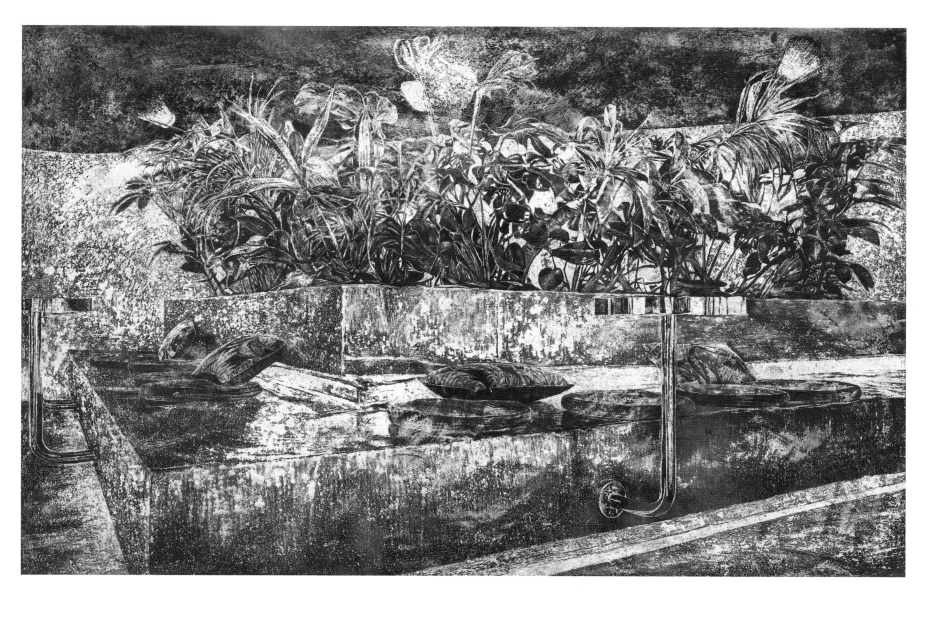

Middle Habitat of Life
중간 서식지

2021
fresco, scratch on lime wall
90x140cm

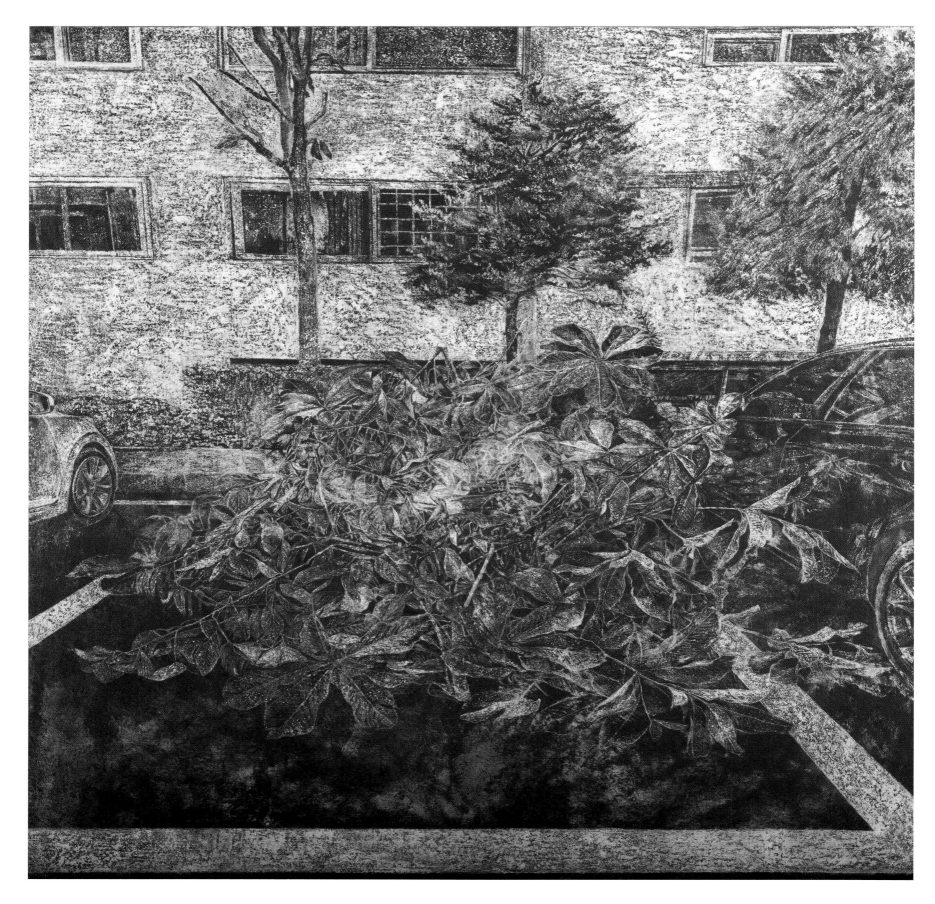

At times, plants offer protection and healing to people living in the city, only to end up abandoned. People need the presence of plants, yet we are constantly creating environments of artificial symbiosis.

도시의 삶을 사는 사람들에게 식물은 보호와 힐링의 대상이었다가 때로는 버림을 받기도 한다. 인간은 식물의 존재를 필요로 하면서도 끊임없이 인위적인 공생 환경을 조성한다.

Pieces in Between
사이 섬

2021
fresco, scratch on lime wall
120x120cm

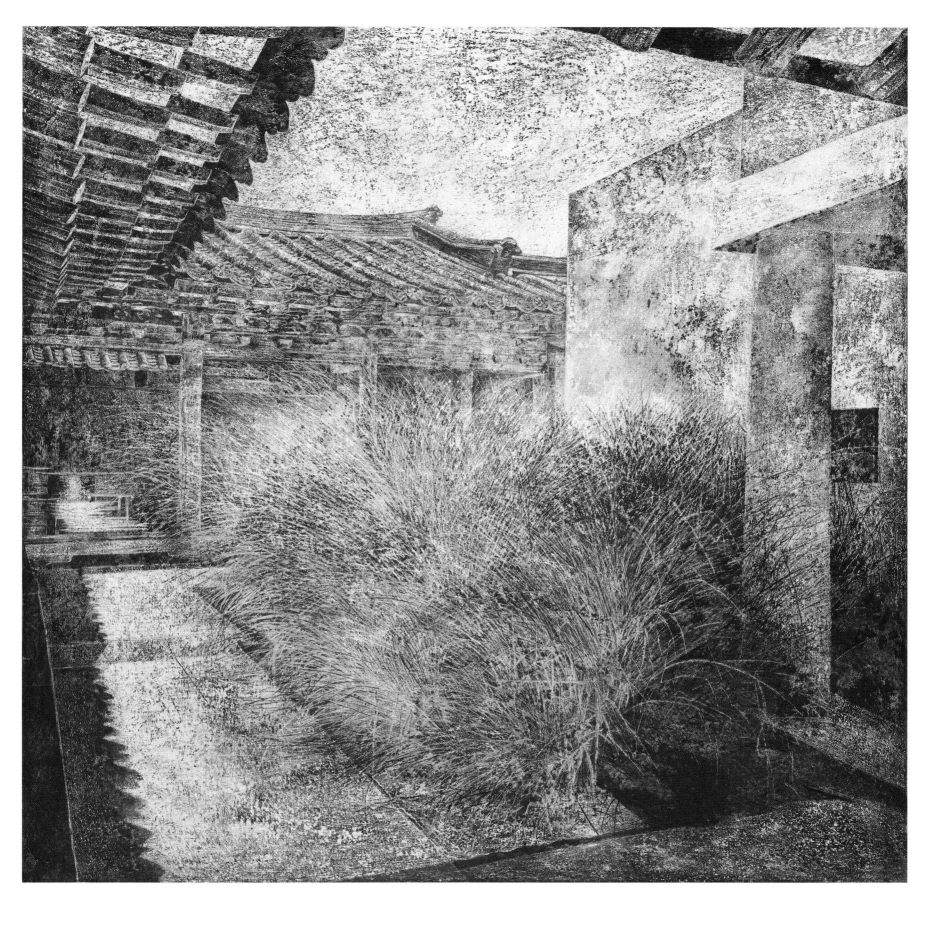

Middle Habitat of Life
중간 서식지

2021
fresco, scratch on lime wall
120x120cm

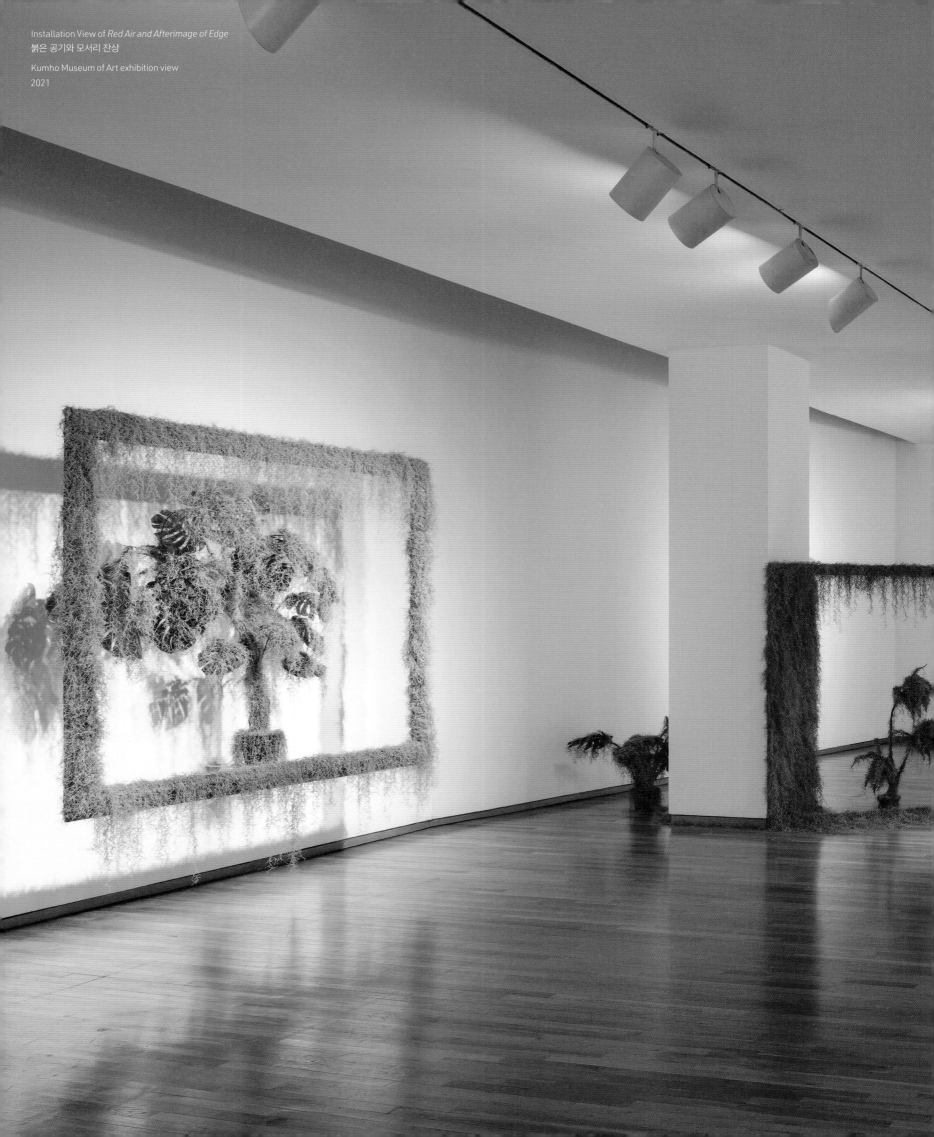

Installation View of *Red Air and Afterimage of Edge*
붉은 공기와 모서리 잔상
Kumho Museum of Art exhibition view
2021

붉은 공기와 모서리 잔상

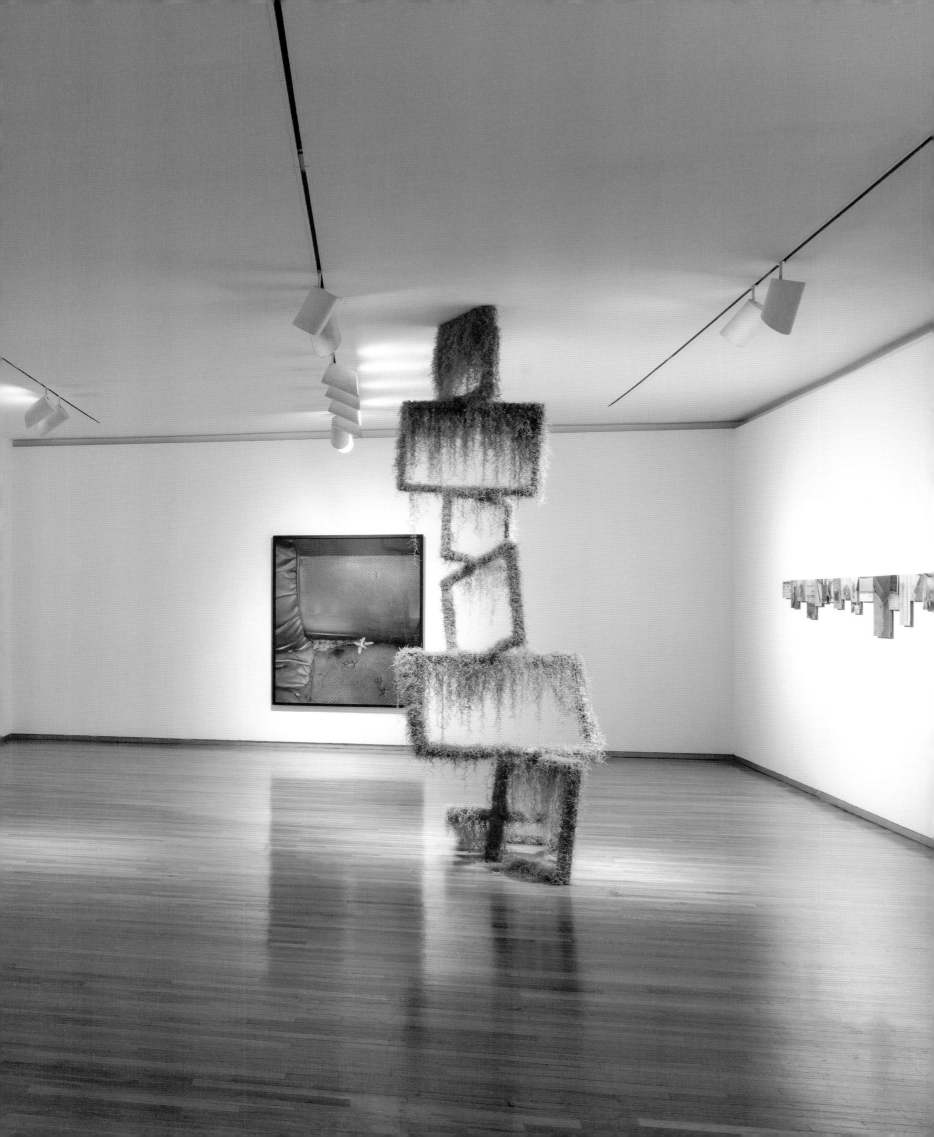

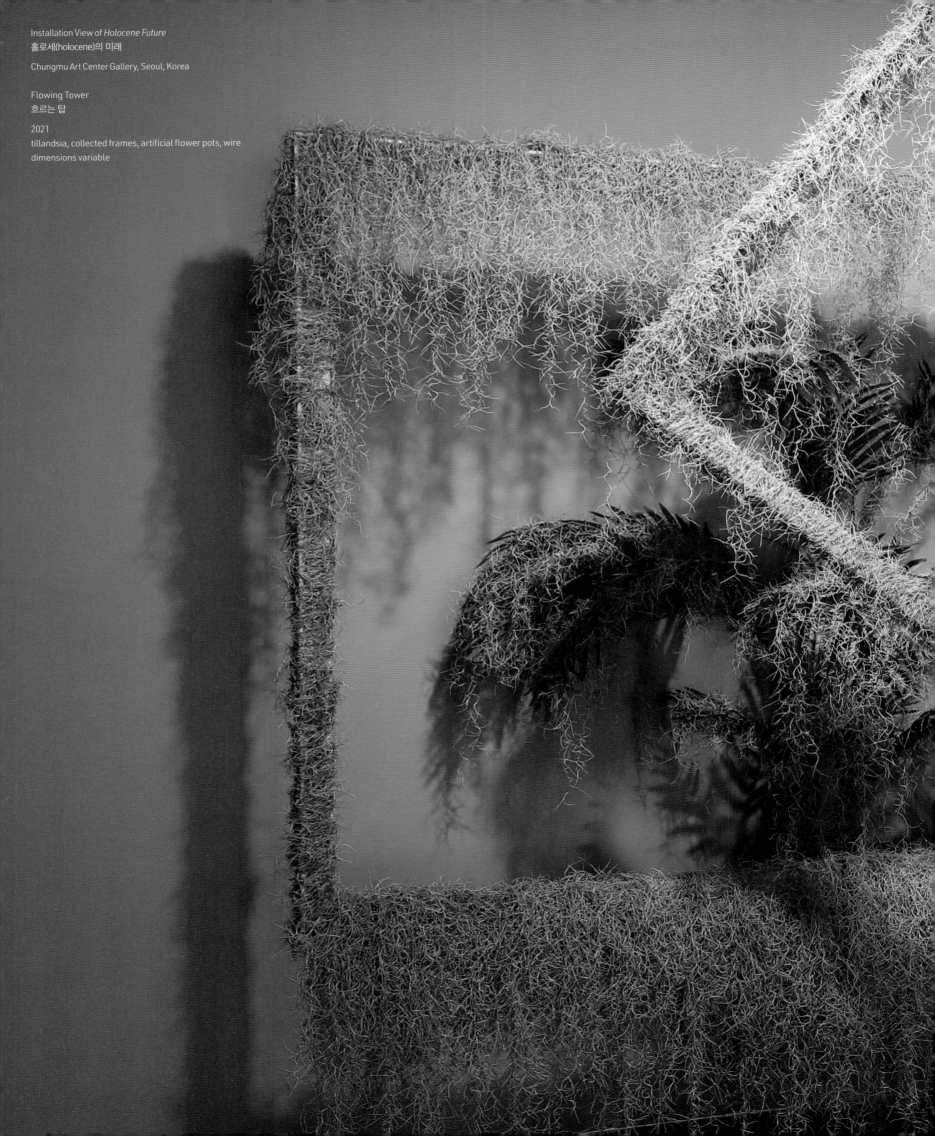

Installation View of *Holocene Future*
홀로세(holocene)의 미래

Chungmu Art Center Gallery, Seoul, Korea

Flowing Tower
흐르는 탑

2021
tillandsia, collected frames, artificial flower pots, wire
dimensions variable

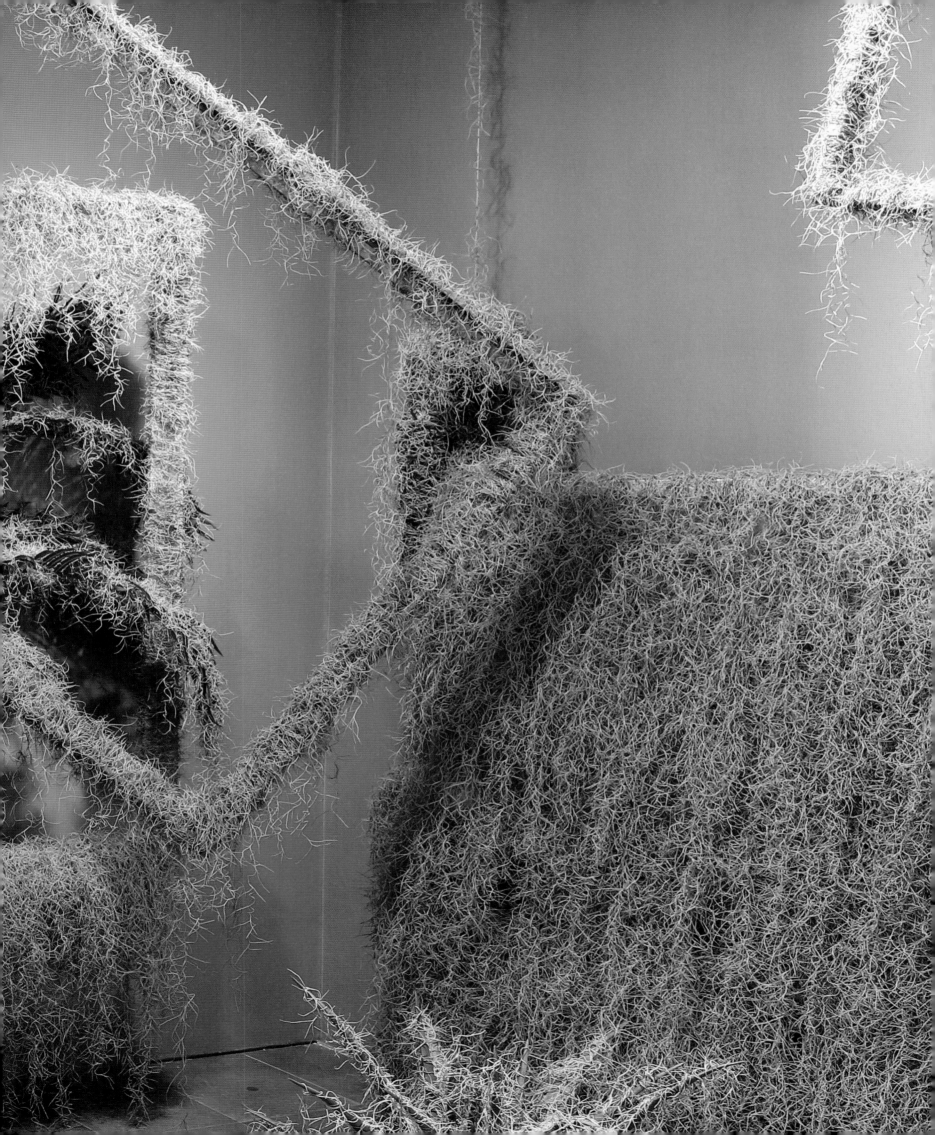

From a Life-Suppressing Civilization to a Life-Attuned Civilization

Sim Sangyong, professor, Seoul National University; Ph.D., art history

Tillandsia: Defining a new relationship between life and civilization

Since 2015, Kim Yujung has been involved in the tillandsia project. It began out of the attitude toward life that she developed while raising her own tillandsia plant, as well as the concrete experiences associated with it. Lacking roots or the flower pots that serve as mechanisms for managing roots, tillandsia might come across like interior decorations. During the exhibitions, they carry on their rootless life activities. Since they don't have roots, tillandsia must get all of the necessary moisture for survival from the atmosphere. It is supplied for the purpose of essential metabolic activities—the sort of thing where its body cannot be treated as a mere "exhibit." In this context, there appears to be some merit to Kim detecting in the tillandsia a narrative of fundamental resistance toward cold objectification. In the art gallery setting, the plant's precariously stretching DNA becomes a genome of resistance, taking on a new narrative quality as a revolutionary definition of the relationship between art and life.

Thanks to this newly acquired narrative quality, the rootless plant is no sooner placed somewhere than it transforms that setting into a place of controversy. This notion of living and breathing within the gallery, of refusing to remain simply "appreciated" as a source of intellectual stimulation or sensory pleasure, is itself in clear contravention of the idea of "museum art." This has to do with the exhibition space being an institutionalized, privileged space arranged for the objectification of things—with the lack of place, to be more precise. The tension between the two reaches its zenith at the moment when life (in the symbolic sense) assails civilization, as the *tillandsia* overruns the frame as the traditional mechanism of meaning devised to justify painting.

That tension is not greatly diminished in the fresco paintings, which seem to focus on indoor scenes with little special about them. These apparently simple indoor scenes are actually a narrative about the fate of the potted plants appearing in them. They are about life that has been tamed, forced to acquiesce to a fate of being admired—"used as a healing object and then discarded." In this instance, the crucial mechanism that appropriates a plant's growth as an object of admiration is the flower pot, which shares its context with the frame in painting. Both of them execute a fascist authority of the gaze that subjugates the life of living things, and both of them ensure the moral aesthetic and legitimacy of doing so.

All living things have the right to demand approaches that are suited to their dignity of life. Exploring a history of subjugation in which plants are defined as potted interior decorations, Kim's fresco paintings take on the quality of a report on predatory human desires. In the main, these painting-reports convey a message how the phenomenon of life being rendered "expendable" is like a mirror reflecting the "consumed" souls of the ones who do so. Oscar Wilde once said that art was more veil than mirror—but since we need a mirror to realize the meaning of a veil, we also need art-as-mirror as much as we require art-as-veil.

Even so, there is an important truth about this world that we cannot overlook. It has to do with Kim Yujung's attitude in writing this report: it in no way resembles the attitude of conquest and dominance commented on by Jean-Paul Sartre, the modernist perspective or the "imperial gaze." Kim's ways of addressing the conflict between life and civilization is not coarse or violent at all. There is no need to be violent (as many works of contemporary art tend to be) when writing a report about violence. The American philosopher Nelson Goodman referred to art as a "manière de faire le monde—a way of making the world." It is a form of knowledge about how to make a certain world, and it is a willful execution. The world that Kim Yujung desires is not one where civilization subjugates life, but one where life attunes civilization, and her means of achieving this is to use an inclusive gaze and a non-antagonistic way of revealing. This entails keen observation and consilient intuition; rather than condemning or indicting, she cultivates a healing gaze that approaches and embraces. Kim's world is devoted first and foremost to the marginalized, encircled in a warm gaze that focuses its attention on irrational origins. Because of this, the viewer can enjoy the privilege of approaching the pathologies of civilization at their own tempo without becoming infected by them.

Kochia: A balance between the power to entrance and the reflective gaze

Kochia appears as a new element in this world. It has to be kochia, not pink muhly grass. While its color may capture people's eye, pink muhly is a representative example of an ecosystem-disrupting species that threatens native fauna with its swift proliferation. Attractive it may be, but there is a lethal threat lurking beneath that. The desiring mechanism of the gaze operates along similar lines. The gaze is prone to overlooking the hidden truths that lurk beneath the surface—truths that are often dangerous or fatal. The aestheticism of the gaze is insensitive, even hostile, toward truth. In contrast, kochia is a species that takes the place of pink muhly. It also paints the fields pink, but it does not pose any deadly threat. The magic of kochia is about more than the gaze alone.

Kim Yujung's paintings are a new experience with exploring a balance of sensation and cognition between aesthetic reflection and kochia's equally intoxicating color. They are a form of training to restore equilibrium between visual desire and cognitive discrimination. We savor deeply and commune—but without succumbing to the trap! That is the aesthetic horizon of this world. Like Kim's tillandsia, the objects on this horizon avoid "other-izing." There is no need for them to be reduced to surrogates of desire, to be abandoned as interior decor.

Kim adjusts the intensity of her message as she attunes the pitch of her expression. The artistic gaze that surrounds the canvas preserves the warmth of generosity while carefully filtering out the excessive, empty aestheticism. Hers is an artistic attunement that expands possibilities for appreciation. It is an attunement at a level that does not dull the sensitivity of her reflection on "life rendered artificial" and "citified nature." The stimulation is softened, the message conveyed indirectly—but the awareness contained with them is consistently sharp. The more this outwardly soft, inwardly firm aesthetic appears before us, the more we are able to confront what we have lost.

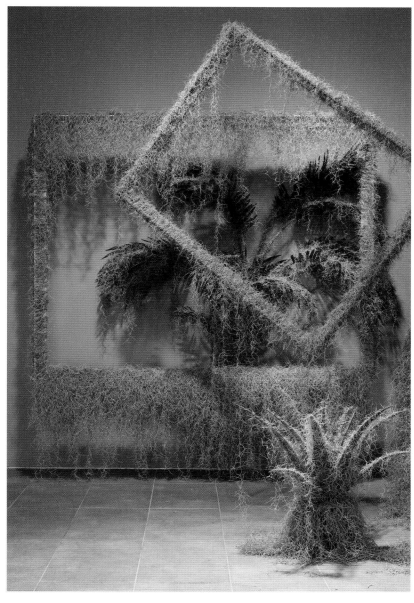

Flowing Tower
흐르는 탑
2021
tillandsia, collected frames, artificial flower pots, wire
dimensions variable

생명을 억압하는 문명에서 생명이 조율하는 문명으로

심상용, 서울대학교 교수, 미술사학 박사

틸란드시아(tillandsia): 생명과 문명의 새로운 관계 설정

김유정은 2015년 이후 '틸란드시아' 관련 작업을 지속해 오고 있다. 이 작업은 작가가 틸란드시아(tillandsia)를 손수 키우면서 갖게 된 생명의 인식과 그와 결부된 구체적인 경험에서 비롯되었다. 뿌리나 그것을 관리하는 기제인 화분이 없기에, 얼핏 인테리어 소품처럼 보이기 십상인 이 식물은 전시 중에도 뿌리 없는 자신의 고유한 생명활동을 지속한다. 뿌리가 부재하는 특성 상 틸란드시아는 생존에 필요한 수분 전체를 대기 중의 수분에서 공급받아야 한다. 그것의 전 신체가 단지 '전시물'로 취급되어서는 곤란한 필수적인 대사활동에 투입되는 것이다. 김유정이 틸란드시아에서 차갑게 대상화 되는 것에 대한 원천적인 저항의 서사를 읽어내었던 것은 이런 맥락에서 설득력이 있다. 위태롭게 늘어진 이 식물의 유전자는 미술관 안에서 저항의 유전자로 거듭나고, 예술과 생명의 혁명적인 관계설정이라는 새로운 서사성을 부여받는다.

이 새롭게 부여된 서사성으로 인해 그 뿌리 없는 식물은 그것이 놓이는 공간을 즉각 논쟁적인 공간으로 바꾸어놓는다. 전시실 안에서 살아있고 호흡한다는 것, 지적 자극이나 감각적 쾌를 유발하는 감상으로 그치기를 거부하는 것, 그 자체로 그것은 소위 '뮤지엄 아트(museum art)'에 대한 명시적인 위반의 성격을 띤다. 미술관의 전시공간이야말로 사물의 대상화를 위해 예약된 제도화, 특권화 된 장소, 정확히 하자면 장소의 부재이기 때문이다. 양자 간의 긴장은 틸란드시아가 회화를 정당화하기 위해 고안된 전통적인 의미기제인 '액자'를 뒤덮을 때, (상징적 의미에서) 생명이 문명을 습격했을 때 가장 고조된다.

이 긴장감은 특이할 것이라곤 없는 실내풍경을 소재로 삼은 듯해 보이는 프레스코 회화에서도 크게 완화되지 않는다. 사실 이 평이해 보이는 실내풍경은 그 안에 등장하는, 화분에 담긴 관상용 식물의 운명에 관한 서사다. 그것들은 '힐링의 대상으로 쓰이다가 버려지는' 관상용으로서의 운명에 순응하도록 강요되고 길들여진 생명에 대한 것이다. 이 경우 식물의 생장을 관상용으로 전유하는 결정적인 기제가 화분으로, 그림의 액자와 동일한 맥락이다. 이 둘 모두는 살아있는 것들의 살아있음을 억압하는 시선의 파시스트적 권력을 수행함과 동시에 그것의 도덕적, 미학적 정당성을 동시에 담보한다.

생명을 지닌 모든 것들은 그 살아있음의 존엄성에 걸맞은 방식을 요구할 권리를 지니고 있다. 그렇기에 화분에 담긴 채 인테리어 소품으로 규정되는 억압의 서사를 다룬 김유정의 프레스코 회화는 인간의 약탈적 욕망에 대한 보고서의 성격도 아울러 지니게 된다. 이 '회화-보고서'의 요약은 생명이 소모품화 하는 현상은 그렇게 하는 존재의 소모품화 된 영혼의 상태를 비춰주는 거울과도 같다는 것 아닐까! 언젠가 오스카 와일드(Oscar Wilde)는 예술은 "거울이라기보다는 베일"이라고 말했지만, 베일의 의미를 깨닫기 위해서는 반드시 거울이 먼저 필요하기에, 베일로서의 예술 만큼이나 거울로 기능하는 예술도 마땅히 필요하다.

그렇더라도 이 세계에 관한 누락해선 안 될 중요한 진실이 있다. 이 보고서를 작성하는 김유정의 태도에 관한 것으로, 장 폴 사르트르(Jean-Paul Sartre)가 지적한 바 있던 정복과 군림의 그것, 곧 근대주의적 시선, 제국의 눈빛과는 전혀 닮아있지 않다는 것이 그것이다. 김유정이 생명과 문명의 갈등을 다루는 방식은 조금도 거칠거나 폭력적이지 않다. 폭력에 대한 보고서를 작성하는 방식이 (많은 동시대 미술이 그렇게 하는 것처럼) 폭력적일 필요는 없다. 미국의 철학자 넬슨 굿맨(Nelson Goodman)에 의하면, 예술은 '세계를 만드는 방식(maniere de faire le monde)'이다. 어떤 세계를, 어떻게 만들 것인가에 관한 지식인 동시에 의지적 수행인 것이다. 김유정이 원하는 세계는 문명이 생명을 억압하는 것이 아니라 생명이 문명을 조율하는 세계고, 그렇게 하기 위한 방식은 적대적이지 않은 폭로와 포용적인 직시를 사용하는 것이다. 예민한 관찰과 통섭적 직관을 동반하되, 비난하거나 고발하는 대신 가까이 다가서고 포용하는 치유의 시선을 가다듬는 것이다. 김유정의 세계는 소외된 것에 먼저 할당되고, 부조리한 태생에 주의를 기울이는 따뜻한 시선으로 감싸여져 있다. 그 덕에 관람자는 스스로 환자가 되지 않고서도, 자신의 호흡으로 이 문명의 병리학에 다가서는 특권을 누릴 수 있다.

댑싸리: 매료시키는 힘과 성찰적 시선의 균형

이 세계에 댑싸리가 새롭게 등장한다. 그것은 반드시, 핑크 뮬리(pink muhly grass)가 아니라 댑싸리여야 한다. 시선을 사로잡는 매료시키는 색채에도 불구하고, 핑크 뮬리는 빠르게 종을 번식시키는 특성으로 인해 토종 식물계를 위협하는 대표적인 생태계 교란종이기 때문이다. 그것은 매력적이지만 그 이면에는 치명적인 위협이 도사리고 있다. 시선이라는 욕망 메커니즘도 이와 유사하게 작동한다. 시선은 이면에 도사리고 있는 은폐된 진실, 종종 치명적이거나 위협적인 그것을 쉽게 지나치고 누락한다. 시선의 유미주의는 진실에 무감각하거나 적대적이기도 하다. 반면 댑싸리는 핑크 뮬리의 대체 종이다. 댑싸리도 들녘을 핑크 빛으로 물들이지만 치명적인 위협은 없다. 댑싸리의 매력은 단지 시선의 그것으로만 그치지 않는다.

김유정의 회화는 댑싸리의 동일하게 매료시키는 색과 미학적 성찰 사이에서 감각과 인식의 균형점을 짚어 나가는 새로운 실험에 나선다. 시각적 욕망과 인식적 분별 간의 균형을 회복하는 훈련이다. 깊이 음미하고 교감하되 덫에 걸리지는 않기! 이것이 이 세계의 미학적 지평이다. 이 지평 위에서 대상들은 김유정의 틸란드시아가 그랬던 것처럼 타자화를 모면한다. 욕망의 대용품으로 전락하고, 인테리어 소품으로 유기되지 않아도 된다.

김유정은 표현의 높낮이를 고르고 메시지의 강약을 조율한다. 화면을 감싸는 작가의 시선은 관용의 온기를 유지하면서, 과한 심미성과 덧없는 유미주의는 신중하게 걸러낸다. 감상의 가능성을 넓히는 조형적 조율인 셈이다. '인공화된 생명'과 '도시화된 자연'에 대한 성찰의 감도를 늦추지 않는 범위 내에서의 조율이다. 자극은 완화되고 메시지는 우회하지만, 그 안에 내재된 각성의 결은 일관되게 예민하다. 이 외유내강(外柔內剛)의 미학이 더 전개될수록, 우리는 우리의 잃어버린 것과 더 많이 마주할 수 있을 것이다.

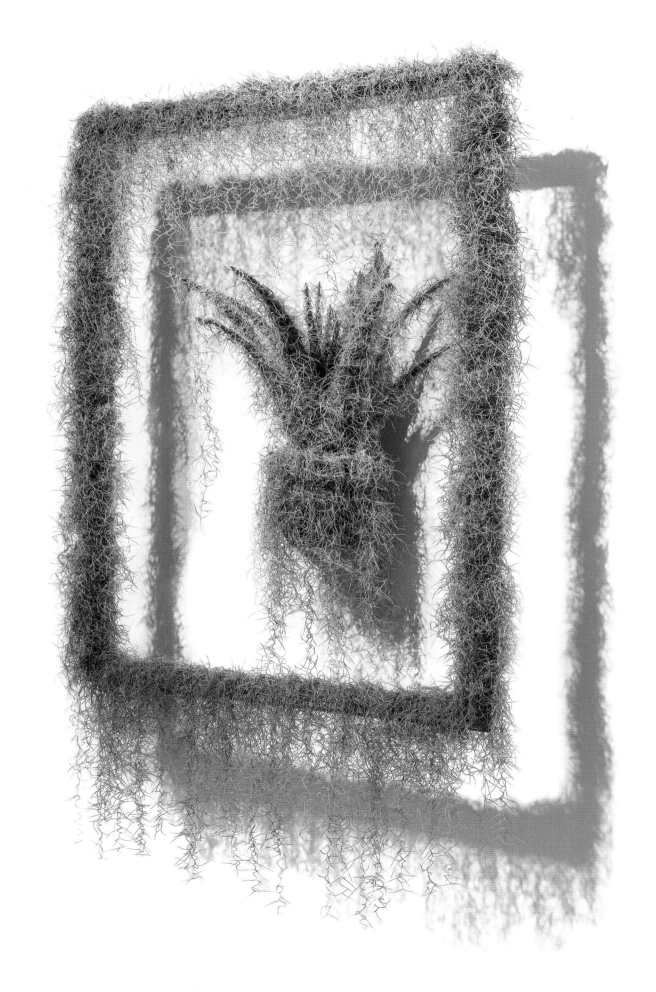

The tillandsia plants in space encroach along and across the boundaries of the exhibition space. From a distance, they resemble a landscape painting rendered in plants. This green veil of tillandsia starts from a hole in the gray exposed concrete wall and takes over the foreground, creating a wild landscape that resembles a vast atmosphere. While the plants seem to eat into the wall, they are also transformed into objects requiring care, forming one large composition. Giving rise to a new space, the tillandsia becomes a medium linking people, time, and nature—calling to mind the meaning of "transplanted" or "socialized" nature.

틸란드시아 식물이 전시공간의 경계를 넘거나 타고 침범한다. 멀리서 보면 식물로 그림을 그린 듯한 산수화로 보인다. 그린 덮개 틸란드시아는 회색 노출 콘크리트 벽면에 나 있는 구멍에서부터 시작하여 전면을 장악하며 거대한 대기의 형상을 띠고 야생 풍경을 연출한다. 식물이 벽을 잠식하는 듯 하지만 돌봄의 대상으로 전환되기도 하면서 하나의 컴포지션을 연출한다. 새로운 공간을 탄생시킨 틸란드시아는 인간과 자연 그리고 시간을 잇는 매개체가 되며 '이식된 자연', '사회화된 자연'의 의미를 환기시킨다.

Installation View of *The Time of Water and Wind*
물과 바람의 시간

Daecheong ho Museum of Art, Cheongju, Korea

Parasitic Air
기생하는 대기

2021
tillandsia, artificial flower pots, wire
dimensions variable

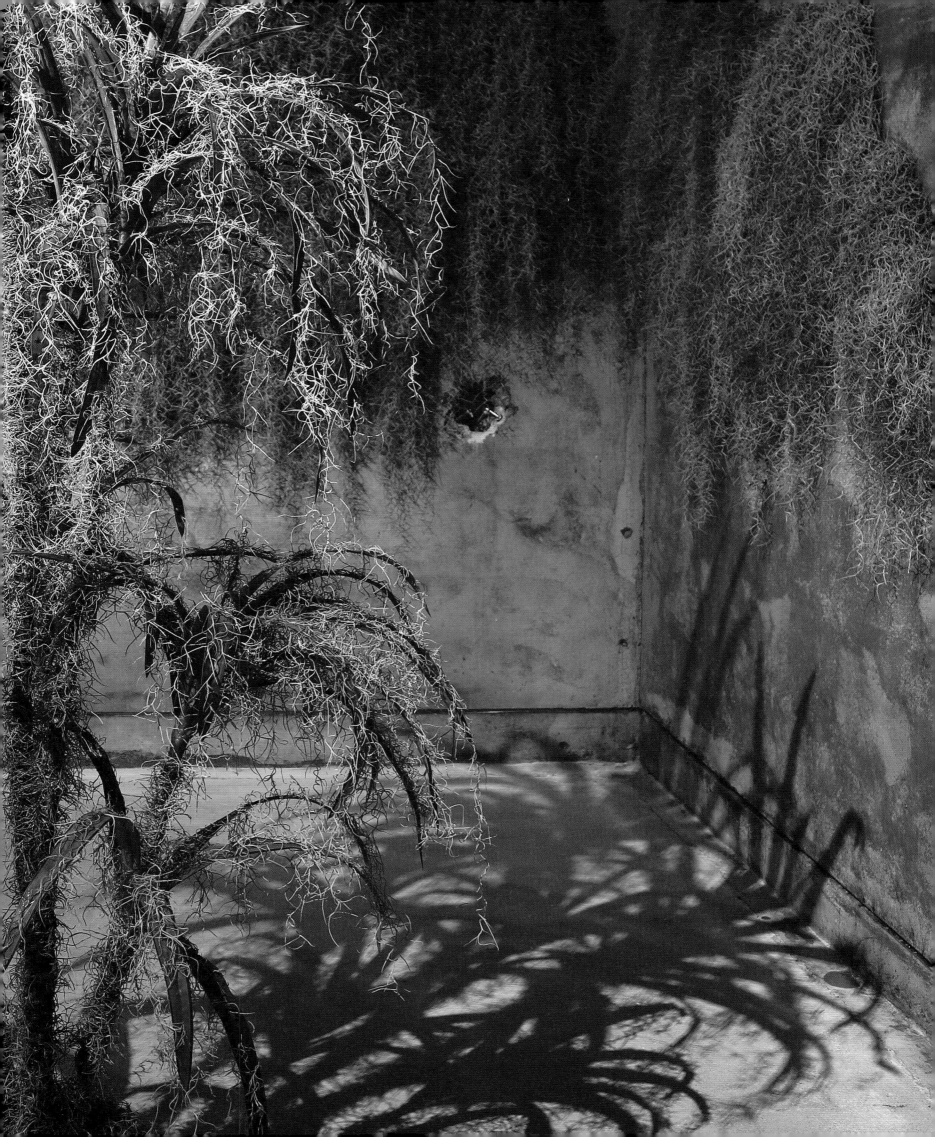

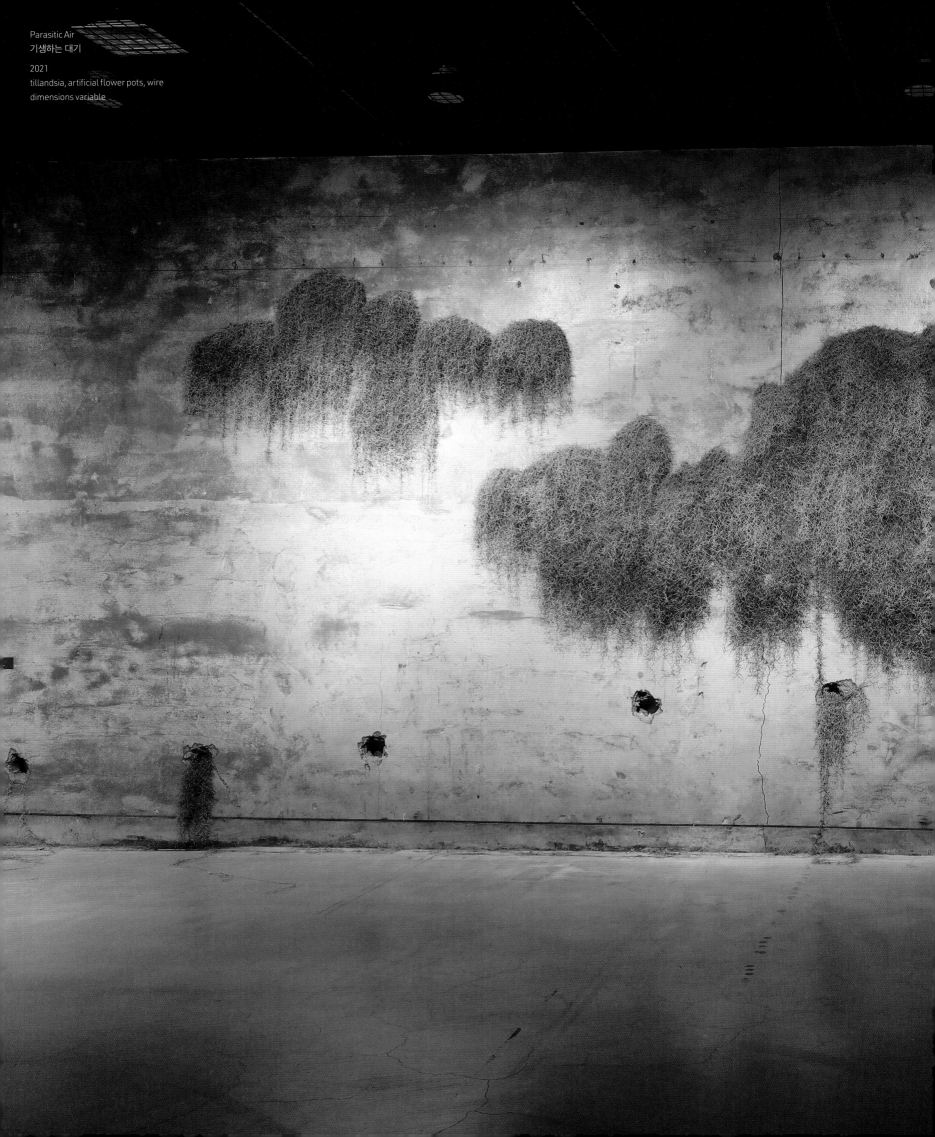

Parasitic Air
기생하는 대기
2021
tillandsia, artificial flower pots, wire
dimensions variable

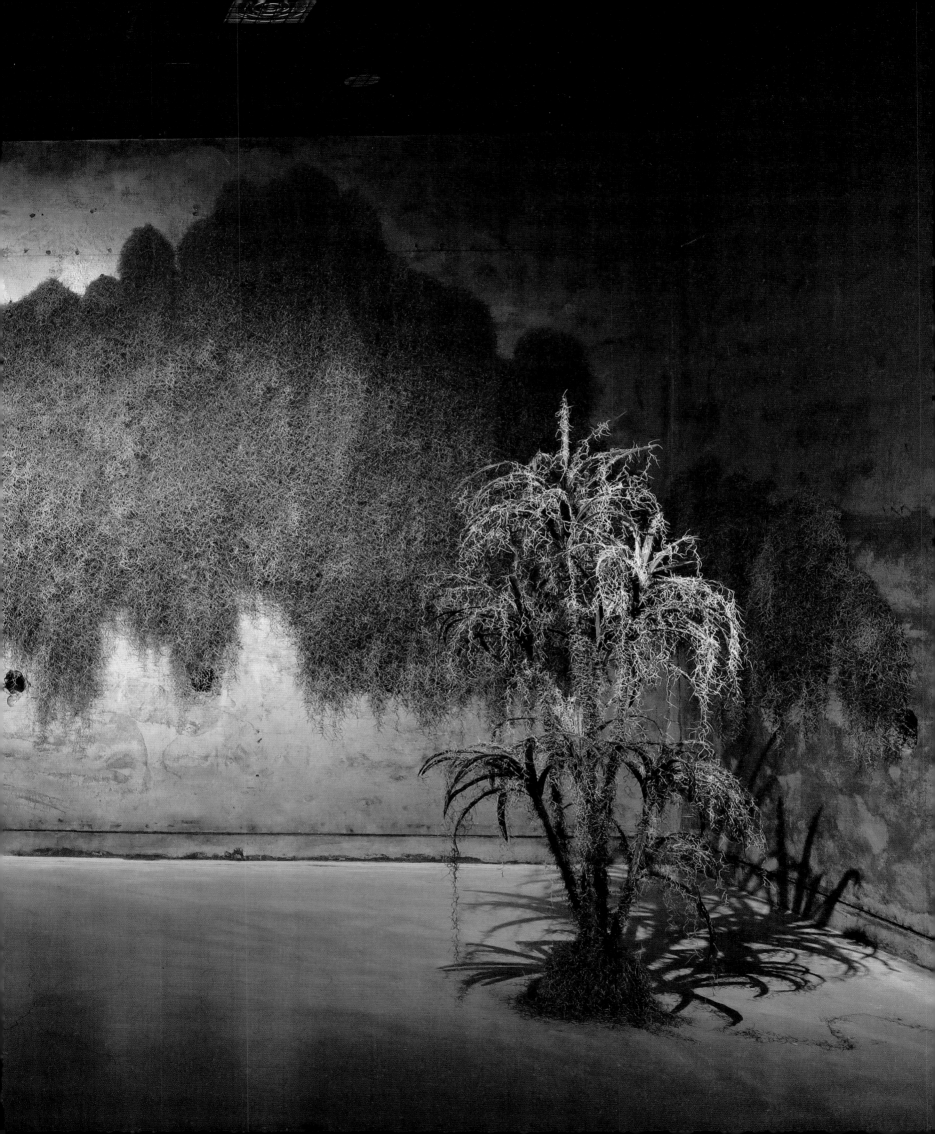

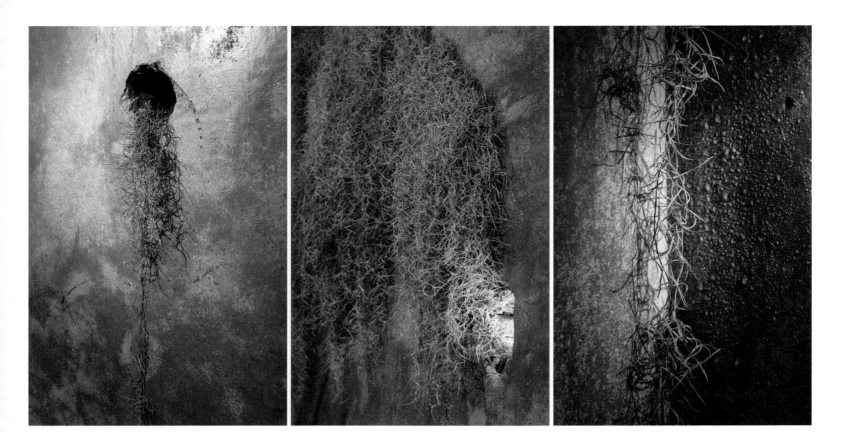

Parasitic Air
기생하는 대기

2021
tillandsia, artificial flower pots, wire
dimensions variable

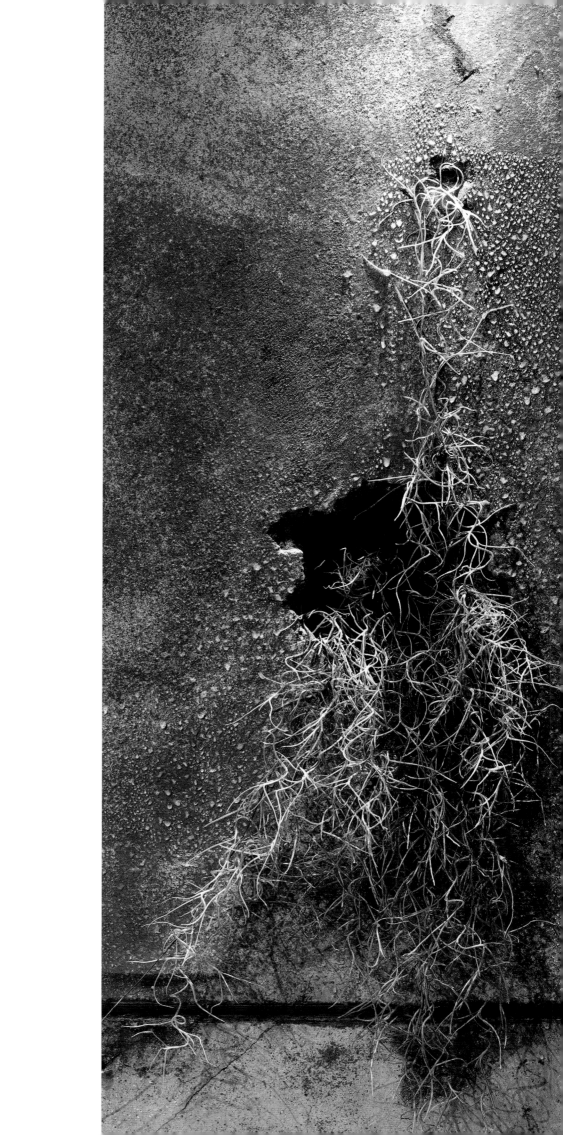

Parasitic Air
기생하는 대기

2021
tillandsia, artificial flower pots, wire
dimensions variable

Parasitic Air
기생하는 대기

tillandsia, artificial flower pots, wire
dimensions variable

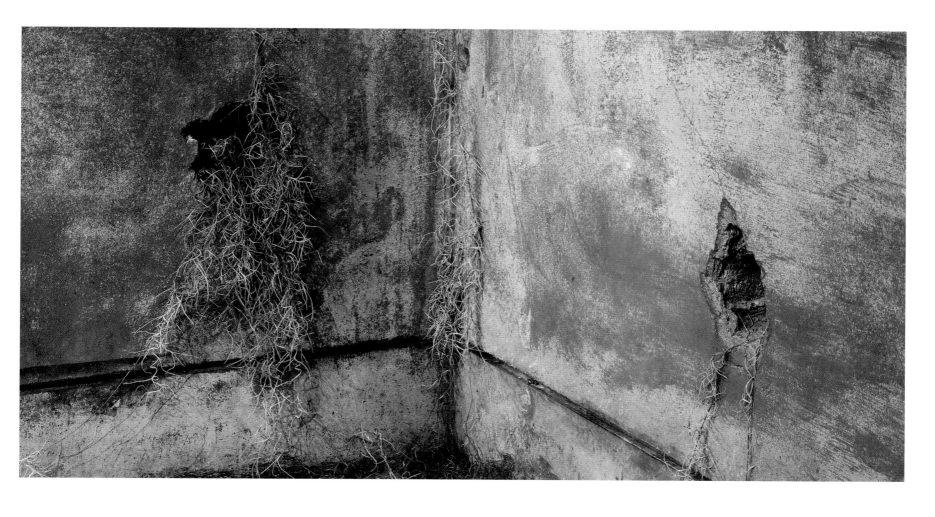

Installation View of *The Time of Water and Wind*
물과 바람의 시간

Daecheong ho Museum of Art
2021

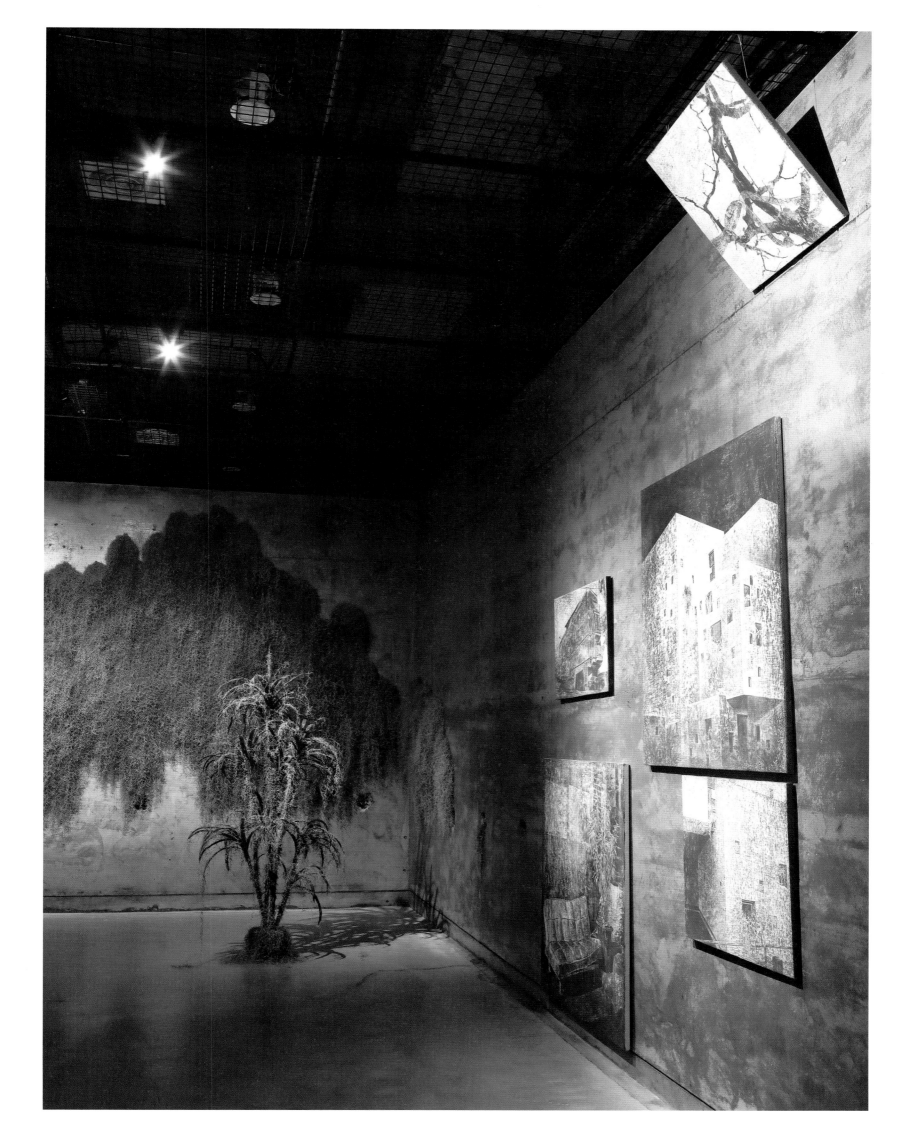

A Whitewashed Tree
회칠한 다락

2018
acrylic on the back of the canvas, birds sound art
100x1400cm
Daecheong ho Museum of Art installation view

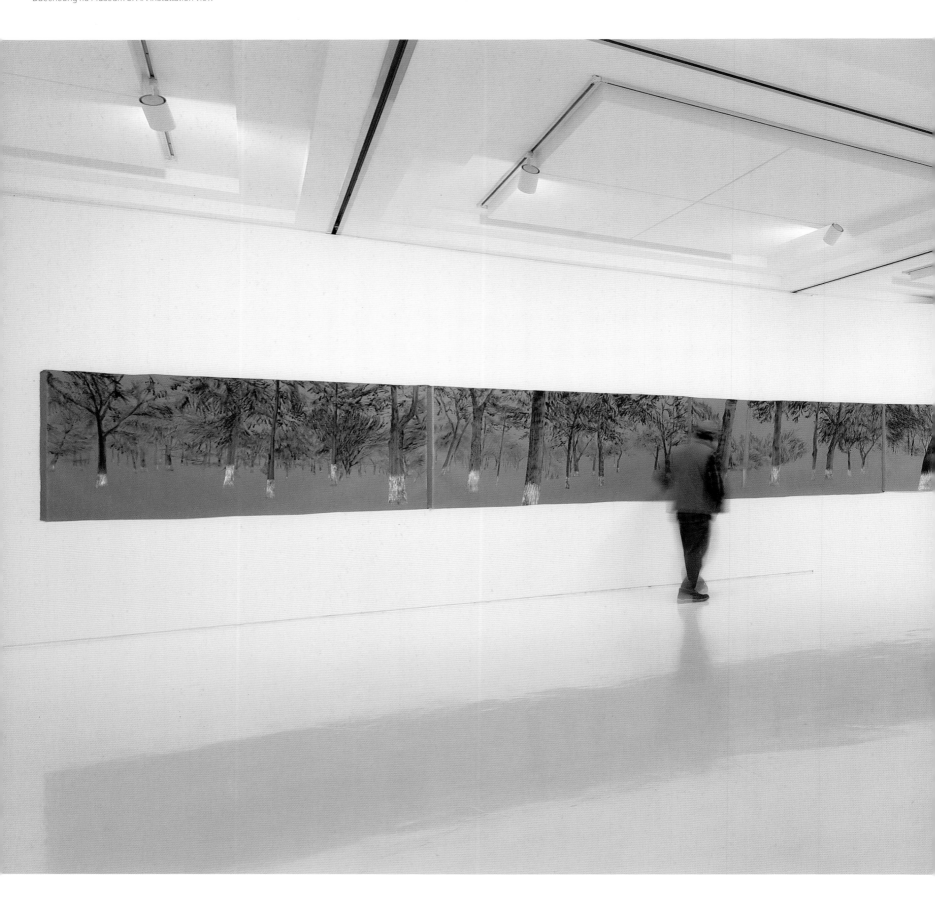

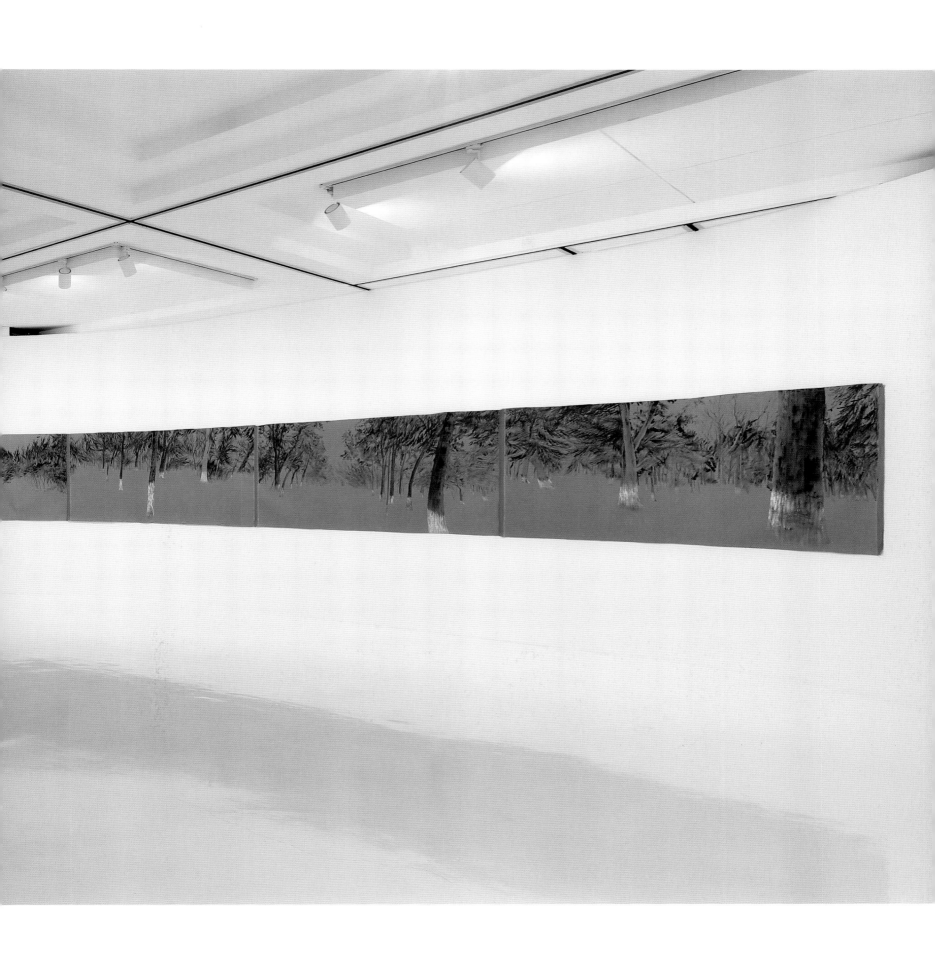

A series of seven long drawings measuring 100x200cm, *Whitewashed Daraxt* refers to the Uzbek word *daraxt*, meaning "tree." In Korea, the similar word *darak* (also *darakbang*) refers to an attic, which originally served as a place to avoid the ravages of insects. The blank space of the wall is used here in an artwork that playfully illustrates the meaning of the words "attic/*darak*," "insect damage," and "whitewash." When I first arrived in Tashkent, the capital of Uzbekistan, my curiosity was piqued when I learned that whitewash had been applied to all the trees—and even to the telephone poles—to prevent insect damage. Spontaneously drawing several trees whitewashed at their base and placing them side-by-side, I created a similar effect to a forest in a desert climate. With them I included the unfamiliar sounds of Uzbekistan's exotic birds, using audio-visual language to recreate the landscape of a foreign wood.

100x200cm의 크기로 길게 늘어선 7개의 드로잉 연작인 <회칠한 다락>에서 '다락'은 우즈베키스탄어로 '나무'란 의미다. 본래 다락 혹은 다락방의 기능은 병충해를 피하기 위함이다. 벽의 여백을 이용하여 다락, 병충해, 흰칠, 회칠이라는 말의 의미를 유희적으로 드러내는 작품을 구현했다. 우즈베키스탄의 수도인 타슈켄트에 처음 도착했을 때, 병충해 방지를 위한 흰 칠이 모든 나무들을 비롯해서 전봇대 등에도 칠해져 있는 것을 발견하고 호기심이 생겼다. 밑동이 회칠 된 여러 그루의 나무를 즉흥적으로 드로잉하고 나란히 설치하여 사막기후의 숲과 같은 효과를 줌과 동시에 생경한 소리를 내는 우즈베키스탄의 이국적인 새소리를 녹음하여 함께 배치하면서, 타국의 숲 풍경을 시청각 언어의 방식으로 새롭게 재구성한다.

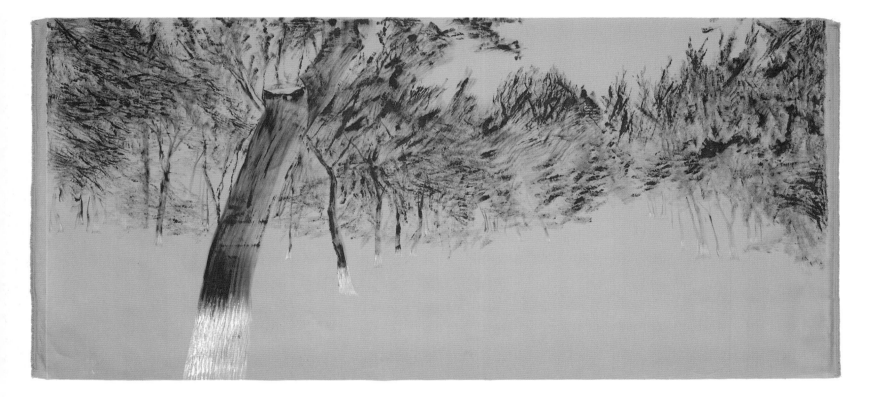

A Whitewashed Tree
회칠한 다락

2018
acrylic on the back of the canvas
100x200cm

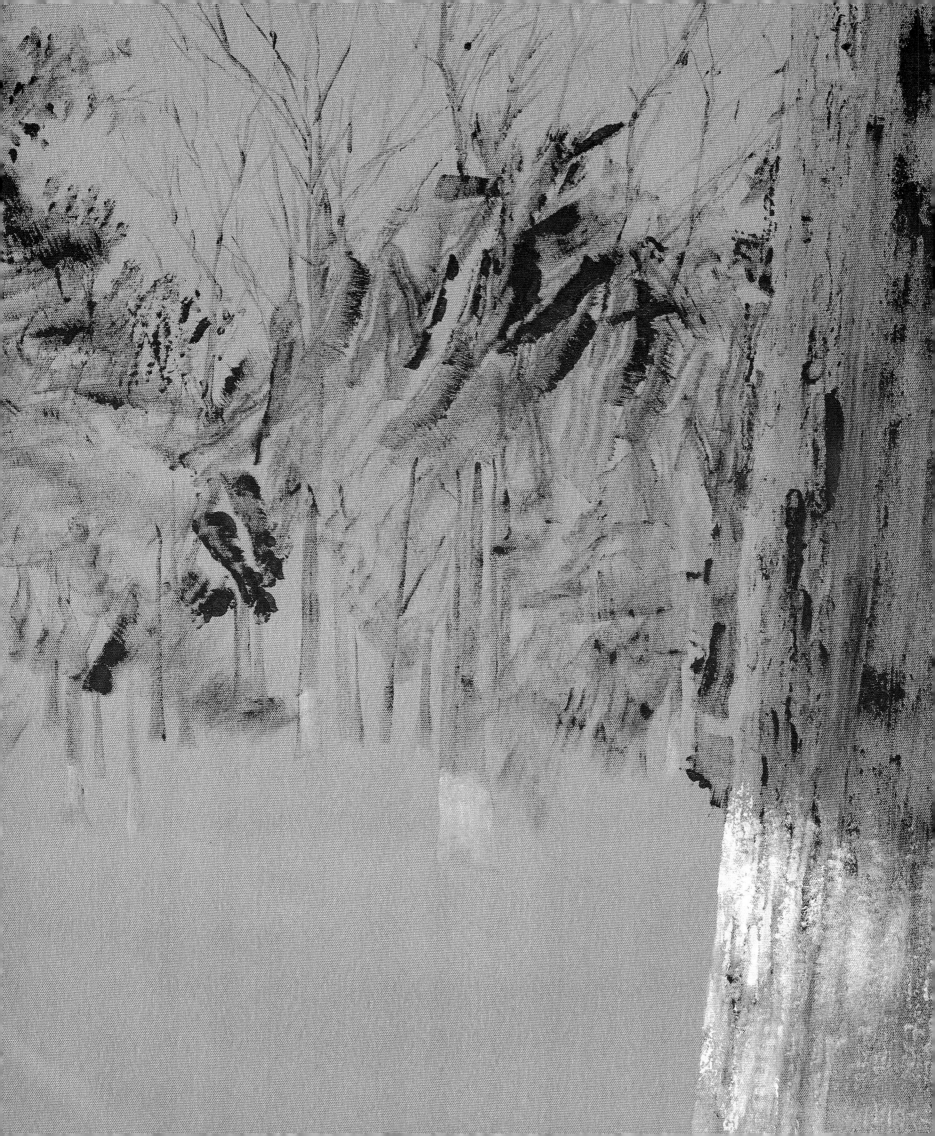

The Samyuk Building's closet space shows a recreation of a primeval landscape overtaken by plants—or perhaps a post-civilization landscape. In *Play Age* (2021), a collection of toys such as horses and dinosaurs—the kind a child might have played with—is now covered over in *tillandsia*. Focusing on toys that are no longer useful, it evokes the sort of memories that we have all passed through and can never return to. The result is a landscape that is odd and profound. Enmeshed with the traces of an old structure, the landscape invites the viewer as it transforms into a new time and place.

삼육빌딩 벽장 공간에는 식물이 잠식해버린 원시적 풍경, 혹은 문명 이후의 풍경이 재현된다. <유희 시대>(2021)는 수집한 말, 아이들이 가지고 놀았을 법한 공룡 같은 장난감들을 수집하여 틸란드시아 식물로 뒤덮는다. 쓸모가 없어진 장난감을 소재로 하며, 누구나 지나쳐온 돌아갈 수 없는 추억의 시간을 호환하며, 오묘하고 기괴한 풍경을 자아낸다. 오래된 건물의 흔적과 맞물린 풍경은 새로운 시공간으로 탈바꿈하며 관객을 초대한다.

Installation View of *a mark* II _*Unfamiliar Signal, Tilted Target*
a mark II _낯선 신호, 기울어진 대상

Sahmyook Building, Seoul, Korea

Play Age
유희 시대

2021
tillandsia, collected frames, collected toys, artificial flower pots, wire, net
dimensions variable

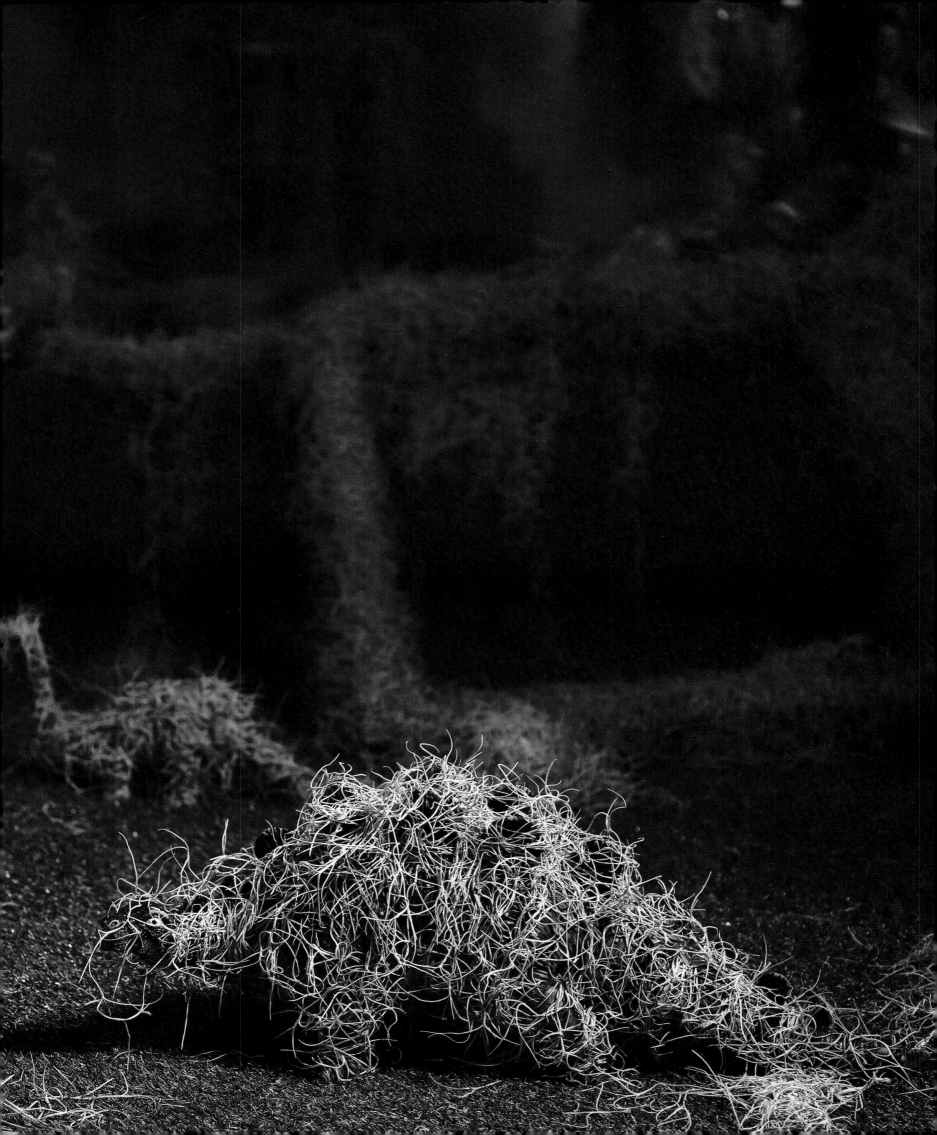

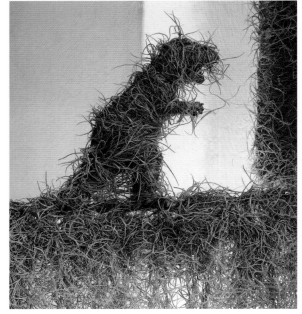 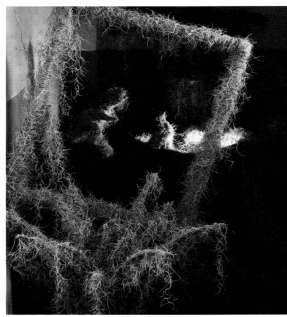 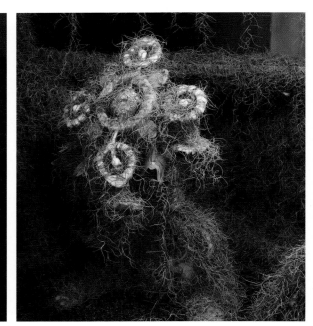

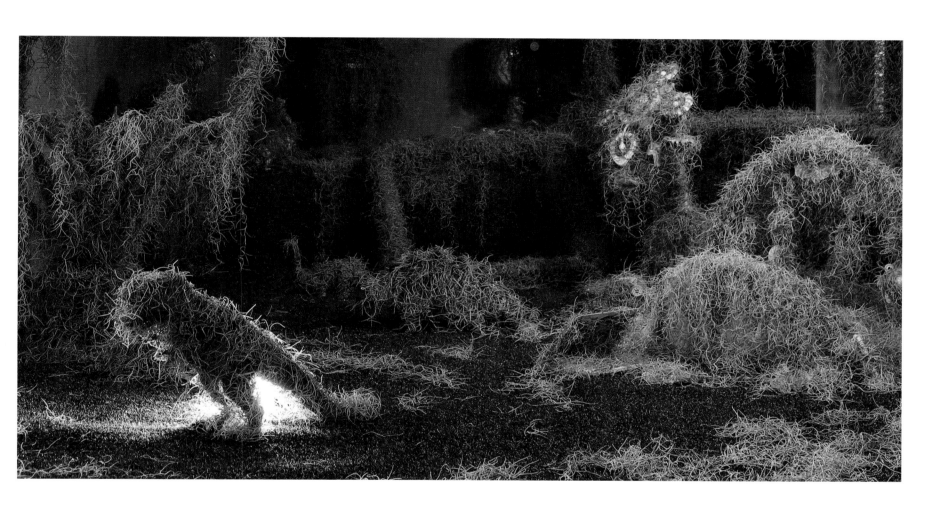

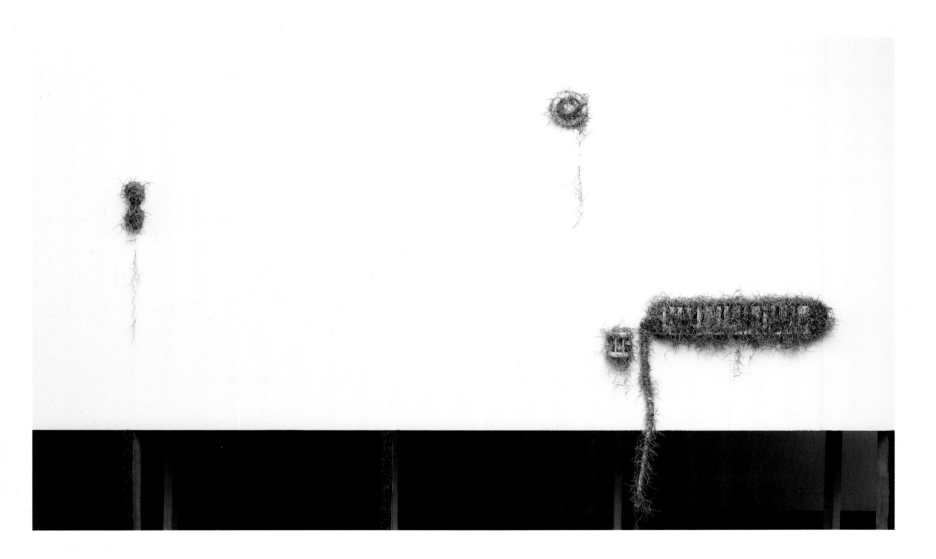

Rattles and other toys that create sounds stimulating the different senses of small children have been transformed here into art objects. They offer an opportunity to contemplate the play of infancy, an important time for cognitive and social development.

아기 딸랑이를 비롯하여 유아들의 오감을 자극하는 소리가 나는 장난감이 오브제가 되었다. 인지 발달, 사회성 발달이 중요한 시기인 유아기의 놀이에 관해 생각해 보는 기회를 제공한다.

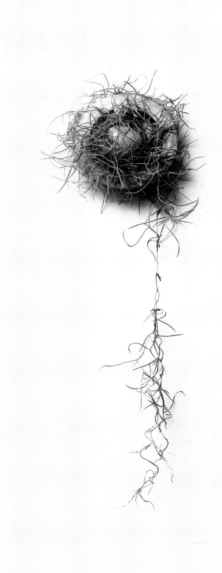

Installation View of *Sounds of the Blue Marble:Mourning the Anthropocene*
푸른 유리구슬 소리:인류세 시대를 애도하기

Seoul National University, Museum of Art, Seoul, Korea

Landscape Still Life_Ornamental
풍경이 된 정물_보여지기 위한
2021
tillandsia, collected flower pots, collected bookshelves, net, wire
dimensions variable

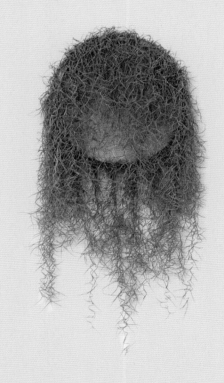

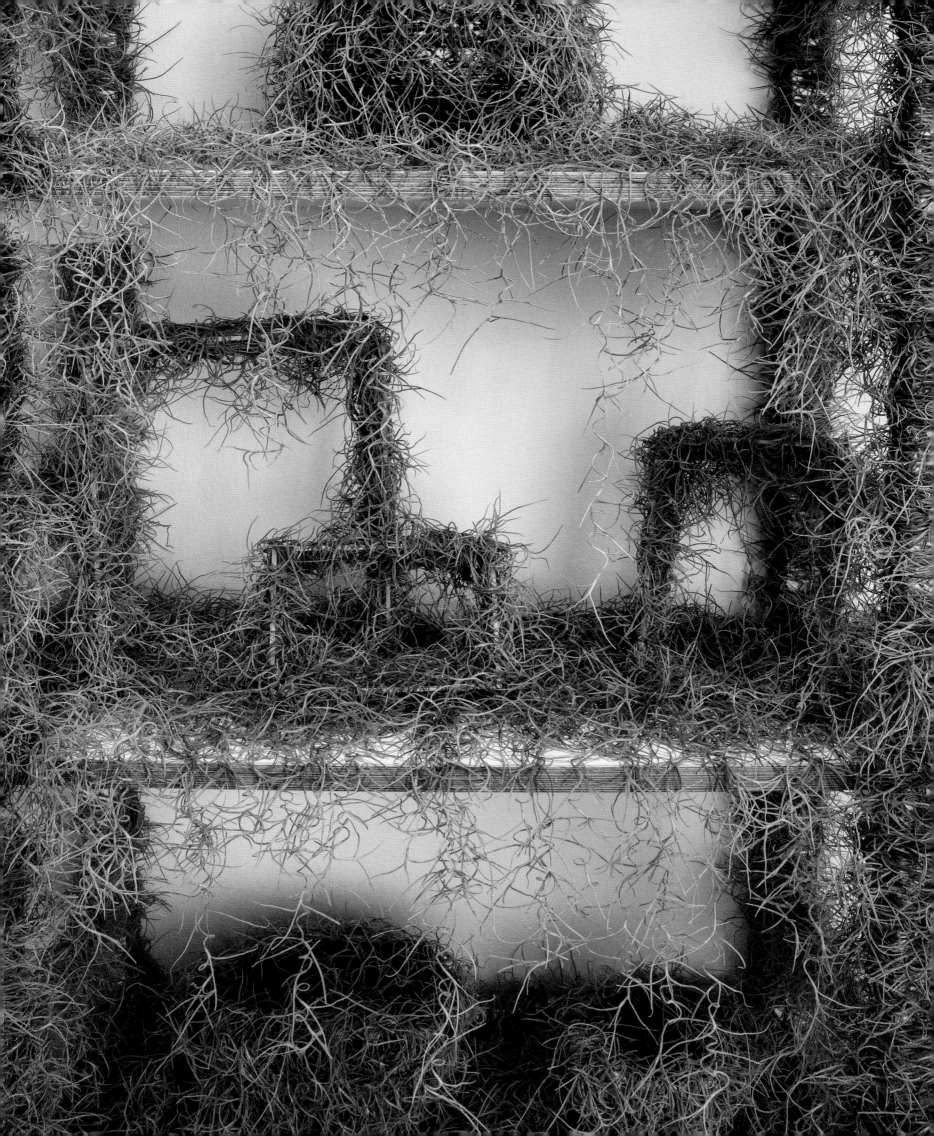

Landscape Still Life_Ornamental
풍경이 된 정물_보여지기 위한

2021
tillandsia, net, objects collected during travel, collected bookshelves, wire
dimensions variable

A landscape has been formed in an openly designed wall-mounted bookcase. Important and meaningful objects collected during my travels keep a record of times and places. Over time, the memories become blurred, leaving only objects of appreciation. Set down, transported, or occupying space in a passive way so that they can be seen, objects are representations of things disappearing heedlessly from memory. Existing now only as decorations, the objects become topiary that requires care, growing slowly within their space. Disappearance gives way to formation.

벽면 오픈형 책장에는 어떤 풍경이 연출된다. 여행 중에 수집한 소중하고 의미 있는 사물들은 시공간의 기록을 담고 있다. 시간이 지나면 당시의 기억들은 흐려지고 사물들은 관상용 오브제로 남게 된다. 놓이거나 옮겨지거나, 누군가에게 보이기 위해 수동적인 방식으로 자리를 차지한 오브제들은 무심히 기억 속에서 사라져 가는 것들의 표상이다. 장식으로만 존재하게 된 오브제들은 돌봄이 필요한 토피어리가 되어가면서 공간 안에서 서서히 자라난다. 사라지는 것이 생성되는 것으로 변환한다.

Landscape Still Life_Ornamental
풍경이 된 정물_보여지기 위한

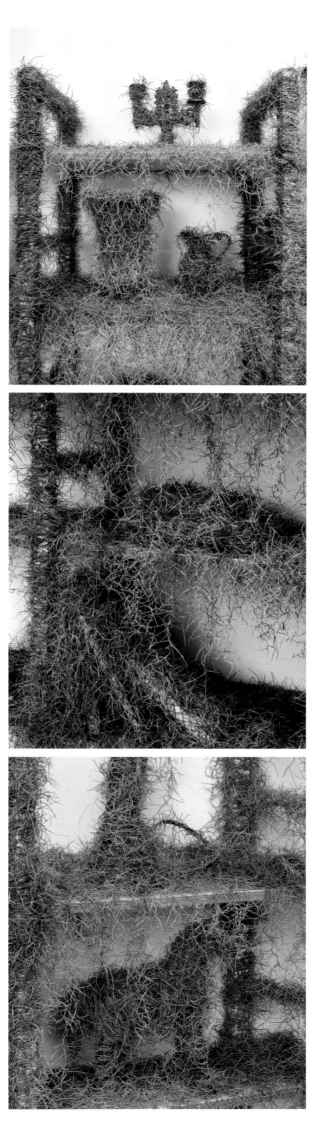

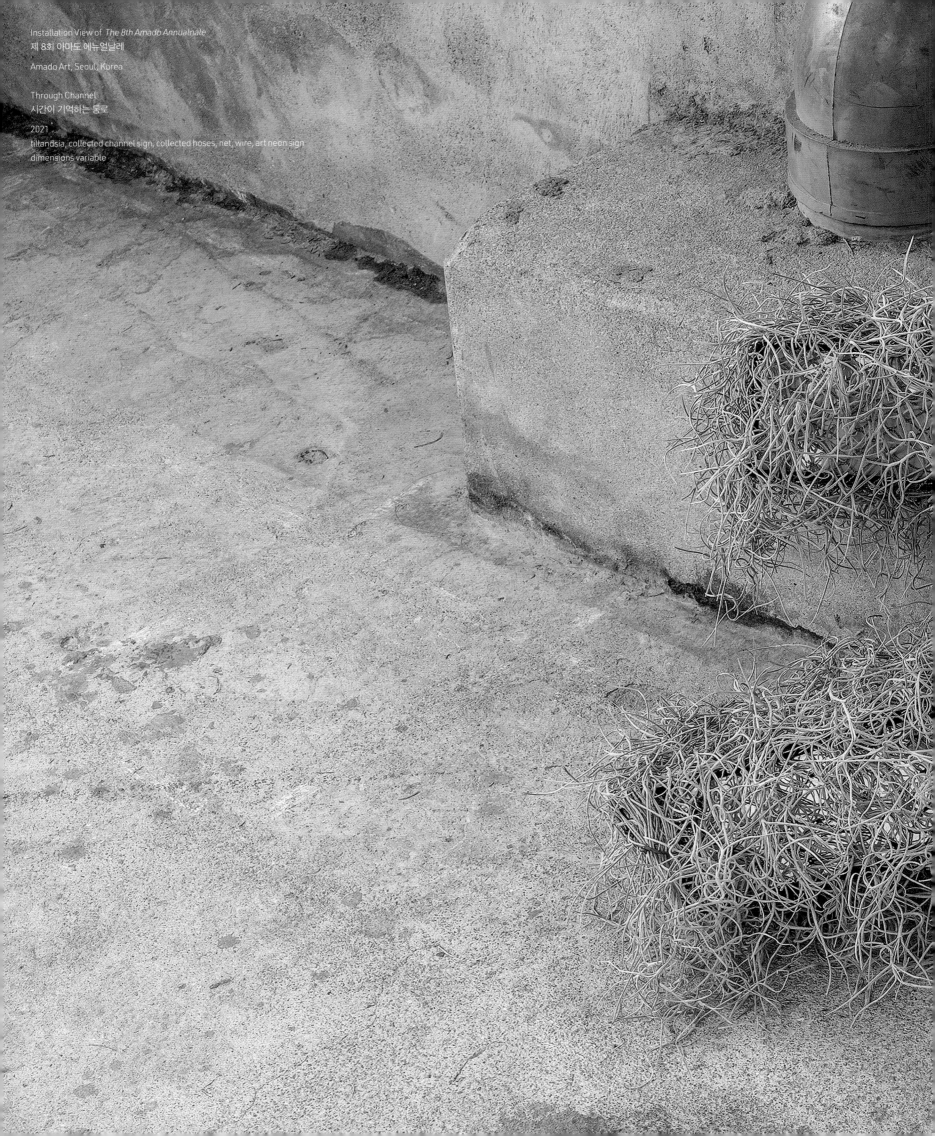

Installation View of *The 8th Amado Annualnale*
제 8회 아마도 에뉴얼날레

Amado Art, Seoul, Korea

Through Channel
시간이 기억하는 통로
2021
tillandsia, collected channel sign, collected hoses, net, wire, art neon sign
dimensions variable

Through Channel
시간이 기억하는 통로

Amado Art, Seoul, Korea

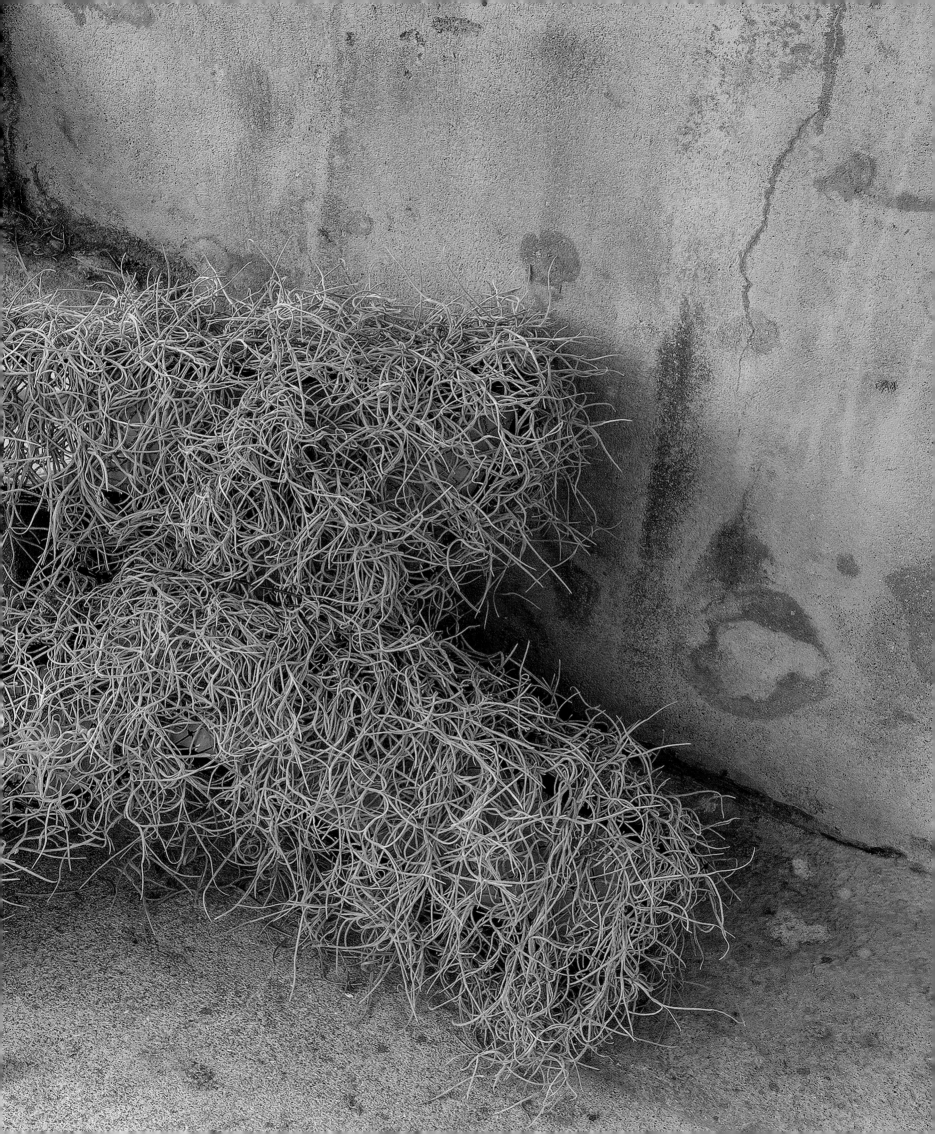

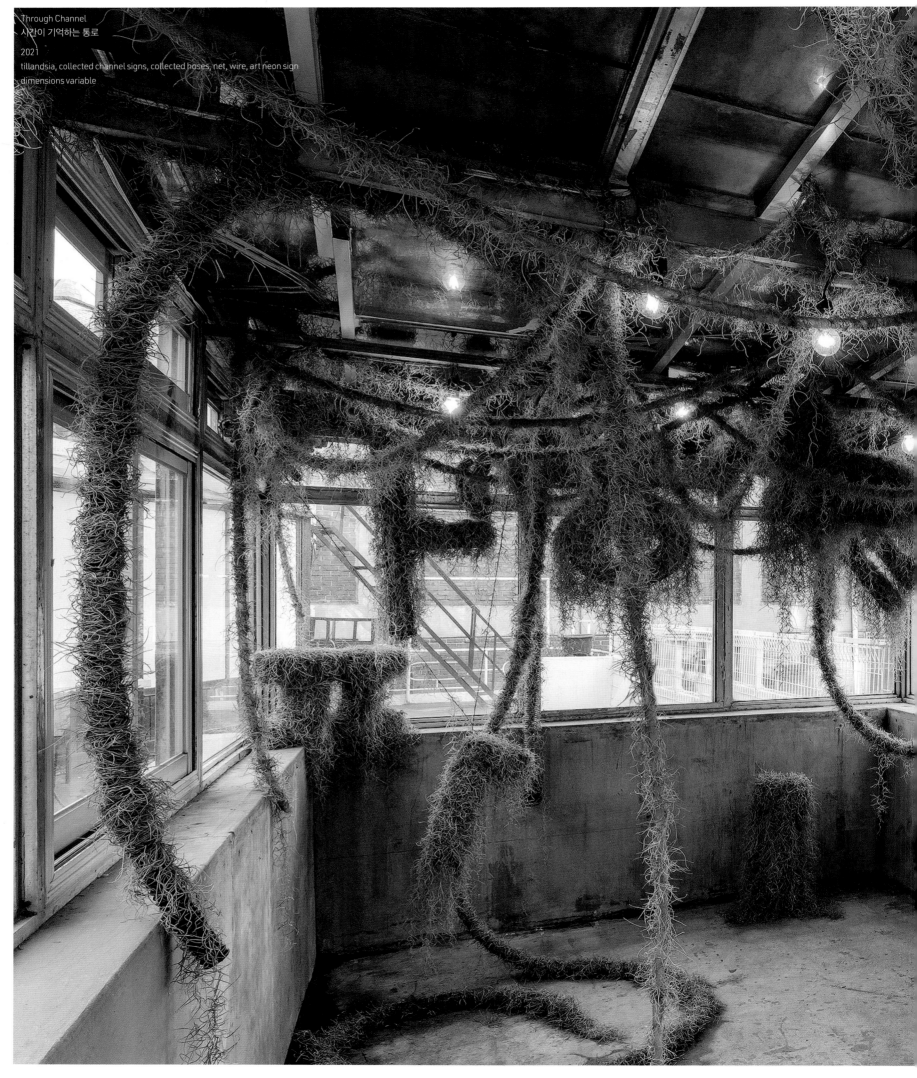

Through Channel
시간이 기억하는 통로
2021
tillandsia, collected channel signs, collected hoses, net, wire, art neon sign
dimensions variable

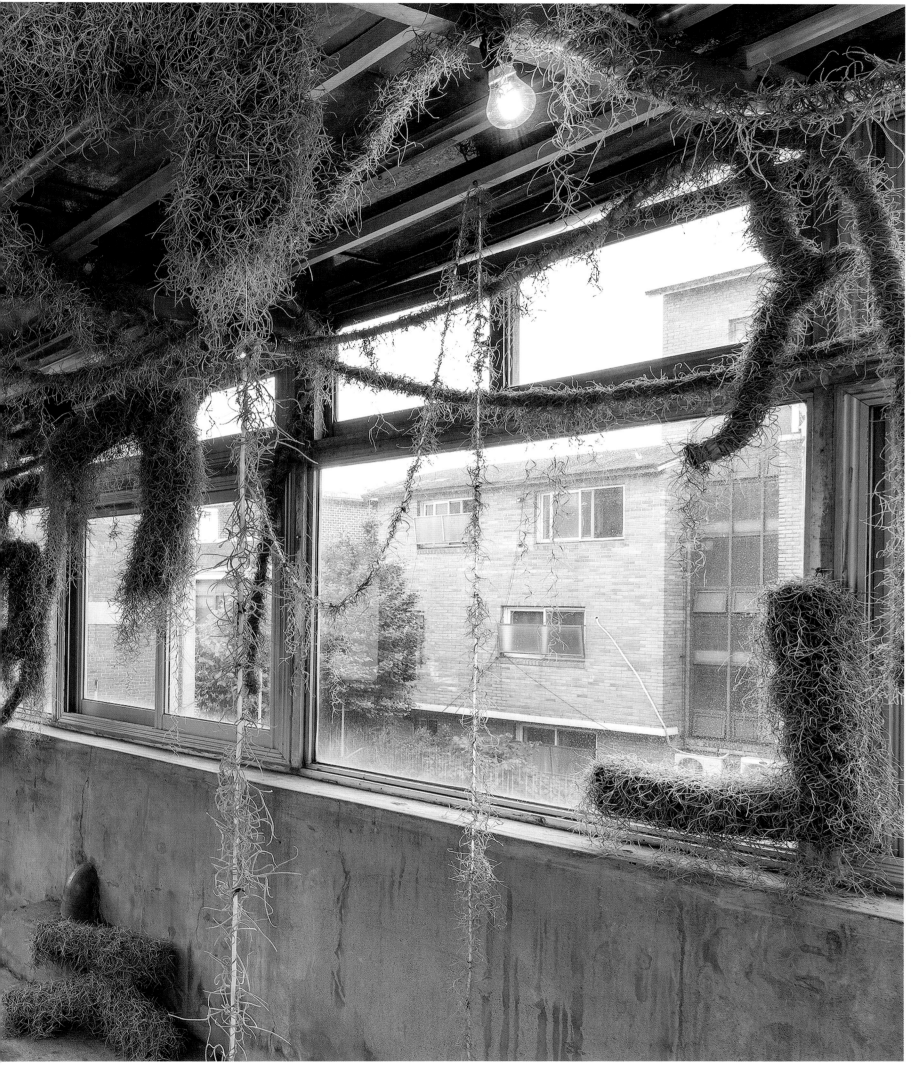

In Kim Yujung's work *Through Channel* (2021), a greenhouse space is occupied by discarded hoses and channel signs, along with an installation of tillandsia plants that wind around them. The tubular rubber and plastic hoses are things essential to our lives. They filter media that are essential to us, including both liquids and gases—serving as both the starting and end points for introduction and release. Hoses are the final channels through which human beings prolong their lives, and they are metaphorical media associated with movement, with undulations, and with relationships formed with other objects. The (discarded) channel signs are placed among the tendrils. Assembled by the artist as she traveled through different parts of the city, the signs once served as the faces and representatives of businesses, but are now abandoned texts. The artist's concept is one in which these discarded texts float amid the greenhouse space, their consonants and vowels split apart, while the tillandsia completes a kind of topiary around them. Once cast aside into the streets, the hoses and signs assume a new life as organisms, transposed with the things protected inside the greenhouse.

Cho Sookhyun 조숙현, curator, 큐레이터

김유정 작가는 폐기된 호스와 채널 간판, 그것을 감고 있는 틸란드시아 식물 설치를 통해 온실 공간을 점령하는 설치 작업 <시간이 기억하는 통로>(2021)를 선보인다. 고무나 비닐로 이루어진 관 형태의 호스는 우리의 생활에 없어서는 안 되는 존재이다. 액체나 가스 등 생활에서 반드시 필요한 매체를 투과하고, 유입과 배출의 시작점이자 마무리를 이어주기도 한다. 호스는 인간이 생명을 연장하는 마지막 통로가 되기도 하고, 이동과 굴곡, 혹은 또 다른 대상과의 관계 맺음을 하는 메타포적인 매체이다. 식물 넝쿨 사이에는 채널 간판(폐기된 간판)이 설치된다. 작가가 도시의 여기저기를 돌아다니며 직접 수집한 채널 간판은, 한때는 가게의 얼굴이자 표상이었으나 이제는 버려진 텍스트에 불과하다. 이렇게 자음과 모음이 쪼개진 채 폐기된 텍스트는 작가의 작업 콘셉트에 의해 온실 공간 안에서 부유하고, 이것을 감싼 틸란드시아가 하나의 토피어리를 완성하게 된다. 길거리에 버려졌던 호스와 간판은 다시 하나의 생명체로 탄생하여 온실 속 보호의 대상으로 치환된다.

Through Channel
시간이 기억하는 통로

2021
tillandsia, collected channel signs, collected hoses, net, wire, art neon sign
dimensions variable

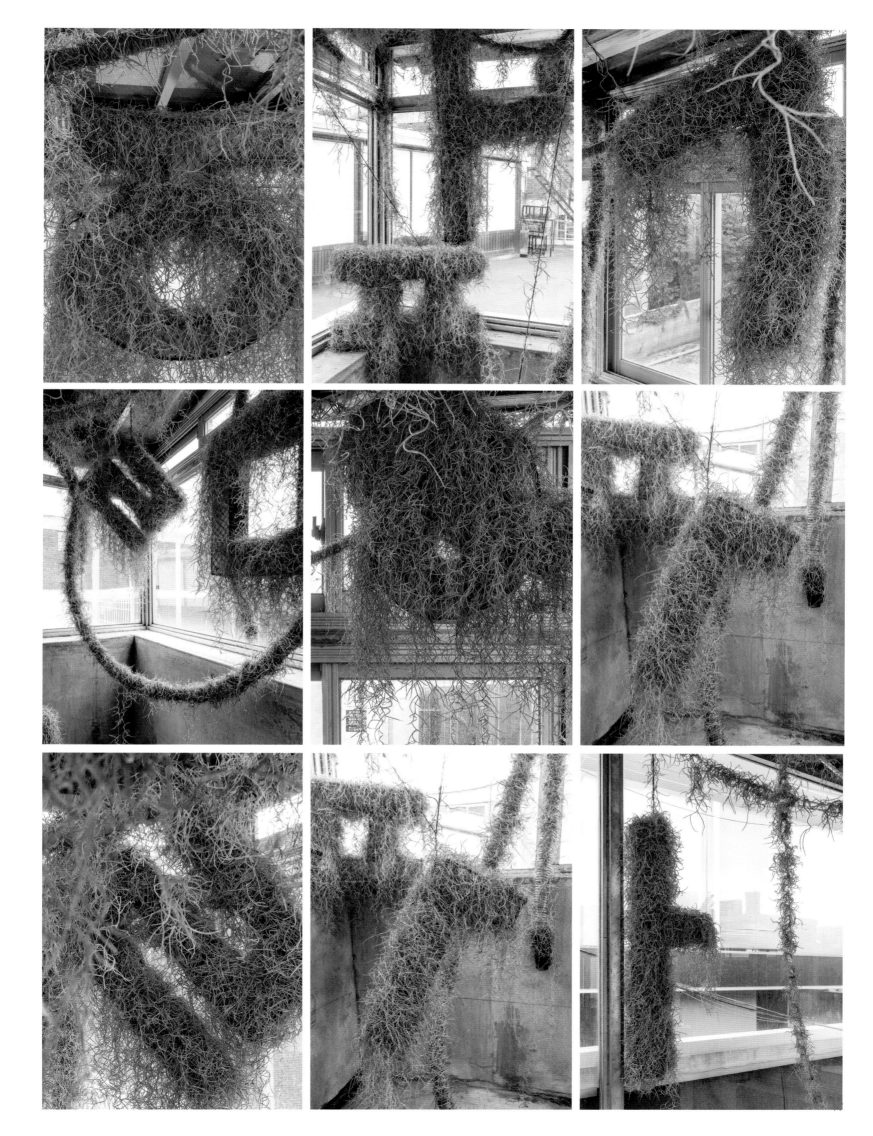

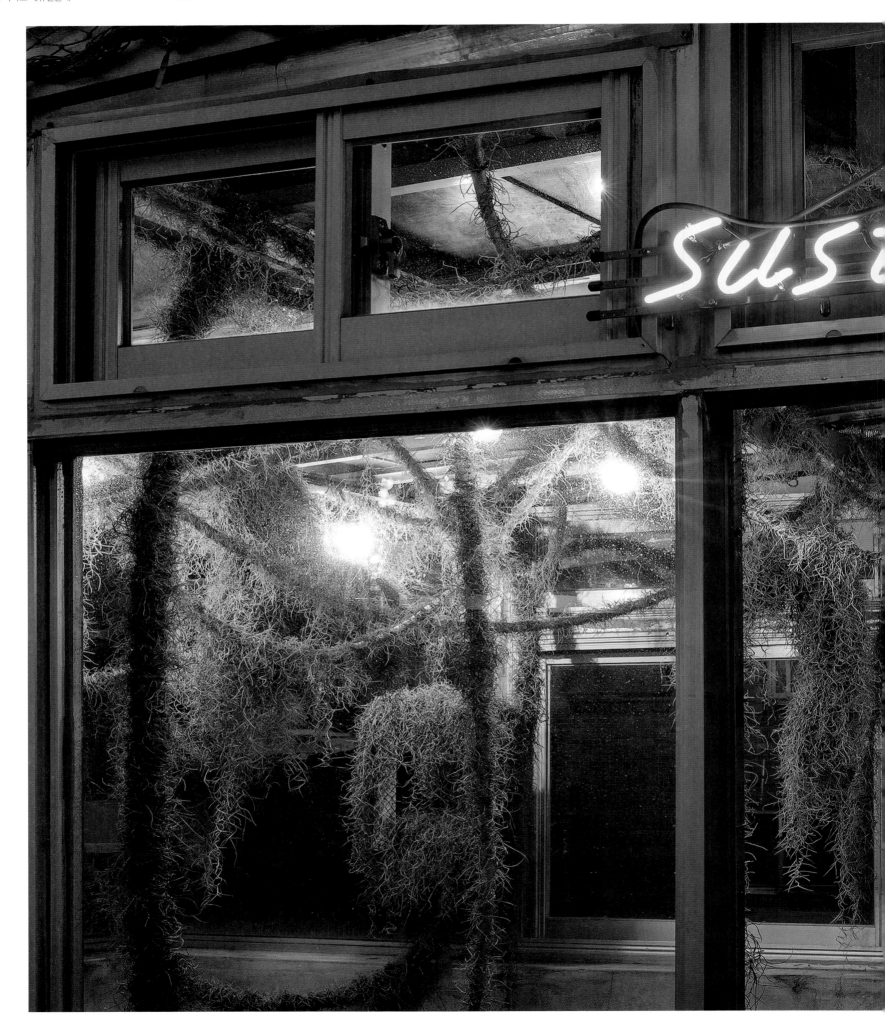

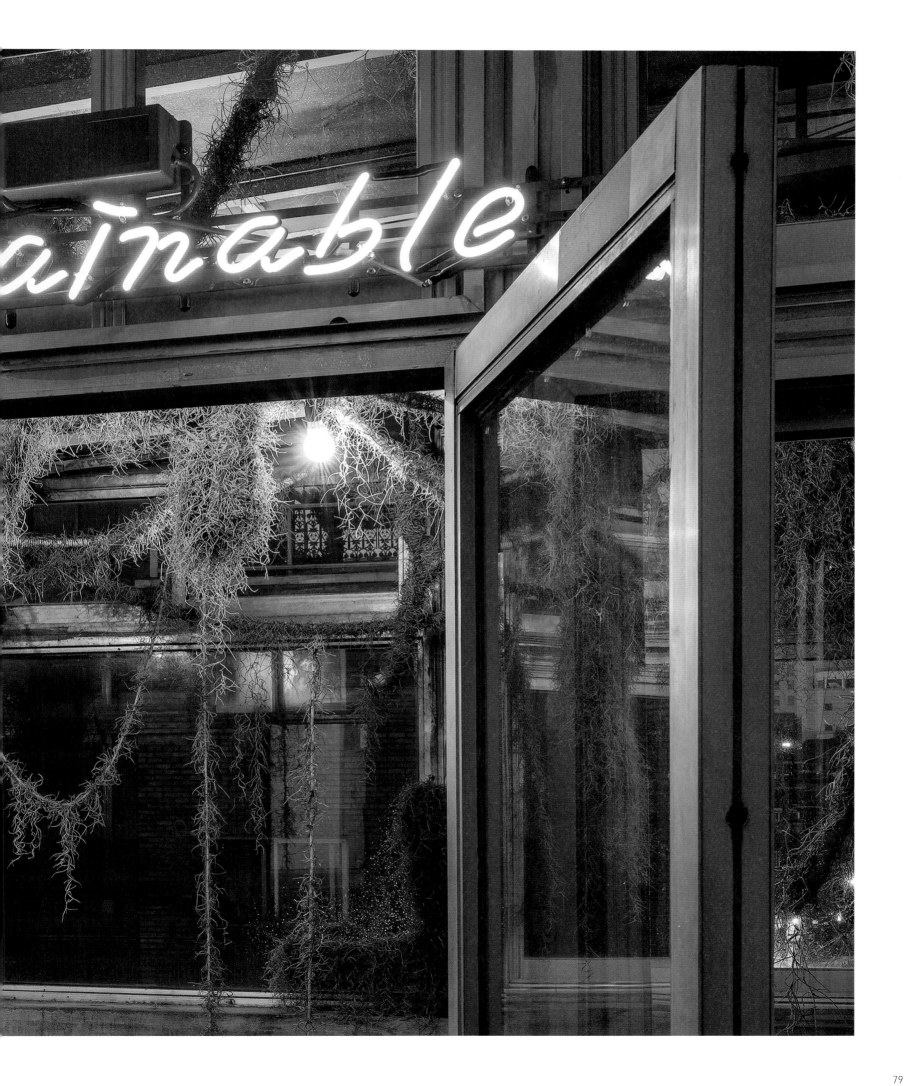

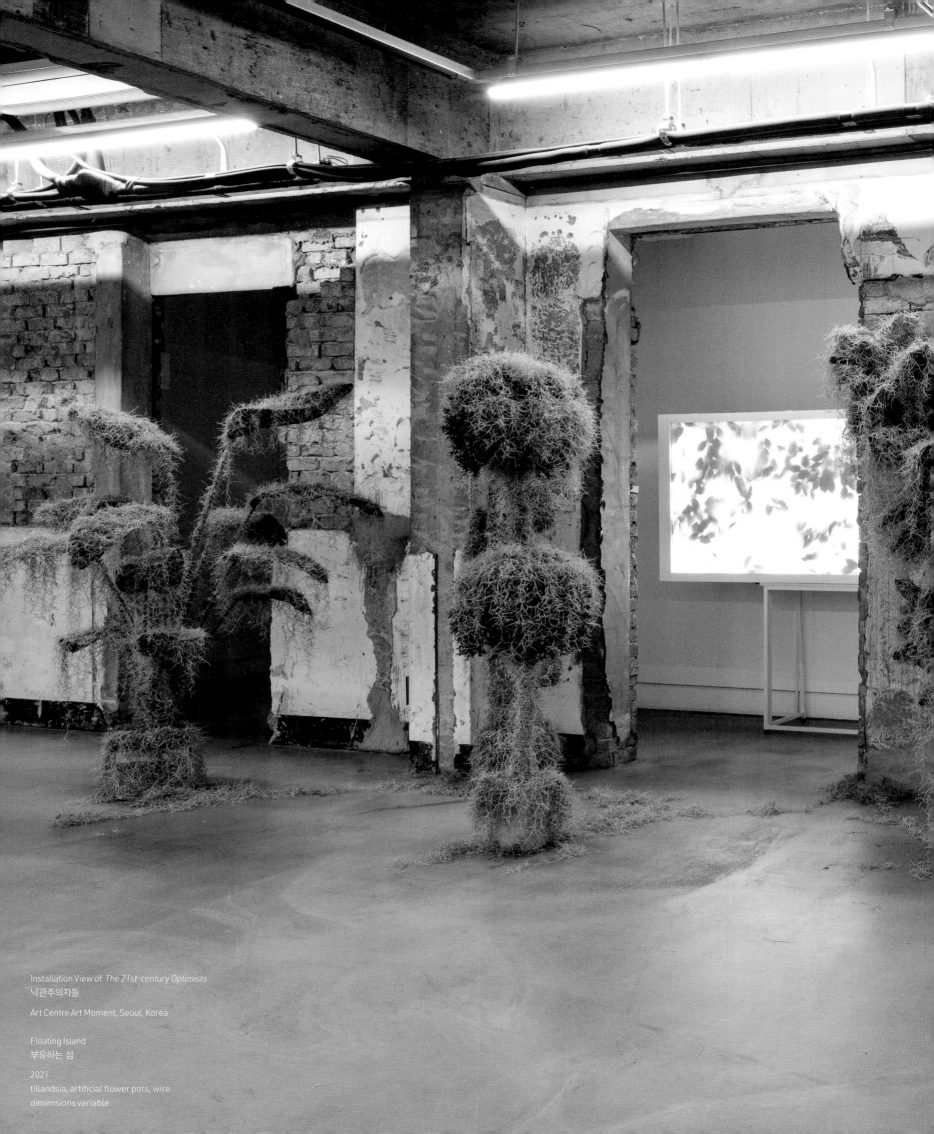

Installation View of *The 21st-century Optimists*
낙관주의자들

Art Centre Art Moment, Seoul, Korea

Floating Island
부유하는 섬

2021
tillandsia, artificial flower pots, wire
dimensions variable

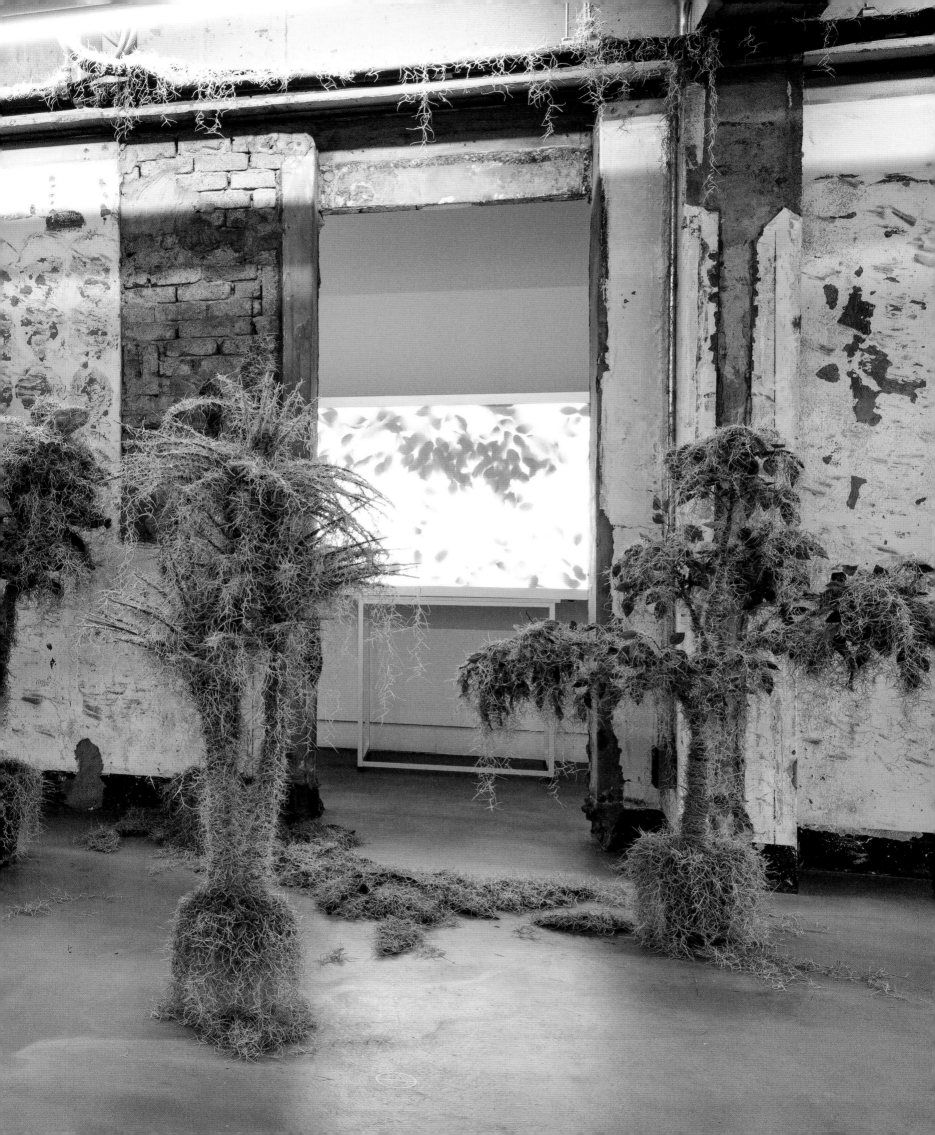

As artificial flower pots are submerged in actual plants, this raises questions about the artificial and the natural. Projecting the superficial phenomena of human relations, they also reflect the uncertain phenomena of individuals within society. For people living in the city, gardens are replaced by flower pots to be tended. The objects are quite passive—frail and precarious things that demand care—yet they also exert a hidden power in their environment, pushing their boundaries ever outward as they establish themselves.

인조 화분에 실제 식물이 덮어지면서 인공적인 것과 자연적인 것에 대한 물음을 던진다. 인간관계에서의 표피적인 현상들을 투영하면서 사회 안에 속한 개인의 불안한 현상을 반영한다. 도시적 삶을 사는 인간의 정원은 화분을 돌보거나 키우는 것으로 대체된다. 그 대상들은 지극히 수동적이고 보살핌을 받아야 하는 위태롭고 연약한 존재이나, 자신의 환경에서 숨은 힘으로 경계를 뻗어 나가며 자리매김한다.

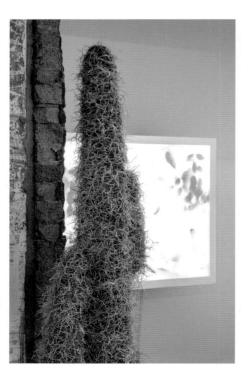
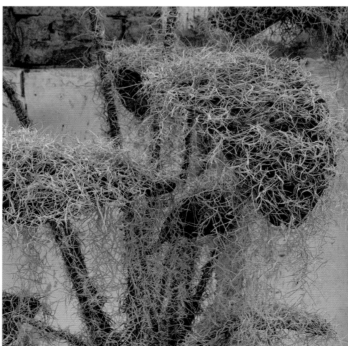
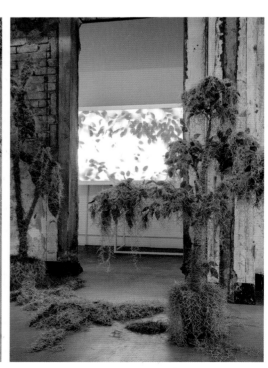

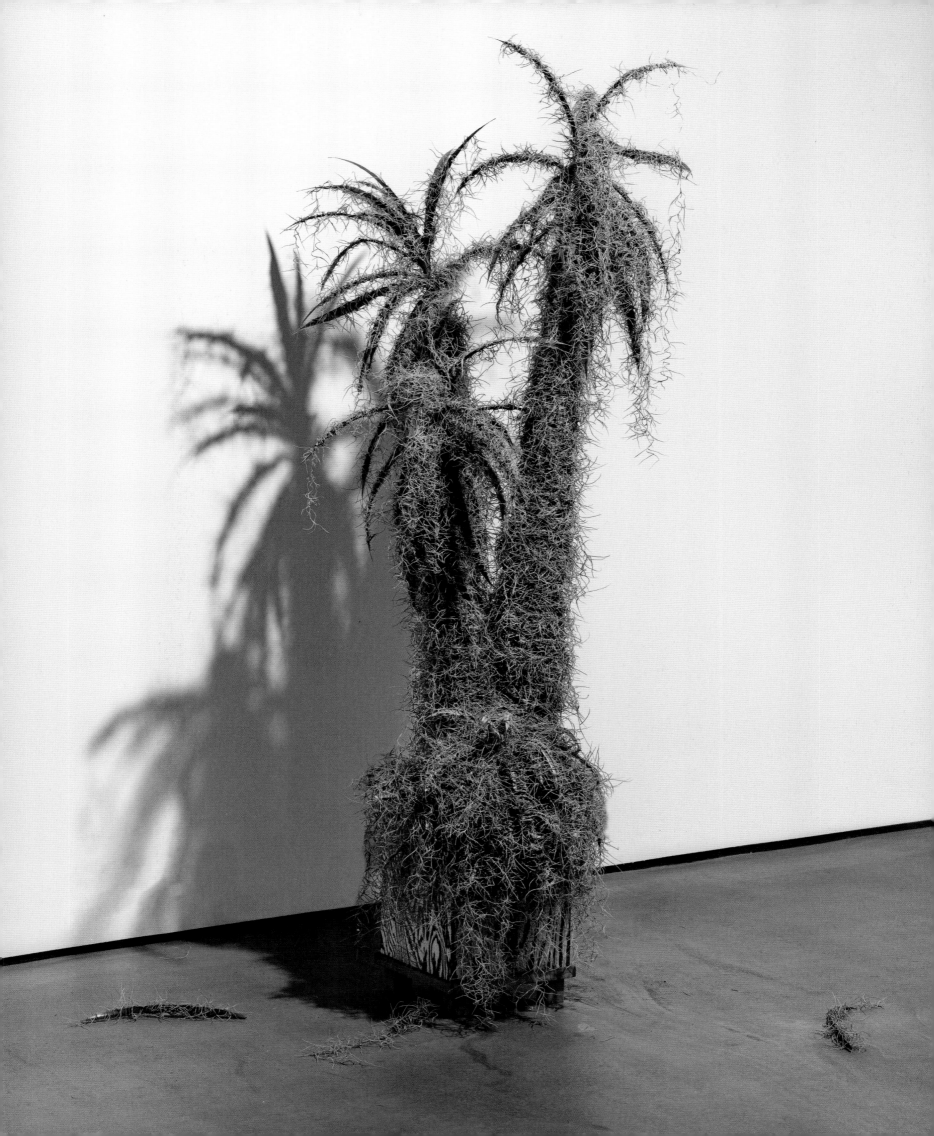

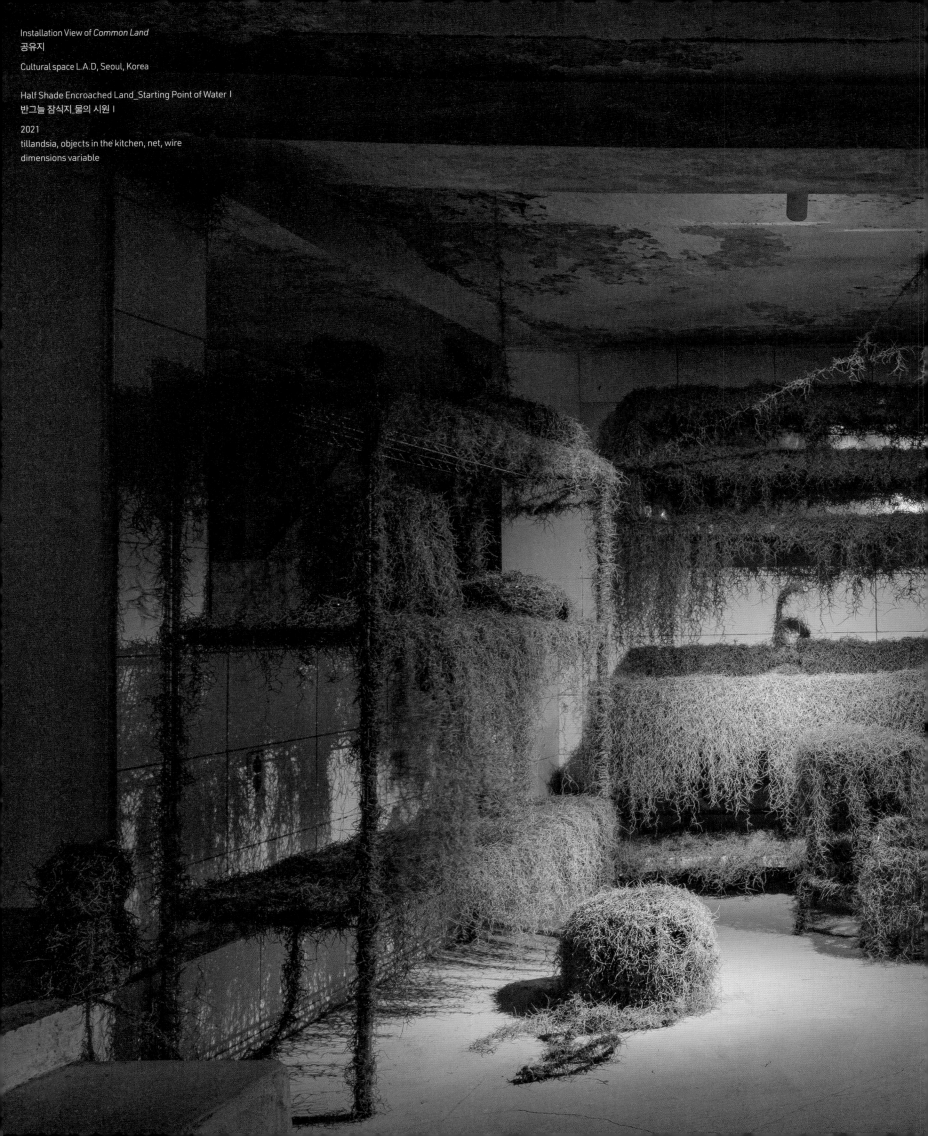

Installation View of *Common Land*
공유지

Cultural space L.A.D, Seoul, Korea

Half Shade Encroached Land_Starting Point of Water Ⅰ
반그늘 잠식지_물의 시원 Ⅰ
2021
tillandsia, objects in the kitchen, net, wire
dimensions variable

Half Shade Encroached Land_Starting Point of Water Ⅰ
반그늘 잠식지_물의 시원 Ⅰ

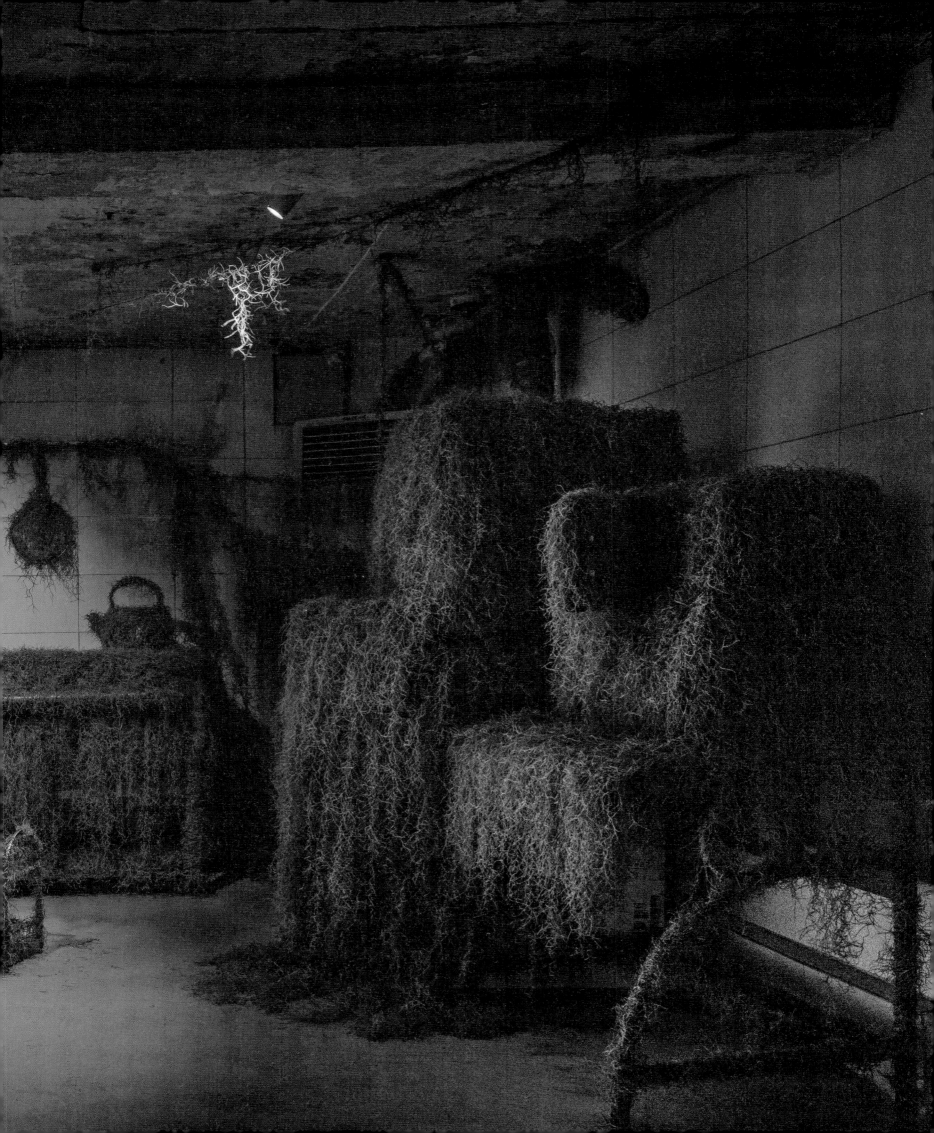

This is a landscape made with objects in the actual kitchen where water was supplied in human residential environment. This also signifies a meeting between the spatiality of the kitchen (a place for supplying water) and the habitat of plant life. There are all objects that I have either used or collected, including devices and fixtures from the kitchen (a sink, a stove, a rack, a gas range, a refrigerator, a microwave, a rice cooker, and so on) as well as things from another place where water is supplied, namely the bathroom: a bathtub, toilet, shelf, mirror, sink, and so forth. Ambushing and occupying space, the plants present us with an environment that is both strange and familiar. Water is a crucial element for plants' survival, and the objects that are covered in plants in residential settings that require water become transformed as they are invoked in a newly arranged environment. Inanimate objects are taken over by the tillandsia, a decorative plant. From tools that were once essential for human survival but were discarded after completing their service, they are transformed into new objects of attention, gaining a new life to become living, animate beings.

인간의 거주 환경에서 물이 공급되는 실제 주방이었던 전시 공간에서 주방의 집기로 만들어진 풍경이다. 물이 공급되는 주방의 장소성과 식물의 서식 환경이 만나는 의미도 있다. 즉 싱크대, 간택기, 선반, 가스렌지, 냉장고, 전자렌지, 밥통 등 각종 주방기기와 주방기구들과 물이 공급되는 장소인 욕실의 욕조, 변기, 선반, 거울, 세면대 등 각종 오브제들은 직접 사용했거나 수집한 오브제들이다. 식물들은 공간을 점령하고 습격하며 낯선 듯 익숙한 공간으로 다가온다. 식물의 생존에 중요한 요소인 물이 필요한 주거 공간에 식물로 뒤덮인 대상물들은 새로 단장한 공간에 다시 호환되어 탈바꿈된다. 이러한 무기체 대상물들은 관상용 인테리어 식물인 틸란드시아에 덮이면서 한때는 인간의 생존에서 필요한 도구였지만 수명을 다해 버려진 물건들에서 새로운 관심의 대상으로 규정되며 생명을 얻어 살아있는 유기체로 둔갑한다.

Half Shade Encroached Land_Starting Point of Water I
반그늘 잠식지_물의 시원 I

2021
tillandsia, objects in the kitchen, net, wire
dimensions variable

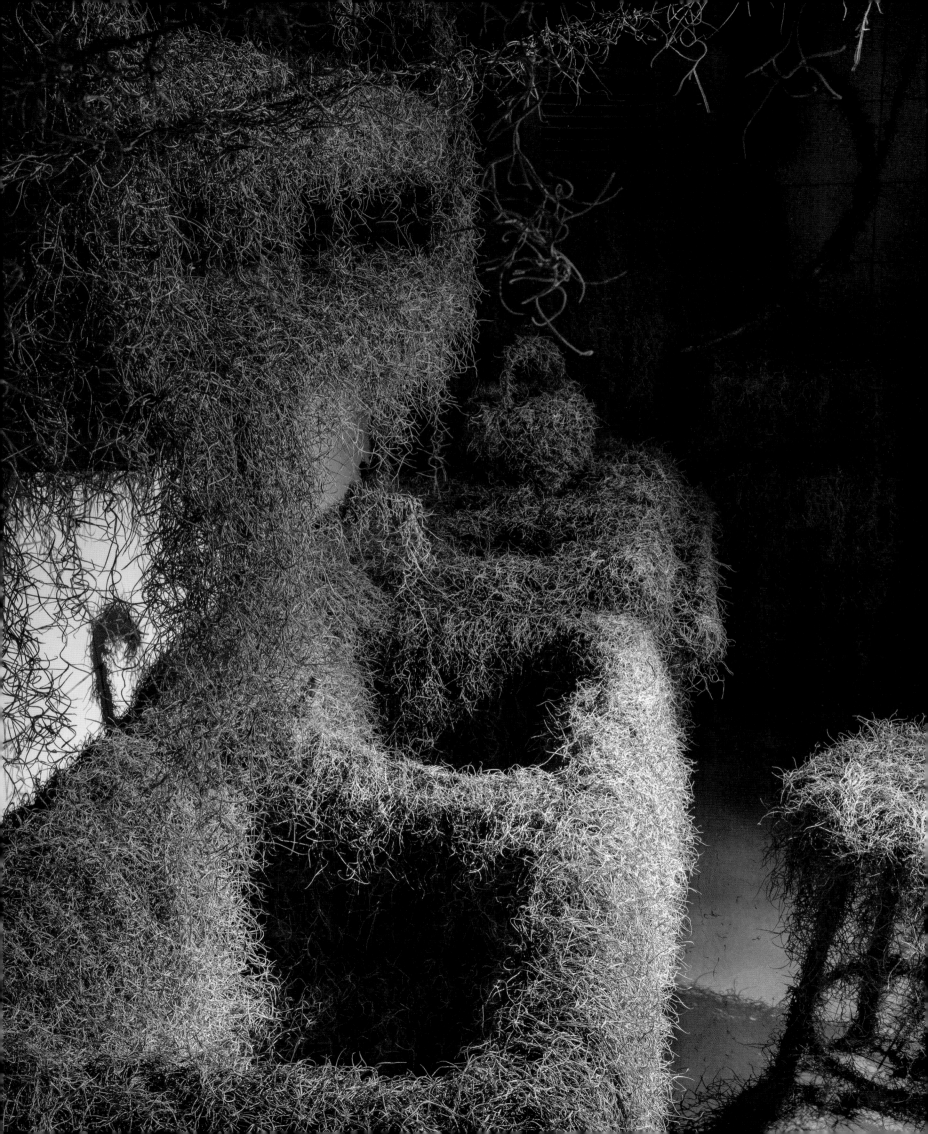

Half Shade Encroached Land_Starting Point of Water II
반그늘 잠식지_물의 시원 II

2021
tillandsia, objects in the bathroom, net, wire
dimensions variable

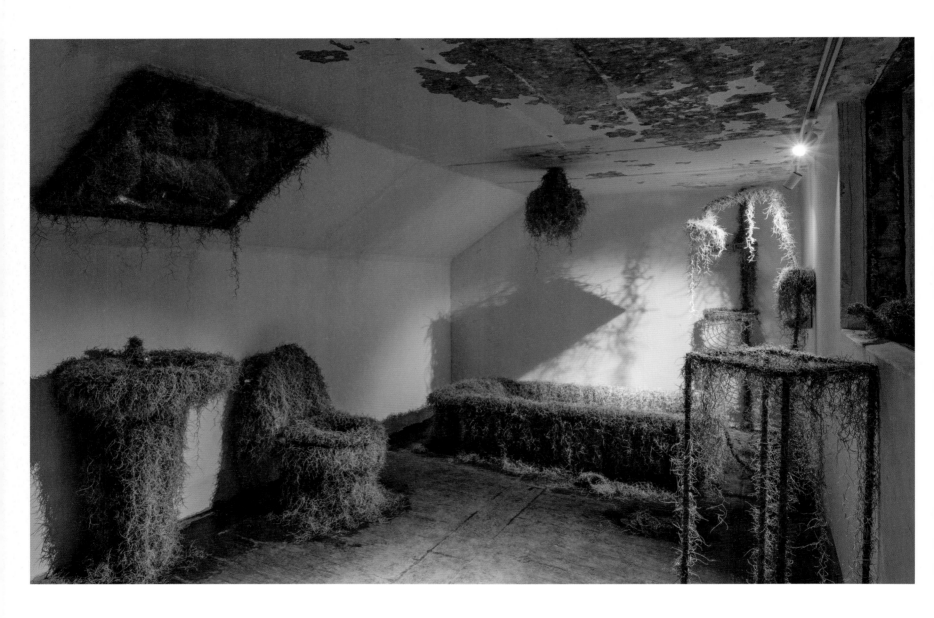

Half Shade Encroached Land_Starting Point of Water II
반그늘 잠식지_물의 시원 II

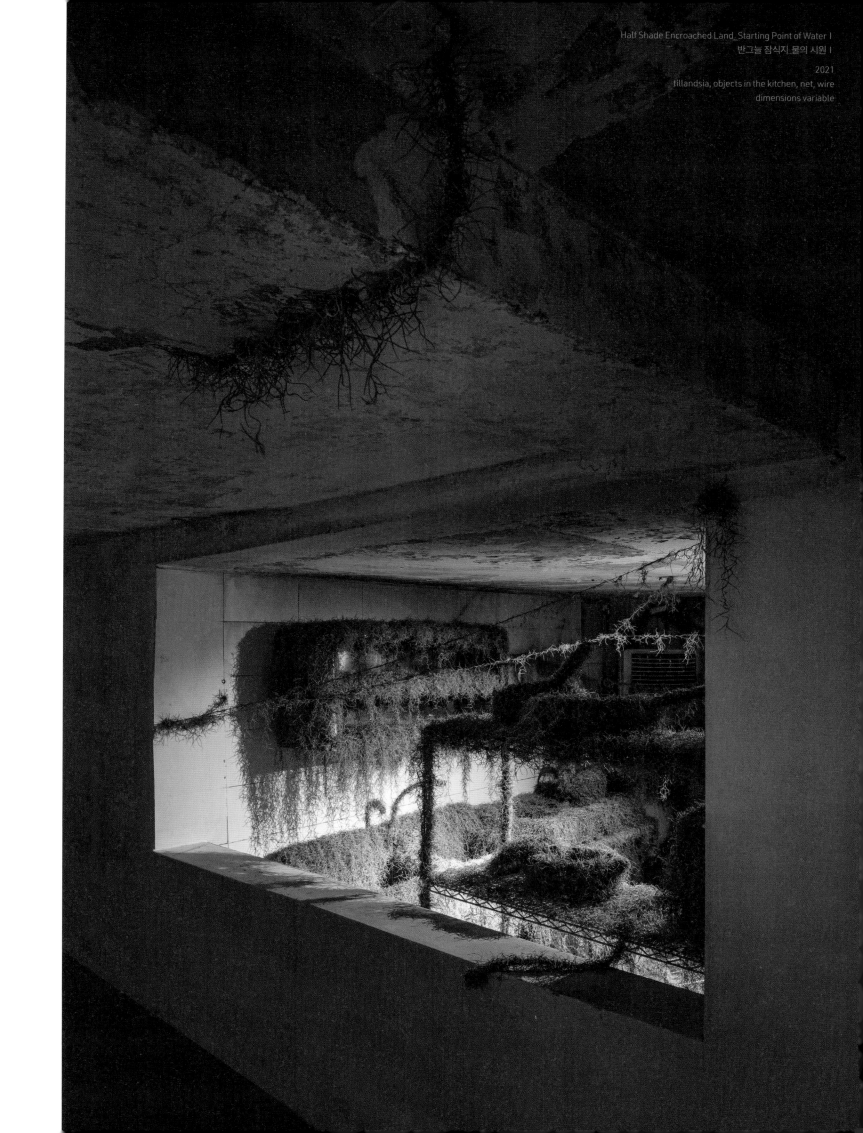

Half Shade Encroached Land_Starting Point of Water I
반그늘 잠식지 물의 시원 I

2021
tillandsia, objects in the kitchen, net, wire
dimensions variable

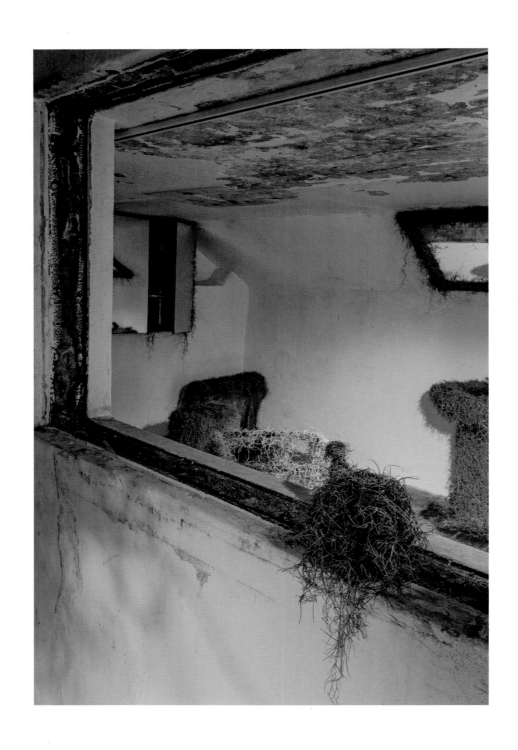

Half Shade Encroached Land_Starting Point of Water II
반그늘 잠식지_물의 시원 II

2021
tillandsia, objects in the bathroom, net, wire
dimensions variable

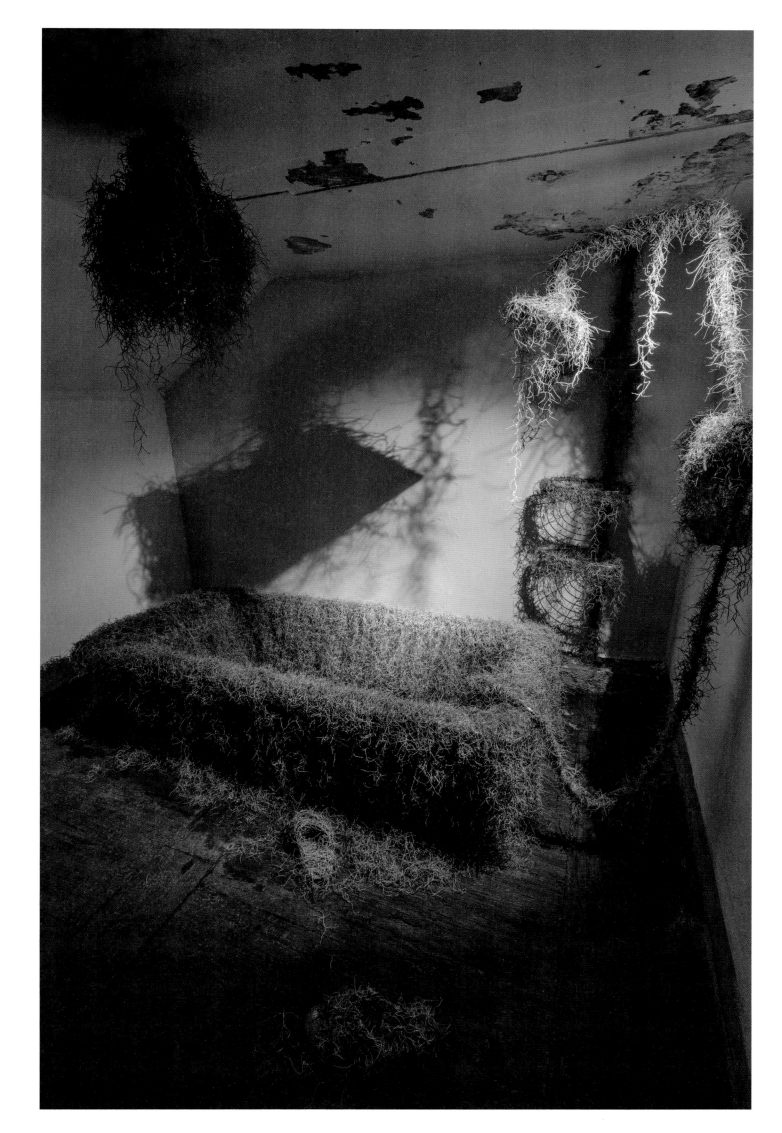

Concrete Jungle
콘크리트 정글

2021
pigment print
dimensions variable

Concrete Jungle
콘크리트 정글

Submerged Vessel 2020—19

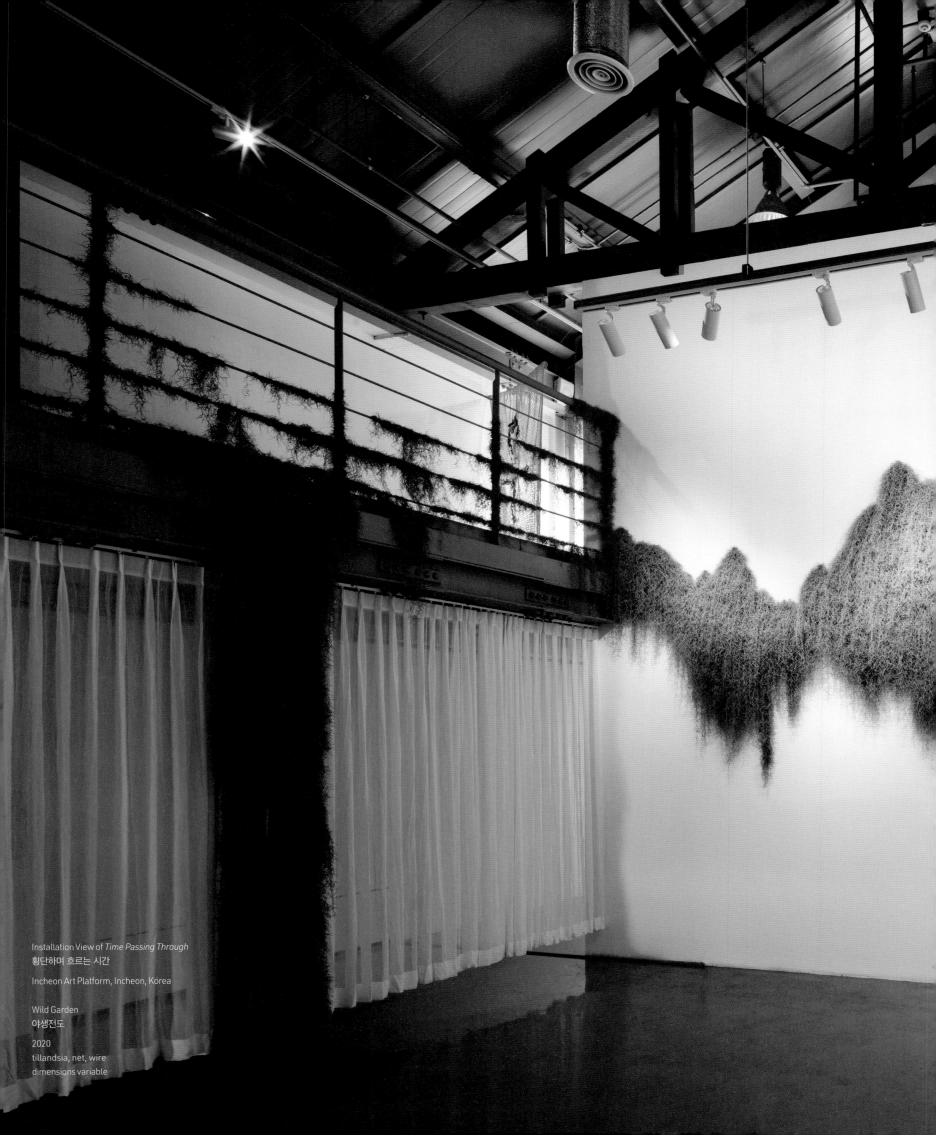

Installation View of *Time Passing Through*
횡단하며 흐르는 시간

Incheon Art Platform, Incheon, Korea

Wild Garden
야생전도

2020
tillandsia, net, wire
dimensions variable

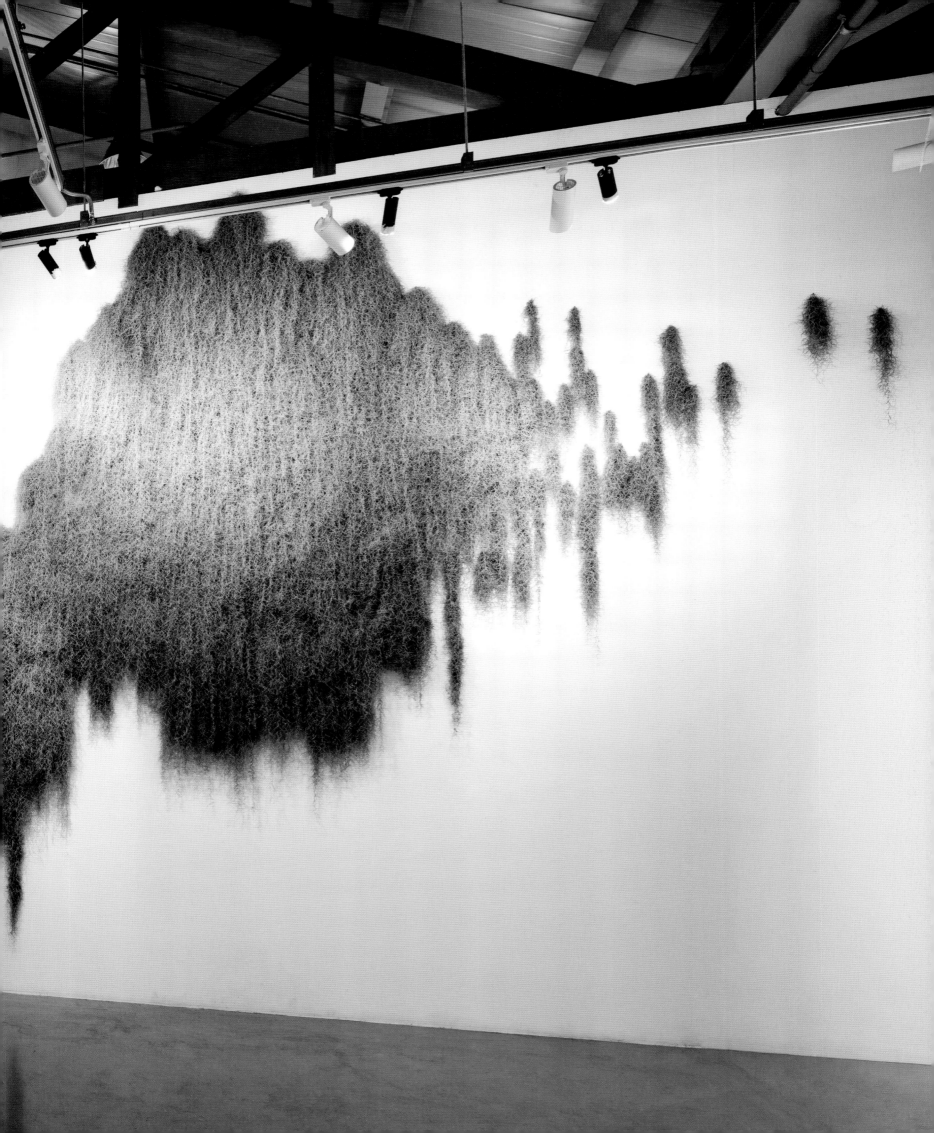

Situated at the center of the gallery in Incheon Art Platform's B wing, *Wild Garden* (2020) gives the sense of intruding along or across the boundaries of the exhibition space. Stretching from the column and railing, it takes on the form of an enormous hill, creating a wild landscape. A new space is formed and reinterpreted as a medium connecting time. Already imbued with various historical records and the contemplation of different traces, a space that might easily have been perceived as peripheral transformed into a zone of submersion or occupation by plants.

인천아트플랫폼 B동 전시장 중앙에 설치한 <야생전도>(2020)는 전시 공간의 경계를 넘거나 타고 들어오는 느낌을 준다. 기둥과 난관에서부터 이어지며 거대한 산의 형상을 띠며 야생 풍경으로 완성된다. 시간을 잇는 하나의 매개체로 새로운 공간을 탄생시키고 재해석한다. 이미 많은 역사적 기록과 흔적의 사유가 담긴 이 공간은 자칫 주변부로 인식되거나 인식됐던 식물의 잠식지대이자 점령지가 된다.

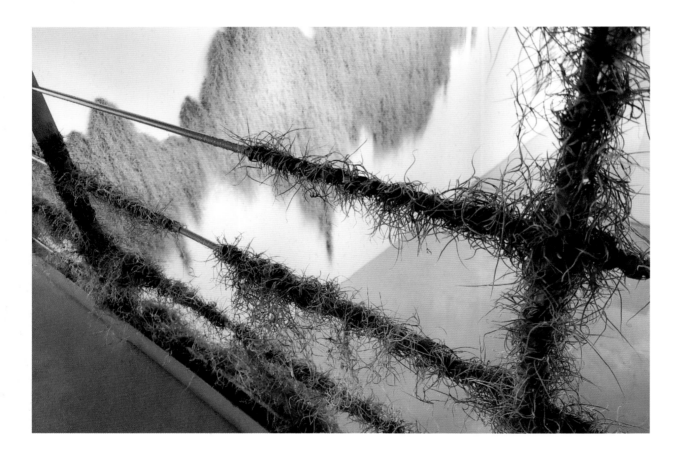

Wild Garden
야생전도

2020
tillandsia, net, wire
dimensions variable

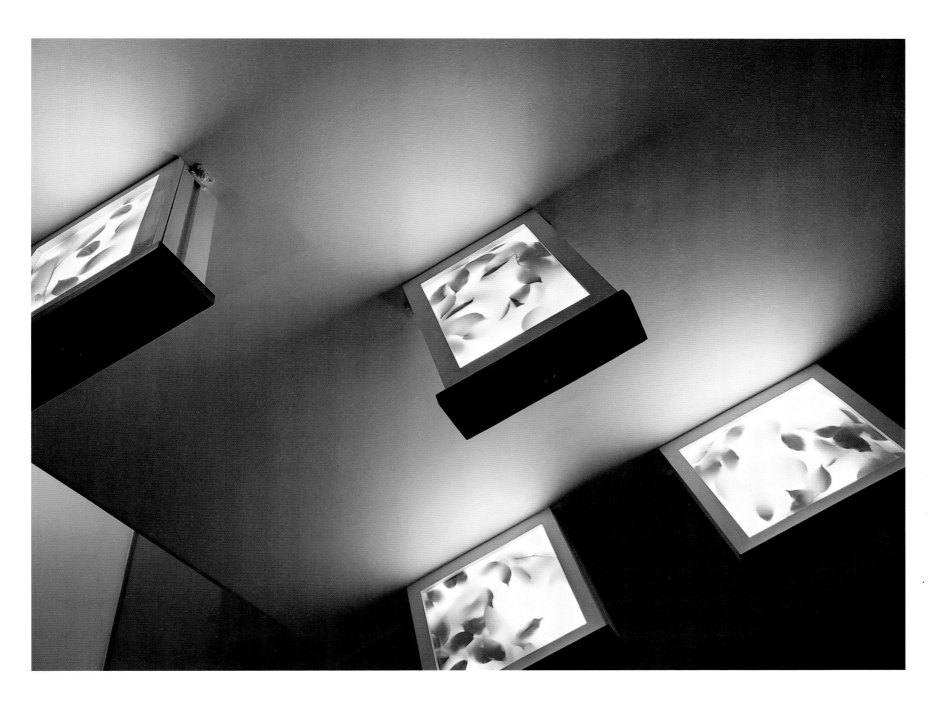

Recycle_Breath
재생_숨

2020
recycle living furniture drawer lightbox, recycle antique furniture drawer lightbox, artificial plants, fabric
17x50x42cm, 3ea
10x34x42cm, 1ea

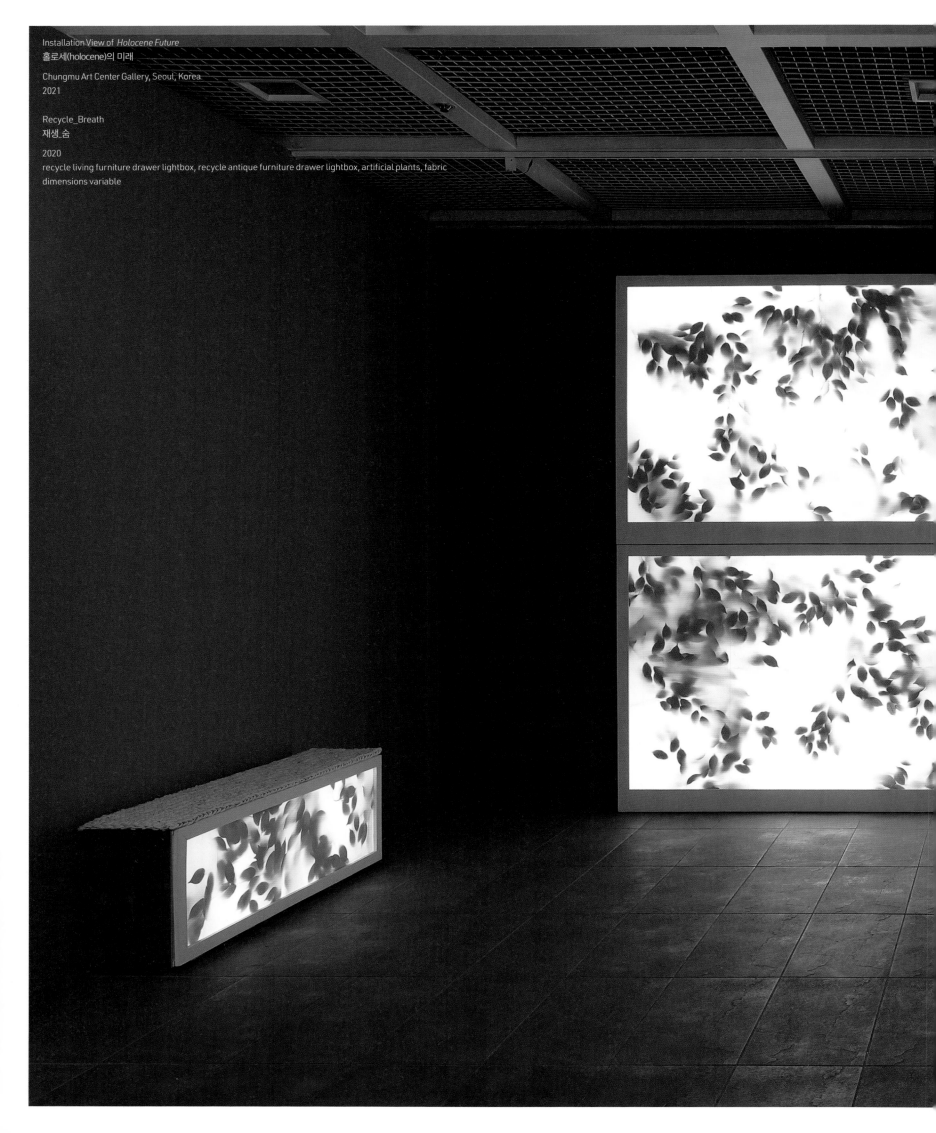

Installation View of *Holocene Future*
홀로세(holocene)의 미래

Chungmu Art Center Gallery, Seoul, Korea
2021

Recycle_Breath
재생_숨

2020
recycle living furniture drawer lightbox, recycle antique furniture drawer lightbox, artificial plants, fabric
dimensions variable

Installation View of *Holocene Future*
홀로세(holocene)의 미래

Chungmu Art Center Gallery, Seoul, Korea

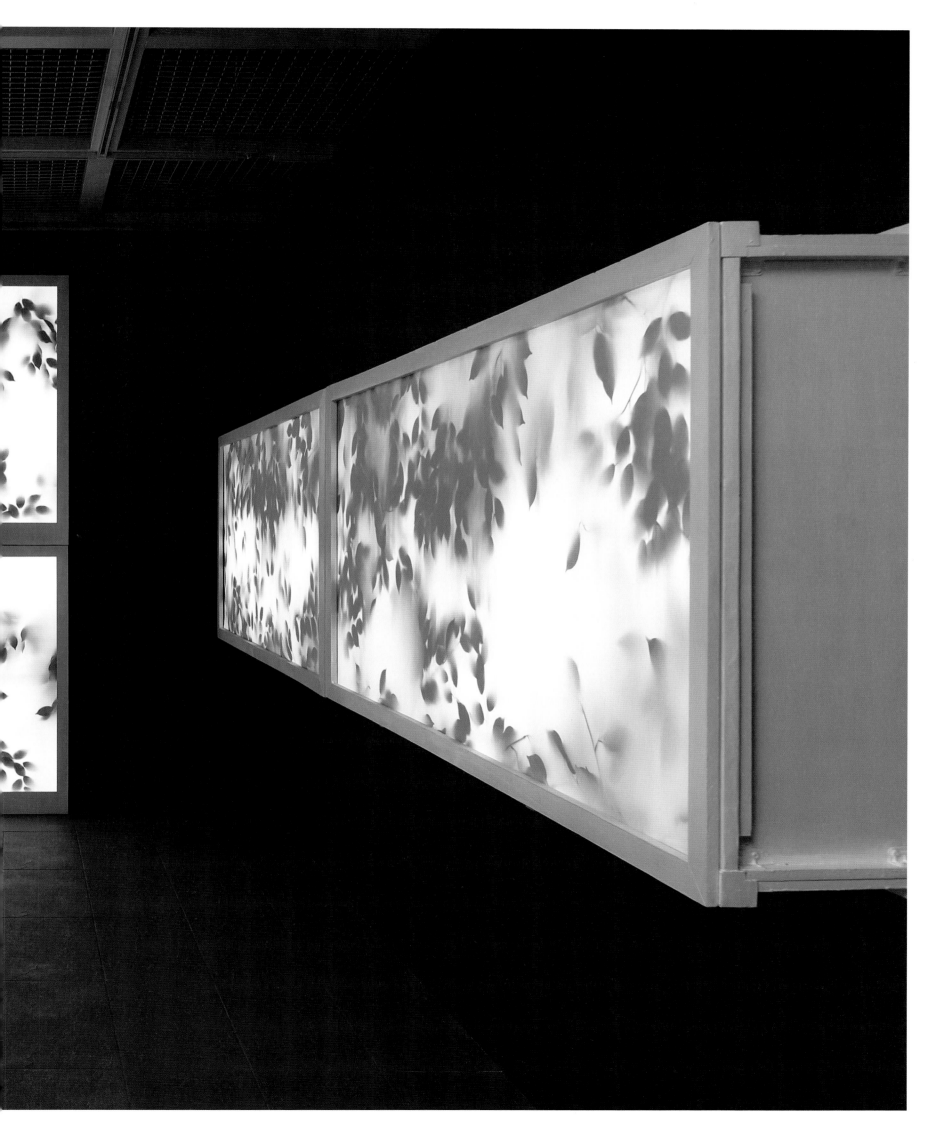

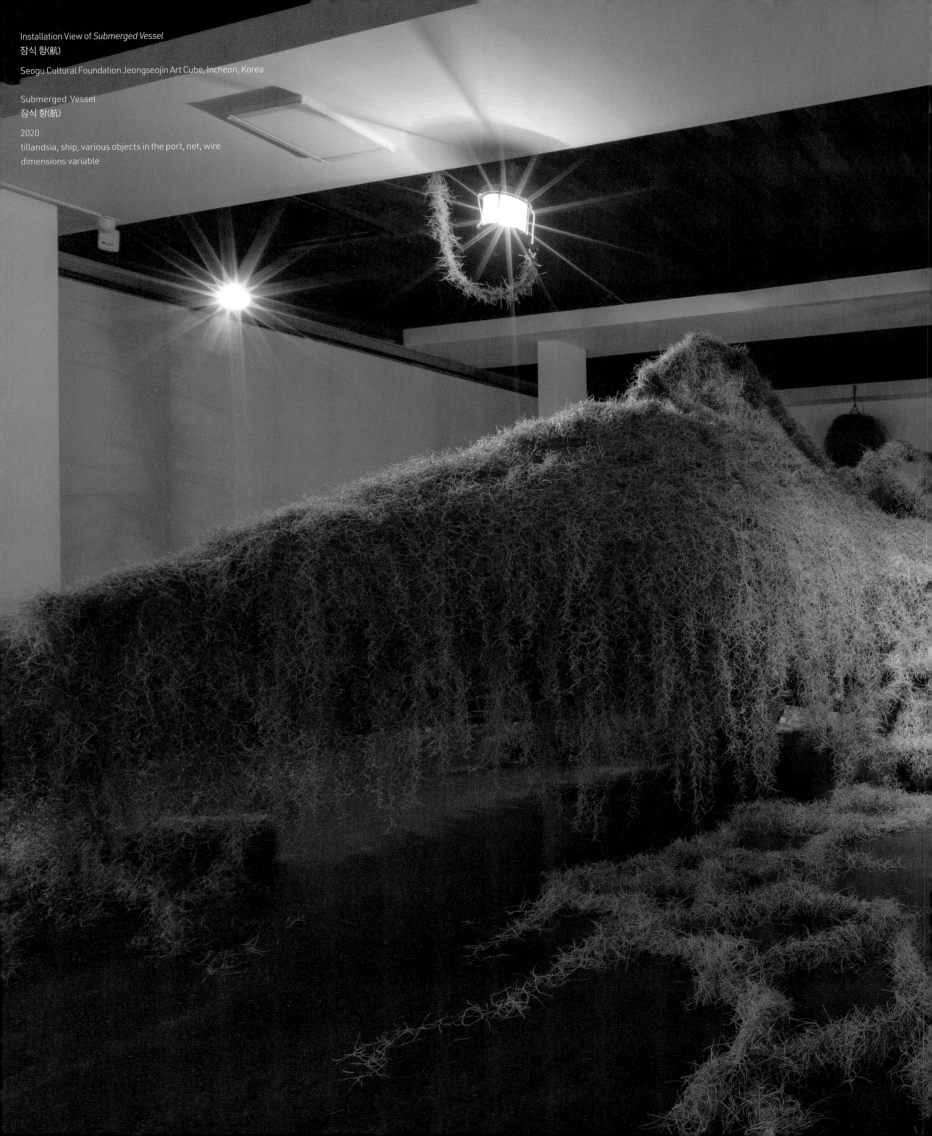

Installation View of *Submerged Vessel*
잠식 항(航)

Seogu Cultural Foundation Jeongseojin Art Cube, Incheon, Korea

Submerged Vessel
잠식 항(航)

2020
tillandsia, ship, various objects in the port, net, wire
dimensions variable

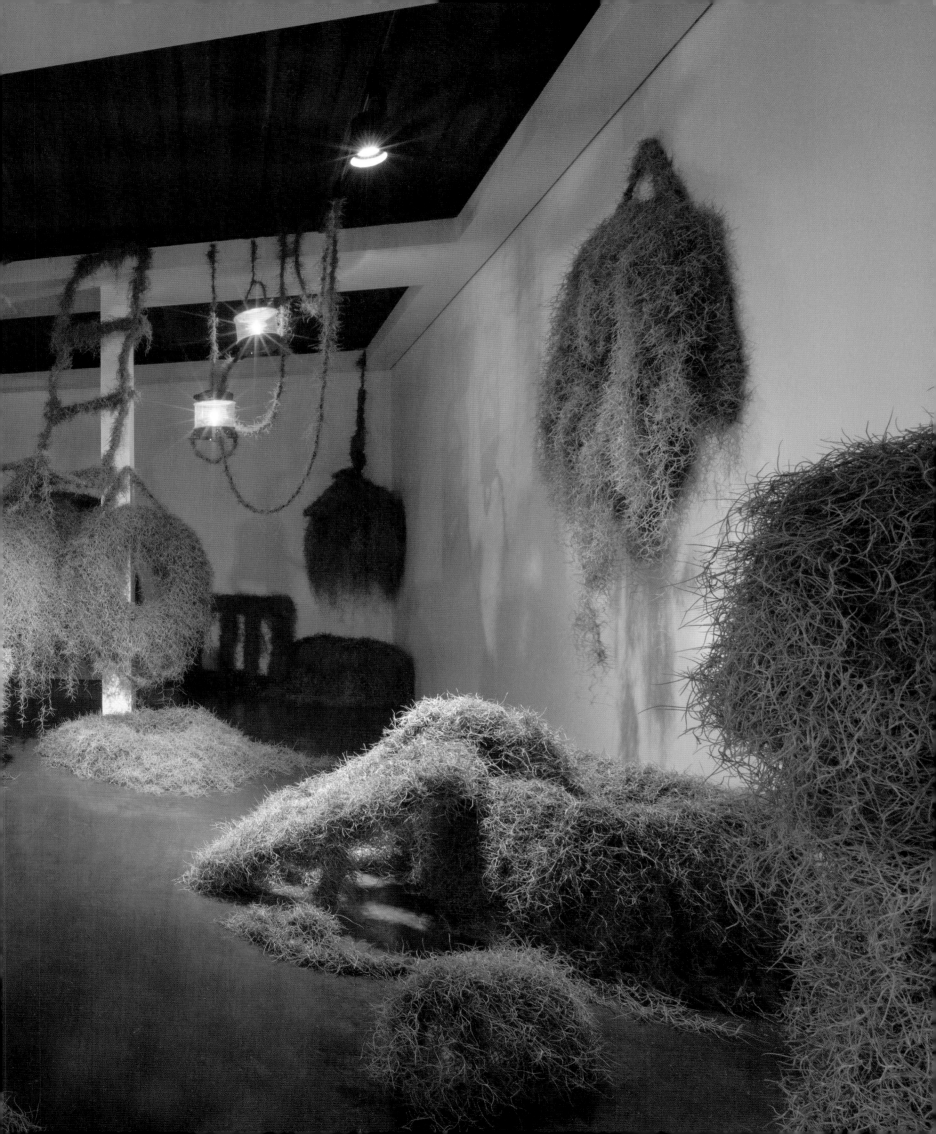

Submerged Vessel
잠식 항(航)

2020
tillandsia, ship, various objects in the port, net, wire
dimensions variable

 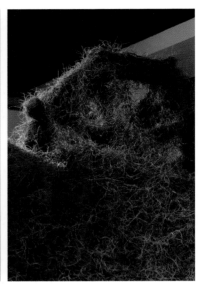

The location of the Jeongseojin Art Cube is the starting point of the Ara Waterway, an artificial route to the sea. At the entrance to the exhibition space, a large boat and a wall-mounted object are presented as a new form of garden. In my previous work on themes of the relationship of control between plants and people and of nature that has been socialized or rendered artificial, I developed an interest in waterway routes; in the motorless boats that once served as a key means of transportation and survival along waterways; in the boxes used for transportation at warehouses; and in the items such as life jackets, life preservers, steering devices, steering handles, navigation lights, and fishing traps. Here, I have transported them into the gallery as art objects. Through an installation in which my objects are submerged by tillandsia, I explore the violence and consuming nature of plants. In between a combination of an inanimate boat and organic plants, a net used at sea has been firmly fixed to form what looks like a unified whole. Overtaken by the tillandsia, the harbor objects resemble an end to civilization and return to the primeval. Yet through the active involvement of the viewer, it is shown that the time associated with this space is ultimately the present moment. It is ironic that the existential place of plants today should be one in which they require human care. The spray can is a tool for the plants' survival, providing ongoing moisture. Amid this process of creating and reinterpreting space as a medium connecting people, nature, and the Ara Waterway, there is a search for socialized nature. The viewers are made part of the watering process through the spray can provided for them for the sake of the artificial conditions needed to sustain the elements of survival (the bright semi-shade, the ongoing moisture). At the same time, they are presented both with a question—Is it really possible to tame something that is alive?—and the duty of one-sided care. Through an artwork that looks at the human/plant relationship from a somewhat odd perspective, I contemplate the context of intersecting "natural" and "artificial" aspects in the Ara Waterway setting, as well as the human/nature relationship intertwined with that.

정서진 아트큐브가 위치한 곳은 바다에 인공적으로 물길을 낸 아라뱃길의 시작점이다. 전시공간의 입구에는 거대한 배 한 척과 벽면의 오브제가 새로운 정원으로 재현되어 있다. 식물과 인간의 지배 관계, 인공화 또는 사회화된 자연에 대한 주제로 작업을 이어 오면서 뱃길의 뱃길, 물길의 중요한 이동수단이자 생존 수단이었던 무동력의 배, 물류창고의 운반 상자들, 구명, 부환, 조타장치, 핸들조타기, 향해등, 통발어구 등에 관심을 가지고, 오브제로서 전시장으로 호환했다. 오브제의 대상들이 식물 틸란드시아에 의해 잠식되는 설치작업을 통해 식물의 폭력성과 잠식성을 탐구한다. 무기체인 배와 유기체인 식물의 결합 사이에는 바다에서 사용되는 그물이 단단히 고정되어 하나를 이룬 것처럼 보인다. 틸란드시아에 의해 잠식되어버린 항구의 오브제들은 마치 원시로 돌아간 문명의 종말처럼 보이지만 관람객의 적극적인 개입을 통해 공간의 시간이 결국은 현재의 시간이라는 사실을 환기시킨다. 동시대 식물의 존재론적 위치가 인간에 의한 돌봄이 필수적일 수밖에 없다는 점이 아이러니하다. 식물의 생존을 위한 도구인 물을 주는 분무기는 지속적인 수분을 제공한다. 인간과 자연 그리고 아라뱃길을 잇는 하나의 매개체로 공간을 탄생시키고 재해석하는 과정에서 사회화된 자연을 모색해보고자 한다. 생존에 필요한 요소들을 유지하려는 인위적인 조건들(밝은 반그늘, 지속적인 수분)을 위해 관람객들에게 미리 준비한 분무기로 물주기에 참여시킨다. 그리고 그들에게 '살아있는 것을 길들이는 것이 과연 가능한가' 에 관한 물음과 일방적인 돌봄에 대한 의무를 전가한다. 인간과 식물의 관계를 다소 낯선 시선으로 바라보는 작품을 통해 아라뱃길이라는 장소가 가진 자연성과 인공성이 교차하는 맥락, 그리고 그 안에 얽힌 인간과 자연의 관계를 고민해본다.

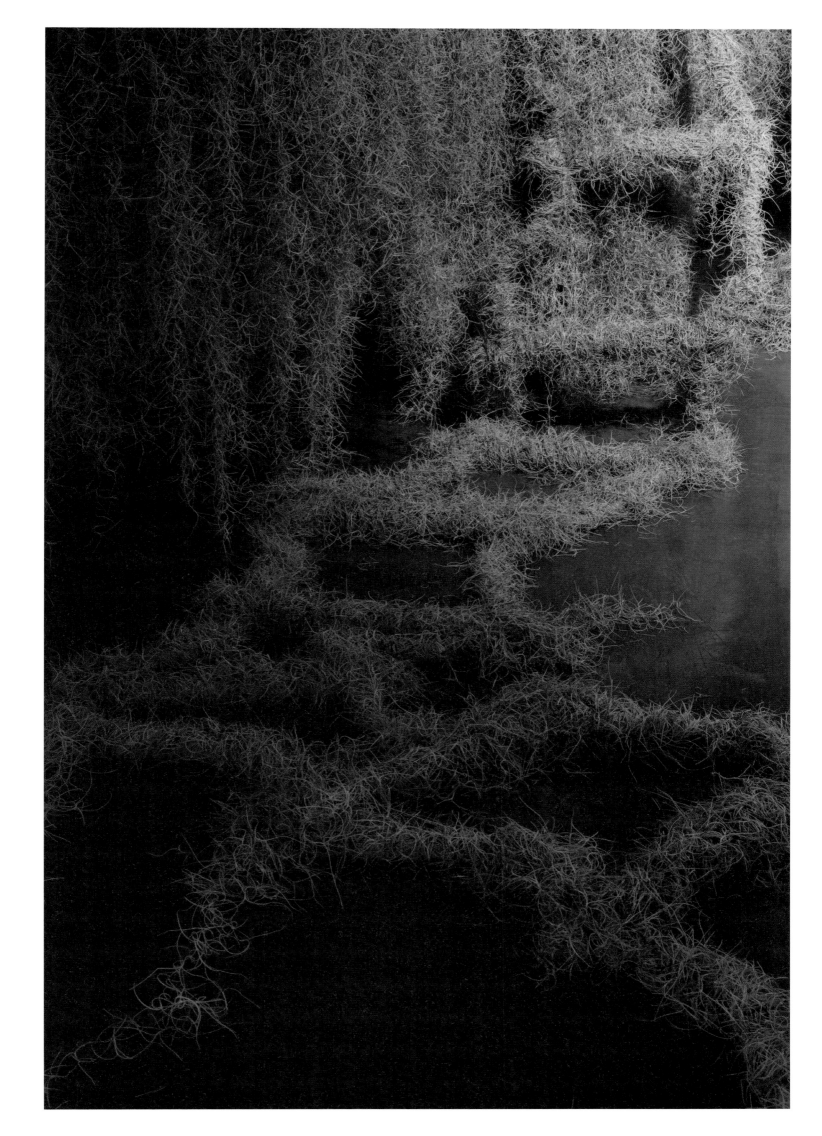

Recycle_Breath (detail)
재생_숨

2020
collected wood bookcase furniture lightbox, artificial plants, fabric

Items of furniture that were created to reduce inconvenience in people's lives have lived out their lives and been discarded. Drawers and bookshelves within a collected cabinet with mother-of-pearl inlay have been newly transformed through a process of recycling. The window looking in is a place for breathing a psychological landscape based on each individual's memories. The green formed by the intervals of light and space, as well as the harmony of gray and shade, evokes the experience of an Eastern aesthetic of nature.

인간의 삶에서 불편함을 덜기 위해 생겨났던 가구들이 존재의 수명을 다해서 버려졌다. 수집된 자개장 안의 서랍과 책장 등은 재순환 과정을 통해 새롭게 탈바꿈된다. 들여다본 창은 숨의 공간이자 각자가 기억하는 방식의 심리적 풍경이기도 하다. 빛과 공간의 간격으로 조성되는 초록색과 회색빛의 음영의 조화는 자연의 동양적인 미감을 체감하게 한다.

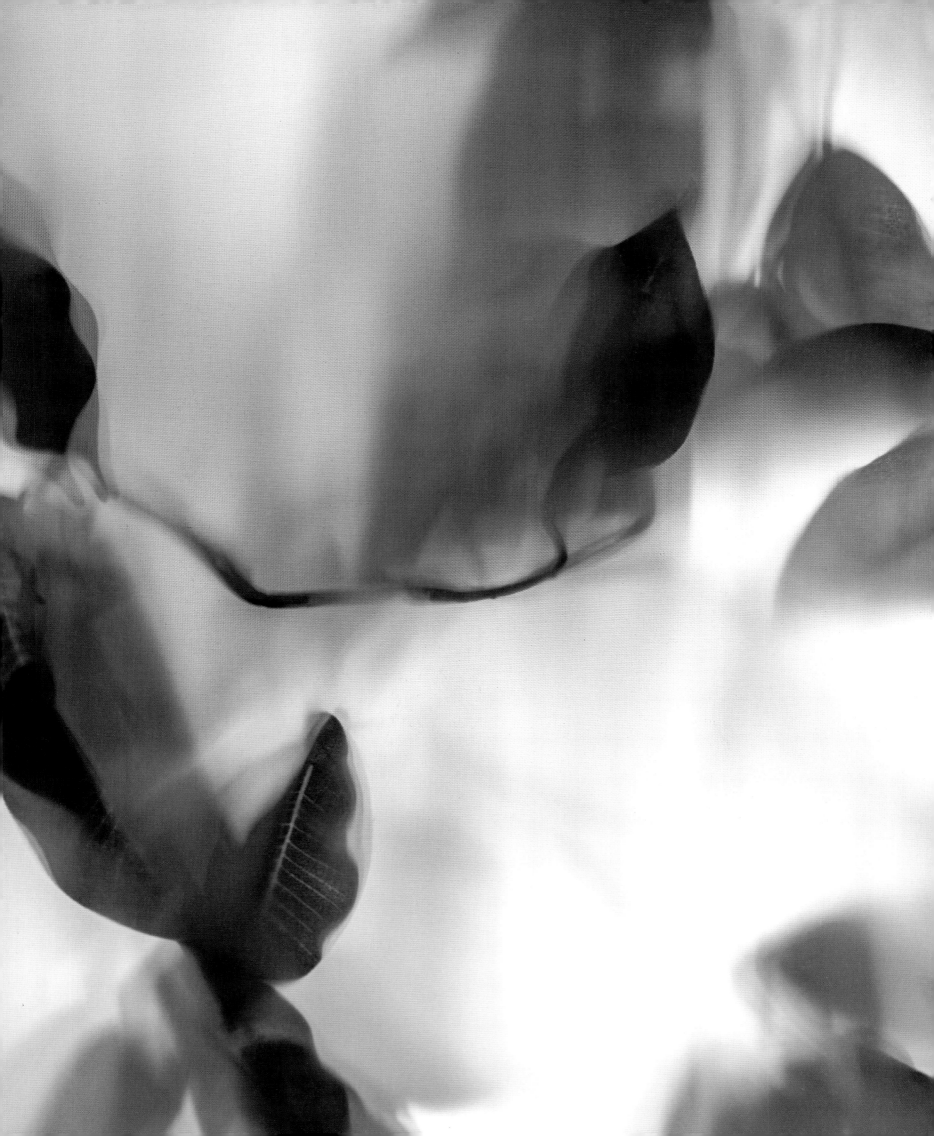

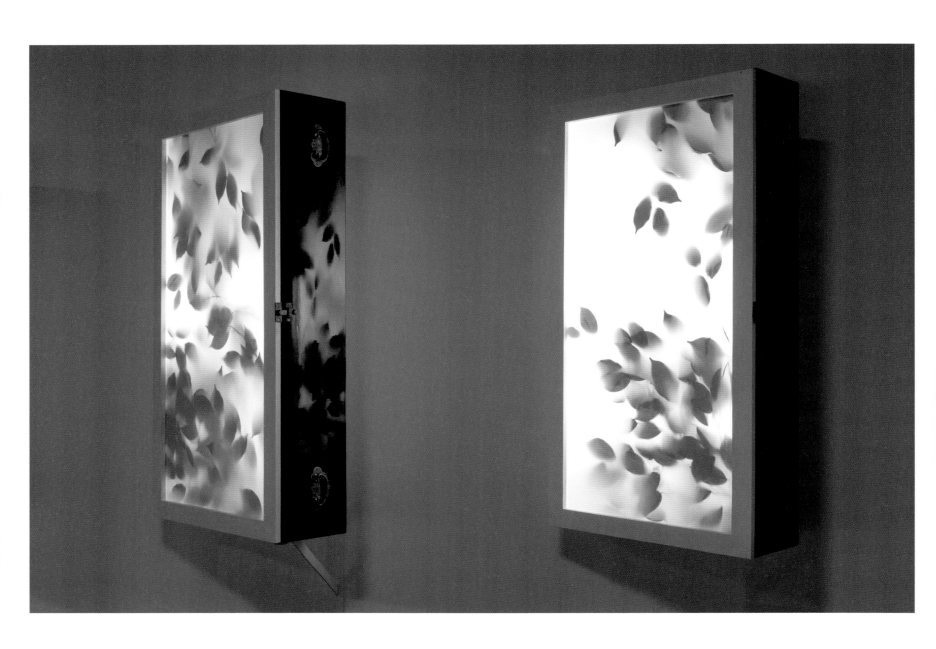

Recycle_Breath
재생_숨

2020
collected mother-of-pearl drawer lightbox, artificial plants, fabric
93.5x48.7x16.5cm, 87x47x18cm

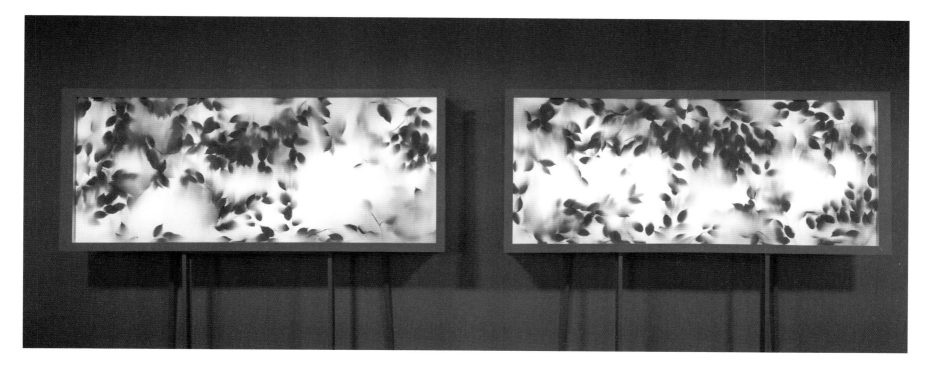

Recycle_Breath
재생_숨

2020
collected wood bookcase furniture lightbox, steel frame, artificial plants, fabric
122x196.8x30cm, 2ea

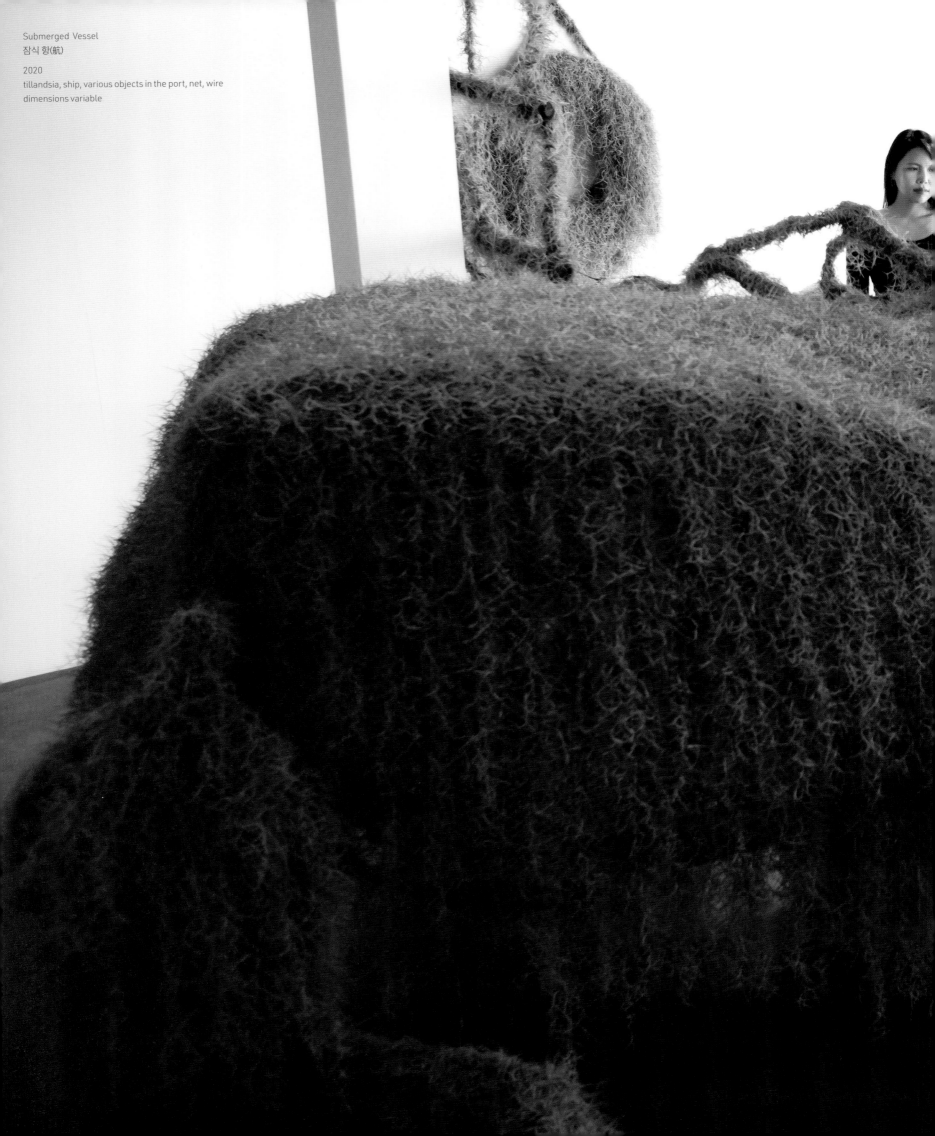

Submerged Vessel
잠식 항(航)

2020
tillandsia, ship, various objects in the port, net, wire
dimensions variable

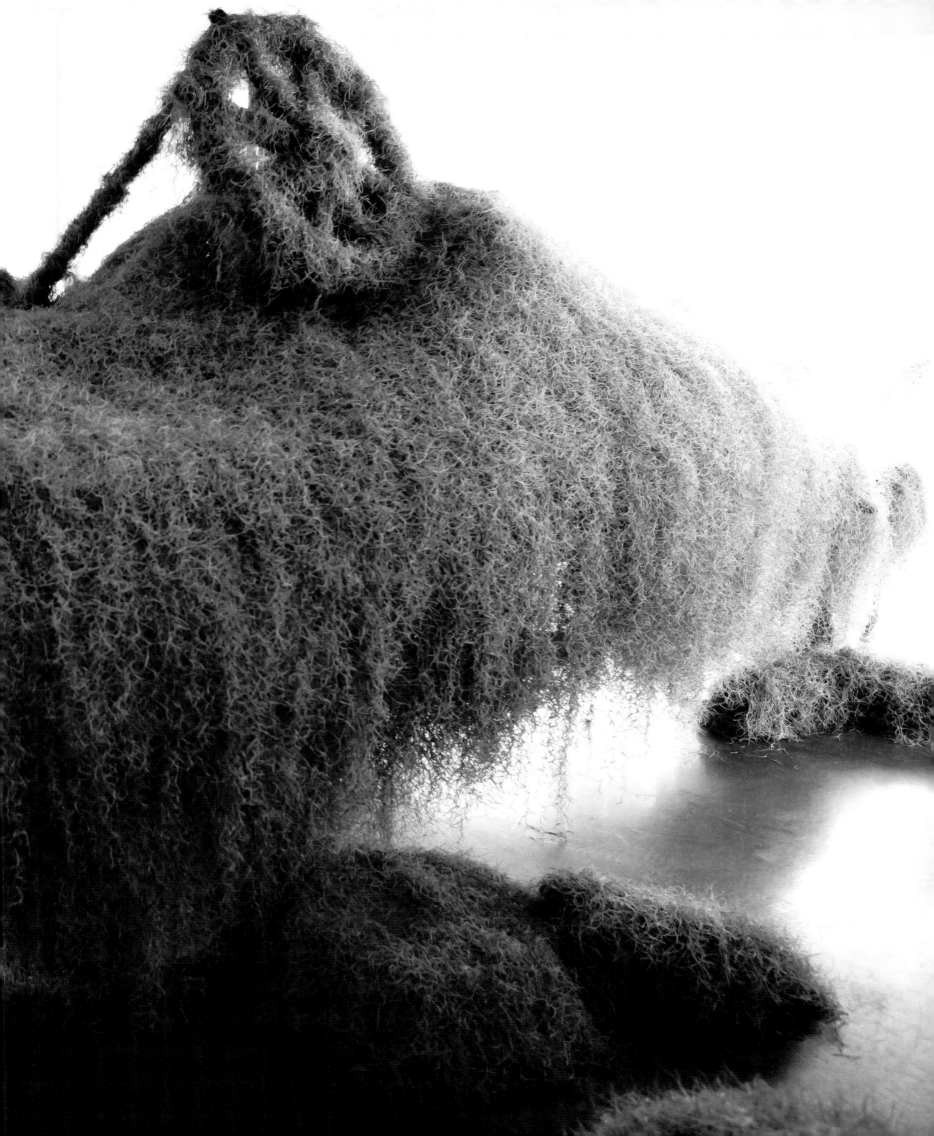

Not having roots, the tillandsia lives by taking up moisture and dust from the air through its leaves. Hence its reputation as an "air plant," or a plant that sucks up dust. Over the years, my painting approach has produced a great deal of dust due to the nature of its process, which involves scraping the surfaces of plastered walls. I began raising the uniquely shaped tillandsia as a way of drawing physical and psychological comfort amid a daily life saturated in fine dust. After I moved into the residency, I began taking comfort in watering and looking after the tillandsia. As it became both a "companion plant" and a means of solace, I began thinking about the act of one-sided care. The tillandsia caused me to question whether it is really possible to tame something living. It was also drawn upon in the artwork as an alluring object. Moments like these served as the starting point for my installation work. The bearded tillandsia was a bit of a hassle, since you have to spray it periodically, but it also required care as a living organism that can neither move nor speak. It's an odorless air plant that I started raising because I was fascinated by its unique shape. My eyes went to plants, which remain so still that you cannot tell if they are alive or dead. While I was reflecting on this heedless, seemingly suspended life that had come across my view, I began thinking about the conditions of survival for organisms to suit their environment. The tillandsia was meaningful as a breathing medium to present this theme. When a dangling plant is hung on a wall, it creates a peculiar feeling, as though it is either stuck to or has somehow bored through that gray wall, which introduces a natural quality. So I decided to create an opportunity for breathing with a new, somewhat unfamiliar perspective on plants—not just the ones we are familiar with, but ones that we are not aware of.

틸란드시아는 뿌리가 없어서 공중에 있는 습기나 먼지를 잎으로 흡수하여 살아간다. 그래서 에어플랜트, 공중식물, 먼지 먹는 식물로 알려져 있다. 오랜 기간 진행해왔던 나의 회화작업은 회벽의 표면을 긁어내는 과정의 특성상 먼지가 많은 작업이다. 나는 미세먼지로 뒤덮인 일상으로부터 몸과 마음의 위안을 받고자 유니크한 형상을 하고 있는 틸란드시아를 키우기 시작했다. 레지던시에 입주해서부터 틸란드시아에 물을 주면서 위안을 받거나 돌봄의 행위가 시작되었다. 위안을 삼는 도구이자 반려식물이 되면서 일방적인 돌봄이 주는 행위에 대해 고찰했다. 틸란드시아는 살아있는 것을 길들이는 것이 과연 가능한가에 대해서 질문하게 했다. 또한 매력적인 오브제로써 작업에 호출되기도 했다. 이 시간들이 설치작업의 시작점이 되었다. 수염 틸란드시아는 수시로 분무를 해주어야 하므로 번거로운 면이 있었지만, 움직이지도 말도 못하는 살아있는 생명이라서 보살핌은 필수였다. 그 독특한 형상에 매료되어 키워왔던 무취 공중식물이다. 가만히 정지해있어 살았는지 죽었는지 모르는 식물에 눈길이 갔다. 나의 시선에 들어온 정지된 듯 무심한 생명을 관조하면서 환경에 맞게 살아내는 생명체의 생존 조건에 대해 고민했다. 틸란드시아는 이 주제를 제시하는데 호흡하고 있는 매개체로서 의미가 있는 대상이었다. 축 늘어진 식물은 벽면에 걸어두면 마치 회색의 벽에 붙어있거나 뚫고 나온 듯한 묘한 분위기를 조성하며 자연스러운 느낌을 준다. 지금까지 익숙하게만 생각했던 식물 너머 우리가 알지 못하는 식물에 대한 다소 낯설고 새로운 시선으로 호흡하는 시간을 마련하고자 한다.

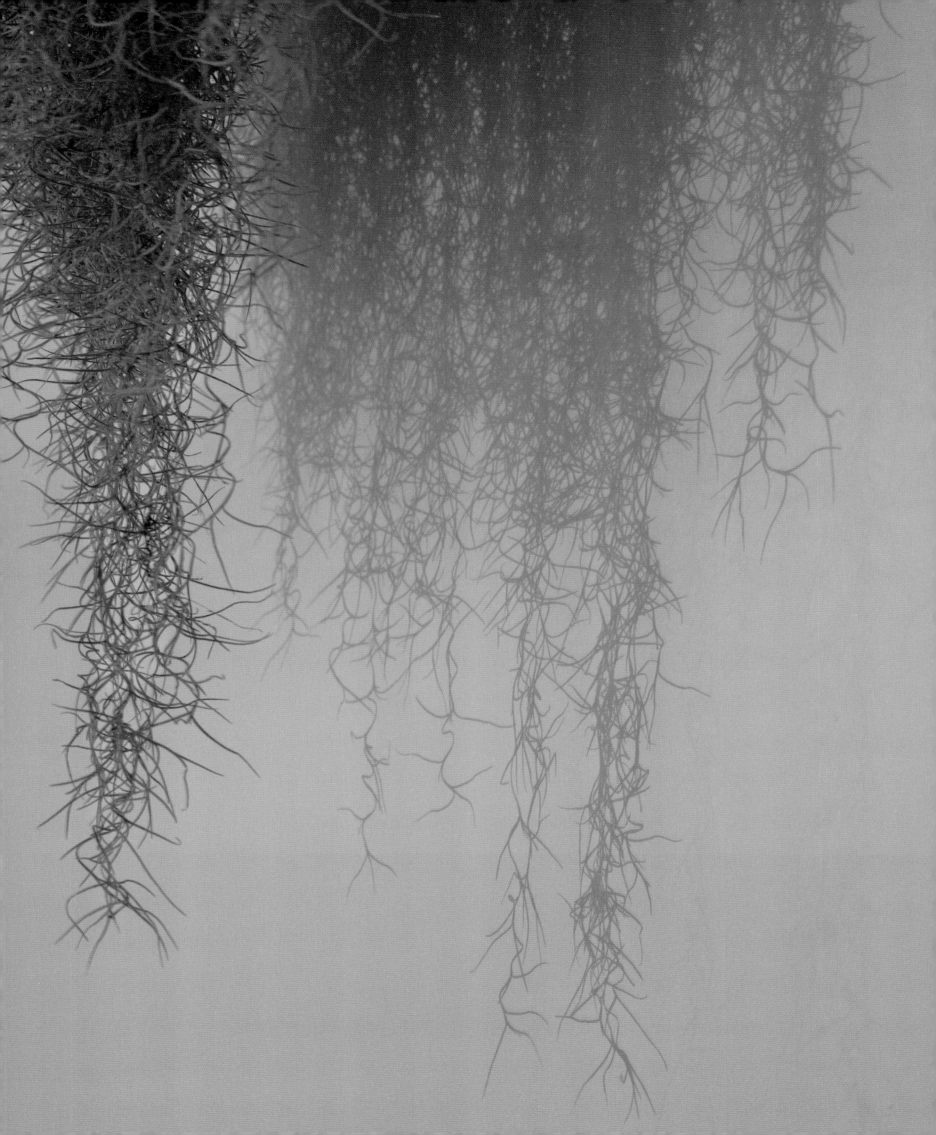

Grove Structure
숲의 구조

2019
fresco, scratch on lime wall
60x60cm

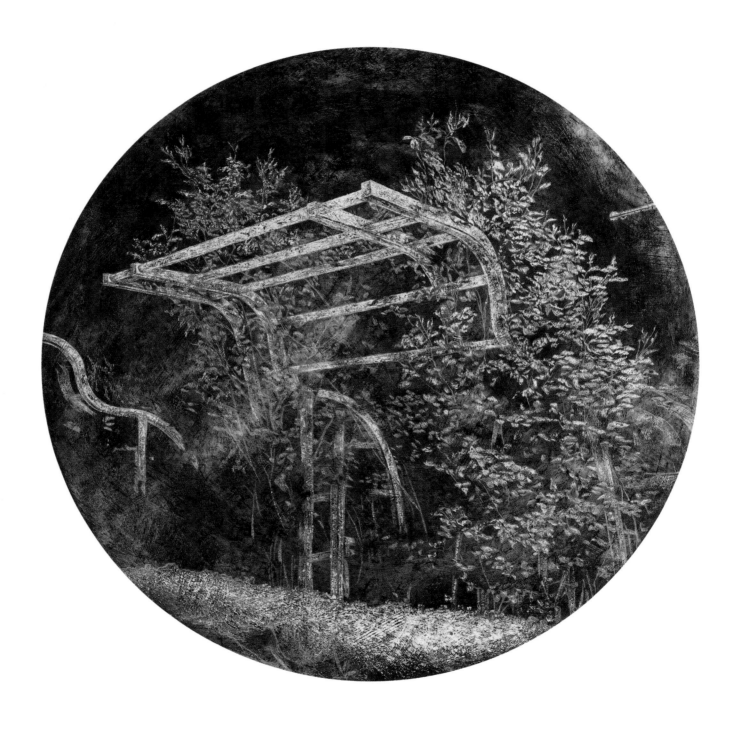

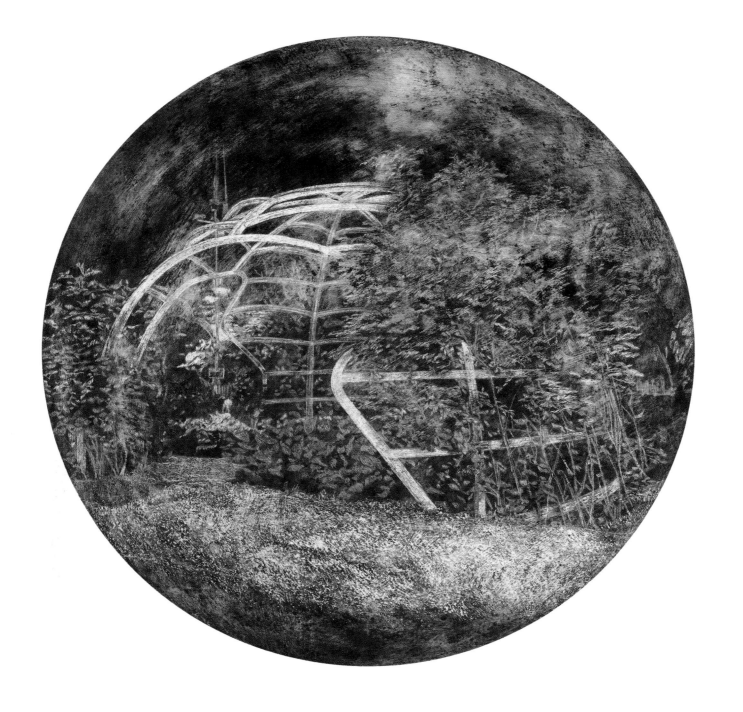

Plants Also Have Power 2018

An Illustrated Book of Forces–*Plants Also Have Power*

Kho Chunghwan, art critic

A fresco with fresh white plaster and a black ground is initially applied to a lime plaster wall. Kim Yujung's frescos are a bit special. The entire lime plaster wall is painted black and then scratches are rendered using fine tools, like a needle, to create images. The whitewashed ground is exposed by stripping away the gloomy scene with scratches. The scratches here work as a medium symbolic of wounds while the gloomy black scene stands for the unconscious (an abyss). Her act of painting via scratches has a symbolic, shamanistic meaning that heals wounds through a process of unmasking wounds suppressed by the unconscious and facing them. Hence, her work is closely bound up with wounds and their healing.

In this way, plants, especially those in pots, are appropriated as subject matter. Potted plants are transplanted or artificial nature rather than nature itself. Such plants are like wounds in that persistent concern and care for them are required. A botanical garden is an expanded application of transplanted, artificial nature. In particular, a botanical garden allows visitors to meditate on the true meaning of nature in a highly civilized social setting in which a geometric structure and organic plants as well as an artificial structure and nature are at odds. Kim's attention is caught by a survival passage in an ecological park. It is a passage for squirrels that has been made out of wire mesh. As it turns out, it has nothing to do with the squirrels' livelihoods. Whether or not there is a man-made passage is irrelevant to their survival. Because squirrels usually stay in hiding and are not frequently seen, the passage was made to reveal them. It is for display just as a botanical garden is not for plants but for men.

Her interest in such natural elements being used for display purposes led to her taking note of the maze created with basalt on Jeju Island. Gardens in the West are largely classified into two types: English and French. A maze garden is a typical artificial garden. Kim presents an artificial garden through the medium of a maze made of basalt as well as nature that has been developed into a tourist product or a natural factor for display. A maze is a network of pathways in which visitors are intended to wander. It resembles an allegory of contemporary

humans who have lost their way between nature itself and nature as a commodity (who have probably lost the true meaning of nature).

In this way, capitalism does not hesitate to commercialize even nature. In terms of the capitalistic canon, nothing is free from commercialization—not personal feelings or private moods, let alone nature. The artist finds an extreme case within artificially made and reduplicated rooms and gardens in an IKEA store. A living room and greenhouse (or a private café decked like a greenhouse) are reproduced to mimic those of a middle-class family. They make us feel good and comfortable, but they are derived from a commercial spirit. Each small article has a price tag, suggesting that it is for arousing customer interest. It is, in a way, like buying something you like without hesitation to reassure yourself you are among the middle class, or flaunting the standard of living of a middle class individual.

Kim deals with the theme of capitalism that commercializes not only nature but also even private feelings, selling fantasies, not products. Scratches serve as a medium, exposing suppressed wounds (such as distorted nature and artificial nature) and disclosing the hidden side (such as a mercantile mind).

An Illustrated Garden of Forces, a gentle vengeance by an amicable intruder

Kim envisages vengeance by nature. She imagines the end of the world and the extinction of mankind. Her imagination is apocalyptic. An artist's imagination based on assumption may be a determinant for art in that it prefigures another possible world. (Typical of this is to envisage a utopia.) It is also an ecological imagination in that nature works as a vehicle for such an imagination.

The artist incarnates her imagination in a spatial installation. She employs furniture she uses in her actual life, such as a bed, a sofa, a table, a frame, flower pots, a mirror, a chandelier, and a hanger to represent her everyday space as it is. She seems to be taking her subject from her daily life by representing her living space, but this is not the case. As her everyday environment becomes entirely covered with plants, it turns into a weird, unfamiliar, uncanny, foreign, unrealistic, and surrealistic space. This spectacle is a reproduction of a situation in which plants encroach on and occupy the space where humans lived before they went extinct. From the standpoint of humans, it is obviously a somber circumstance but her represented scene is not quite like that. Organic forms intrinsic to plants and their colors and textures bring about a favorable feeling while plants covering a bed arouse an unrealistic sensation, stimulating our poetic imagination as if in a dream. We may feel as though we are witnessing a gentle vengeance by an amicable intruder. Plants occupying the human world appear tactile like a soft carpet. They seem to be in an antinomic state in which a dismal situation collides head-on with a positive feeling.

The sight of plants completely enveloping the human world seems much like the primitive world before human civilization came into being. Perhaps this is a feeling of returning to primitive times? In terms of existing on earth, there is no comparison between man and plant. Primeval plants existed before humans appeared. The artist uses *tillandsia* as a primeval plant in her work. If any primeval plant still exists today, perhaps it resembles this one. *Tillandsia*

has roots but they cannot be distinguished from its body (as is widely known, organs have gradually been differentiated) and it can survive off of a minimal amount of moisture in the air. (I do not know for sure, but the proto-earth environment was probably even more sterile than now.) In this way, the artist illustrates a scene of the world using plants that encroach on the world of humans with a persistent life force.

An Illustrated Book of Forces, a revolution innate in surplus

Here is a series of photographs. They feature a cluster of grapevines whose twigs are vivid, a cluster of figs whose insides are hollow, and a cluster of wild grass that has withered. These pictures feature common things that are abandoned after their cores are eaten, and seem ill-suited for being the subject matter of photographs as they are clearly not that unusual. Are they another version of a vanitas, a symbolic work of art indicating the transience of life? They might be, in part. There is a more decisive meaning than this even though they are perhaps not unrelated. These photographs mean to retrieve things that have been abandoned, things whose function was lost, and things whose meaning has been lost. They are intended to make known the fact that even meaningless things can create a force when they unite.

There is nothing that is meaningless from the beginning. There is also no man who is nothing from the start. Such a thing or man cannot be thrown away thoughtlessly even though they become nothing. What is a determinant of something meaningful or meaningless? Who can judge a man to be something or nothing? The answer is institutions and power, and especially the principles of capitalism's economism and efficiency maximization. That which is less economical or efficient is punished or tabooed. Georges Bataille refers to such things as surplus. They are initially anti-capitalistic as they have been designated as surplus by capitalism. They are revolutionary by destiny. Her series of photographs featuring abandoned things, things whose function was

lost, and meaningless things serves as an opportunity for us to realize the anti-capitalistic and revolutionary quality inherent in surplus.

From Uzbekistan, marginal power

The artist stayed in Tashkent, Uzbekistan for several months. Working for a detached duty there, she engaged in artistic work in her spare time while teaching students. What impressed her most was how the bottom of every tree there was painted white. The bottoms of trees in Uzbekistan are painted three times a year to prevent damage from blight and harmful insects, serve as a guide in the black of night, and beautify the city. Kim painted this forest scene in an area featuring an arid desert climate. She illustrated forests with sparse trees. She worked using only paint, no water, on the back of a coarse canvas with the intention of conveying the mood of the arid climate. The bottom part of the canvas remains unpainted so as to remind viewers of a desert. In addition, she plays the sound of a bird chirping that was recorded in the region. (Whitewashed *daraxt* means whitewashed tree in Uzbek.)

Uzbek women wear ceremonial dresses made of traditional cloth for their weddings. The dresses ae like hanbok, traditional Korean costumes. Kim created an installation with seven rolls of traditional cloth, referring to it as *7 Prayers*. It reflects the local custom that lends a special meaning to the number 7. Many Korean people also consider "7" a lucky number. This custom did not originate in Korea or Kazakhastan, it is thought to have originated in the West. She also produced a video featuring the portraits of students she had taught in Kazakhstan. As its title K's Dream implies, they are multiracial students who yearn to live in Korea. The close-up images of their diverse faces are captured and reproduced. As a few different faces overlap in a frame, it presents an example of typological photography in which difference (heterogeneity) and repetition (similarity) intersect.

Kim defines the theme of her recent work as An *Illustrated Book of Forces, Plants also have power*. In a word, this would be the force of plants. This work is meaningful in that it pays attention to the possibility of forming power via trifling, insignificant things such as plants. She also finds another possibility for latent power in the border. In this sense, plants form marginal power. By doing this, she expands and deepens her initial thematic consciousness from her interest in species (plant power) to her interest in capitalistic fetishism (her work addressing the subject matter of an IKEA store) or to her interest in local cultures and mores (marginal power).

김유정의 작업, 세력도감, 식물에도 세력이 있다

고충환, 미술비평

프레스코, 흰 살과 검은 화면. 원래 프레스코는 회칠된 벽 위에 그림을 그린다. 그런데 김유정의 프레스코는 좀 특별하다. 회칠한 벽면 전체를 검게 칠한 연후에, 니들처럼 날카로운 도구를 이용해 스크래치를 만들면서 그린다. 스크래치로 덧칠된 어두운 화면을 벗겨내 바탕화면의 회칠이 드러나게 한 것이다. 스크래치가 매개 역할을 하는 것인데, 여기서 스크래치는 상처를 상징한다. 그리고 검게 칠해진 어두운 화면은 무의식(그리고 심연)을 상징한다. 결국 스크래치를 매개로 한 작가의 그림 그리기는 무의식에 억압된 상처를 드러내고 상처와 대면하는 과정을 통해서 종래에는 상처를 치유한다는 상징적이고 주술적인 의미를 갖는다. 그런 만큼 작가의 작업은 상처와, 그리고 상처의 치유와 관련이 깊다.

그렇게 식물이, 특히 화분에 심겨진 식물이 소재로서 차용된다. 화분에 심겨진 식물은 자연 자체라기보다는 이식된 자연이며 인공적인 자연이다. 지속적인 관심과 보살핌이 필요한 것이 꼭 사람의 상처를 닮았다고 생각했다. 그리고 이식된 자연이며 인공적인 자연이 확대 적용된 것이 식물원이다. 특히 식물원은 기하학적인 구조와 유기적인 식물, 인공적인 구조물과 자연을 대비시켜 고도로 문명화된 사회 환경 속에서 자연의 진정한 의미를 되새기게 했다. 그리고 생태공원에 조성해 놓은 생존 통로에 작가의 필이 꽂힌다. 섬세한 철망으로 만든, 다람쥐가 지나다니는 통로다. 다람쥐의 생존을 위해 조성해 놓은 것이지만, 사실을 알고 보면 그렇지도 않다. 인공적으로 만든 통로가 있건 없건 다람쥐의 생존과는 아무런 상관이 없다. 평소 숨어 있는 다람쥐가 잘 보이지가 않으니, 잘 보이라고 만든 것이다. 식물원이 식물이 아닌 사람을 위한 것이듯 관상용이다.

그리고 이런 관상용 자연에 대한 관심이 제주도에 현무암으로 조성해 놓은 미로에 주목하게 했다. 흔히 서양에서 정원은 영국식 정원과 프랑스식 정원으로 구별되는데, 각각 자연 그대로의 정원과 인공적으로 조성된 정원에 해당한다. 그리고 미로정원은 인공정원의 전형에 속한다. 작가는 현무암으로 조성된 미로를 매개로 이처럼 인공정원을, 관상용 자연이며 관광 상품으로 개발된 자연을 예시해주고 있는 것이다. 미로는 원래 그 속에서 헤매라고 만들어놓은 길이다. 자연 자체와 상품으로서의 자연 사이에서 길을 잃은(그러므로 어쩌면 자연의 진정한 의미를 상실한) 현대인의 알레고리를 보는 것 같다.

이처럼 자본주의는 자연마저도 상품으로 만드는 것에 주저함이 없다. 자본주의의 준칙에 관한한 상품화의 기획으로부터 자유로운 것은 아무 것도 없다. 자연은 물론이거니와 심지어 사사로운 감정이나 기분마저도. 이를테면 이케아 매장에 인공적으로 조성해 놓은 복제된 방과

정원에서 작가는 그 극단적인 경우를 본다. 평범한 중산층 가정의 거실과 온실(혹은 온실처럼 꾸며놓은 개인카페) 그대로를 옮겨놓은 것 같지만, 그리고 그렇게 안락함과 안온한 기분마저 들게 만들지만, 사실을 알고 보면 다 장삿속에 지나지 않는다. 세심하게 연출된 공간을 꾸미고 있는 소품들마다에는 어김없이 가격표가 붙어있어서 구매 욕구를 자극하기 위한 것임을 알 수 있다. 자신이 중산층 계급에 속한다는 사실을 스스로 확인하고 싶다면, 나아가 남들이 보기에 중산층 계급에 걸맞은 생활수준을 과시하고 싶다면 주저하지 말고 이걸 사라는 식이다.

그렇게 작가는 자연을 상품화하고 사사로운 심리마저 상품화하는, 상품이 아닌 사실은 환상을 파는 자본주의의 상품화 기획을 주제화한다. 그 매개역할을 스크래치가 한다. 겉보기에 멀쩡한 표면에 억압된 상처(이를테면 왜곡된 자연, 인공적인 자연과 같은)를 드러내고, 겉보기와는 다른 이면(이를테면 공공연한 장삿속 같은)을 폭로한 것이다.

세력도원, 우호적인 침입자의 부드러운 복수

그리고 작가는 자연의 복수에 대해 상상해본다. 만약 지구에 종말이 온다면, 그리고 마침내 인간이 사라진다면, 하고 상상해본다. 종말론적 상상력이다. 예술의 계기가 여럿 있지만, 그 중 특히 이처럼 가정법에 근거한 상상력은 가능한 다른 세상을 예시해준다는 점에서 예술을 위한 결정적인 계기일 수 있다(그 전형적인 경우가 유토피아를 상상하는 것이다). 자연이 그 상상력을 위한 매개역할을 하고 있는 경우란 점에서 생태학적 상상력이기도 하다.

작가는 공간설치작업으로 상상력을 구현하는데, 침대, 소파, 탁자, 선반, 화분, 거울, 샹들리에, 그리고 옷걸이와 같은 자신이 실제로 사용하는 가구들을 가져와 자신의 일상 공간 그대로를 재현한다. 작가의 생활공간을 재현하는 것이며 이로써 사사로운 일상을 주제화한 것인가도 싶지만 그렇지는 않다. 이렇듯 가구들이 배치된 일상적인 공간을 식물이 온통 뒤덮으면서 공간은 졸지에 이상한 공간, 낯선 공간, 생경하고 이질적인 공간, 비현실적인 공간, 초현실적인 공간으로 탈바꿈한다. 지구 종말의 날 인간이 사라지고 없는 공간을 식물이 온통 잠식하고 점유한 상황을 연출한 것이다. 적어도 사라진 인간의 관점에서 볼 때 벌어진 일 자체는 분명 암울한 상황이지만, 정작 연출된 상황을 보면 꼭 그렇지만도 않다. 식물 특유의 유기적인 형태며 색감과 질감이 우호적인 느낌을 주고, 특히 침대를 뒤덮고 있는 식물은 마치 꿈꾸는 식물을 보는 것 같은 비현실적인 인상과 시상마저 자아낸다. 우호적인 침입자의 부드러운 복수를 보는 것 같다고나 할까. 그렇게 인간세상을 접수한 식물들이 부드러운 카펫처럼 촉각적으로 다가온다. 암울한 상황과 우호적인 느낌이 충돌하는 이율배반적인 풍경으로 다가온다.

그렇게 인간세상을 뒤덮은 식물풍경이 꼭 문명 이전의 원시로 되돌려진 느낌이다. 원시로 되돌려진 느낌? 지구에 살기 시작한 것으로 치자면 인간은 식물에 비교가 안 된다. 인간 이전에 원시식물이 있었다. 그리고 작가는 원시식물로서 틸란드시아 식물을 도입하는데, 아마도 원시식물이 지금도 여전히 실제로 존재한다면 꼭 이렇게 생기지 않았을까 싶다. 실제로는 뿌리가 있지만 적어도 겉보기에 뿌리와 몸통을 구분할 수 없다는 점이 그렇고(주지하다시피 생물기관은 미분화상태에서 점차 분화돼온 것으로 알려져 있다), 대기 중에 떠도는 최소한의 습기만으로도 생존할 수 있다는 점이 그렇다(모르긴 해도 원시지구환경은 지금보다 더 척박했을 것이다). 그렇게 작가는 이미 원시부터 이어져온 지극한 생명력으로 인간세계를 잠식한, 그리고 그렇게 원래 주인(식물)에게 되돌려진 세상풍경을 예시해준다.

세력도감, 잉여에 잠재된 혁명

여기에 일련의 사진들이 있다. 다 먹고 버린 잔가지가 총총한 포도나무가 군집을 이룬, 속을 파먹은 무화과 껍질이 군집을 이룬, 말라죽은 들풀들이 군집을 이룬 사진들이다. 먹을 만한 건 다 빼먹고 버려진 것들의 집합이라는 공통점을 가지고 있다. 사진의 소재치고는 좀 그렇다. 평범하지는 않다. 성찬 이후의 허망함을 그린 바니타스(인생무상) 정물화의 또 다른 버전인가. 부분적으로는 그럴 것이다. 이러한 사실과 무관하지는 않을 것이지만, 이보다는 더 결정적인 의미가 있다. 버려진 것들, 기능을 상실한 것들, 그래서 무의미한 것들이 상실한 의미를 되찾아주는 것이다. 비록 무의미한 것들이지만, 무의미한 것들이 하나로 모이면 힘이 된다는 사실을 주지시키는 것이다.

처음부터 무의미한 것은 없었다. 처음부터 아무 것도 아닌 사람도 없었다. 그랬던 것이 무의미해졌다고, 그랬던 사람이 아무 것도 아닌 것이 되었다고 함부로 버려질 수는 없는 일이다. 나아가 누가 의미와 무의미함을 재단하는가. 누가 아무개와 아무 것도 아닌 사람을 판단하는가. 제도와 권력이 그렇게 한다. 자본주의의 경제제일주의 원칙과 효율성극대화의 법칙이 그렇게 한다. 그렇게 경제성이며 효율성이 떨어지는 것들이 단죄되고 금기시된다. 조르주 바타이유는 그렇게 자본주의에 의해 단죄되고 금기시된 것들을 잉여라고 부른다. 그것들은 자본주의에 의해 잉여로 지목된 탓에 태생적으로 반자본주의적이다. 운명적으로 혁명적이다. 버려진 것들, 기능을 상실한 것들, 그래서 무의미한 것들을 소재로 한 작가의 일련의 사진들은 이처럼 잉여들에 잠재된 반자본주의적이고 혁명적인 계기를 주지시킨다.

우즈베키스탄으로부터, 변방세력

수개월 전부터 작가는 우즈베키스탄 타슈켄트에 체류해오고 있다. 파견근무로 현지에 체류하면서 학생들을 지도하는 틈틈이 작업을 했다. 현지에서 작가에게 인상 깊었던 것은 나무 아래 부분에 흰색으로 회칠된 것이었다. 일 년에 세 차례 덧칠한다고 했다. 방충을 위한 것이라고도 했고, 가로등이 없는 캄캄한 밤에 길잡이(지표) 역할을 한다고도 했고, 미관을 위한 것이라고도 했다. 작가는 이 나무숲을 그렸다. 현지는 건조한 사막기후다. 그렇게 작가는 사막에 듬성듬성한 나무숲을 그렸다. 건조한 현지기후의 질감 그대로를 전달할 요량으로 올이 굵은 캔버스 뒷면에다가 일부러 물을 사용하지 않고 다만 물감으로만 그렸다. 그리고 화면 아래 부분을 그리지 않은 채로 남겨 사막을 연상케 했다. 그리고 여기에 현지에서 채록해온 새소리를 들려준다(회칠한 다락. 우즈벡어로 회칠한 나무란 뜻이다).

그리고 여기에 현지 여자들은 결혼할 때면 전통 천으로 예복을 만들어 입는다고 했다. 우리나라의 한복과 같은 경우로 보면 되겠다. 작가는 그 전통 천 7필을 길게 늘어트려 설치했다. 그리고 <7의 기원>이라고 불렀다. 7이란 숫자에 각별한 의미를 부여하는 현지인들의 관습(기원)을 반영한 것이다. 우리나라에서도 7이란 숫자를 행운의 숫자라고 생각한다. 그 관습은 우리나라의 자생적인 것은 아니다. 현지에서의 관습도 마찬가지일 것이다. 아마도 서양에서 유래한 것일 터이다. 그리고 작가는 현지에서 지도하는 학생들의 초상사진을 영상으로 담았다. <K의 꿈>이라는 제목처럼 한국행을 꿈꾸는 다민족 학생들이다. 다민족국가답게 온갖 유형의 얼굴들이 다 있는데, 그 다양한 얼굴들을 클로즈업해 재생시켰다. 다른 얼굴들이 하나의 프레임 속에 중첩되면서 차이(이질성)와 반복(유사성)이 교차되는 유형학적 사진을 예시해준다.

작가는 근작의 주제를 <세력도감, 식물에도 세력이 있다>로 명명한다. 한마디로 정리를 하자면 식물세력이 될 것이다. 식물로 대변되는 미미한 것들에 잠재된 세력 가능성, 가능태로서의 세력 가능성에 주목한 것이란 점에 의미가 있다. 그리고 작가는 변방에서 잠재된 세력의 또 다른 한 가능성을 본다. 그런 점에서 식물세력은 어느 정도 변방세력이기도 할 것이다. 그렇게 작가는 종에 대한 관심(식물세력)에서 시작해 자본주의 물신에 대한 관심(특히 이케아 매장을 소재로 한 작업)으로, 그리고 재차 지역의 문화관습에 대한 관심(변방세력)으로 주제의식을 확장 심화시키고 있다.

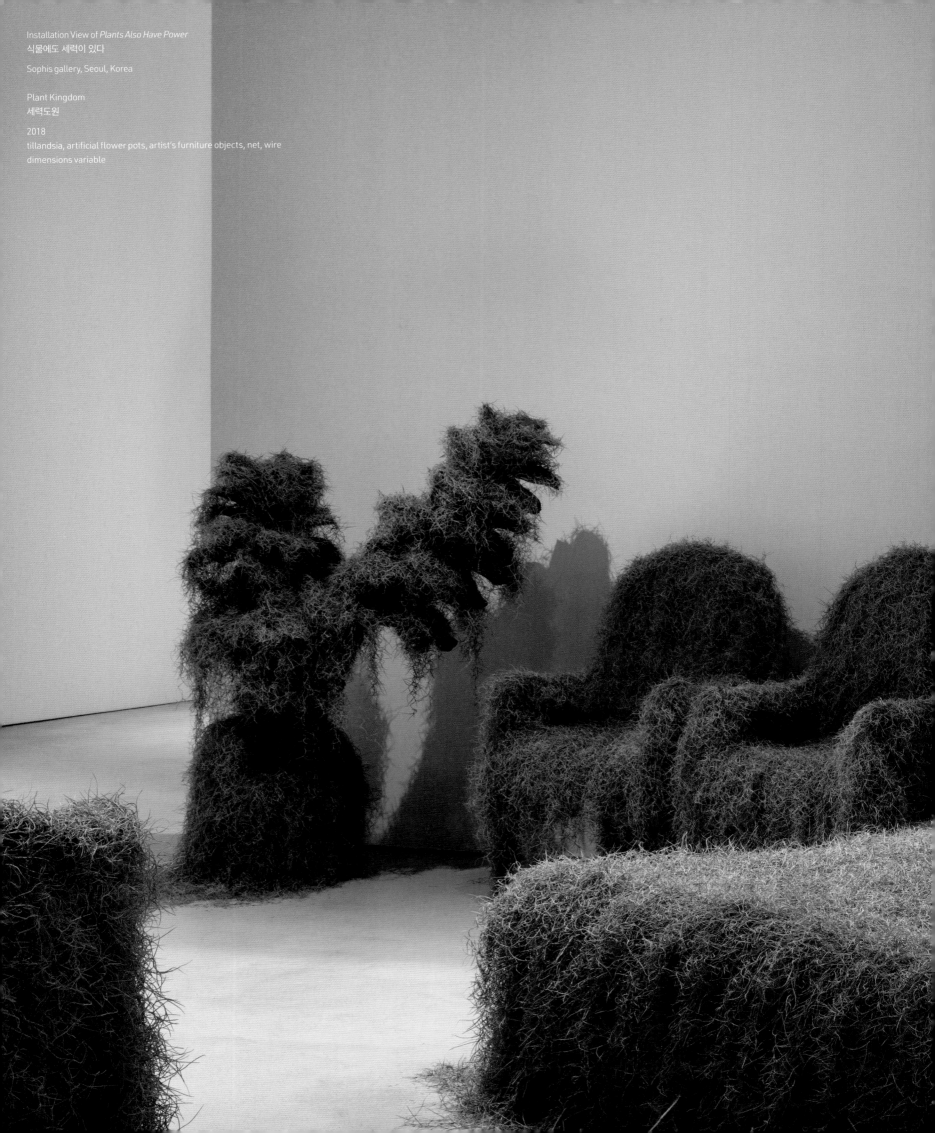

Installation View of *Plants Also Have Power*
식물에도 세력이 있다

Sophis gallery, Seoul, Korea

Plant Kingdom
세력도원

2018
tillandsia, artificial flower pots, artist's furniture objects, net, wire
dimensions variable

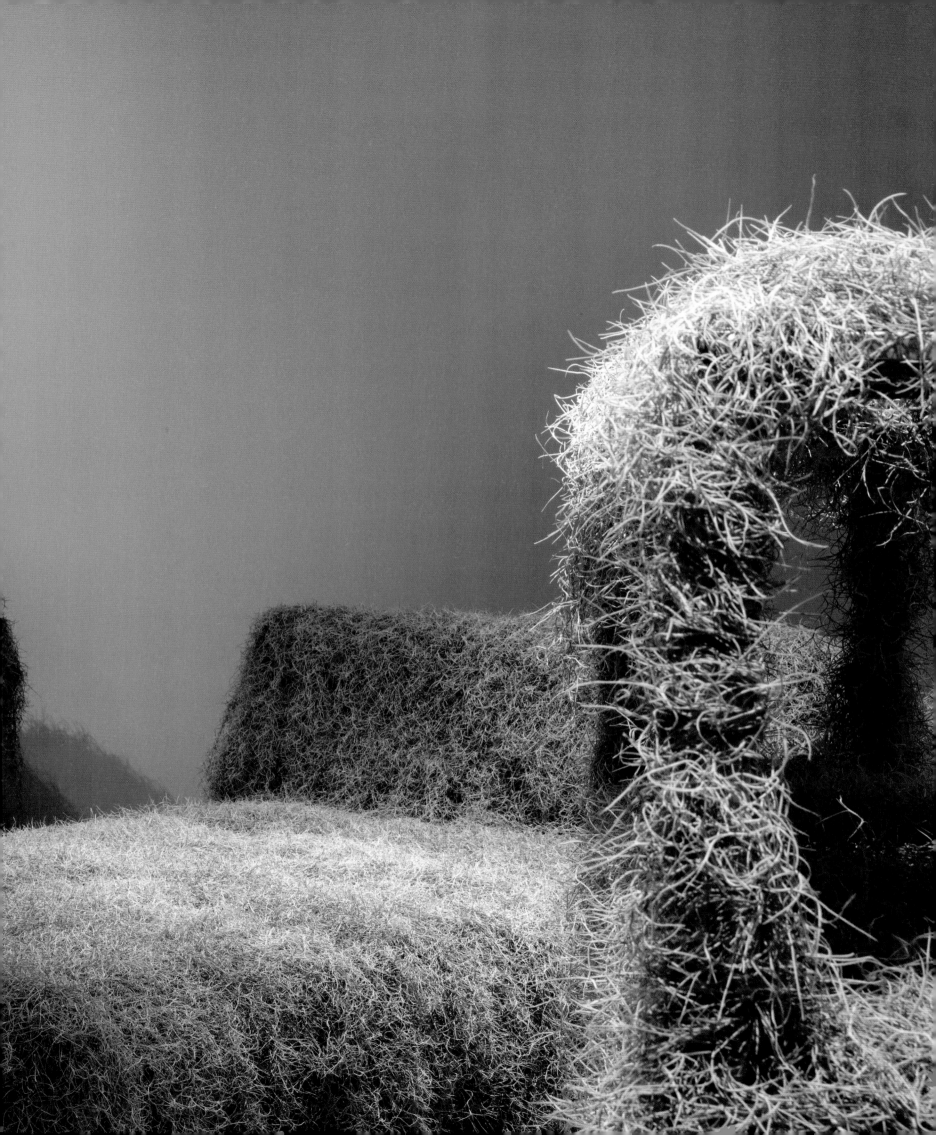

If there is ever a world without human beings. . . . Sometimes I imagine things along dystopian lines. The plants exhibit a kind of violence, submerging even the individual's private spaces. An unfamiliar landscape is created through the hidden power of quiet things that consume the inside of a room. Starting from the concrete wall, the parasitic plants slowly expand to the different items of furniture used in the studio: the bed, the sofa, the table, the mirror, the chandelier and chairs. Personal items find themselves under counterattack by once-passive interior plants.

인간이 없는 세상이 도래한다면... 디스토피아적 상상을 해본다. 식물이 개인의 내밀한 공간까지 뒤덮으며 폭력성을 드러낸다. 방안을 잠식한 조용한 세력들의 숨은 힘으로 낯선 풍경이 만들어진다. 콘크리트 벽에서부터 시작되어 기생하는 식물은 점차 작업실에서 사용해왔던 침대, 쇼파, 탁자, 거울, 샹들리에, 의자 등의 여러 가구로 번져간다. 개인의 사물들이 그동안 수동적이었던 인테리어 식물들의 반격을 맞는다.

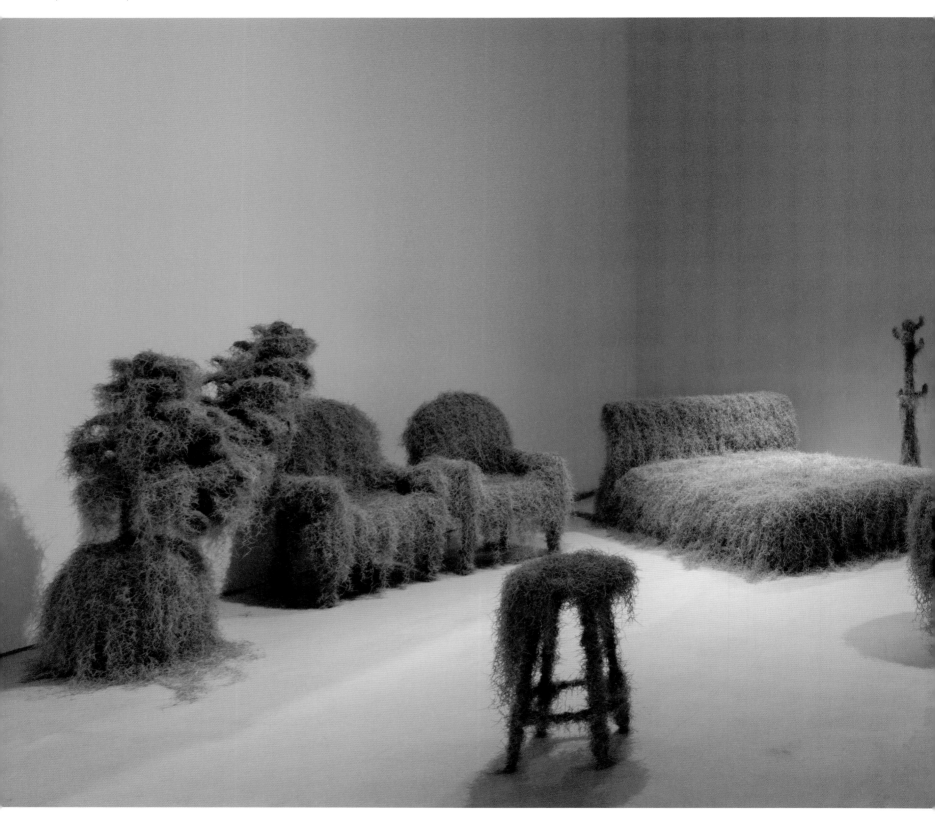

Plant Kingdom
세력도원

2018
tillandsia, artificial flower pots, artist's furniture objects, net, wire
dimensions variable

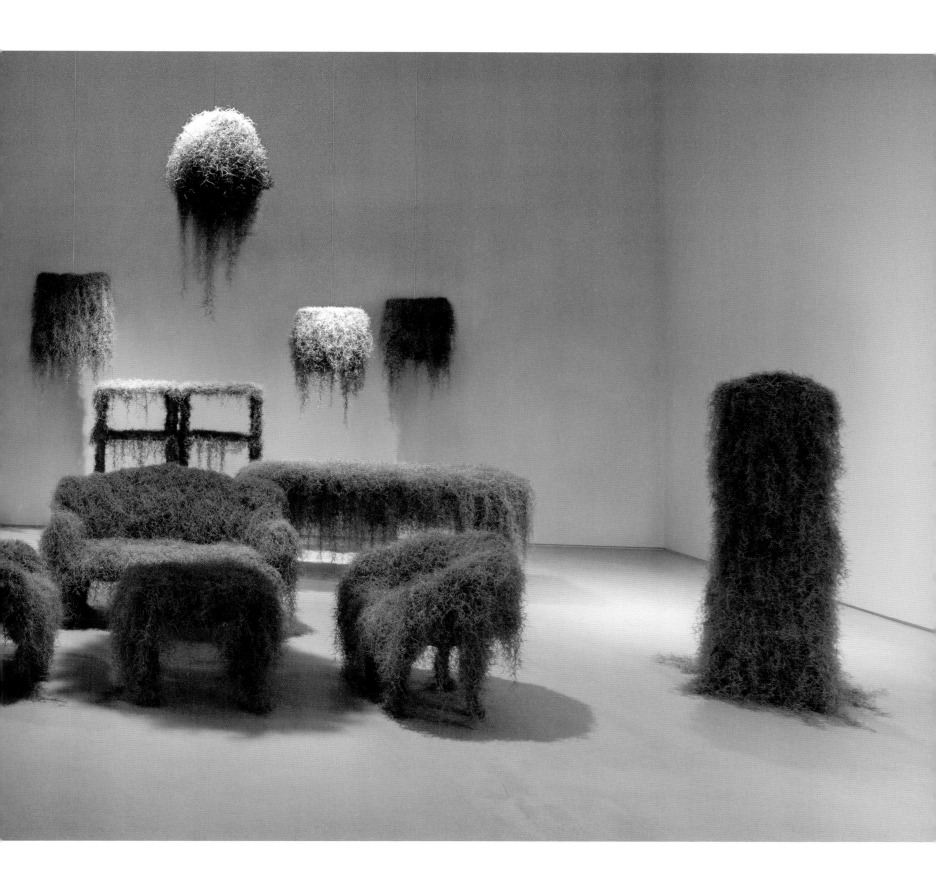

While I was living in Uzbekistan, I infused everyday landscapes, society, and cultures into my work. *7 Prayers* is an installation that incorporates traditional fabric. Traditional clothing known as *chopon* and *kamzul* is worn during important events like weddings and funerals, and the fabric is also used to make outfits that show a person's status and profession. Taking a form that resembles a ritual of praying for good fortune, this work captures an area where people's longstanding belief in the number "7" and their associated practices become an unconscious force that moves multitudes.

우즈베키스탄에 거주하면서 일상적인 풍경과 사회 문화들을 작품에 녹여냈다. <7의 기원>은 초폰(chopon)과 캄줄(kamzul)이라는 전통의상이자 혼례, 장례 등 중요한 행사에 착용하는 것으로, 자신의 신분과 직업 등을 나타내는 의상을 만드는 전통 천을 이용해 설치된다. 행운을 기원하는 의식을 치르는 듯한 이 작업은 '7'이라는 숫자에 대한 사람들의 오랜 믿음, 그 관습이 다수를 움직이는 무의식적인 힘이 되는 지점을 포착한 것이다.

The video work *K's Dream* shows young Uzbek boys and girls watching and enthusiastically admiring Korean culture transformed into fragmentary images through media—including Korean TV series and K-pop—without being aware of the situation for their young Korean counterparts, who are constantly being subjected to testing and evaluation. While we are unable to communicate smoothly due to the language barrier, ID photographs are used to show the individual faces of students sharing friendly greetings in fumbling Korean to a foreign visitor from Korea, the country they admire so much. This shows the gap between the reality and the dreams we each dream.

영상작업 <K의 꿈>은 항상 검사와 평가의 대상에 놓여있는 한국 청소년들의 사정을 알지 못한 채, 한국의 드라마와 K-pop 등 미디어를 통해 파편적으로 이미지화된 한국의 문화를 바라보고 열광하며 동경하는 우즈베키스탄의 소년, 소녀들의 모습을 담았다. 언어의 장벽으로 인해 서로 원활한 소통을 할 수는 없지만, 한국이라는 동경의 나라에서 온 외국인에게 어눌한 발음의 한국말로 호의적인 인사를 건네는 학생들 한 명 한 명의 얼굴을 증명사진으로 기록했다. 각자 꾸는 꿈과 현실의 괴리를 담았다.

K's Dream
K의 꿈

2018
mashrabia pattern sheet, single channel video
120x500cm

Forced Plant
세력도감

2018
pigment print, dried fig peel
70x70cm

Forced Plant
세력도감

2018
pigment print, dried fig peel
70x70cm

131

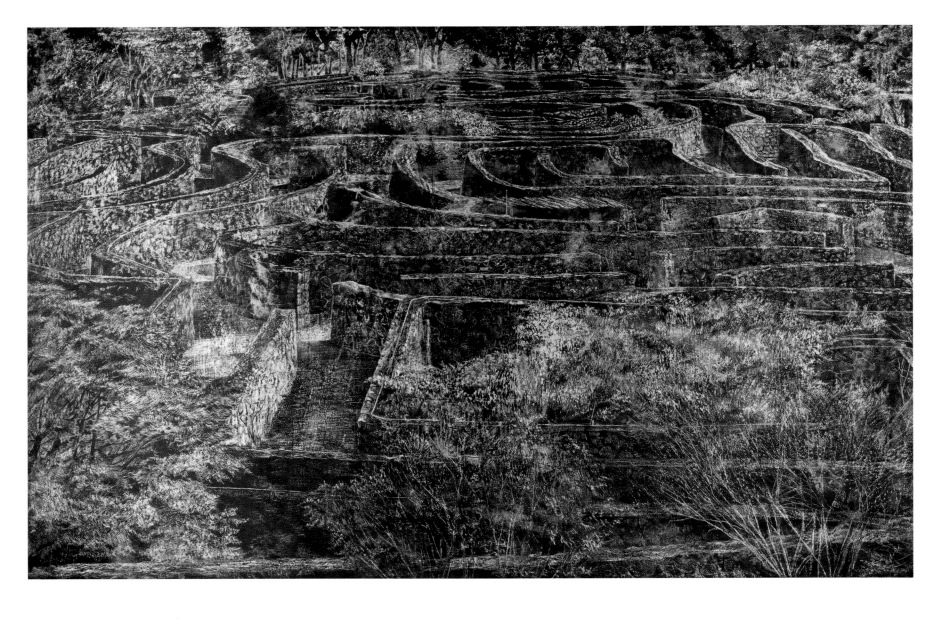

Two Roads
두 개의 길

2018
fresco, scratch on lime wall
90x140cm

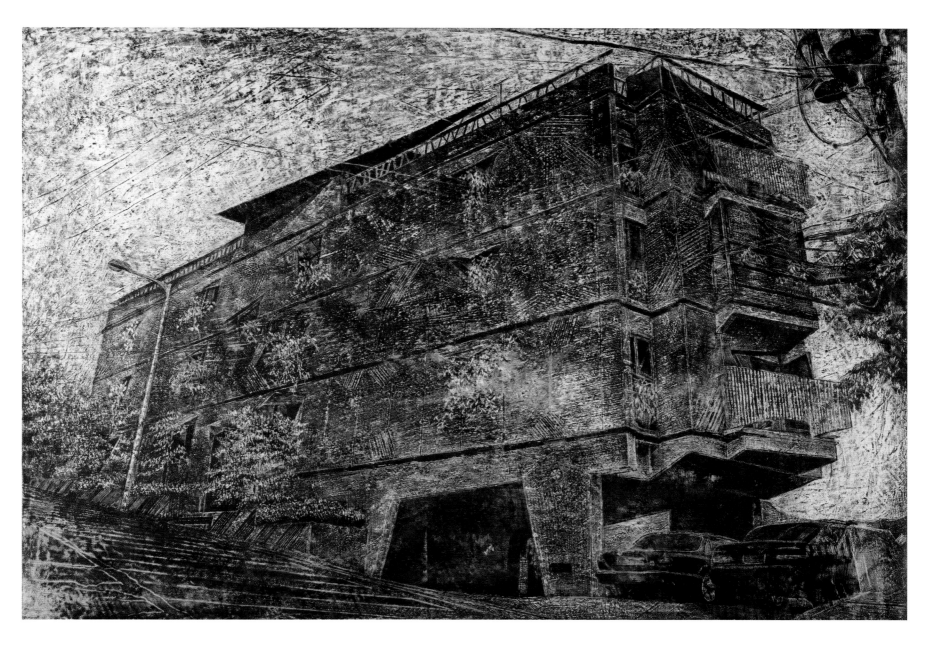

Incubator
인큐베이터

2018
fresco, scratch on lime wall
55x80cm

Fresco technique is delicate work created by the natural process in terms of air, along with the main materials such as highly pure reaction matter or lime, sand, water, and color pigments. In the flow of the times, the present Fresco painting is a genre that requires the creative mission, under the pluralistic tendencies in contemporary art, which proceeds to develop a new area with modern technique and the pursuit of various changes and originality, based on the form and technique over thousands of years inherited from the past art history. With forming the canvas layer in terms of softening and solidification, the pigments painted on the plaster become hard and form unique colors due to the tone of the plastered wall with pigments, after drying. The canvas which forms both *choji* and *hwaji* layers on mortar, has the calcium film with transparent compounds of calcium on the surface through drying process. Since the plastered wall has waterproof, mothproof, and high insulation effects due to the air circulation and the thin calcium film, the durability is continuously maintained even under varying weather conditions and dynamic pressure.

Since the terms *choji* (초지) and *hwaji* (화지) are used in *dancheong* (단청, 丹靑, Korean traditional decorative coloring on wooden buildings with many colors and designs) technique, the material is a little different as compared with that of Fresco. However, the technique and production process is similar to Fresco, so I used these terms in Fresco production: 1st lime mortar or arriccio (*choji*); 2nd lime mortar or intonaco (*hwaji*). *Choji* is usually mixed in the ratio of 2:1 by sand and lime respectively, but the ratios from 1:1 till 1:4 are possible in some cases. In case lots of lime is mixed, crack occurs easily and the surface is smooth, while lots of sand has strong viscosity and high strength of solidification. In the traditional *hwaji*, slaked lime is used only, but in case the rough *matière* effect is needed, some additional materials (such as sand, dolomite, melanite, chamotte, etc.) can be used.

The solidification of mortar is gradually done in comparison to that of cement. But, as the time passes by, the combination and solidification is done with high strength, and it is crystallized in the form of calcium carbonate with forming the calcium compound film. The transparent film works to fix color, protect lime mortar layer, and then petrifaction occurs. When once calcium film occurs due to the hardening of the plaster, it's difficult to paint with Fresco technique. Accordingly, considering the whole process for the perfection of painting, this work has to be finished deliberately and promptly. As wallpaper and surface structure are crucial elements in fresco murals, the original form of fresco should be preserved by reviving the elemental feature of wallpaper.

I express a unique canvas expanding this traditional Fresco and creating unevenness with chisel. It can be said that the expression in terms of engraving done on this plastered wall, is the product of delicate labor which requires high concentration. The tools that can give unevenness on the wall surface, are various kinds of HERA sculpting tool, chisel, etc. Before the plastered wall dries, highly delicate treatment is possible with only a little force. I come to obtain desirable canvas results or outcomes only when calculating the physical resistance on the canvas and arranging time properly. With continuously appropriating the oldest and most permanent technique in terms of a modern interpretation, I will study further regarding the antagonistic relationship between old and new things, or the matter of mutual overlap.

프레스코 화법은 주재료인 고도의 순수 반응 물질 석회(lime)와 모래, 물, 채색 안료와 더불어 공기와의 자연스러운 조우가 만들어내는 섬세한 작업이다. 시대의 흐름 속에서 현재의 프레스코는 과거의 미술사로부터 이어받은 수천년 된 형식과 기법을 모태로 하여 동시대 미술의 다원주의적 성향 속에서 다양한 변화와 독창성을 추구함으로써 현대적 기법으로 새로운 영역을 개척해 나가는 창조적 사명이 요구되는 장르인 것이다. 프레스코는 연화(軟化)와 응결(凝結)작용으로 화면 층을 형성하며 회반죽 위에 그려진 안료는 회반죽과 서로 작용하면서 경화(硬化)되어가고, 건조 후에는 안료를 머금은 회벽의 톤(tone)에 의해 독특한 색채의 빛깔을 형성한다. 모르타르 위에 초지층과 화지층을 형성한 화면은 건조과정을 거치면서 표면에 투명한 석회질의 칼슘막을 형성하게 된다. 회벽은 공기가 순환하고 얇은 칼슘막의 외부적 형성으로 방수효과와 방충효과, 단열효과가 높으므로 다양한 기후와 역학적 압력에도 지속적으로 내구성을 갖는다.

우리나라 전통의 단청기법에 사용되는 '초지', '화지'라는 용어이다. 다소 재료의 차이는 있으나, 그 기법과 제작과정이 프레스코의 제작과 유사하여 첫 번째 모르타르(arriccio)를 초지로, 두 번째 모르타르(intonaco)를 화지로 구분하여 프레스코 제작시의 용어로 사용하였다. 초지는 보통 모래와 석회를 2:1의 비율로 혼합하지만 경우에 따라 1:1에서 1:4의 비율도 가능하다. 석회가 많으면 균열이 생기기 쉽고 표면은 매끄러워지며 모래(강사)가 많으면 점성이 강하고 응고력이 높다. 전통적인 화지는 소석회만을 사용하지만 거친 마티에르 효과를 원할 경우 모래, 백운석, 흑석, 샤모트 등을 혼합하여 사용할 수 있다.

모르타르의 응고는 시멘트의 반죽보다 서서히 이루어지나 시간이 지남에 따라 결합과 응고가 높은 강도로 이루어지며 석회질 막을 형성하여 탄산칼슘의 형태로 결정화된다. 투명한 막은 색을 고정하며 석회 모르타르 층을 보호하고 석화작용(石化作用)을 한다. 이 석회분이 굳어서 일단 칼슘막이 형성되면 프레스코 기법으로 그리기 어려우므로 그림이 완성되기까지의 전 과정을 고려하여 계획성 있게 신속히 작업을 마쳐야 한다. 벽화를 제작하는데 있어서 벽지제작과 표면구조는 주요한 요소가 되므로 벽지의 근본적인 특성을 가장 효과적으로 살려 프레스코화의 원형을 보존하여야 한다.

나는 이러한 전통적인 프레스코화법을 확장하여 조각도로 요철을 생성하면서 스크래치 표현으로 독특한 화면을 구사하고 있다. 회벽에 행해지는 표현은 고도의 집중력이 요구되는 정교한 노동의 산물이라고 할 수 있다. 벽면에 요철을 줄 수 있는 도구는 다양한 종류의 헤라, 조각도 등이다. 회벽이 마르기전까지는 적은 힘으로도 밀도 높은 정교한 처리가 가능하다. 화면의 물리적 저항을 계산하고, 시간을 적절히 안배할 때에만 나는 원하는 화면 혹은 결과를 얻는다. 가장 오래되고 가장 영구적인 기법을 현대적으로 계속 전유함으로써 나는 오래된 것과 새로운 것의 길항관계 혹은 상호중첩성의 문제를 심화시키고 있다.

Grove
숲
2018
fresco, scratch on lime wall
60x60cm

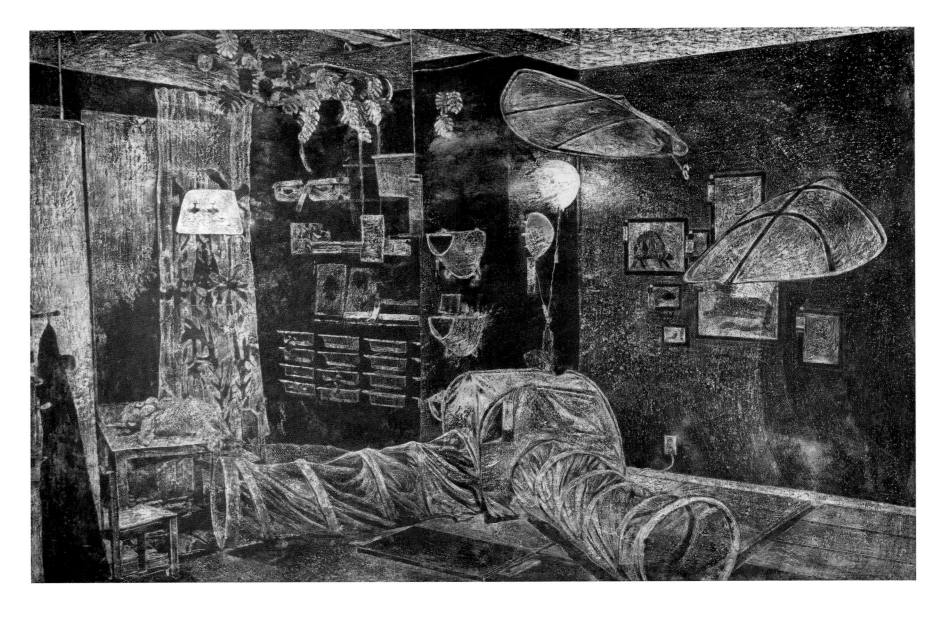

Imitated Room
복제된 방

2018
fresco, scratch on lime wall
90x140cm

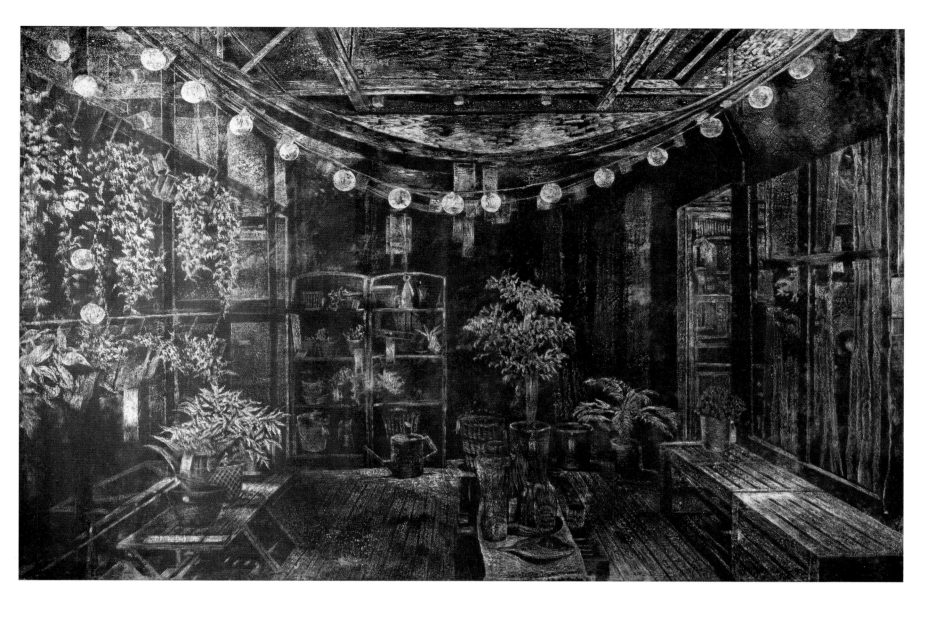

Imatated Garden
복제된 정원

2018
fresco, scratch on lime wall
90x140cm

137

Imatated Garden
복제된 정원

2018
fresco, scratch on lime wall
90x140cm
National museum of
modern and contemporary Art,
Art bank collection

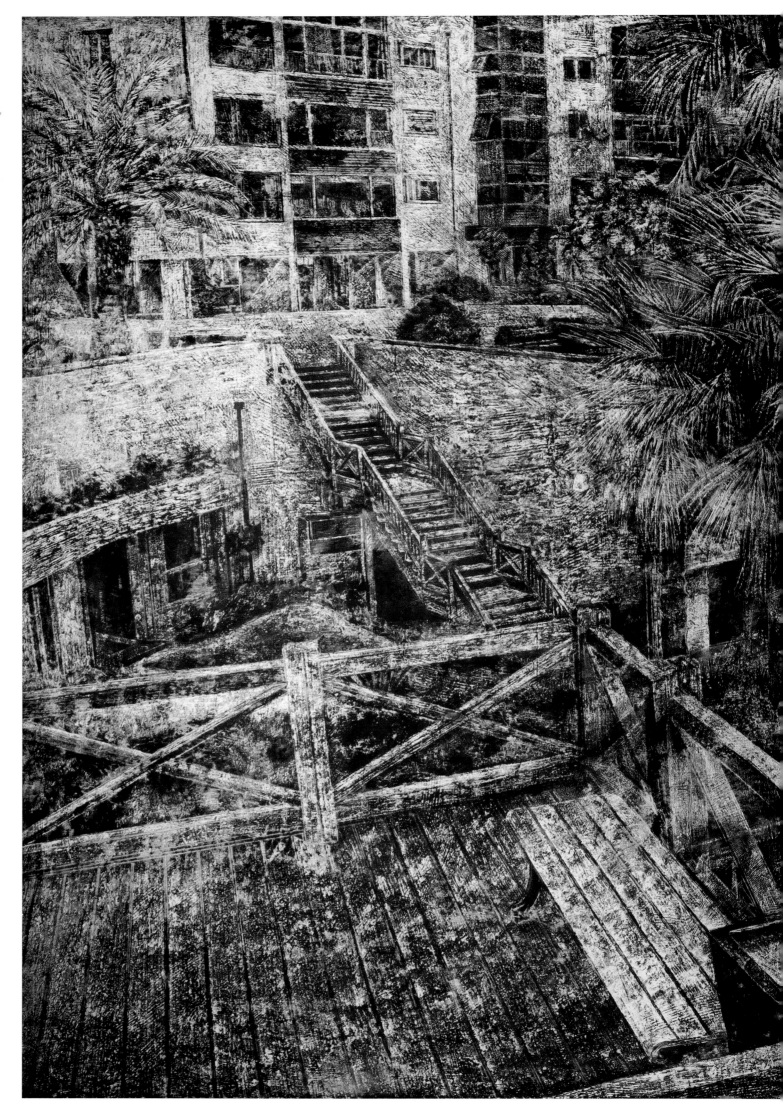

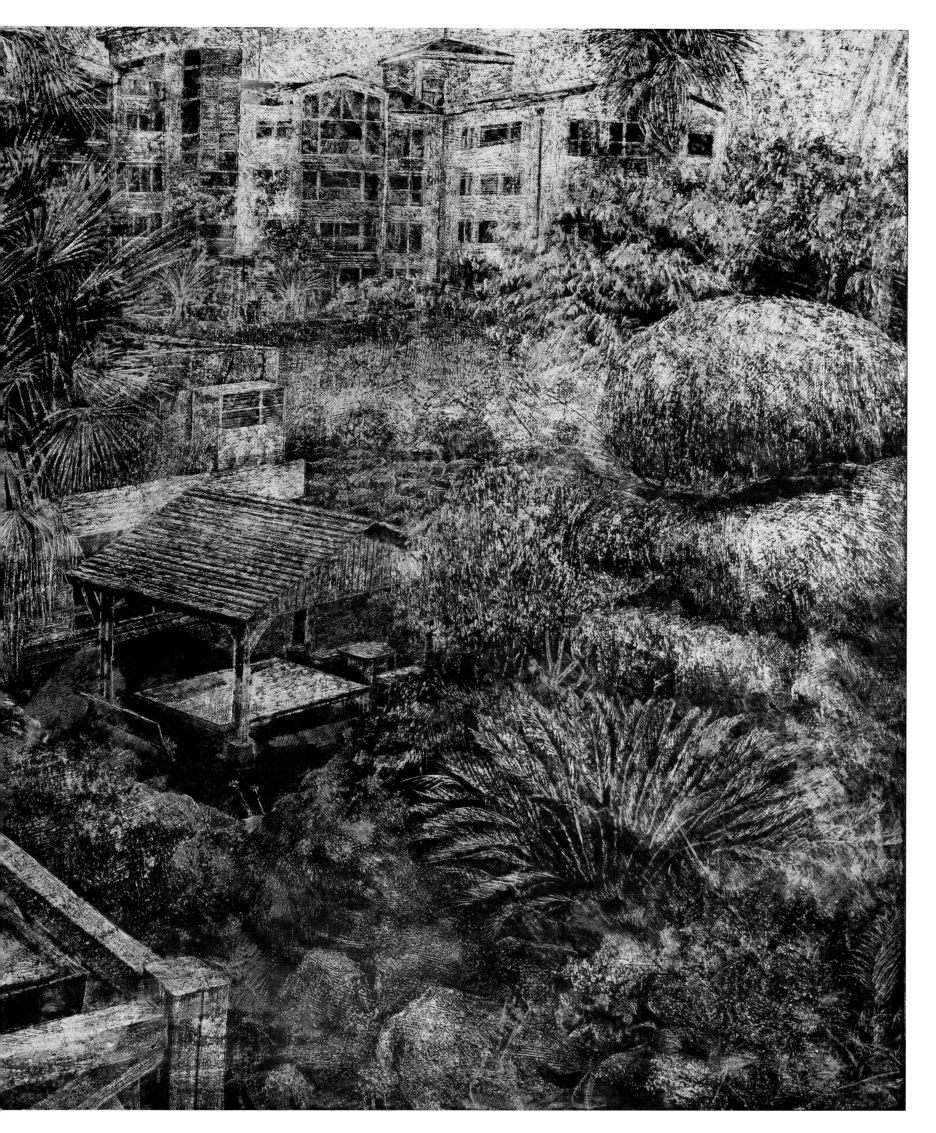

Warmth_Survival Mechanism
온기_생존기제

2018
fresco, scratch on lime wall
113.5x162cm
Namdo Culture Foundation collection

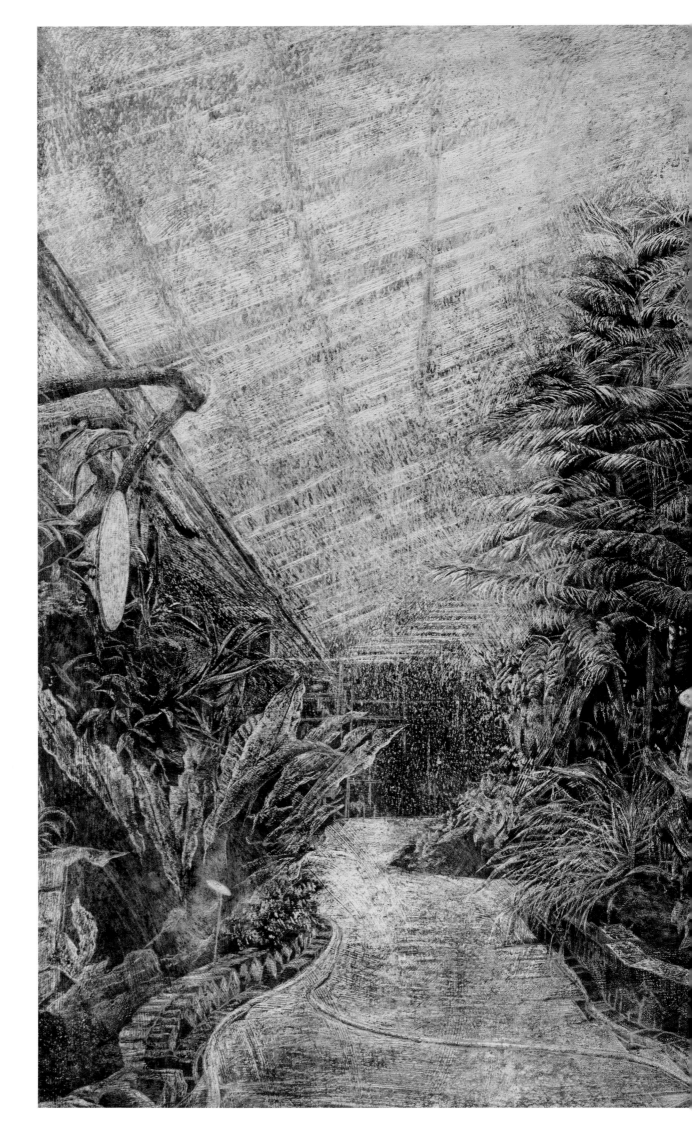

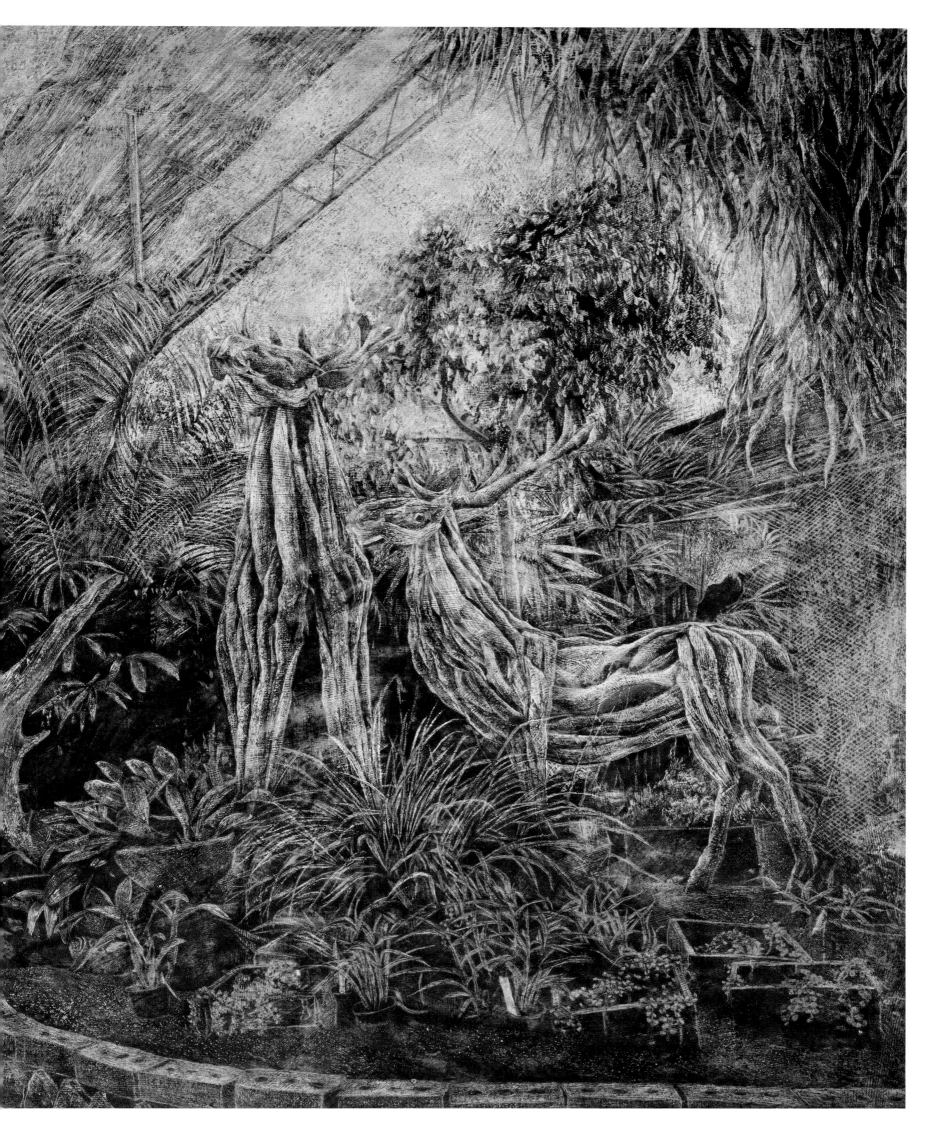

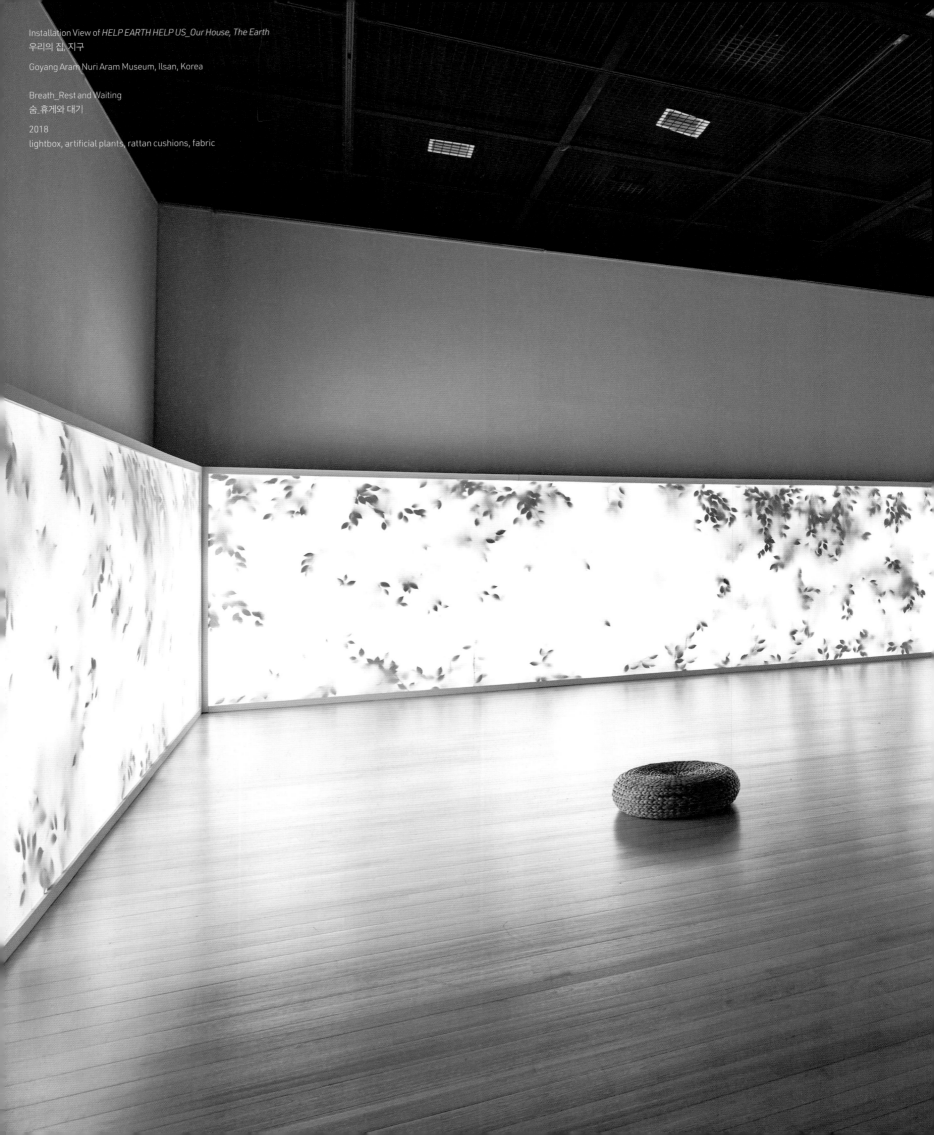

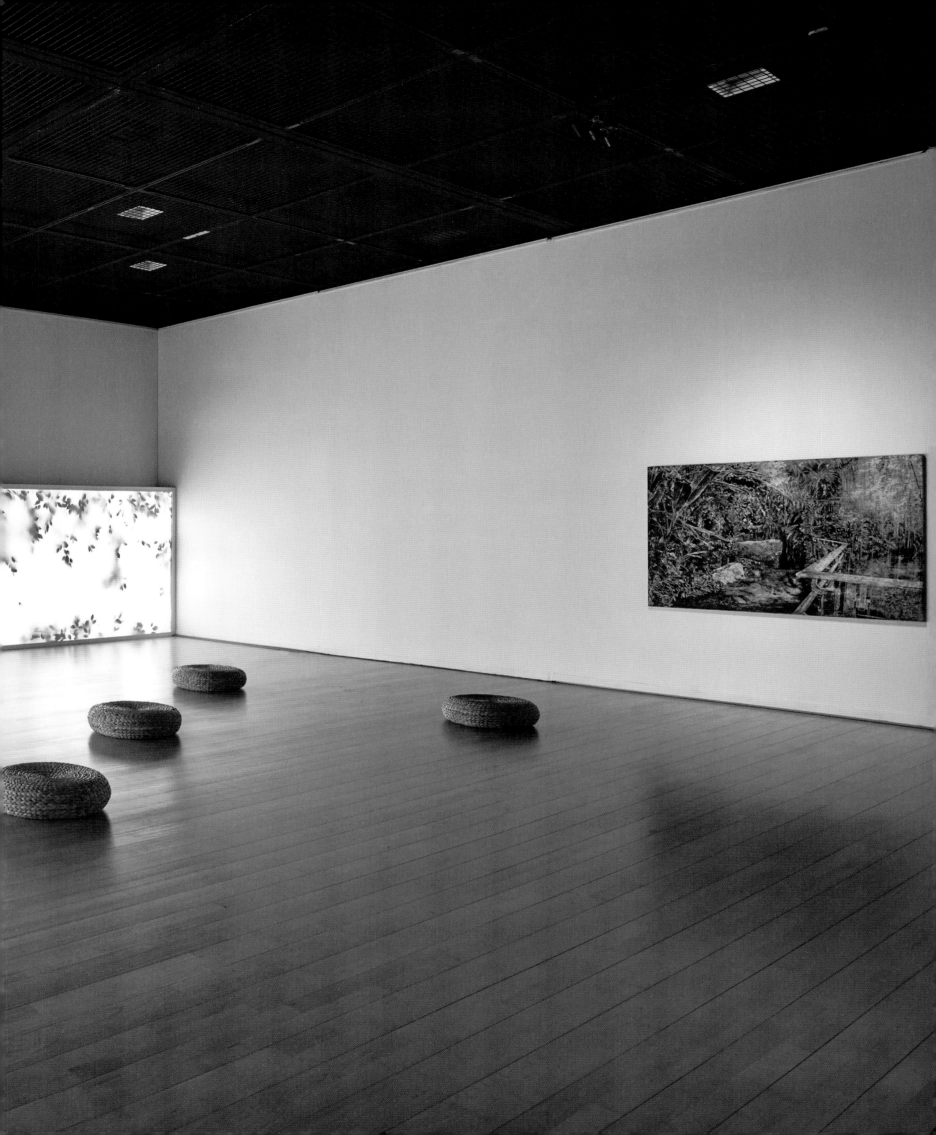

Breath Perspective 2017

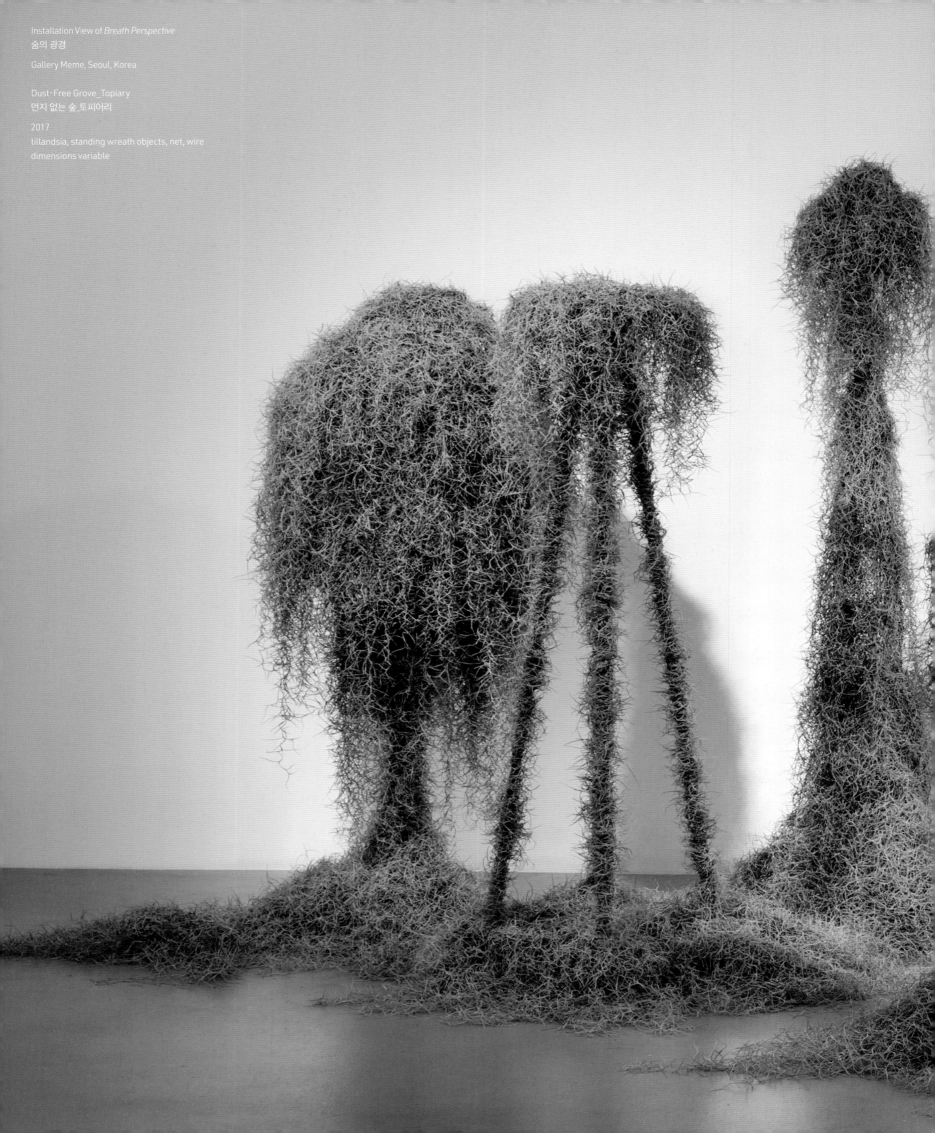

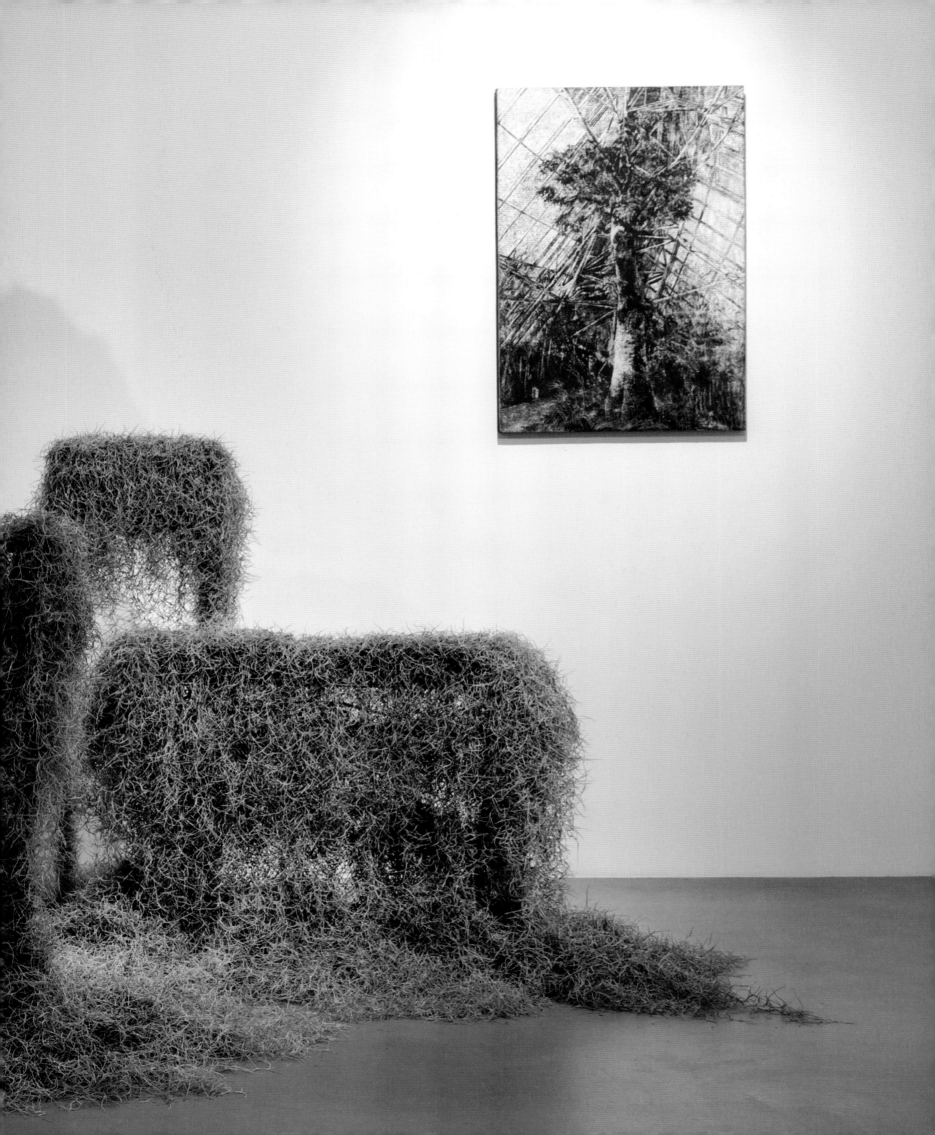

Breath Perspective reflects the inner psychology of someone responding to the events that unfold in a plant's survival phenomena. It shows the subtle, complex imagination with which an individual's psychological aspects began perceiving things in new ways as they encounter social relationships. Chiefly used at hotels at outdoor wedding venues, the ornamental wreath supports are devices to decorate the plant's outward appearance. A grotesque landscape is recreated through use of the characteristics of the tillandsia, a rootless plant that grows by consuming moisture from the air that envelops it. Adapting in new ways to changes in the environment from emergence to growth, plants gradually expand their domain—even on the concrete floor of the gallery building.

<숨의 광경 Breath Perspective>은 식물의 생존 현상에서 벌어진 양태에 반응하는 누군가의 내적인 심리가 반영되어 있다. 개인의 심리적인 면이 사회적 관계들과 만나면서 새롭게 인식하기 시작한 복잡하고 미묘한 상상력을 보여준다. 호텔이나 야외결혼식에서 주로 사용되는 화환 장식 지지대는 식물의 외향적 모습을 치장하기 위한 장치로 쓰인다. 그것을 뒤덮는 공기 중 수분을 먹고 자라는 뿌리 없는 틸란드시아 식물의 특성을 이용하여 그로테스크한 풍경을 재현한다. 생장에서 성장으로 변화되는 환경에 매번 새롭게 적응하는 식물들은 전시장 콘크리트 건물의 바닥에서도 조금씩 그 영역을 확장해 나간다.

Dust-Free Grove_Topiary
먼지 없는 숲_토피어리

2017
tillandsia, standing wreath objects, net, wire
dimensions variable

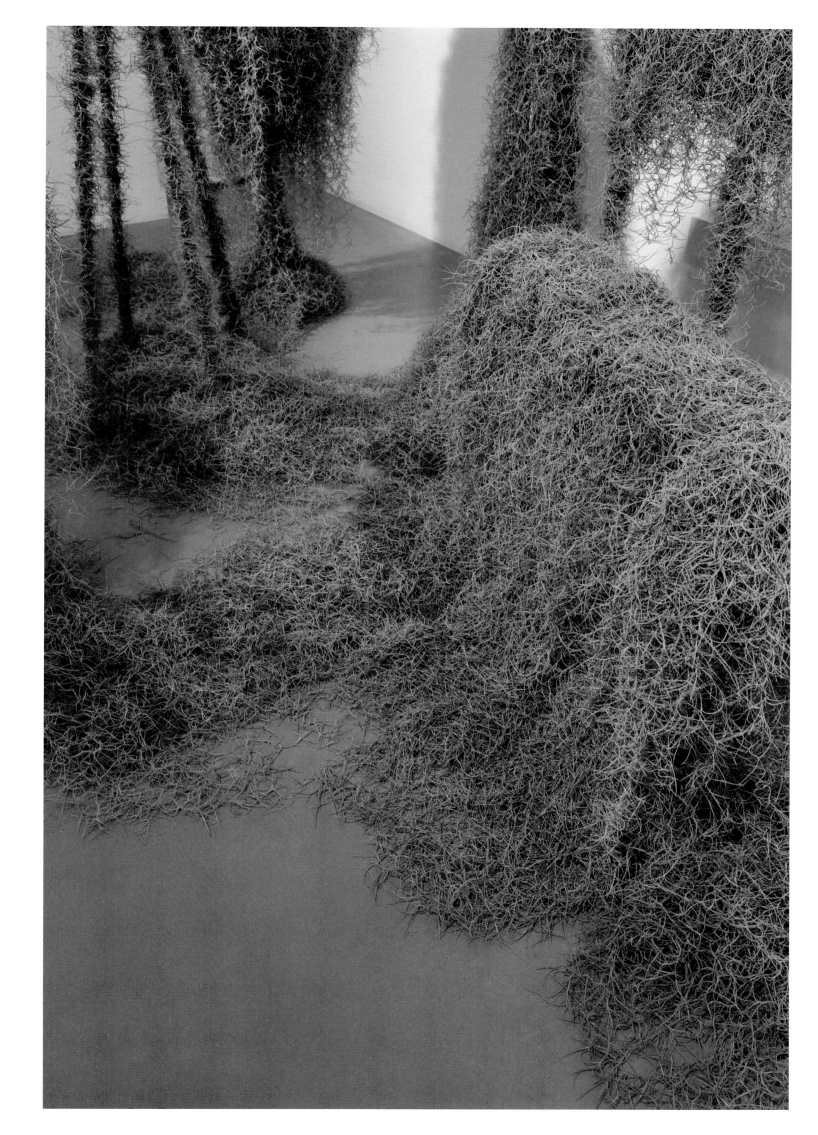

The focus of *Survival Road* is Ecoland, an environment designed for viewing. Ecoland amounts to an ecological pathway created to support the movements of wild flora and fauna, while also serving as a forest and nature center for people living urban lives. The mesh path that appears amid the branches is a single route under the guise of "freedom," as well as an artificial environment to constantly sustain the elements needed for survival.

<생존 통로>의 소재가 된 에코랜드(구경할 수 있게 환경을 조성한)는 도시적 삶을 사는 사람들의 숲이자 자연관이며 야생 동식물의 이동을 돕기 위하여 설치한 생태 통로로 귀결된다. 나뭇가지 사이로 난 그물망 길은 자유로 위장되는 외길 장치이며 끊임없이 생존에 필요한 요소들을 유지하려는 인위적인 조건들이다.

Survival Road
생존 통로

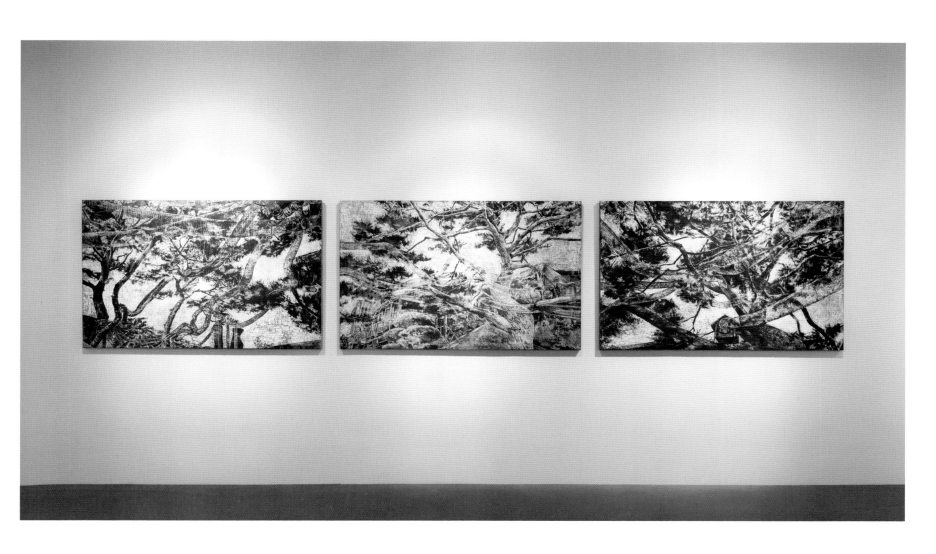

Survival Road
생존 통로

2017
fresco,
scratch on lime wall
90x140cm

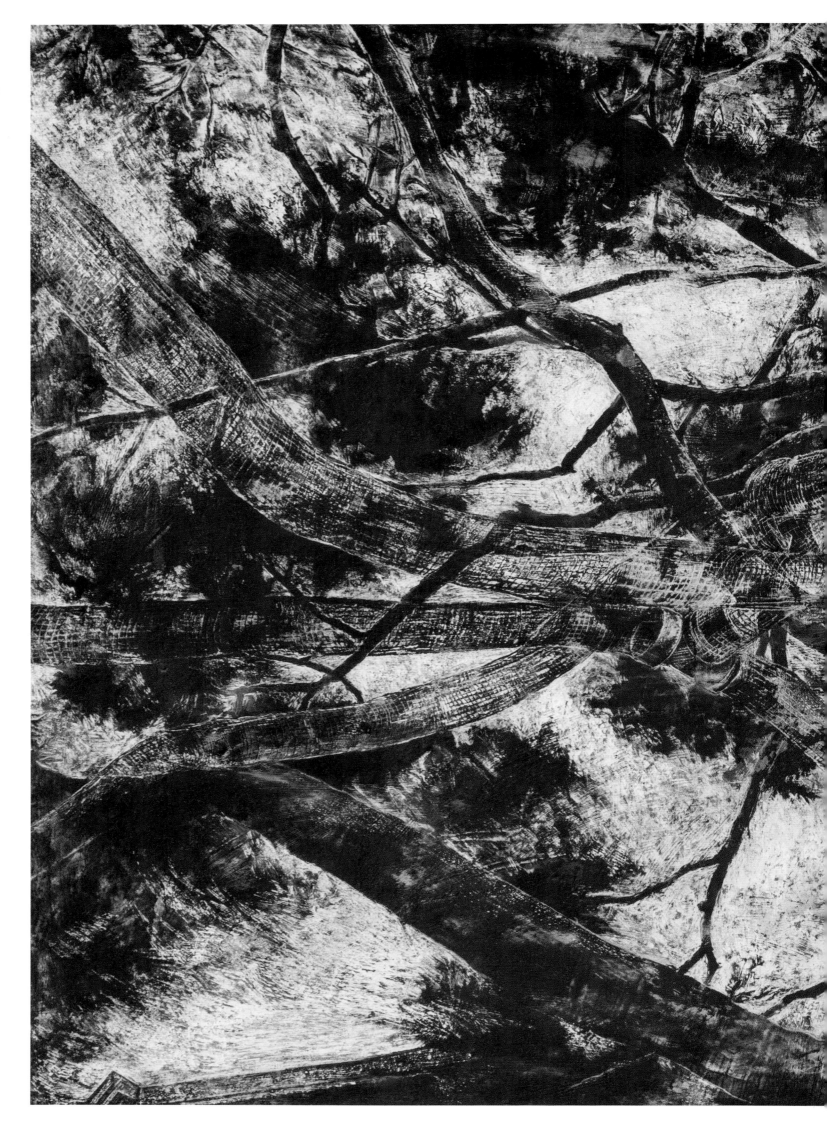

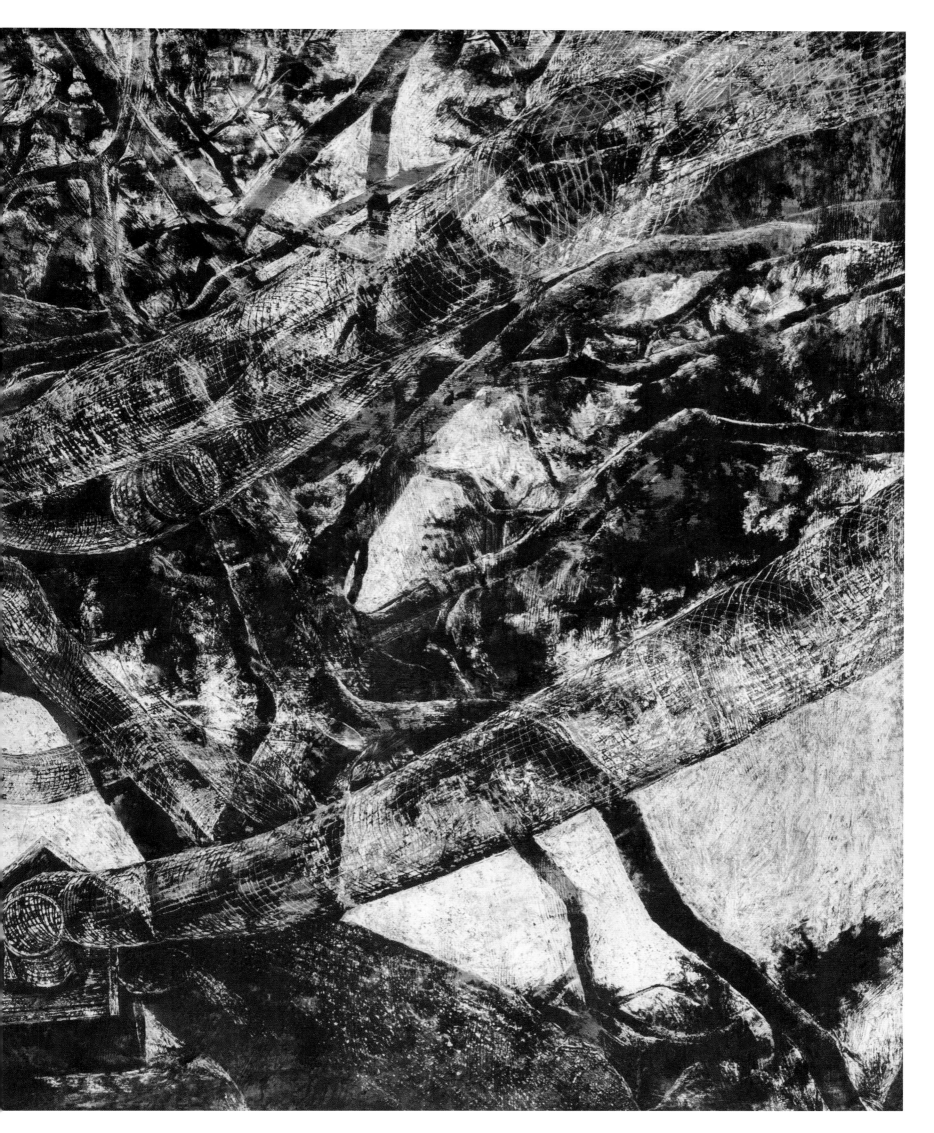

Survival Road
생존 통로

2017
fresco, scratch on lime wall
90x140cm

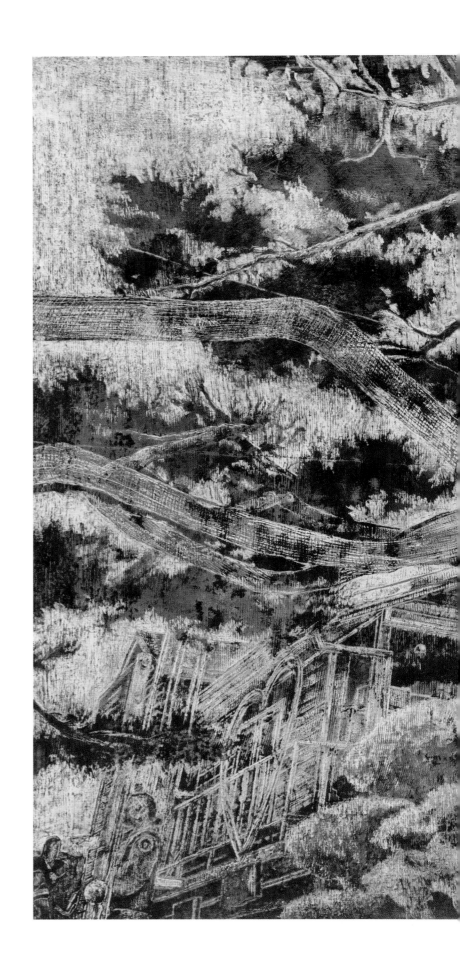

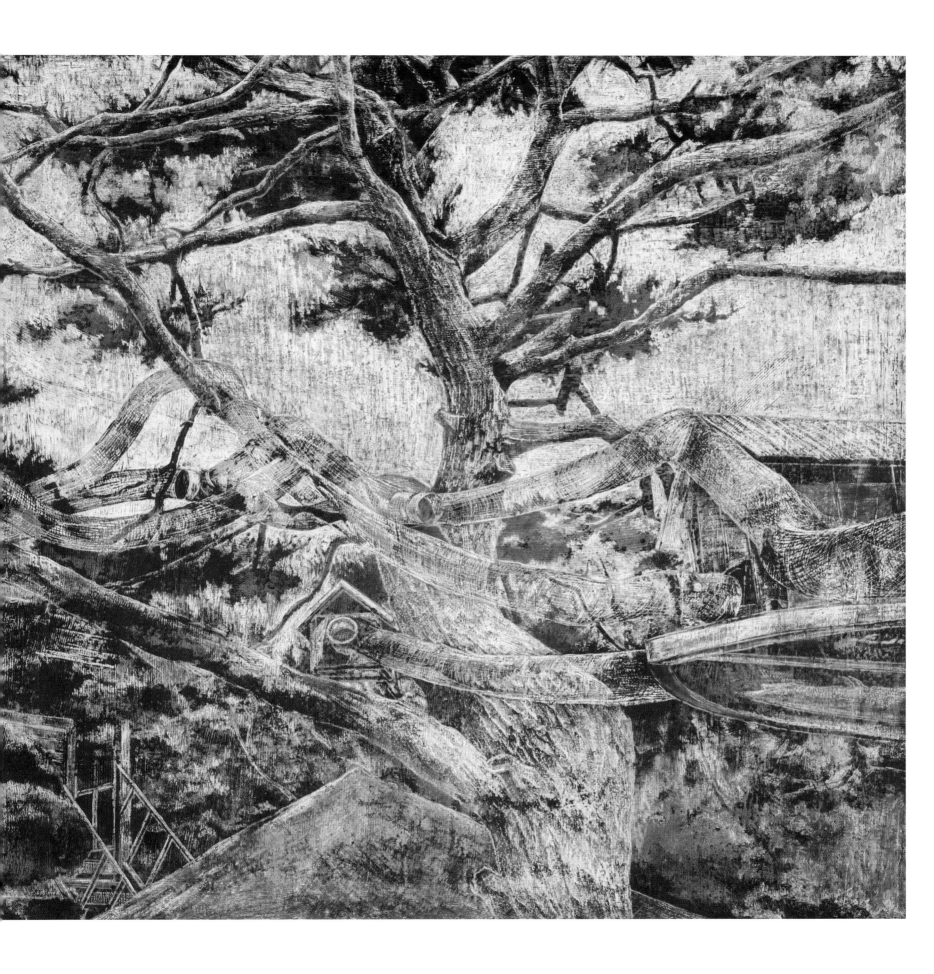

Survival Road
생존 통로

2017
fresco, scratch on lime wall
50x50cm

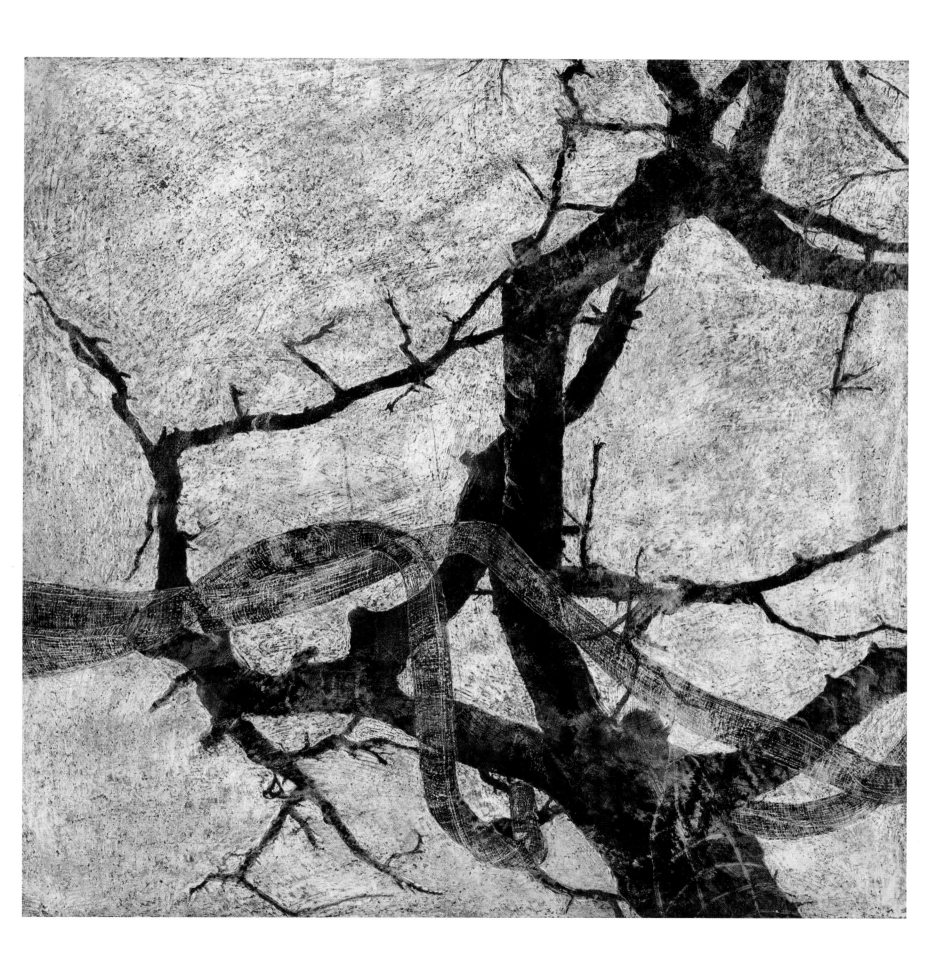

Tamed Future
길들여진 내일

2017
fresco, scratch on lime wall
55x80cm

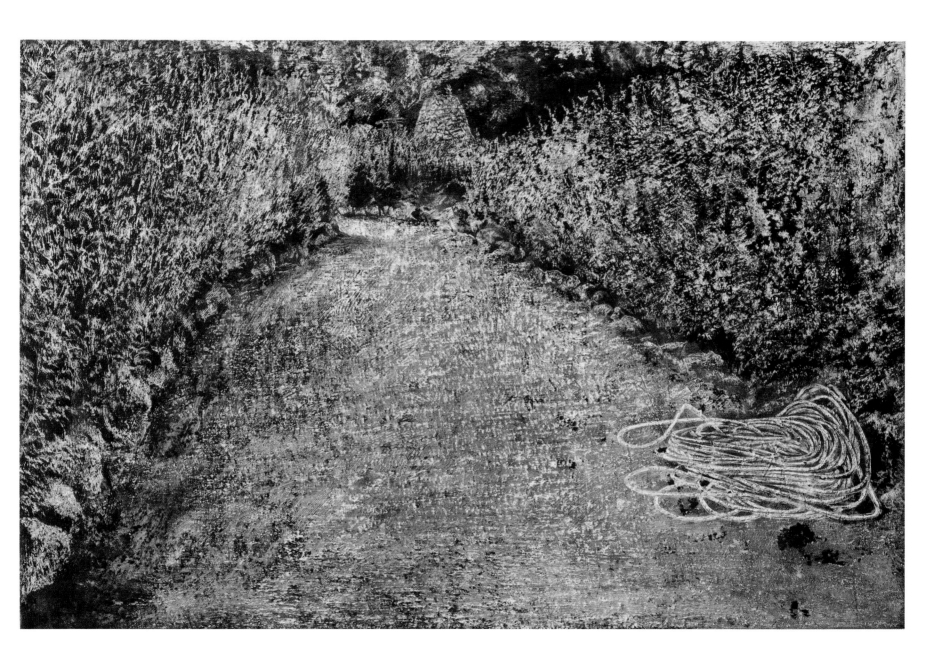

This is a portrait of the nameless weeds that are forever collectively arising and perishing beyond the hill of a wasteland that is soon to be developed in the name of "growth." Hanging as a shadow over a remote wall in the gallery is a single image that overlays the moments remembered by a plant as it grows—a collection and record of the advancement from sprout to blossom.

성장의 이름으로 곧 개발될 황무지 언덕 저편에서 집단적으로 끊임없이 자생하고 소멸되는 이름 없는 잡초들의 초상이다. 식물이 자라면서 기억하는 시간을, 즉 새싹부터 꽃이 피는 형상을 수집하고 기록한 결과물을 하나의 이미지로 오버랩하여 전시장 구석진 벽에 그림자로 드리운다.

Forced Plant
세력 도감

2017
pigment print, dried grapes
70x70cm

Optimal Symbiosis
완전한 공생

2017
fresco, scratch on lime wall
80x55cm
private collection

Natural environments are a place where human beings go about our lives, but they also have decisive impacts on our lives, as well as effects on one another. As it establishes itself in a transplanted environment, the botanical garden plant forms a close-knit relationship with the environment where it will be living.

자연환경은 인간이 살아가는 터전인 동시에 인간의 삶에 결정적인 영향을 미치며, 서로 영향을 주고받는다. 식물원 안에 식물은 이식된 터전에서 자리매김하며 스스로 살아갈 조건과 밀접한 관계를 만들어 간다.

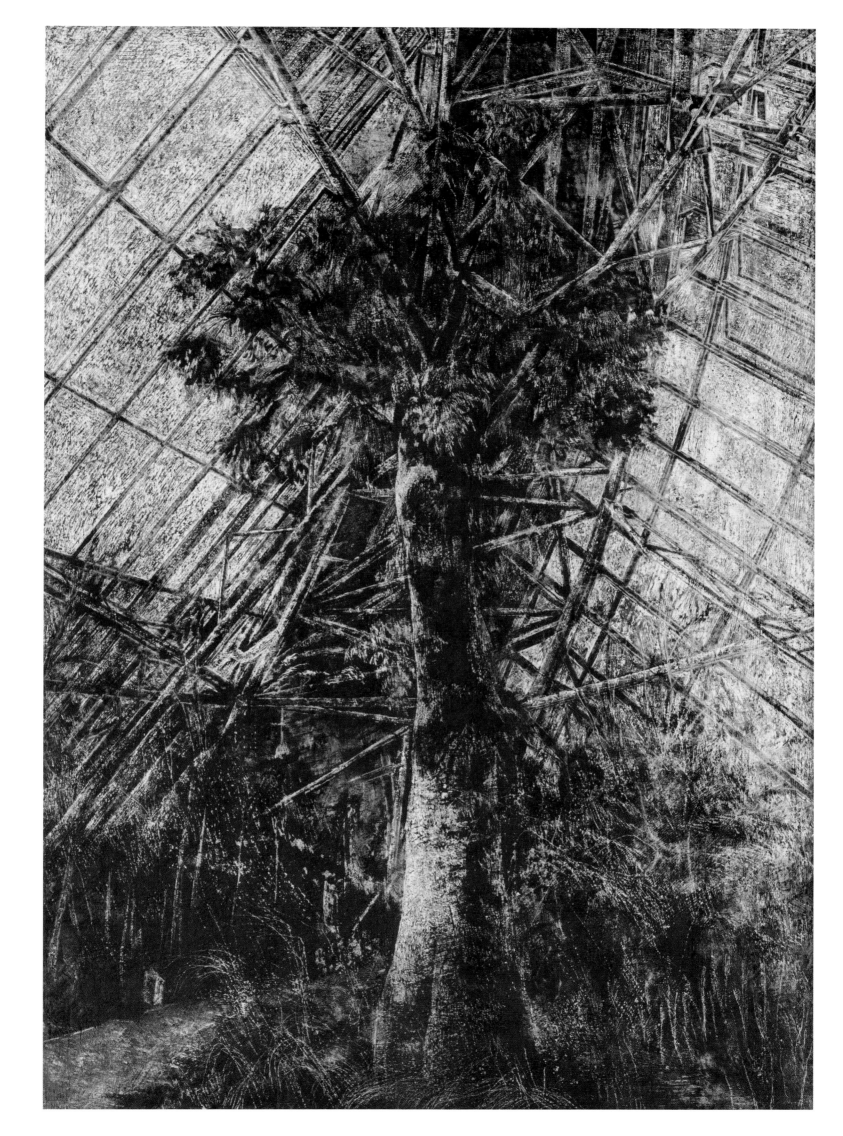

Infested Garden
잠식된 정원

2017
fresco, scratch on lime wall
113.5x162cm
Busan Museum of Art collection

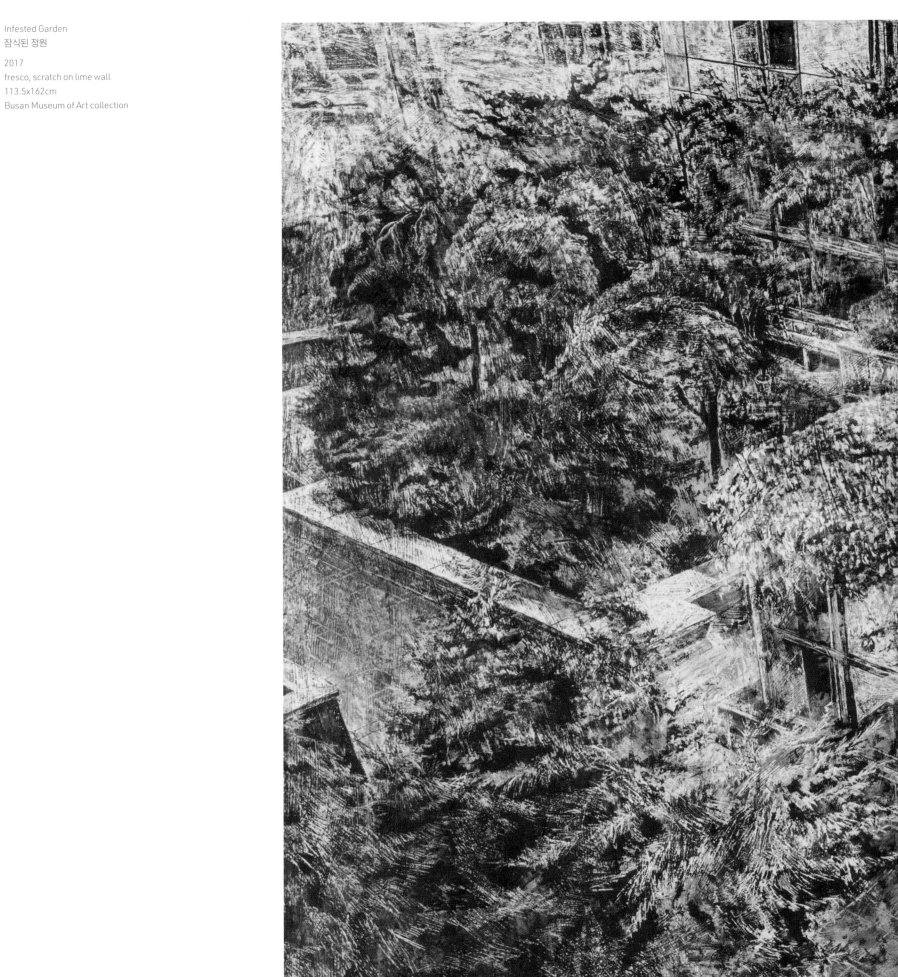

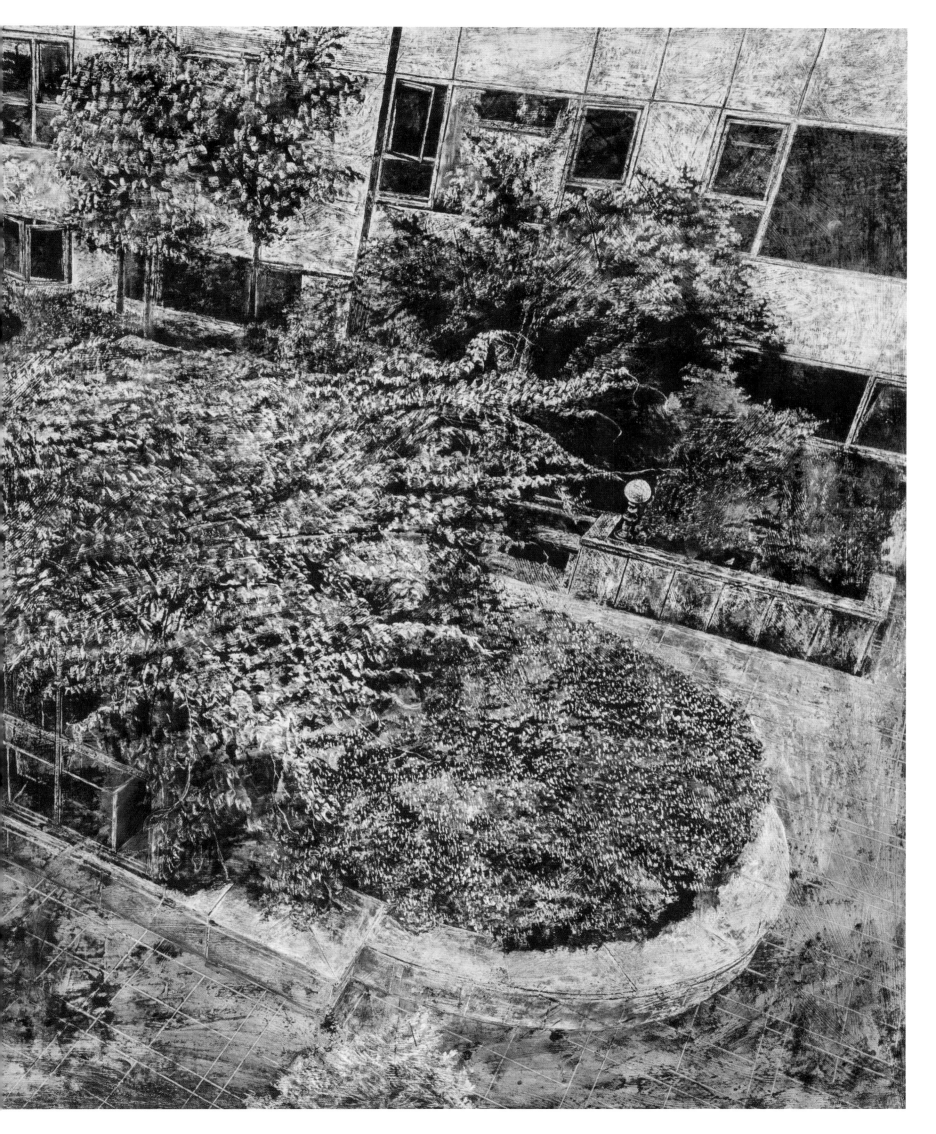

Warmth
온기

2017
fresco, scratch on lime wall
113.5x162cm

After applying melanite over drawing paper forming a wall, I made scratches in the canvas before the plater dried, creating the image of a plant or garden within the dark canvas. The scraping of the plaster wall is both a technical metaphor for modern lives and our hunger for healing of our trauma, as well as the image of contemporary lives themselves. Projecting the relationality of human lives that require a suitable state to be constantly maintained, *Warmth* presents an artistic perspective on life sustained in dual positions: flower pots located between nature and artificial products, plants growing naturally in the cracks of concrete walls rather than in the earth, and scenes from a botanical garden where plants have been relocated from the origins of life.

벽체를 조성한 화지 위에 흑석을 도포한 후 석회가 마르기 전에 화면에 스크래치를 내며 검은 화면 안에 식물이나 정원의 이미지를 만드는데, 회벽을 긁어내며 생채기를 만드는 것은 상처의 치유를 갈망하는 현대인의 삶을 표현하는 기법적 은유이자 그 자체를 나타낸다. <온기>는 지속적으로 알맞은 상태를 유지해야 하는 인간의 삶의 관계성을 투영하며 자연과 인위적인 상품 사이에 위치한 화분, 대지에서 자라는 식물이 아닌 콘크리트 벽면 사이에서 자생하는 식물, 그리고 생명의 기원에서 이주한 식물원의 장면 등 이중적 위치에서 삶을 유지하는 생명체에 관한 작가적 시선을 대변한다.

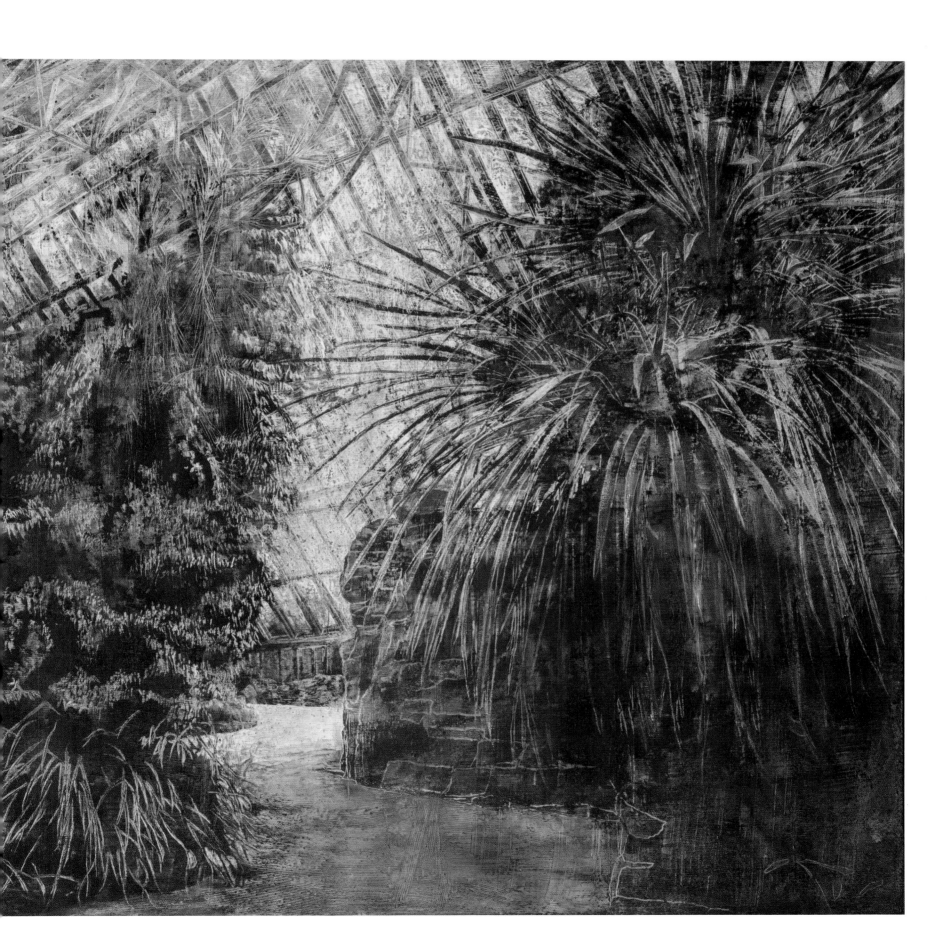

Carved Grove 2016

Grayness, The Possibilities Between Black and White

Jung Hyun, professor, Inha University; art critic

Giles Deleuze believed that the onset of a book occurred not on the first page but in the middle of the book. We unconsciously tend to set "0" as the start of everything and enjoy life and the future as it advances in one direction. Few people rebuke this idea as many believe that such a way of life is desirable. They want to move forward toward a bright future without becoming distracted, but their dreams are always betrayed by their lives. Our lives are not always spent repeating the progress that has been made. As such, Deleuze questions the one-sided view of the world pertaining to an advancing or evolving life. The middle of a book can be seen as containing its onset which asserts that we have to put more emphasis on the context and its surroundings as opposed to advancing life, just as the future Deleuze dreamed of that was likened to a "thousand plateaus." Gray is particularly special to Deleuze. Dichotomous thoughts prevailed in the days of ideological debates. Gray was often to blame in a world where only right and wrong exist since it is ambivalent, equivocal, and uncertain. However, Deleuze alludes that the color gray can act as a departure point since it can move toward black and reverse toward white as well. Gray is like a vacant lot in which possibilities can be raised in the middle of everything, rather than disclosing any sort of meaning or idea.

Kim Yujung's paintings appear oddly unfamiliar despite her portrayals of familiar scenes. Unfamiliarity seems to spring from the movement of plants as they wriggle in her black settings. This does not mean that her paintings are exotic but that the plants wriggling somewhere between black and white are remainders of tropical nature. From a different perspective, her painting style can be compared to ink-wash painting.

Kim's plants, gardens, and landscapes seem unfamiliar due to the colors she adopts, since ink-wash paintings are not unconditionally exotic. Another reason for seeming distant seems related to fresco, a technique specific to her work. As is widely known, fresco is a technique of mural painting that was used on the interiors of churches. In Italy fresco is a considerably popular technique employed to paint murals on the interior walls of private homes. Kim engraves images on the surface of a solidly constructed canvas-type wooden panel after applying black to its surface in various phases (wall formation, mortar, coats the surface, paints the surface).

Her landscapes can be described as appearing through a process of discovering the images that she made by scratching out black and white scenes that were created through the accumulation of such extremely difficult processes. She seems to discover a "grayish" landscape in a space of black and white and light and shade.

We must realize that a landscape is different from nature, the ground of the world that is believed to have existed before the birth of humans. A landscape is not an image of nature that nature itself has created. It is nature that has been cut out into a size and form suitable for a city where humans reside and is set within four walls. This can be correctly referred to as a man-made nature or an urbanized nature in which naturalness is underscored. We often consider beautiful scenery to be a wonderful gift that nature has given to mankind. Nature is obviously the source of all existing things but we have to remember that nature as a visual spectacle or as an object of affection is a concept shaped from a human-centered perspective.

The creation of a landscape thus premises the deconstruction of nature. This is not because natural things are not right but because nature is cut out to fit the world humans inhabit. Of course, this view of landscape approximates more to the Western worldview. This means the East did not cut out nature as people in this world respected it. The cultures of cutting out nature have been pervasive both in East and West. Contemporary society consumes nature as an absolute ideal, an alternative future, and an ecological idea. From today's point of view the flowerpot, a minimum unit of industrialized nature and the botanical garden that came into being in modern times as a heritage of colonialism, can be interpreted from various angles such as human desire, selfishness in civilization, and views of nature in urbanism.

If so, we have to accept the paradox that destroying nature is no better than creating a landscape. Kim's fresco landscape work can never be seen as painting representing nature. The objects she has chosen seem to replace nature as a form of metonymy. They can never replace nature but are able to bring nature into our lives. Kim's works such as *Incubator-Ownerless* (2015) in which abandoned flowerpots cluster and *Incubator* (2014-1015), a series that features plants raising their heads from windows signal what the metonymic nature she has discovered is. These co-miserable plants are regarded as natural objects as consumables, but they appear dense as if defying humans who have neglected life. They appear as a warning nature issues against humanity and civilization, simultaneously disclosing fear stemming from life. A sizable flowerpot from which branches stretch at an abandoned sofa's side in the work of the same title (*Incubator-Ownerless*, 2015) is a showcase of an underlying difference between living and non-living

things. *Symbiosis* (2015), an impressive work in which a horizontal composition is underscored, captures the relationship between fish inhabiting an aquarium and plants by dividing its scene above and below.

Fish in an aquarium seem formal like images in an illustrated guide of fish in consideration of the life force of the plants growing over the water's surface. What is the artist tying to comment on through plants' reproductivity? The exhibit title enables viewers to assume an answer to this question to some degree. *Survival Conditions* are not merely those required for maintaining life in the wild. While humans in modern civilization tried to overcome and dominate nature, humans today seek to coexist with nature. In a world full of hyper-contradictions we humans are requested to be involved in unlimited competition despite rational, justifiable prospects and practices for the future. In the age of globalization, humanity's urban life seems to be cold-hearted, sanitary, reasonable, and refined, but we are plagued by the struggle for survival. *Warmth* (2015) is a serial work reinterpreting common scenes in a botanical garden. Nature in a botanical garden that grows densely maintains its life by virtue of an artificially controlled climate and a gardener's special care. Any specific placeness is of no significance any more. Globalization has gotten rid of not only trade and language barriers but also each place's intrinsic narrative, value, and future. As the botanical garden emerged as a means to display colonialists or imperialists' authority, nature in this closed space is an object of research and another aspect of consumer society.

Exotic unfamiliarity in Kim's work seems to stem from expressive technique and a "grayness" of her subject matter. Grayness here refers to a difference between black and white, a dichotomous border, an edge, or the middle. Kim's perspectives toward living things that maintain their lives at a two-fold position are represented by the contradiction of her painting's trait as painting on the canvas using the fresco technique, flowerpots between nature and artificial commodities, plants growing from a concrete wall, not a land, and the scenes of a botanical garden as a venue displaying the origin of life forms. This grayness can be seen as a state with the possibility of overturning as her beings are wimpish, insignificant, but dynamitic.

회색성, 흑백 사이의 가능성

정현, 인하대 교수, 미술비평

들뢰즈(Deleuze)는 책의 시작은 첫 페이지가 아니라 중간부터라고 생각했다. 우리는 무의식적으로 모든 시작을 '0'으로 놓고 계속 한 방향으로 전진하는 인생과 미래를 꿈꾸기를 즐기는 편이다. 이러한 생각을 놓고 나무랄 사람은 그리 많지 않다. 오히려 전진하는 인생이야말로 바람직한 삶이라고 믿는 사람들이 많다. 한눈 팔지 않고 앞으로, 더 나은 미래로, 더 밝은 꿈을 향해서. 그러나 삶은 늘 꿈을 배반한다. 전진만을 거듭하는 삶이란 있을 수 없다. 들뢰즈는 이처럼 전진하는 또는 발전하는 삶이라는 일방적인 세계관에 대해 의문을 품었다. 책의 중간이 시작일 수 있는 이유는 전진하는 삶보다 자신과 주변과의 맥락을 더 중요하게 생각하자는 의견으로 보아야 한다. 그가 꿈꾸었던 미래가 '천개의 고원'으로 비유됐듯이 말이다. 그래서 들뢰즈에게 회색은 특별하다. 이념의 방향 때문에 논쟁이 심했던 시절에는 이분법적 사고관이 팽배했다. 옳거나 틀린 것만이 존재하는 세상에서 회색은 이중적이고 모호하고 불확실하기에 비난의 화살을 맞아야 했다. 그러나 들뢰즈는 이 회색이 바로 시작이라고 말한다. 회색으로부터 검정색으로 나아갈 수 있으며 반대로 흰색으로 나아갈 수도 있기 때문이다. 회색은 의미나 이념을 드러내기보다 모든 것의 중간에서 가능성이 생성되도록 돕는 공터와 같다.

김유정의 회화는 익숙한 장면임에도 불구하고 이상하리만큼 낯설게 다가온다. 낯섦은 검은 화면 안에서 꿈틀대는 식물의 움직임이 자아내는 몸짓으로부터 기인하는 듯하다. 이는 회화가 이국적이라는 의미가 아니라 흑백 사이 어디 즈음에서 꿈틀대는 식물의 모습이 마치 열대의 자연을 연상시키기 때문이다. 다른 관점에서 수묵화와도 비교할 수 있을 법하다. 그러나 수묵화라고 무조건 이국적인 것은 아니니 김유정이 그린 식물, 정원, 풍경이 낯설게 느껴지는 이유는 단지 색채만의 이유는 아닌 듯하다. 또 다른 가설로는 그녀만의 특유한 작업 방식인 프레스코 기법과 관련을 살펴볼 수 있겠다. 알다시피 프레스코는 교회 건축물 내부의 벽화를 그리는 방식으로 이탈리아에서는 일반 가정의 실내 벽화를 그리는 상당히 대중적인 기법이다. 김유정은 견고하게 제작된 캔버스 형태의 나무 패널 위에 여러 단계(벽체조성-모르타르-초지-화지)를 거쳐 최종적으로 발라진 화지의 표면 위에 검정색을 도포한 후 석회(회벽)가 마르기전에 음각을 하는 방식으로 작업을 진행한다. 이러한 지난한 과정이 쌓여 단순한 흑백회화로 규정 내리기보다는 화면을 만든 후 화면에 흠집을 내어 형상을 찾아가는 과정에 의해 풍경이 나타난다고 표현할 수 있다. 다시 말해 작가는 흑과 백의 공간 혹은 음영 사이에서

'회색풍'의 풍경 또는 세계를 발견하는 것은 아닐까?

어차피 풍경은 이미 존재하는 자연과는 다른, 그러니까 인간의 탄생 이전부터 존재했으리라 믿고 있는 세계의 바탕인 자연의 존재와는 다르다는 점을 깨달을 필요가 있다. 풍경은 자연이 스스로 만들어낸 자연의 형상이 아니다. 풍경은 이처럼 야생으로서의 자연을 인간이 사는 도시에 맞도록 크기와 형태를 재단한 상태이며 네 벽 안에 배치된 자연이다. 그것은 자연스러움을 강조한 인공화된 자연 또는 도시화된 자연이라 부르는 게 더욱 올바른 표현이다. 우리는 흔히 아름다운 풍경이야말로 대자연이 인류에 선사한 큰 선물로 여기는 경우가 많다. 물론 자연은 존재하는 모든 것의 원천임에 분명하지만 시각적인 장관으로서의 자연 그리고 정동(affect)의 대상으로서의 자연은 인간중심의 관점으로 생성된 개념임을 잊지 말아야 한다. 그래서 풍경의 생성에는 자연의 해체가 전제된다. 자연적인 것이 옳지 않아서가 아니다. 자연을 인간이 사는 세상의 축척에 맞도록 재단하기 때문이다. 물론 이 같은 풍경론은 서구적 세계관에 보다 가까운 개념이다. 그렇다고 동양이 자연을 존중했기에 축척을 재단하지 않았다는 게 아니다. 동서양을 막론하고 자연을 재단하는 문화는 동일하게 존속되고 있다. 현대사회는 자연을 절대적 이상으로 대안적 미래로 생태학적 이념으로 소비한다. 그 중에서도 산업화된 풍경의 가장 작은 단위인 화분과 근대기의 식민주의적 성격으로 탄생한 식물원은 오늘의 시점으로 볼 때 인간의 욕망, 문명의 이기심, 도시주의 안에서의 자연관 등 다각적인 관점의 해석을 유추할 수 있다.

그렇다면 자연을 파괴하는 것이야말로 풍경을 생성한다는 역설을 받아들여야 한다. 김유정의 프레스코 풍경은 자연을 재현한 회화로 볼 수 없다. 그녀가 선택한 대상들은 환유로써 자연을 대신하는 셈이다. 그것은 절대로 대자연을 대신할 수 없지만 자연을 우리의 삶 안으로 끌어들이는 대상이다. 다시 김유정의 작업으로 되돌아가보자. 버려진 화분들이 한데 모여 군을 이룬 <Incubator-Ownerless>(2015), 건물의 창틈 사이로 빼꼼히 고개를 들고 있는 식물을 다룬 <Incubator> 연작(2014-2015)은 작가가 발견한 환유적 자연이 무엇인지를 잘 알려주고 있다. 이 가엾은 생명들은 인간의 변덕으로 버림받은 소모품-자연인 셈인데, 생명을 유기한 인간에게 도전이라도 할 것처럼 울창하게 나타난다. 자연이 인간과 문명에 던지는 경고이자 찬란한 생명력이 주는 두려움이 동시에 드러난다. 위 동명의 작업 <Incubator-Ownerless>(2015)에서는 버려진 소파 곁에서 가지를 뻗은 상당한 크기의 화분은 생물과 비생물 사이의 근본적

차이를 보여준다. 수평이 강조된 화면이 인상적인 작업 <공생>(2015)은 위아래로 화면을 분할해 수족관에 서식하는 물고기와 수중식물의 관계를 포착한다. 수면을 뚫고 나온 식물의 생명력에 비해 수족관의 물고기는 마치 도감에 나오는 이미지처럼 형식적이다. 작가는 식물의 번식력을 통해 무엇을 질문하는 것일까? 아마도 전시 표제가 이 질문에 관한 답을 어느 정도 가늠케 한다. <생존조건>은 순전히 야생에서만 필요한 생명유지의 수단은 아닐 것이다. 근대문명이 인간이 자연을 극복하여 이를 지배하려는 노력이었다면, 현대는 자연과의 공생을 추구한다고들 말한다. 이렇듯 이성적이고 정당한 미래에 대한 전망과 실천에도 불구하고 너무도 모순적으로 세상은 무한경쟁을 요구한다. 세계화 시대에서의 도시의 삶은 냉정하고 위생적이며 이성적이고 세련됨으로 치장되지만 이러한 외연의 이면에서는 더 이상 치열하기 힘들 정도의 생존 경쟁이 벌어지는 게 현실이다. <온기>(2015) 연작은 식물원의 흔한 장면을 재해석한 작업이다. 무럭무럭 울창하게 자란 식물원의 자연은 인공적으로 완벽하게 조절된 기후와 정원사의 각별한 배려로 생명을 유지한다. 장소는 더 이상 무의미한 것 같다. 세계화는 무역장벽과 언어의 차이만 없앤 것이 아니라 각 장소가 갖는 고유의 이야기, 발자취, 미래마저 잠식하고 있다. 식물원의 등장이 식민주의의 씨앗이자 제국주의자들의 권위를 보여주는 수단이었듯이, 이 속에서 살아가는 자연은 연구의 대상이고 전시 가치로 채워진 소비사회의 또 다른 단면이다.

김유정의 작업이 발산하는 이국적인 낯섦은 표현기법과 작업의 대상이 주는 '회색성(grayness)'으로 기인하는 듯하다. 여기서 회색성이란 흑과 백의 사이, 이분법의 경계, 가장자리이자 중간을 가리킨다. 프레스코 기법을 이용한 캔버스 회화라는 모순, 자연과 인위적인 상품 사이에 위치한 화분, 대지에서 자라는 식물이 아닌 콘크리트 벽면 사이에서 자생하는 식물, 그리고 생명의 기원(origin)에서 이주한 식물의 전시장인 식물원의 장면 등은 이중적 위치에서 삶을 유지하는 생명체에 관한 작가의 시선을 대변하고 있다. 이 회색성은 나약하지만 위험한 존재이고, 하찮은 존재이기에 늘 전복의 가능성이 잠복하는 상태로 볼 수 있을 것이다.

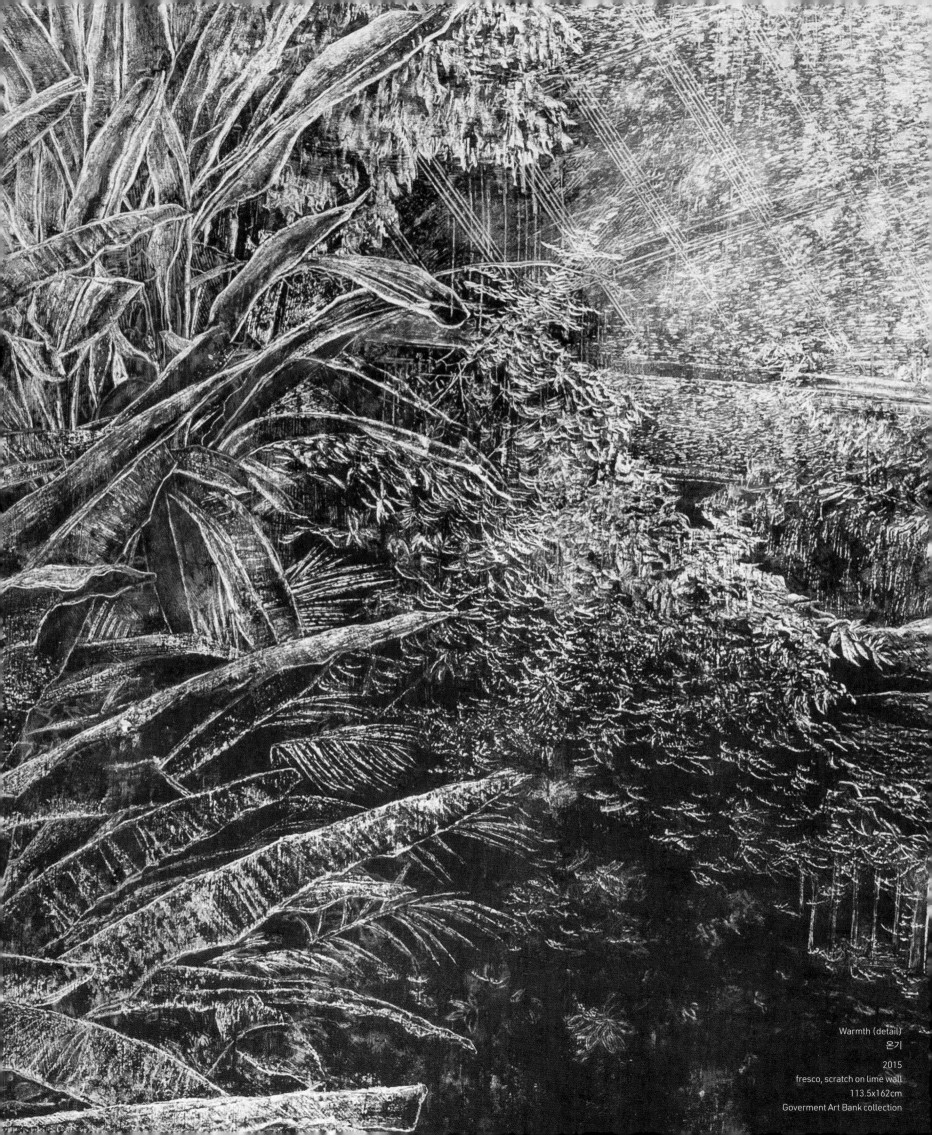

Warmth (detail)
온기
2015
fresco, scratch on lime wall
113.5x162cm
Goverment Art Bank collection

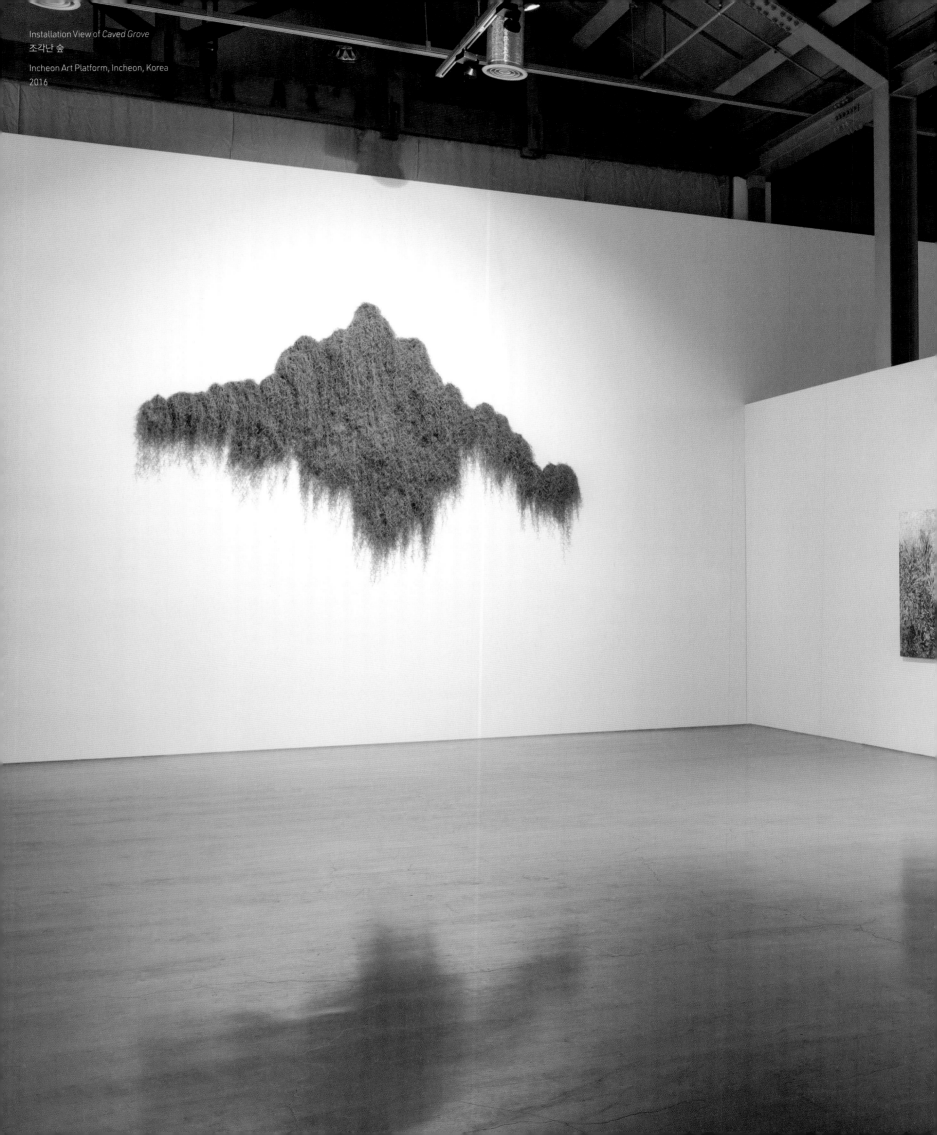

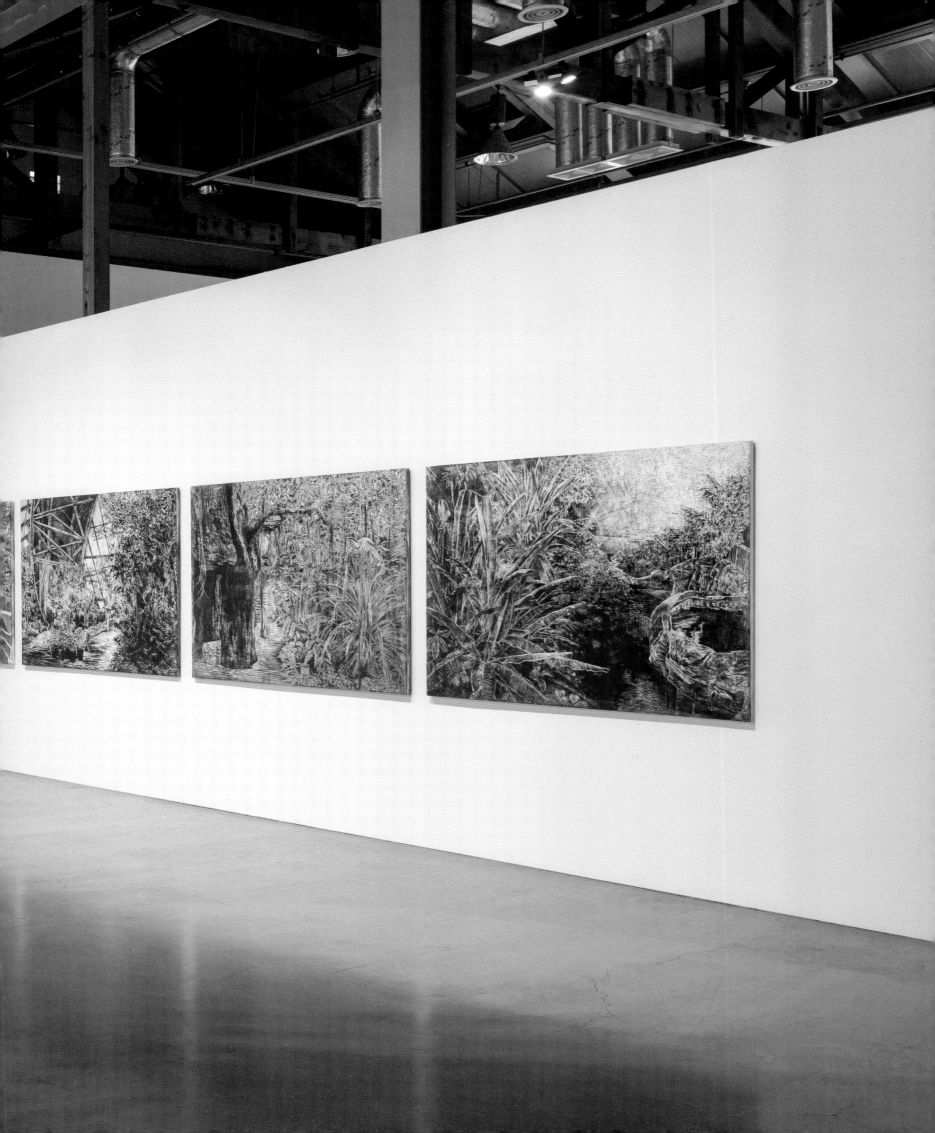

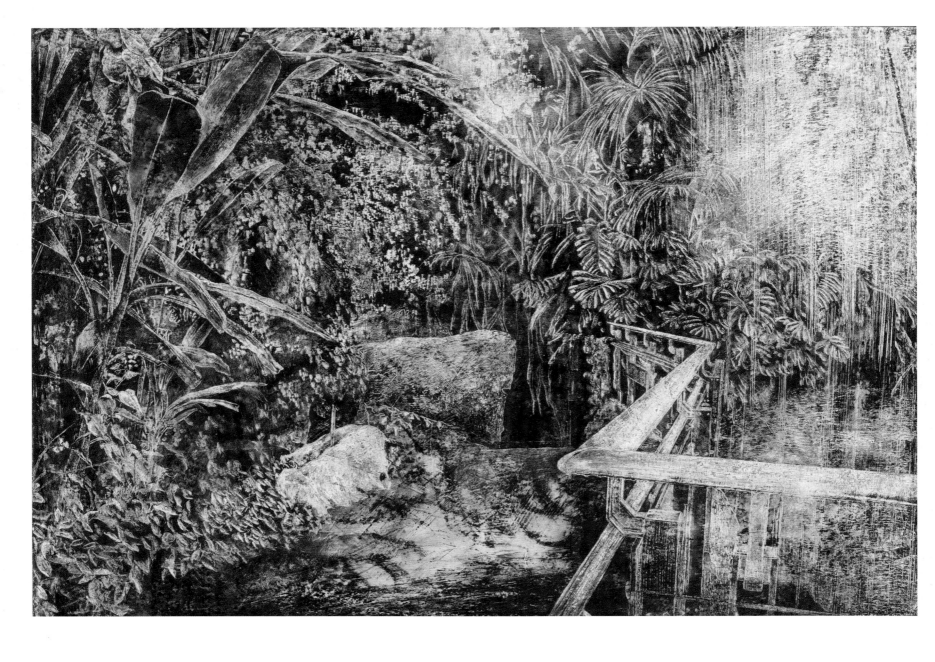

Warmth
온기

2016
fresco, scratch on lime wall
113.5x162cm

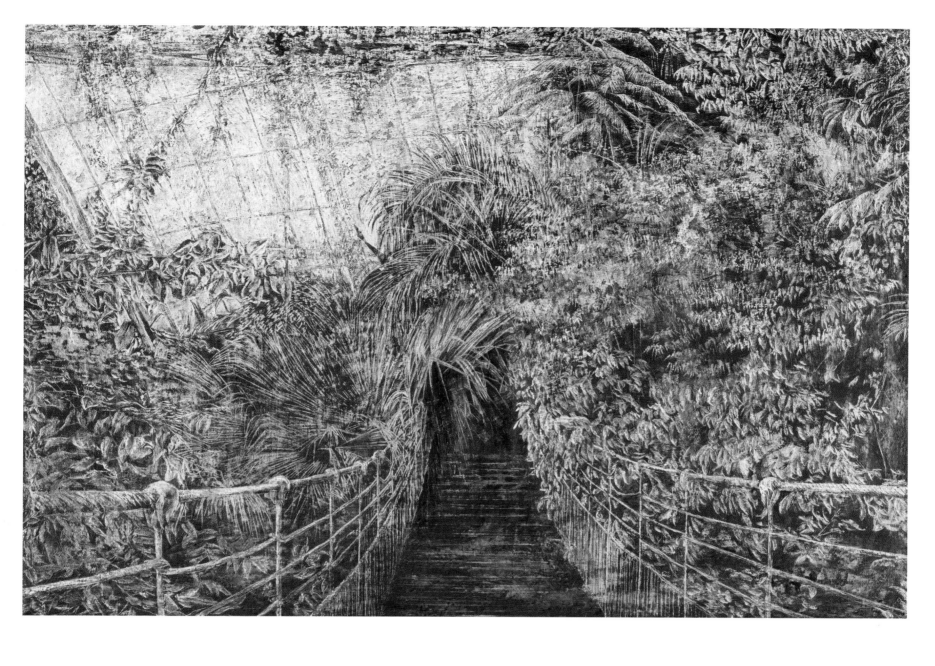

Warmth
온기

2016
fresco, scratch on lime wall
113.5x162cm

179

Breath
숨

2016
light box, artificial plant,
rattan cushions, fabric
180x600x30cm

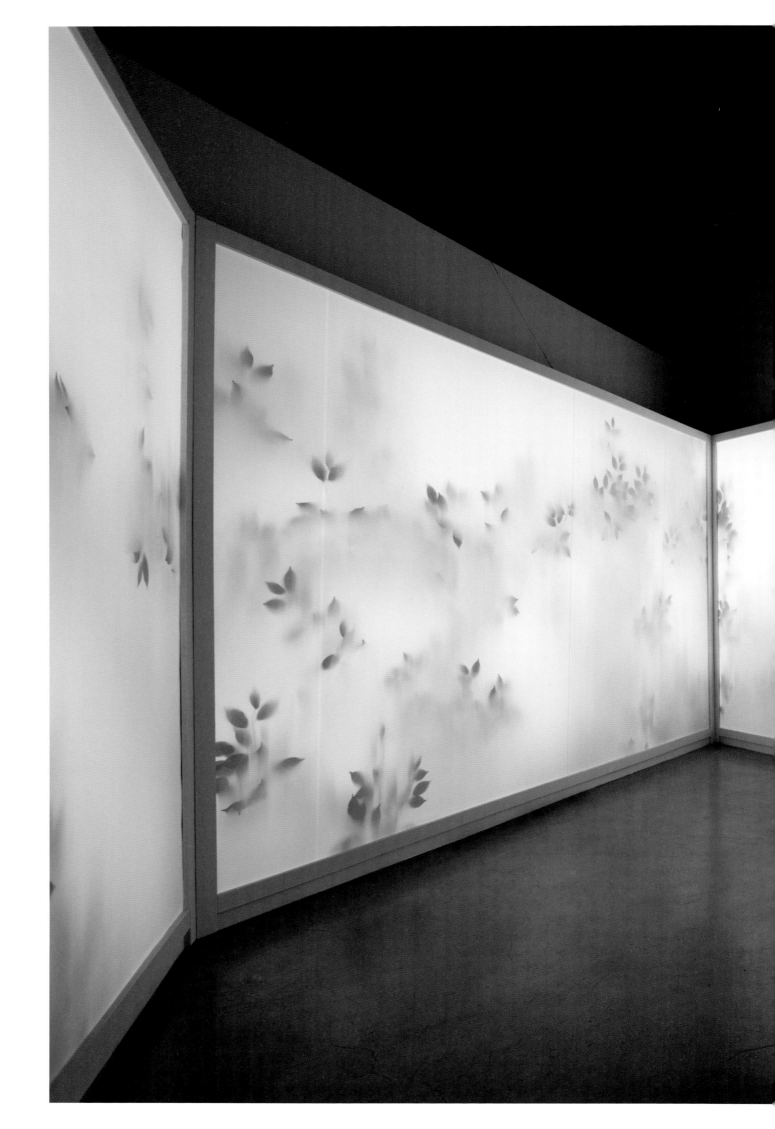

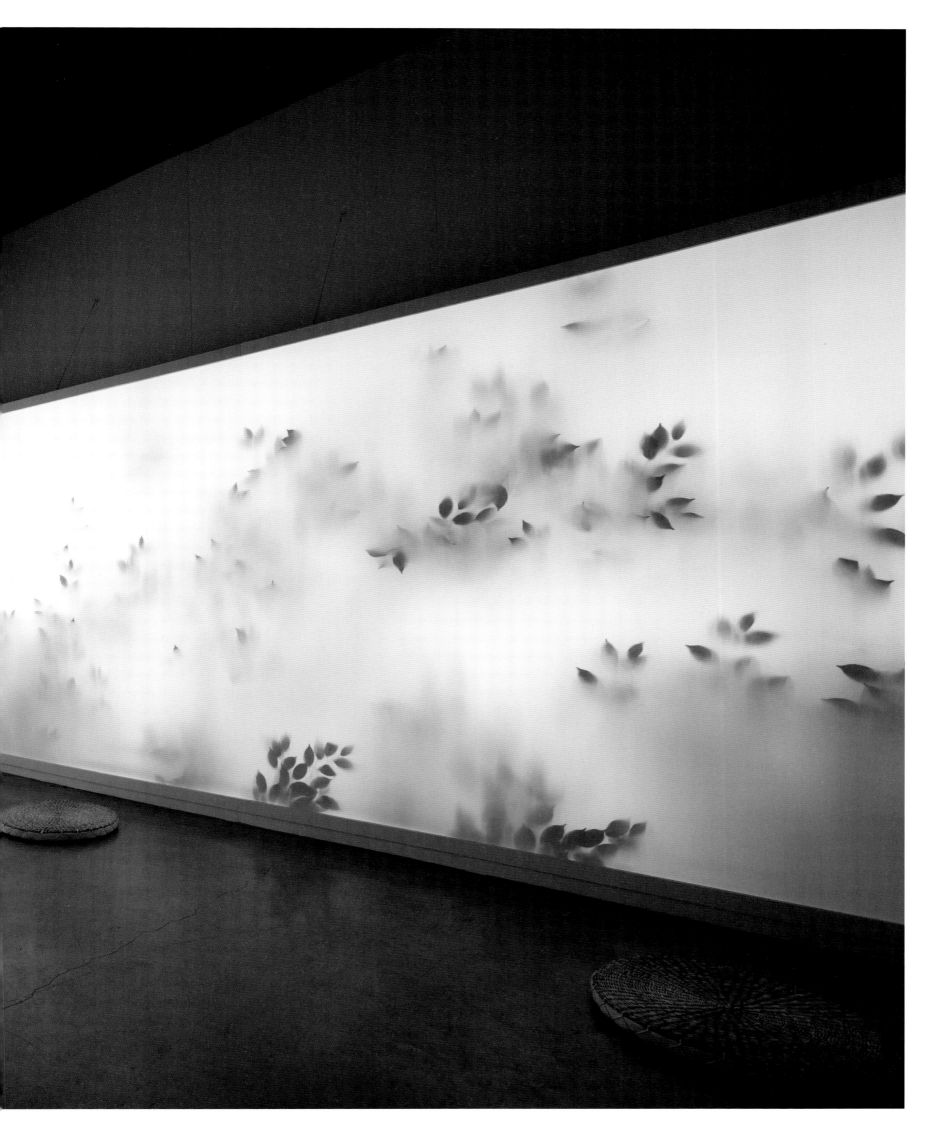

Labyrinth
미로

2014
pigment print on tiles
30x30cm
Incheon Art Platform of Art installation view

The plant maze resembles a well-tended, artificially cleared path, but concealed in it are elements that elicit uncomfortable emotions—resembling the image of a partially truncated human body. The maze park is a place for total contemplation of all the complicated things surrounding us and our own internal suffering, experiencing the footsteps of people passing before us and exploring human connections as we stroll through a beautiful botanical garden. We achieve visual pleasure from a space into which the emotions of ourselves and others are absorbed, but we are seeking a means of healing through the realization that comes when our self is psychologically broken down.

식물 미로는 인공적으로 깎은, 잘 정리된 길 같지만 인체가 부분적으로 절단된 듯한 장면을 연상시키는 불편한 감정을 발생시키는 요소가 숨어 있다. 미로 공원은 자신을 둘러싼 번잡한 모든 것과 내면적 고통을 몰아의 관조 속에서 관찰하고, 아름다운 식물정원을 거닐면서 앞서 지나간 사람들의 흔적을 체감하고 인간의 관계성을 탐색하는 곳이다. 자신과 대상과의 감정이 몰입된 공간 속에서 시각적 쾌감을 성취하지만, 심리적으로는 자아가 해체되면서 깨달음을 얻는 방식을 통한 치유의 방법을 모색하고 있다.

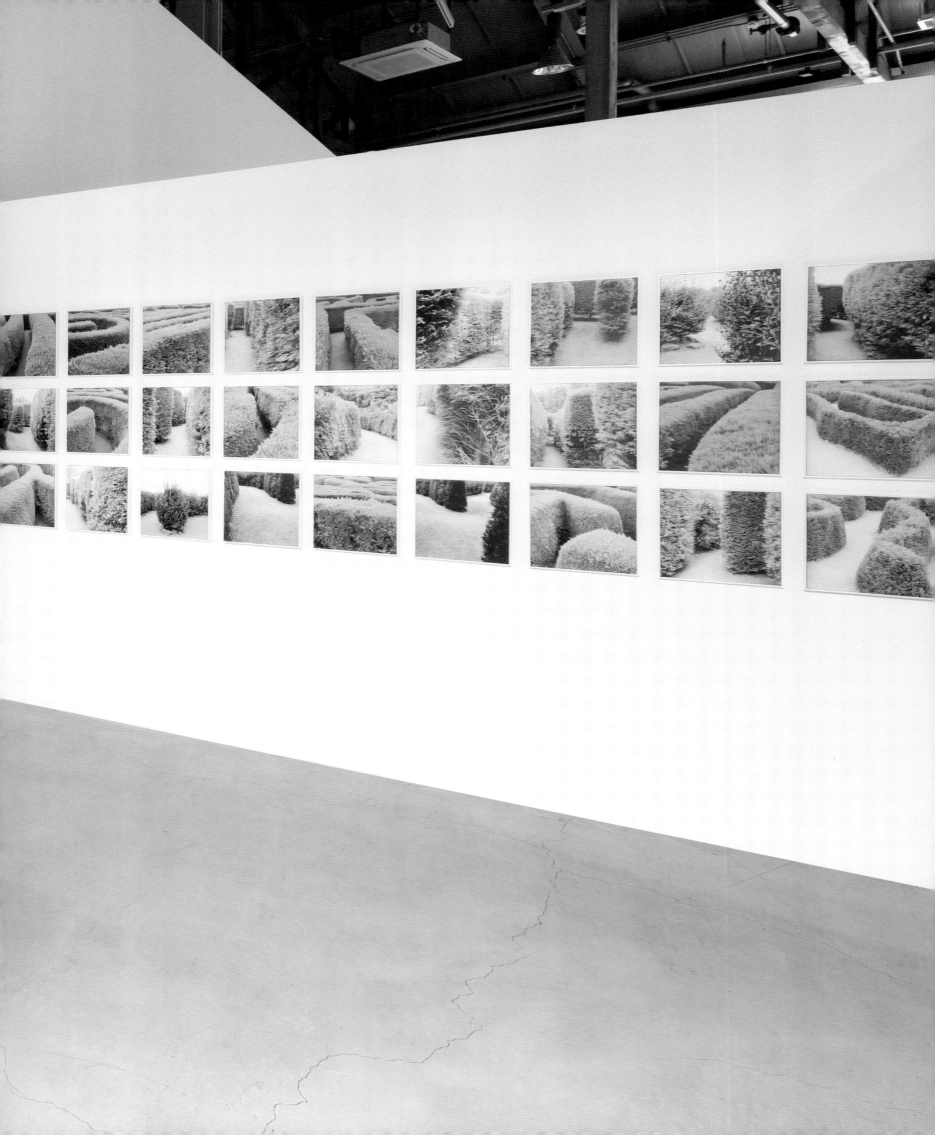

Applied to a plaster wall, the installation *Grove* offers a new perspective on the passive interior plants that afford solace to people living in cities. Looking inside the house, we encounter the pointed, violent sensation that comes from the Stuckyi, a plant that fills a space accentuated with lights. Viewed from the plant's perspective, this is a grotesque scene of vengeance against the selfish human beings who trapped it within the home. This Sansevieria stuckyi has been called the "snake plant" for the snakeskin pattern on its long, pointed leaves, and it has also been known by the slightly frightening name of "mother-in-law tongue."

<숲 Grove>은 회벽으로 발라진 설치 조형물로 도시에 사는 인간에게 위안을 주는 수동적인 인테리어 식물을 향한 새로운 시선이다. 집의 내부를 들여다보면 조명으로 강조된 공간을 가득 메운 '스투키'식물이 주는 뾰족하고 폭력적인 느낌을 마주하게 된다. 이는 식물의 입장에서 볼 때, 자신을 집안에 가둔 이기적인 인간을 향한 식물의 복수심으로 그로테스크한 장면이 연출된다. 이 산세베리아 스투키는 길고 뾰족하게 생긴 잎에 뱀가죽 같은 무늬를 하고 있어 'snake plant'라는 이름으로 불리기도 하며, 잔소리를 많이 하는 장모의 혓바닥 같다는 의미에서 'mother-in-law tongue'라는 조금은 무서운 이름으로 불리기도 한다.

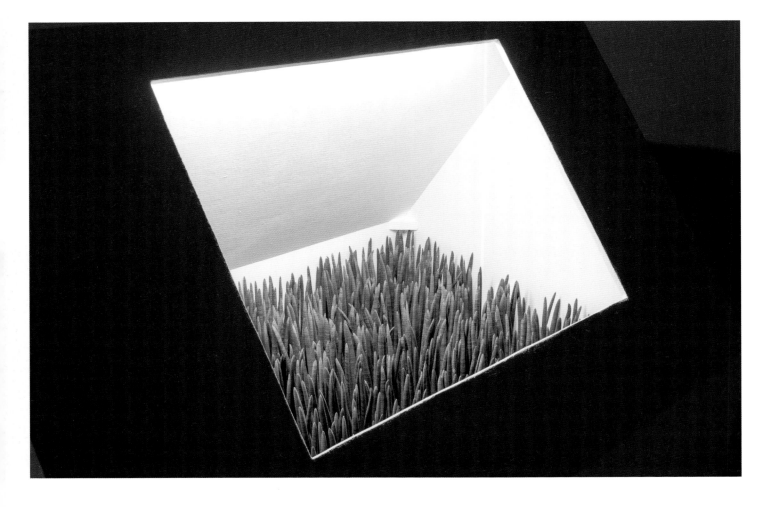

Grove
숲

2016
lime-painted house shape, stucky plants
176x180x152cm

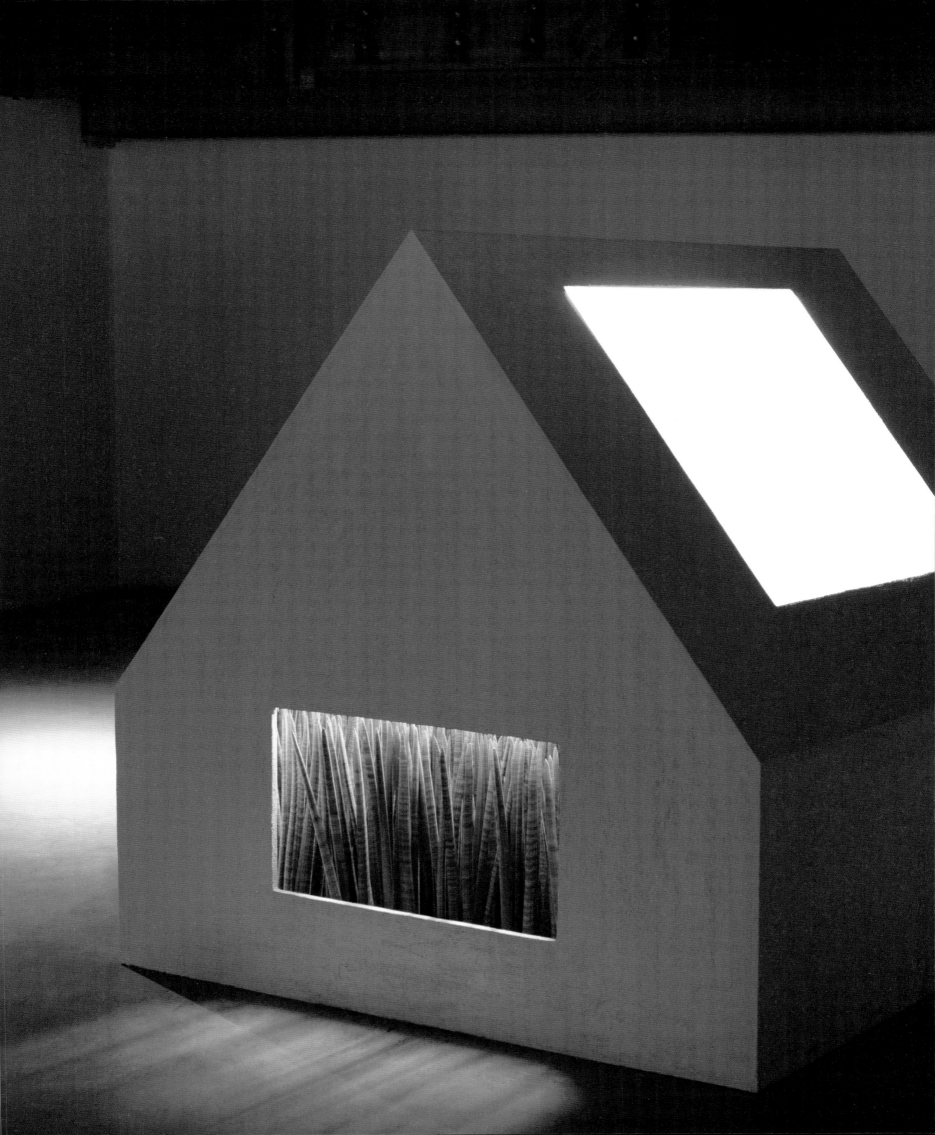

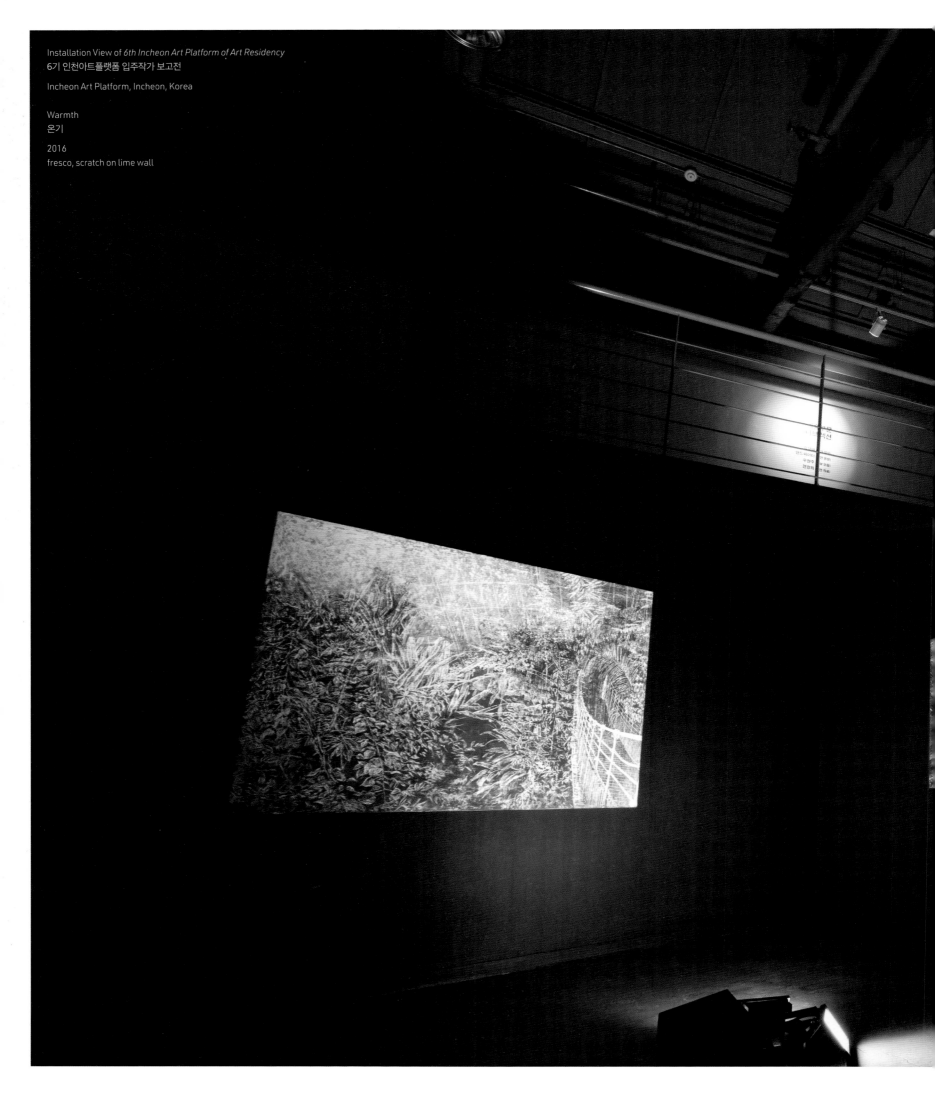

Installation View of *6th Incheon Art Platform of Art Residency*
6기 인천아트플랫폼 입주작가 보고전

Incheon Art Platform, Incheon, Korea

Warmth
온기

2016
fresco, scratch on lime wall

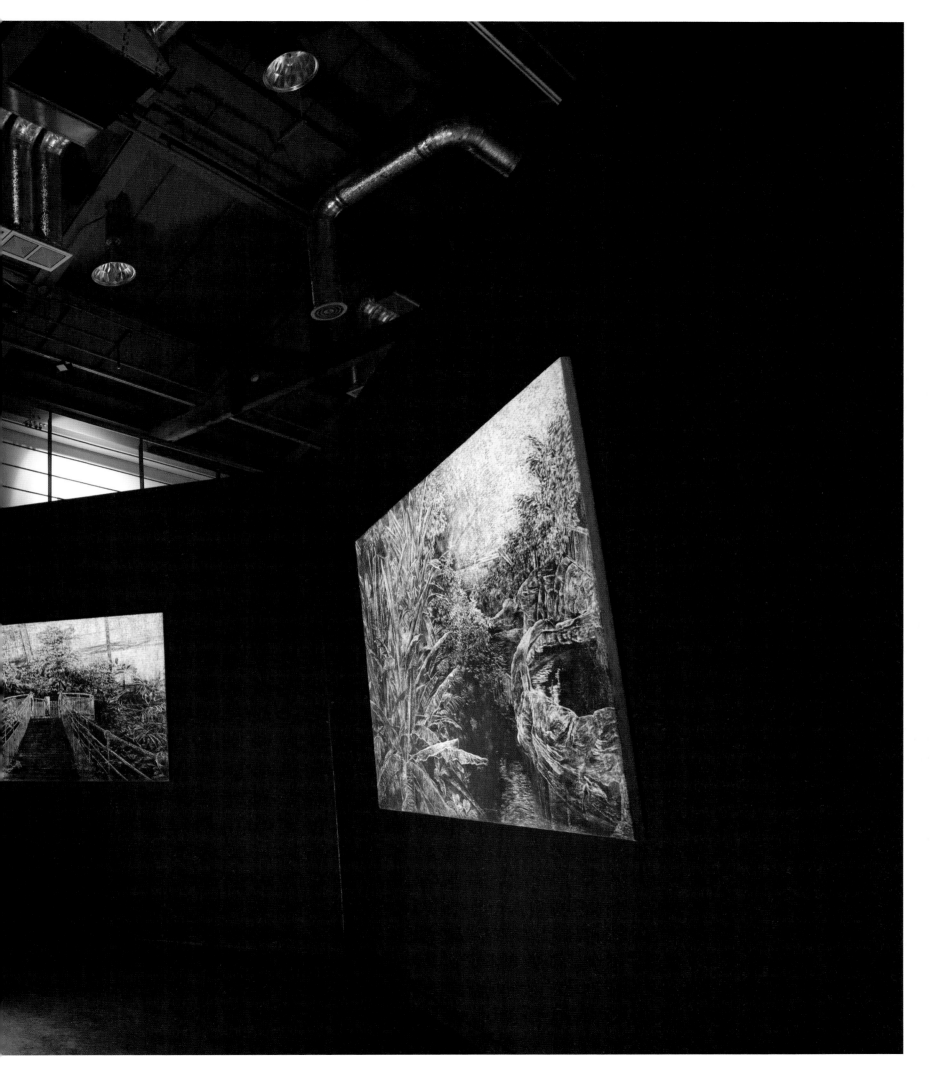

Warmth
온기

2016
fresco, scratch on lime wall
113.5x162cm
Seongnam Cube Art Museum collection

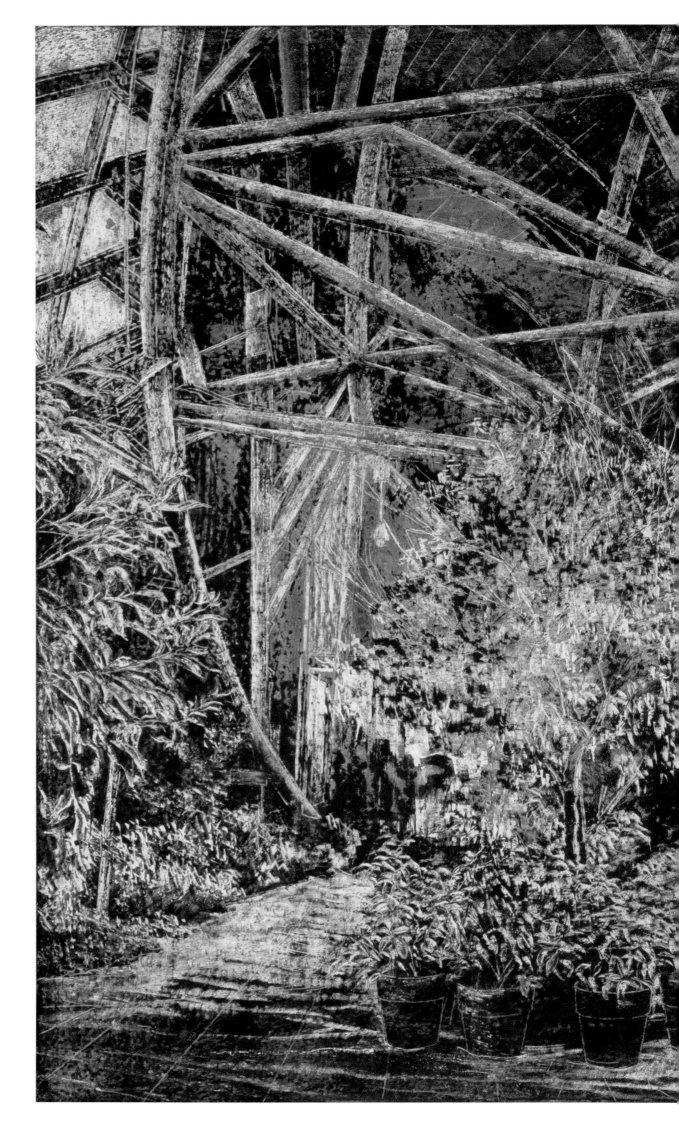

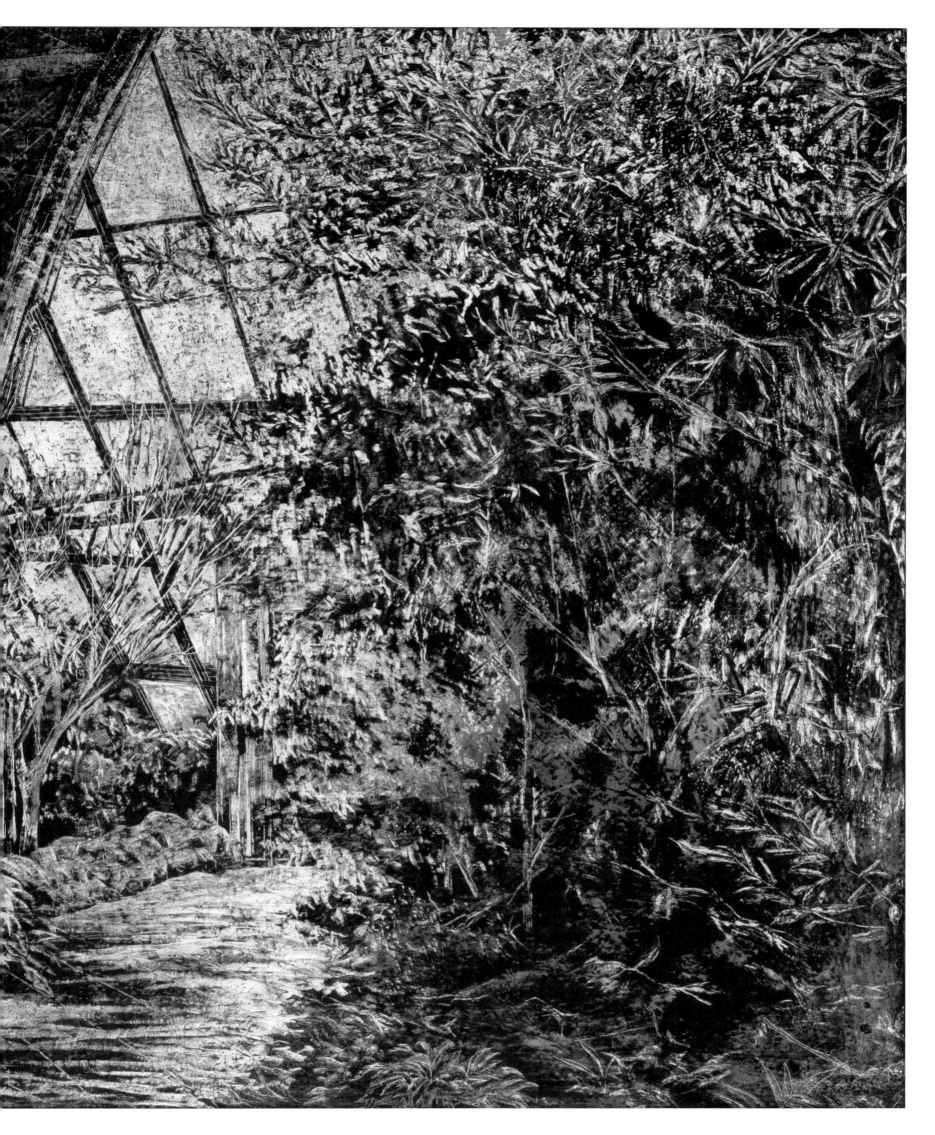

Warmth
온기
2016
fresco, scratch on lime wall
113.5x162cm
Suwon I-Park Museum of Art collection

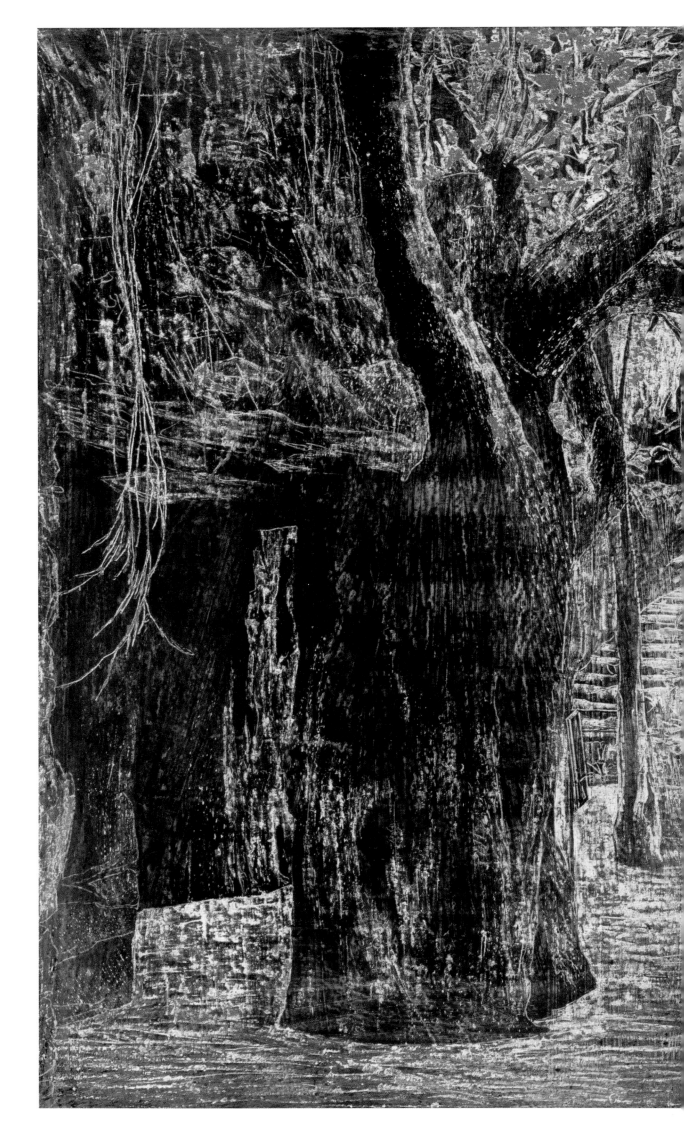

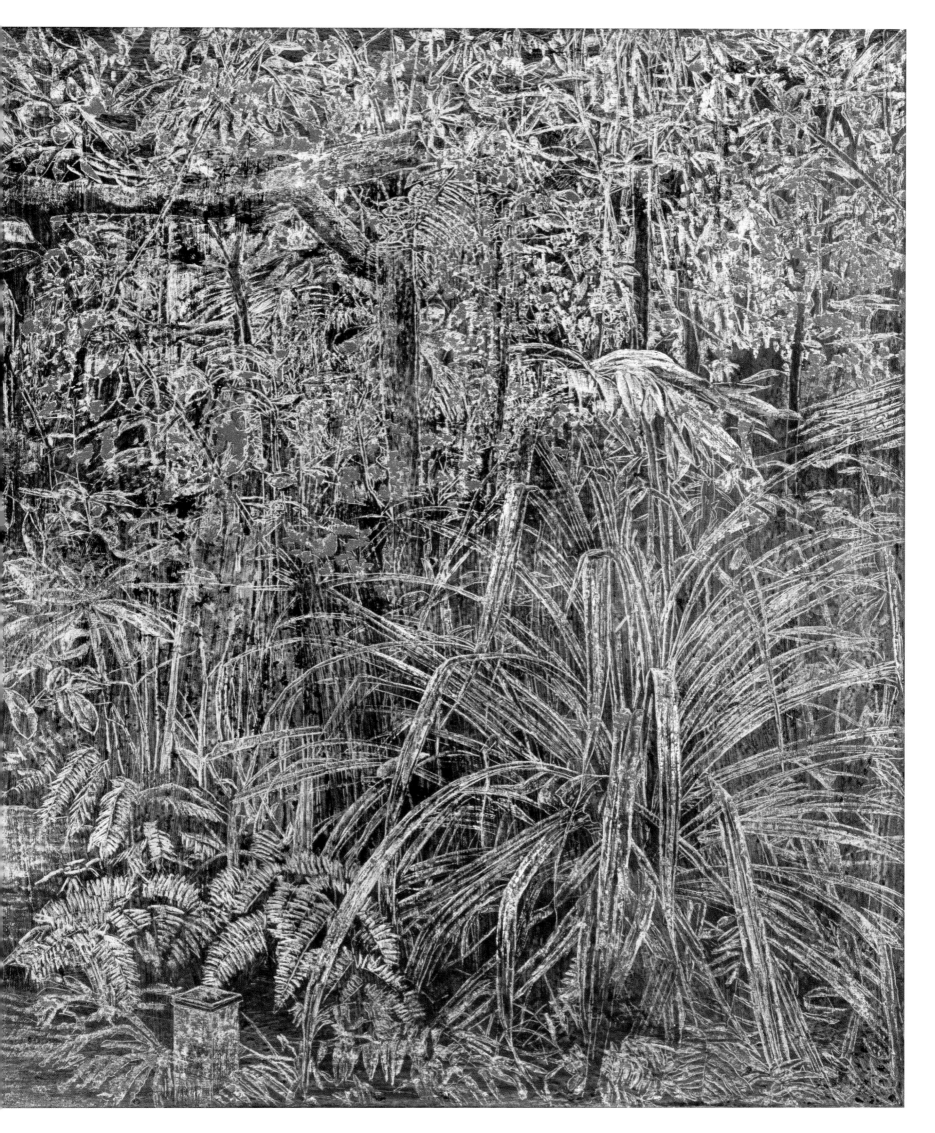

Warmth
온기

2016
fresco, scratch on lime wall
90x140cm

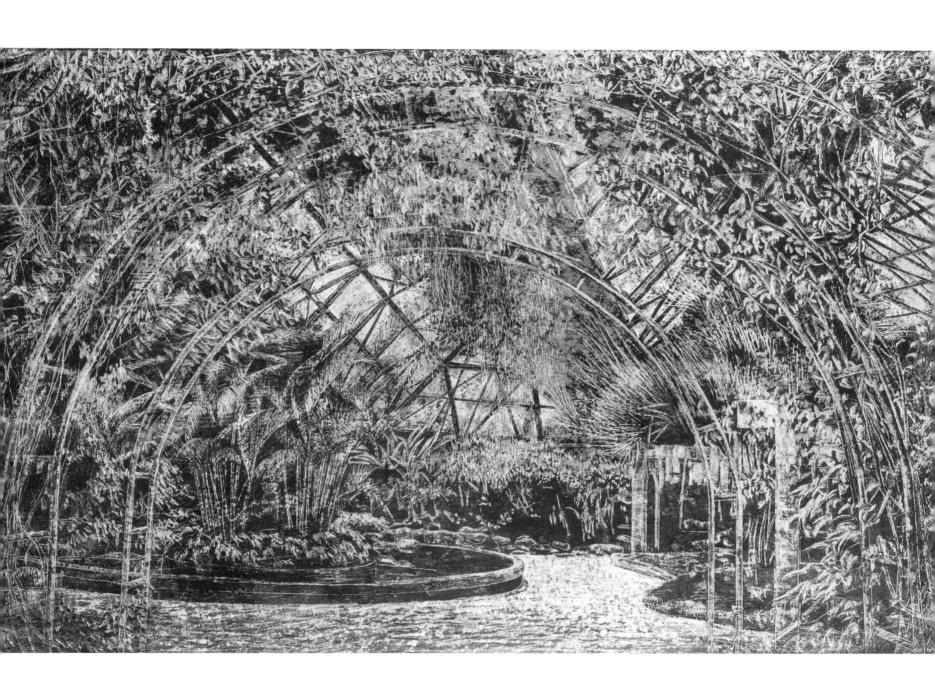

The scratch-based expression process forms a stratum of time and a layer with materiality through the fragments that are scraped and removed as a concrete form is taking shape or an image is being created.

스크래치적 표현 과정은 구체적인 형상이 드러나거나 이미지를 만들면서 긁히고 덜어낸 파편들로, 시간의 지층이자 물성을 가진 하나의 층위를 이룬다.

In stratum
축적

2016
acrylic box, lime powder left after work
13x100x7cm

Survival Needs

2015

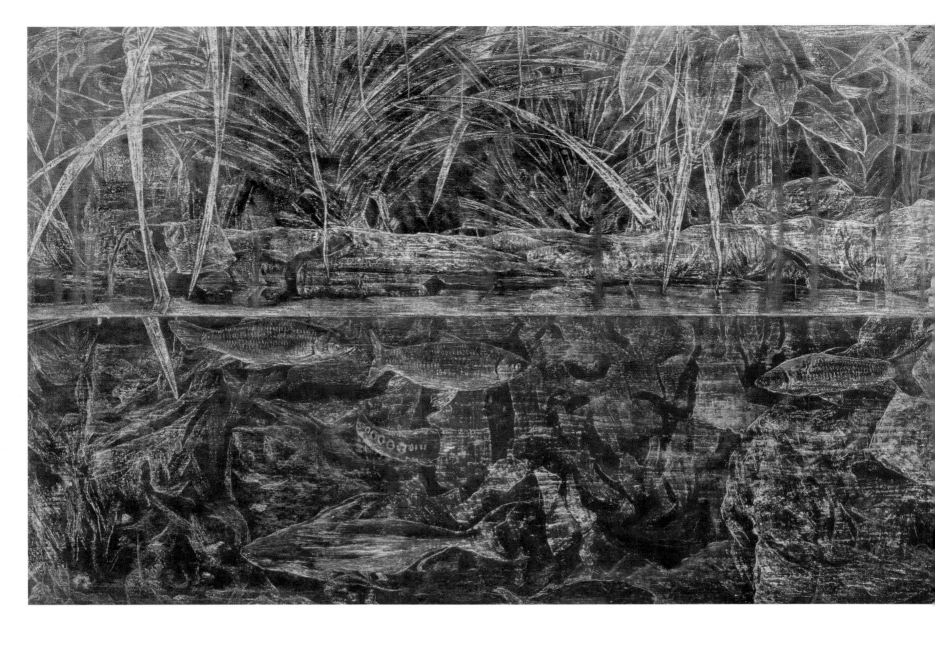

Symbiosis
공생

2015
fresco, scratch on lime wall
90x280cm

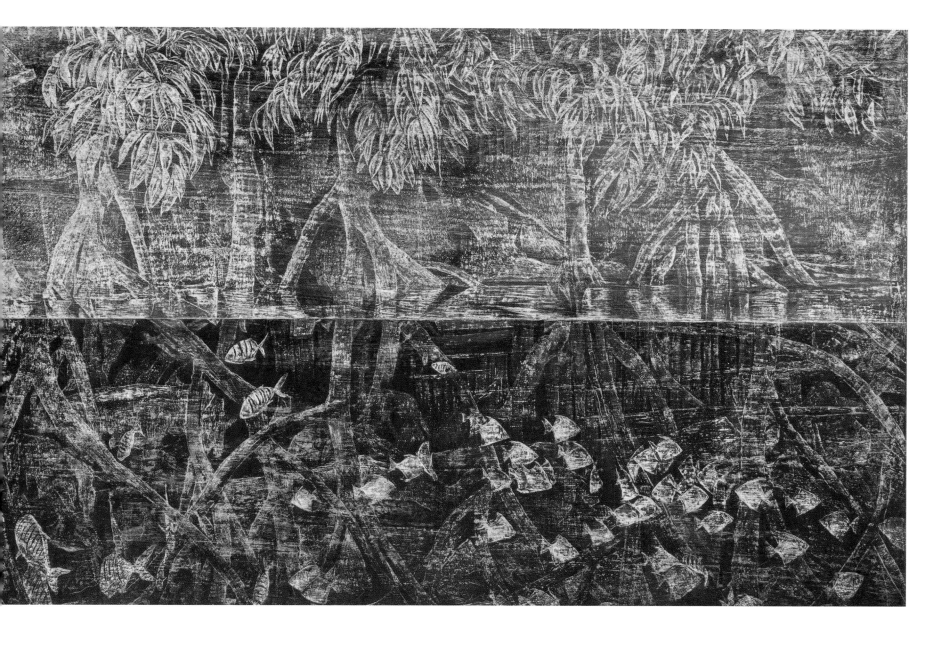

Warmth
온기

2015
fresco, scratch on lime wall
90x140cm
National museum of
modern and contemporary Art,
Art bank collection

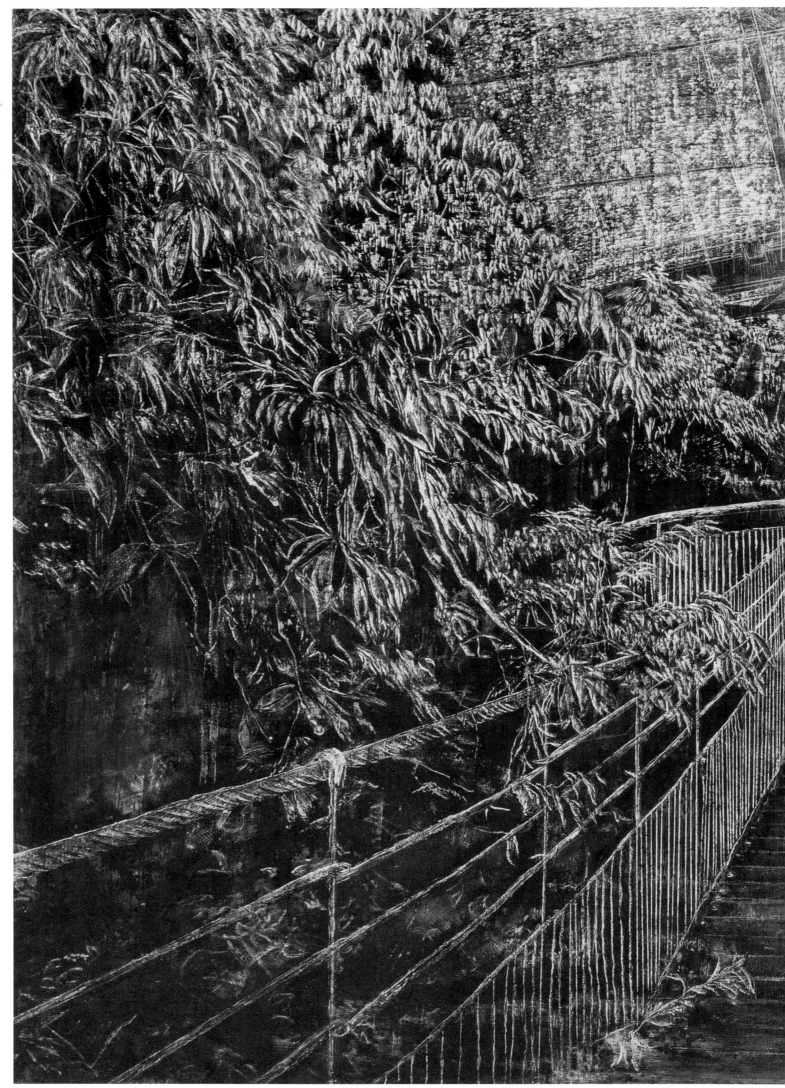

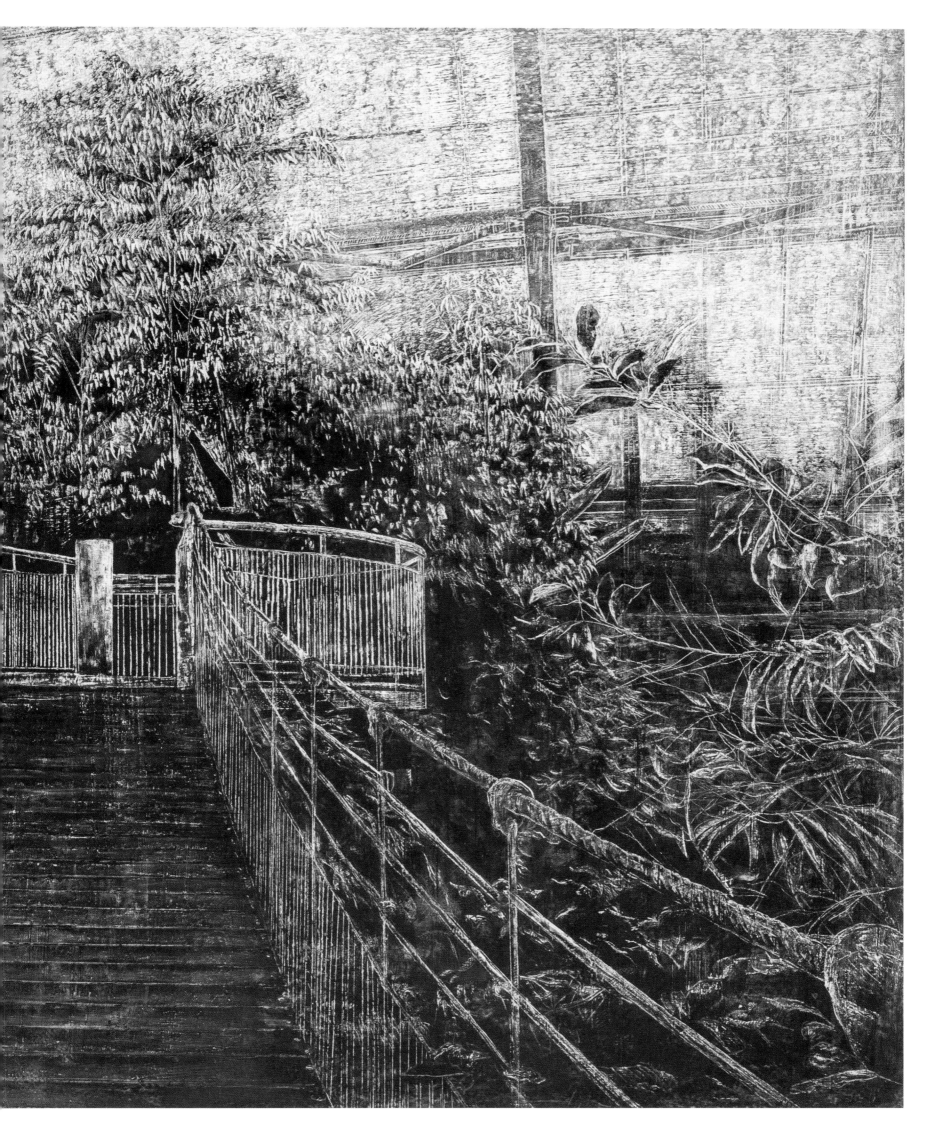

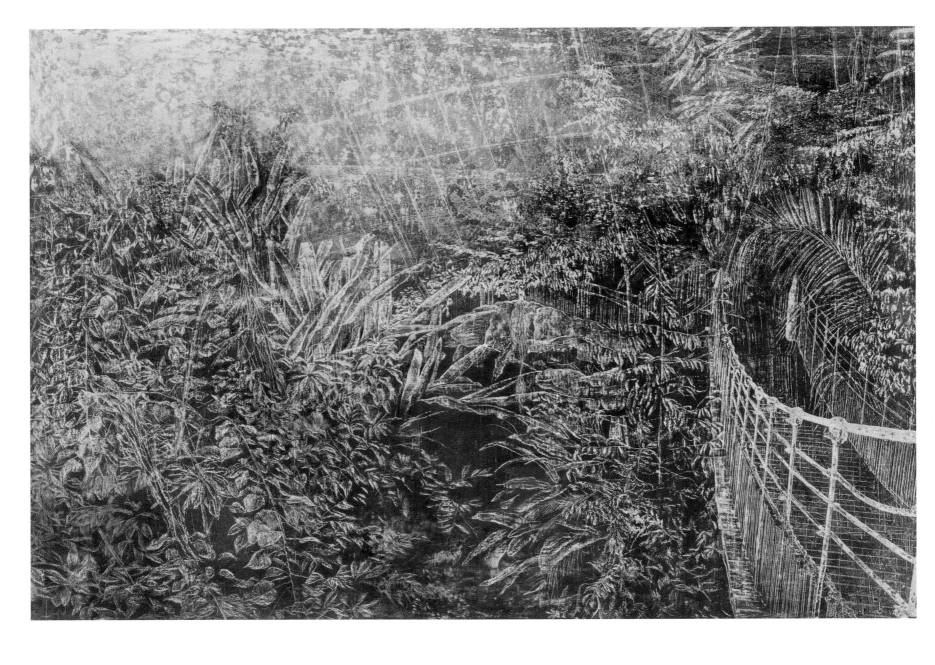

Warmth
온기

2015
fresco, scratch on lime wall
113.5x162cm

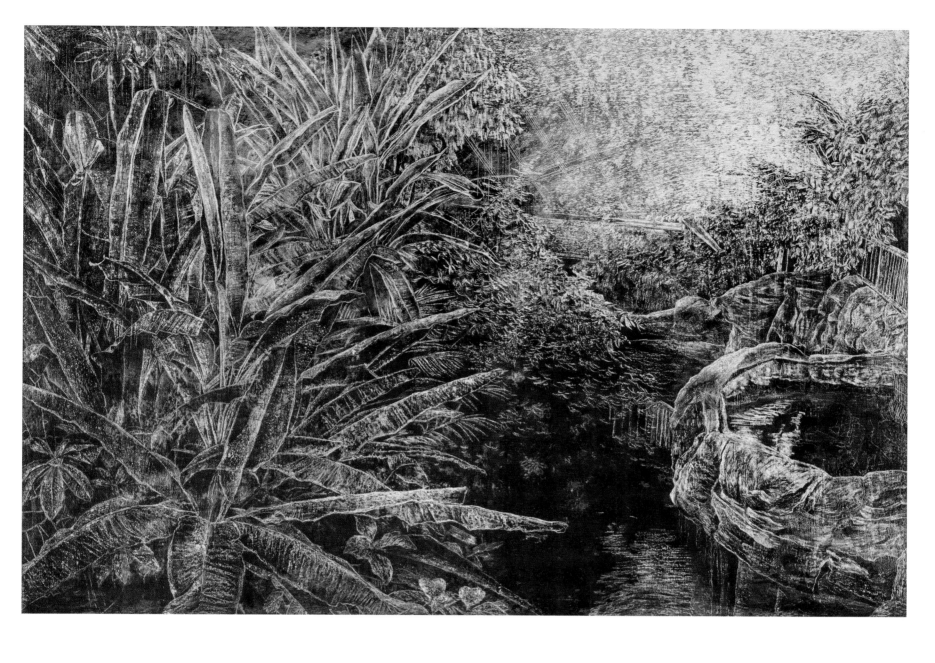

Warmth
온기

2015
fresco, scratch on lime wall
113.5x162cm
Korean Government Art Collection

B1
2015
fresco, scratch on lime wall
113.5x162cm

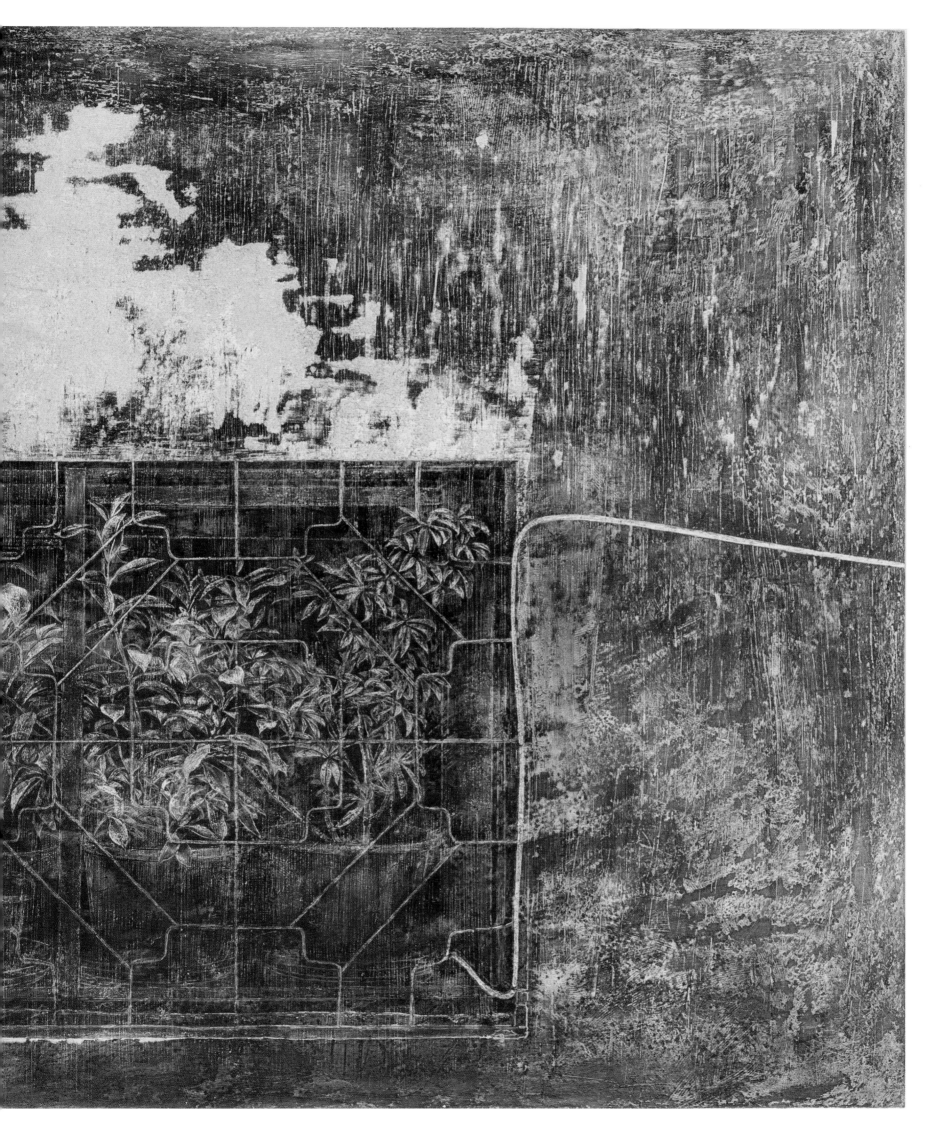

Alternative Plan
대체식물

2015
pigment print after wire drawing
70x80cm

Forever occupying their place within the human residential environment, plants lose their subjecthood as they become the focus of blind "raising." Situated in their pots in remote places where unseen life and death are constantly alternating, they undergo a repeated process of passively receiving care before passing away. The process begins anew as another plant takes their place.

Alternative plant-love is a work that adopts the motif of plants signifying "love." It uses photography to record a wire installation of overlapping drawings showing the absence of what was once an object of someone's tender care. The same thing happens in gardens, when a plant is one part of a larger collection, only to lose its role and end up replaced by another plant. This painting shows the plant as viewed by the mind rather than with the eye. It is constructed with thin wire, symbolically representing the plant's frailty. While plants are incapable of movement, the drawing shows them as though they are moving about actively, indirectly representing the internal movement and activity of the observed plants. Abstracted beyond their original objecthood, the plants lose unnecessary elements as the drawings multiply, leaving only their essence behind—a filtering process in which the plant is depicted by means of my own personal memory. These moments in which we devote care in selfish ways become overlapped. The work becomes a commemorative photograph of those anonymous plants, a record of overlapping moments and spaceless stories—a plant portrait.

인간의 거주 공간에 늘 자리를 차지하는 식물은 주체를 잃고 맹목적인 키움을 받는 대상이기도 하다. 눈여겨보지 않았던 삶과 죽음이 늘 대체하는 그 구석진 곳 화분 안의 식물은 수동적인 보살핌을 받다가 죽기를 반복한다. 그리고 그 자리에는 또 다른 식물이 대체되어 과정을 되풀이한다.

<Alternative plant-love>는 사랑의 의미를 지닌 식물들을 모티브로 표현한 작품이다. 누군가에게 한때는 지극한 보살핌의 대상이었지만 존재감이 사라지고 난 후의 겹쳐진 드로잉을 철사와이어로 설치하여 사진으로 기록한 작업이다. 정원이라는 큰 집합에 부분적인 요소로 있다가 자신의 기능이 상실되어 다른 식물로 교체되는 경우에도 마찬가지로 작용한다. 눈으로 식물을 본 것이 아니라 마음으로 바라본 지점을 그린 것이다. 이 작품의 재질은 가느다란 철사로 구성되어 있는데 식물의 연약함을 상징적으로 묘사했다. 움직일 수 없는 식물을 드로잉을 통해서 마치 식물이 활발하게 활동하는 모습으로 표현하여 바라본 식물의 내면적인 움직임과 활동성을 드로잉을 통해서 간접적으로 표현한 것이다. 그리고 원래의 대상성에서 벗어나 추상화된 식물은 드로잉이 거듭해서 겹쳐질수록 불필요한 요소가 사라지고 본질만 남게 되는데, 걸러내는 과정을 통해서 자신의 '개인적인 기억'에 의지해서 식물을 묘사한 것이다. 한때는 이기적인 방식으로 보살핌에 극진했던 우리의 시간들이 겹쳐져서 오버랩된다. 이 작업은 그 이름 없는 식물들의 기념사진이 되면서 겹쳐진 시간들과 공간 없는 사연들이 기록된다. 즉 식물 초상이다.

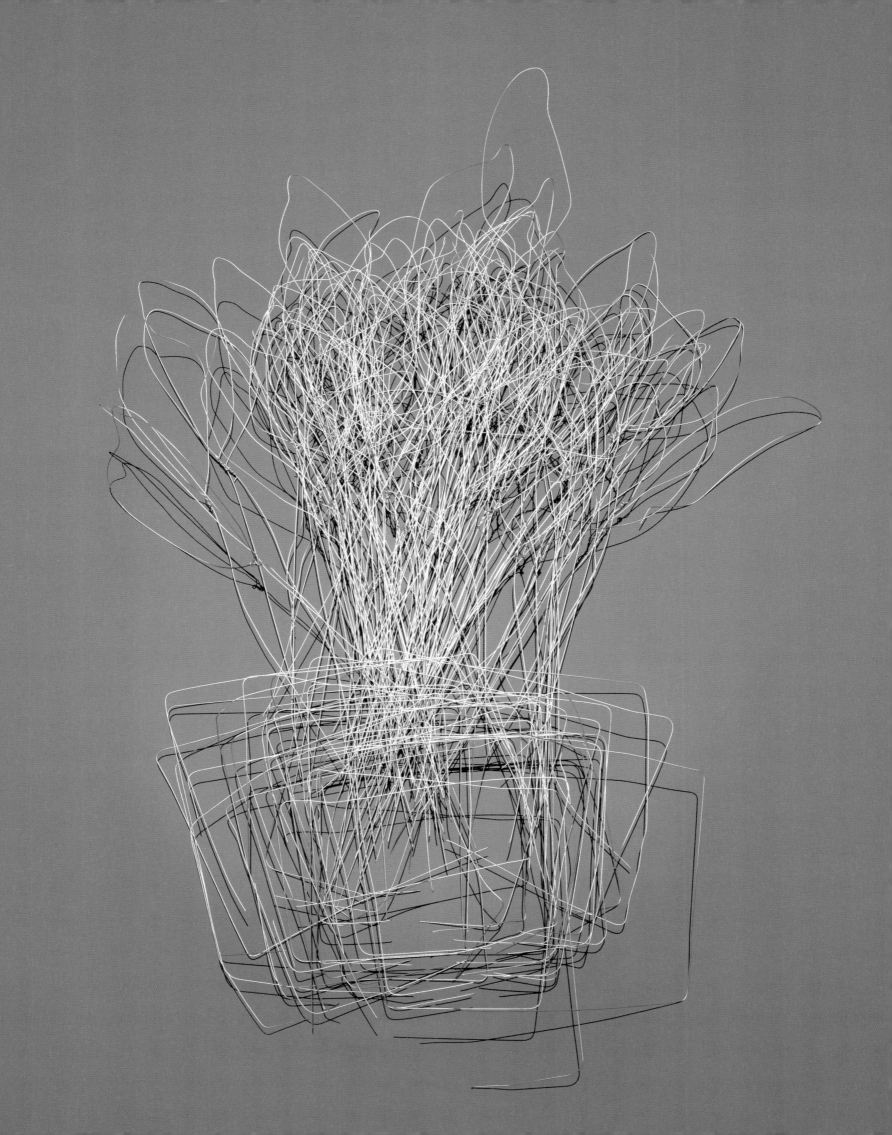

2015
pigment print after wire drawing
70x80cm

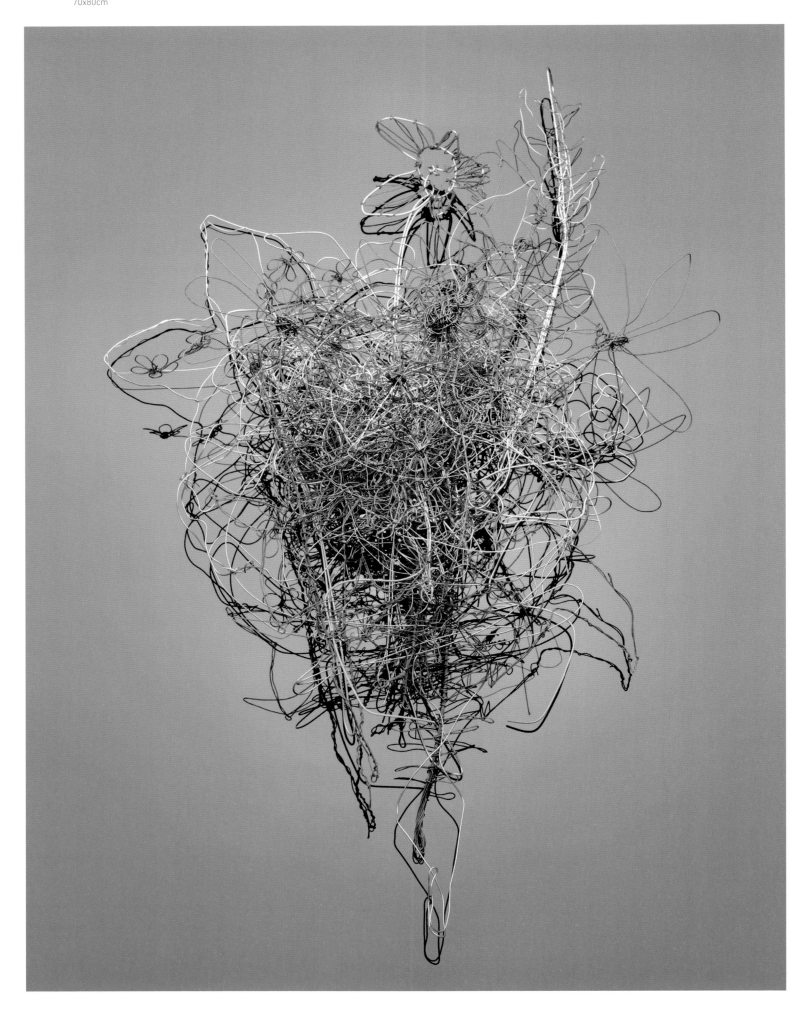

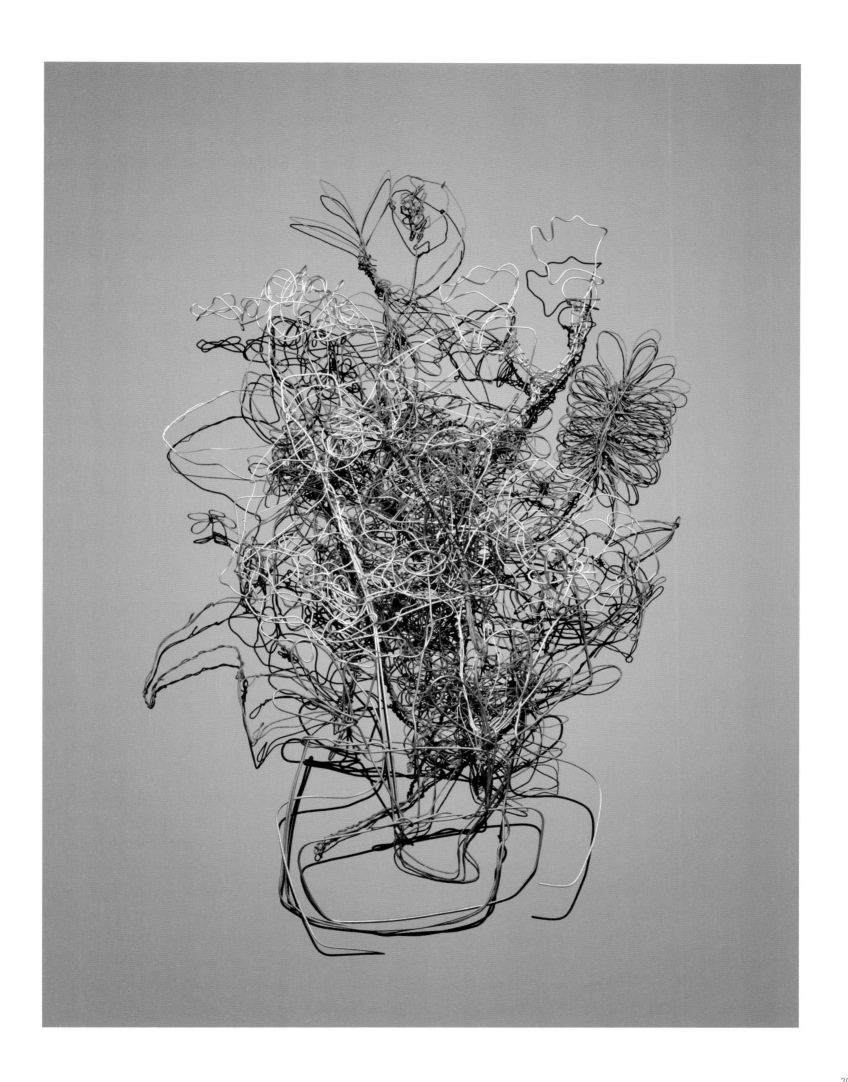

Gray Garden

2015
fresco, scratch on lime wall
50x50cm

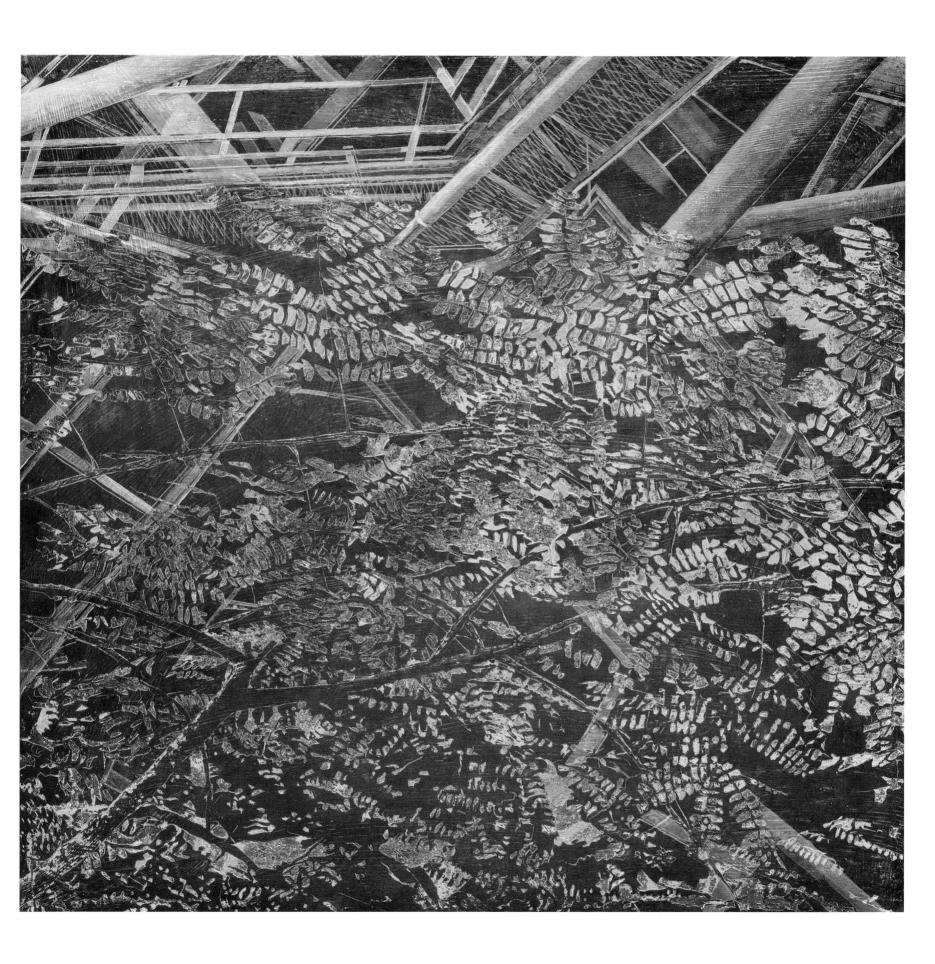

An urban building serves as an incubator, where things like the temperature, moisture, and oxygen supply can be adjusted to suitable levels. Within it, plants push through the crash in the gray walls and emerge outside the structure. As proxies through which human desires are satisfied in selfish ways, they harbor the wish to pry their way outside the cold space and see the light. Places are obliged to set down roots on their own, on hills and in fields. Yet instead, they are transplanted entirely to undergo premature development in the name of "incubating." Now, they have grown so large that the incubator space is left struggling desperately simply to remain in place. Seen from the plants' perspective, the incubator is somewhere they could not escape from if they tried—an incubator for selfish humans. The flower pots are shown in gray, evoking the image of wounded human beings who have lost their drive and a clear sense of subjectivity.

온도나 습도, 산소 공급량 따위를 적당하게 조절할 수 있게 되어 있는 인큐베이터인 도심의 건물 안에서 식물들은 회색 벽 틈을 비집고 건물 밖으로 나온다. 인간의 욕망이 이기적인 방식으로 해소되는 대체물로 차가운 공간을 비집고 나와 빛을 보려는 심리가 내재되어 있다. 산과 들에 자생적으로 뿌리를 내리고 살아가야 하는 식물이 인큐베이팅이라는 미명하에 통째로 퍼 옮겨져서 조기 발육되어 진다. 몸집이 커져 이제 인큐베이터라는 공간은 그대로 머물기에 숨이 가쁘다. 식물의 입장에서 보았을 때 벗어나고 싶어도 벗어날 수 없는 인큐베이터로 이기적 인간의 인큐베이터라고 할 수 있다. 잿빛으로 묘사된 화분들은 뚜렷한 주체성과 동력을 상실한 상처받은 인간의 모습을 상기시킨다.

Incubator

2015
fresco, scratch on lime wall
120x120cm
Seoul Museum of Art collection

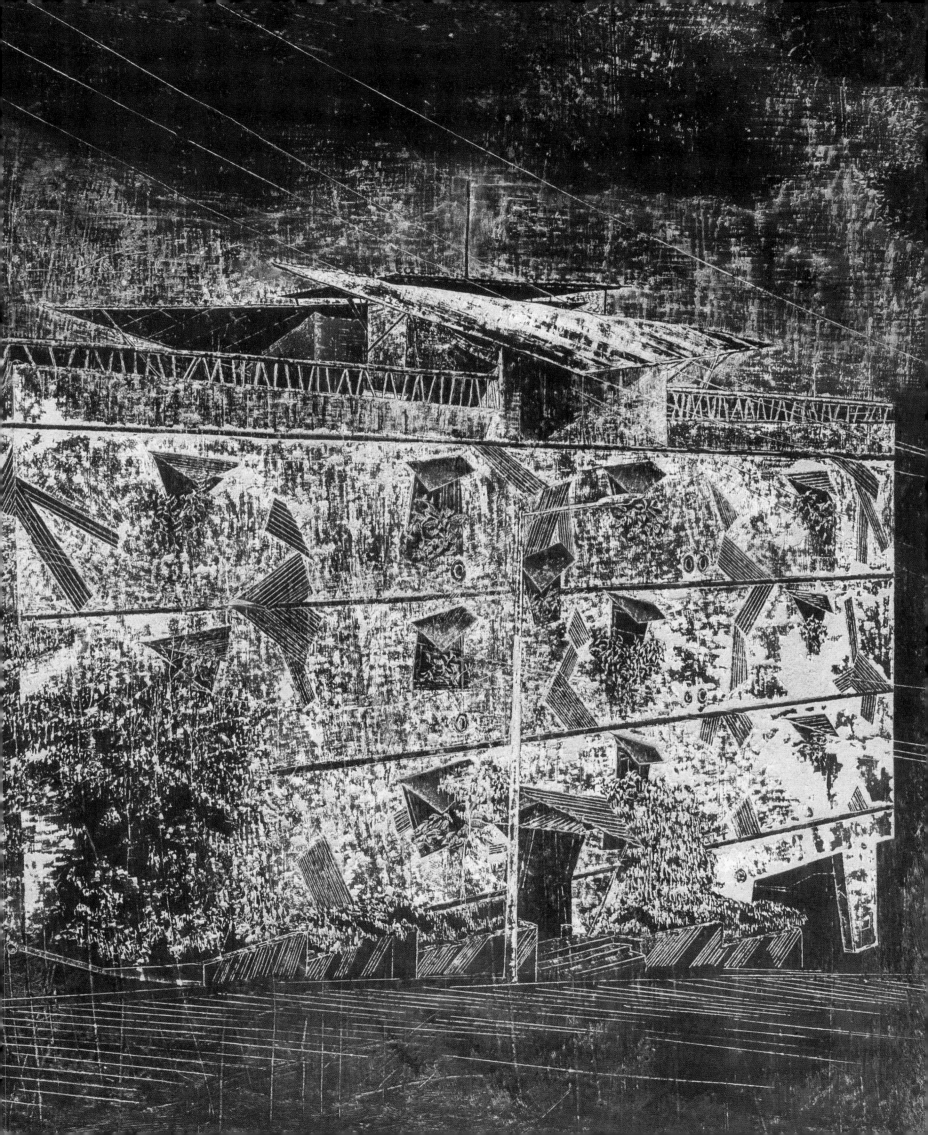

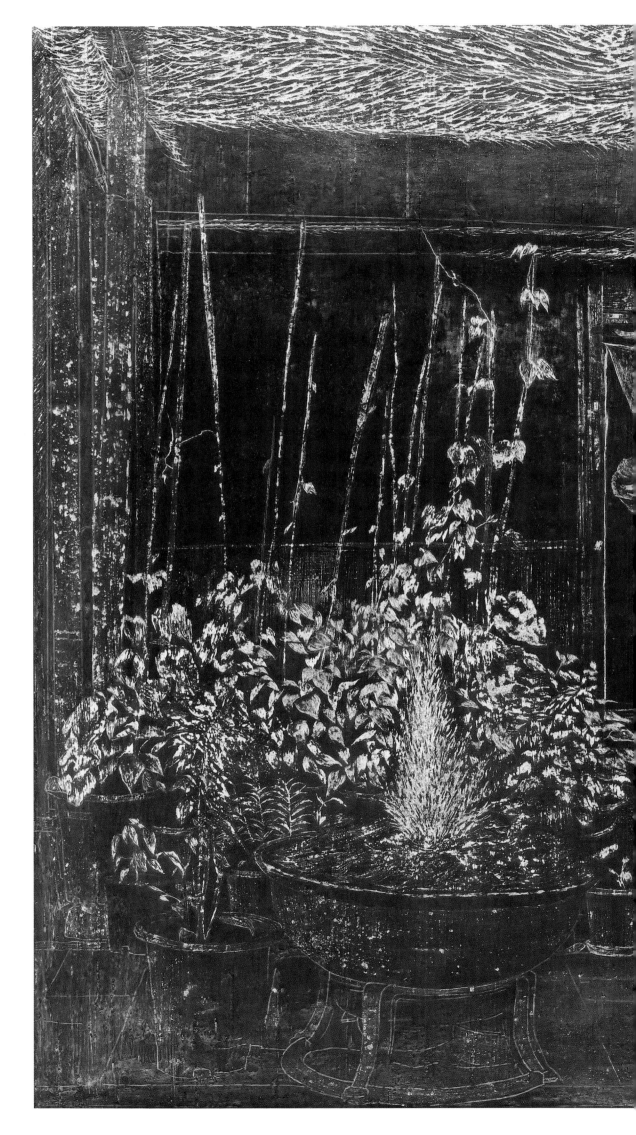

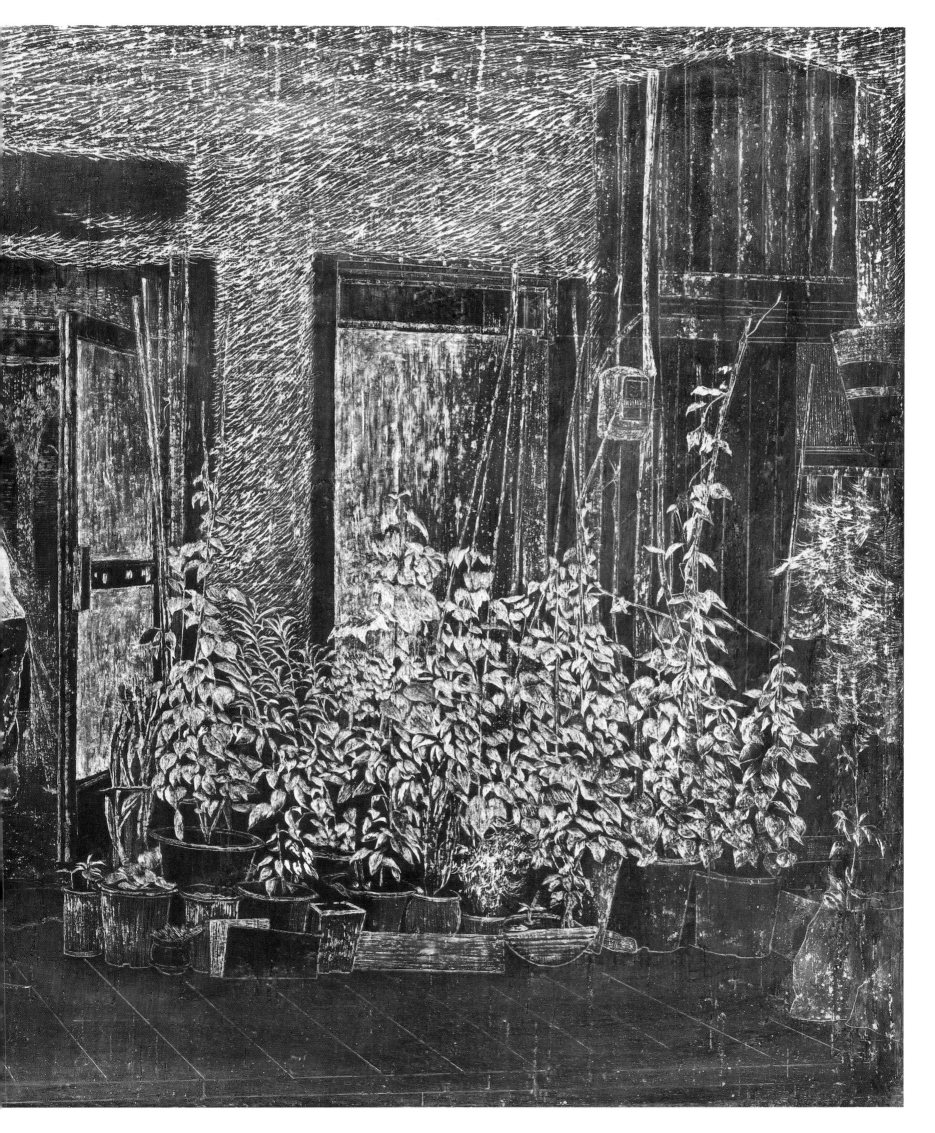

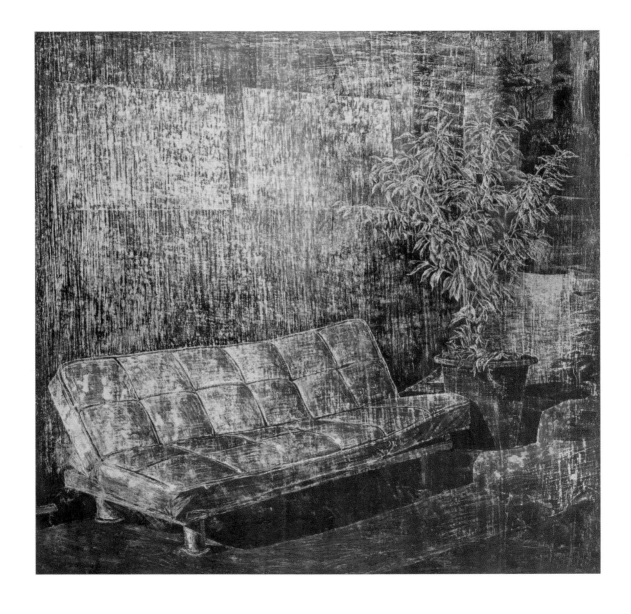

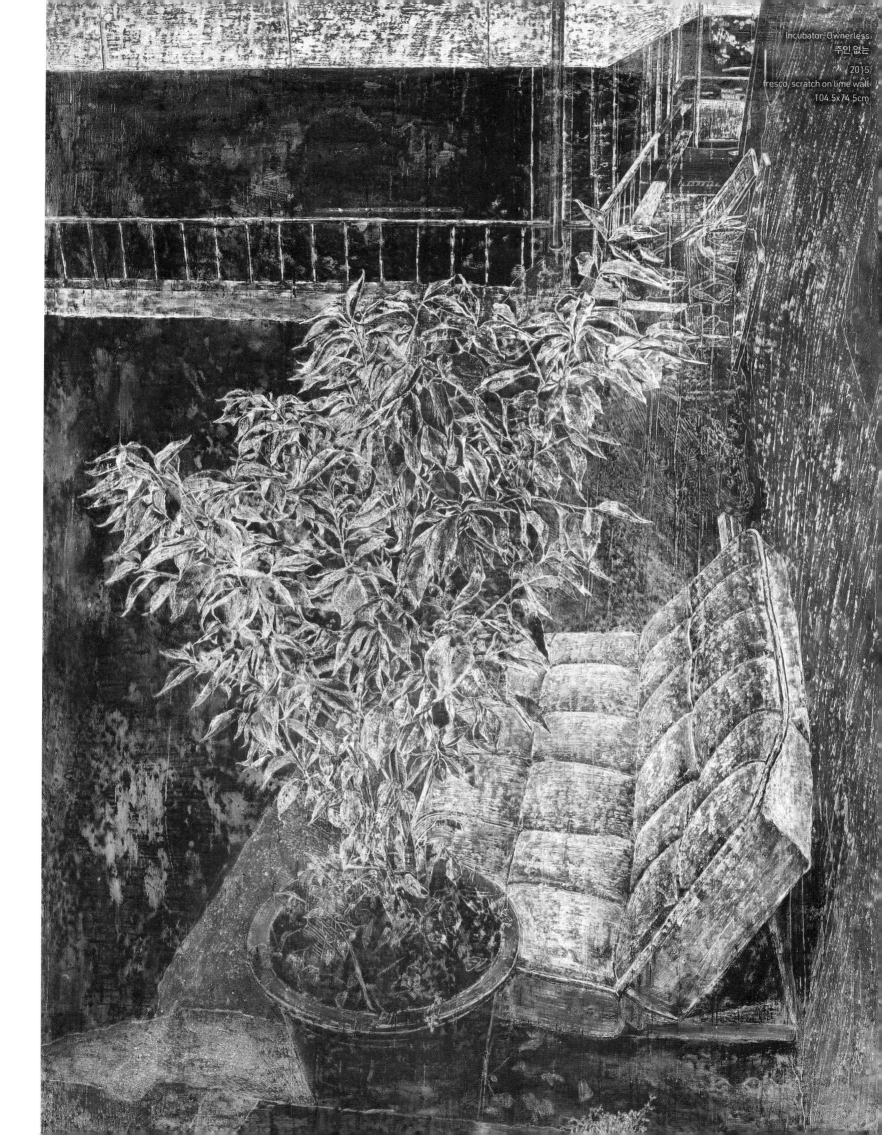

Incubator-Ownerless
주인 없는
2015
fresco, scratch on lime wall
104.5x74.5cm

Reversed Landscape 2014

Return of the Oppressed

Ki Heykyung, director of Busan Museum of Art

Kim Yujung practices waiting through her work. Kim's work takes on a work of art after undergoing the waiting of physical time and physical labor. The artist has tried to encapsulate the dedication of time fresco mural painting implies, its traces, and emotions the traces provoke, bearing accumulated time, labor, and waiting in her work.

When Kim first adopted the fresco technique, she threw herself into the traditional technique of fresco and its effects. Works during this period when she took the motifs from a crack on the wall, a corner of the wall in shadow, and marks of weathering left by the wind, were presented in the form of objects. These works were at times created on supersized canvases but look like they are naturally part of an actual wall. Afterwards, this quality was further reinforced when her works took the form of biscuit fired pottery of female torsos. These pieces were far away from any function as containers or our elemental notion of female torsos.

Her containers are hung on the wall, not placed on a table, losing their function as vessels. They bear traces of time and surrounding scenes as if the walls about us reflect our periphery and endure time. Her female torsos also make viewers look back on traces of their desire through the texture of an old plastered wall in the name of memory and reminiscence. As such, Kim's juvenilia was produced by placing transitory things that existed by us but soon disappeared in her scenes, presenting them as works of art with the power of reminiscence and the ability to recollect by the enduring time peculiar to frescos.

It may be around 2007 or 2008 when Kim's art underwent a dramatic change. Her previous works' object-like quality shifted to present imposing scenes on the canvas. This change was made possible through her mastery of fresco technique and its unrestricted application to her work. As a result, the artist could manifest her own distinctive modeling language, modernizing the fresco technique. In her previous work,

Kim tried to provoke sorrowful emotions through projected or reflected images, fleeting shadowy images, or the images absent yet leaving behind deep traces. She was interested in enduring time, a hallmark of fresco mural painting. In these days the artist objectified landscapes, not images, encapsulating living plants and landscapes in her works. Her paintings now focus on objects with a strong sense of reality and presence. This means the artist has started investigating objects, reviewing their features, and hearing their stories, breaking away from her previous attitude trying to evoke some pitiful emotions.

As mentioned above, the big change her work underwent was the emergence of landscape. While her previous work was led by landscape as a motif, walls and roofs as part of a landscape and landscapes with plants now emerge in her work. Because frescos absorb pigments rather than accumulate them, buildings and plants in concert with those buildings appear moderate and peaceful, stimulating nostalgia. Unlike work titles such as *Living Together*, *Overwhelmed*, and *Coexistence But* ---- reminiscent of some peacefulness, the relation between plants and buildings as natural and artificial objects has a different context. Plants as part of nature and buildings as man-made objects try to coexist in her work, but they are in conflict, not at peace, and in a situation in which it is hard to coexist.

In the relationship between the natural and the man-made, we usually regard natural things as weaker. Kim's paintings are peaceful since nature and artificiality appear balanced and harmonized in her work. On closer scrutiny however, we come to know that the relation among objects in her work may be different from what we presume. In her work, plants encircle artificial objects with their persistent, tenacious life force in weakness and mildness, and gradually encroach on the territory of man-made structures. Afterwards, Kim highlights plants within artificial things, deviating from the equal relations

between plant and man, nature and artificiality. This appears as an objectification of potted plants placed in an indoor space or a greenhouse. These plants seem bound by an order humans have established, losing their natural instinct, or have become domesticated and hung on the wall in a row.

Plants domesticated in a greenhouse are usually regarded as tender, powerless things to be protected by humans. However, plants in Kim's work have been embodied through keen, spiky scars that make viewers feel pain. Kim carves plant objects with sharp burins rather than painting them with pigment. The veins of leaves and stems are formed and plants are completed when the marks of her sculpture knives generate nervous, keen scars across the skin of her frescos. As such, the greenhouse plants Kim portrays can be said to result from a duet of oppression and wounds, healing scars deriving from the process of shedding their natural instincts.

The *Taming the Plant* series depicts plants tamed by the man-made like close-up pictures. Overwhelmed by black, the series is filled with a dark, gloomy energy. As the calm before the storm conceals the tremendous swirling energy to come, wounds and pain, thirst for the life force of lost nature, a lost sense of self-respect and confused identity are swirling in concert with one another in this series. Gloominess and rage inherent in a superficial serenity is bound up with wounds stemming from suppression of natural instinct. For Sigmund Freud, something oppressed should be consistently vented for one's deferred satisfaction, and the mechanism of oppression constantly tries to control the expression of the oppressed. The oppressed, however, explore new ways of expression due to a collision between the desire to vent and their oppression. In this sense, return of the oppressed in a direct way can be regarded as part of suppression; furthermore the two can be one and the same. Without mentioning Freud's theory, we can notice plants in Kim's work constantly try to challenge the power to suppress them. As a result, plants in the *Taming the Plant* series radiate energy and seem to be on the verge of wriggling into life. The space deriving from

this wriggling energy is a reminder of *The Heart of Darkness*, in which a protagonist considers himself the lamplight of civilization in the barbaric land of Africa, but is confined to an abyss of his own savagery. Nature returns to Kim's work with tentacles surrounding those who try to tame nature in the name of coexistence with nature, opening its mouth like an abyss of gloom.

The bilateral relation among objects in her work reminds us of the diverse relations we have with our surroundings, moving beyond the relations between man and plant, artificiality and nature. This reveals suppression and violence, plus the injury and conflict innate in our quotidian relations. As the objects reflect the relationships social members have established, they make us feel inconvenient. Meanwhile, a return of the oppressed creates cracks in social relations, establishes something new that replaces the pre-existing relation that has been considered quite natural. In her recent work *Dream of the Green*, the artist recovers the life force of nature ousted from an artificial environment. Moderate color is intermittently used to accent her scene, revealing intense symbolism. In *Dream of the Green*, green plants at the center of the scene are in stark contrast with black-and-white nature in a greenhouse full of distorted energy and lost vitality.

The appearance of a woman digging up a plant from the lifeless man-made earth or an artificial garden dominated by distorted life force at the center of the scene suggests that Kim's work has moved on to a different phase. Whereas her previous work was a symbolic manifestation of the relation between man and plant, attention and suppression, and the problem of establishing relations with surroundings, she now creates narratives through figures in her work. Whether these figures are truth-seekers who establish new relations or "deus ex machina" (gods from the machine) created to fill the gap, remains to be seen.

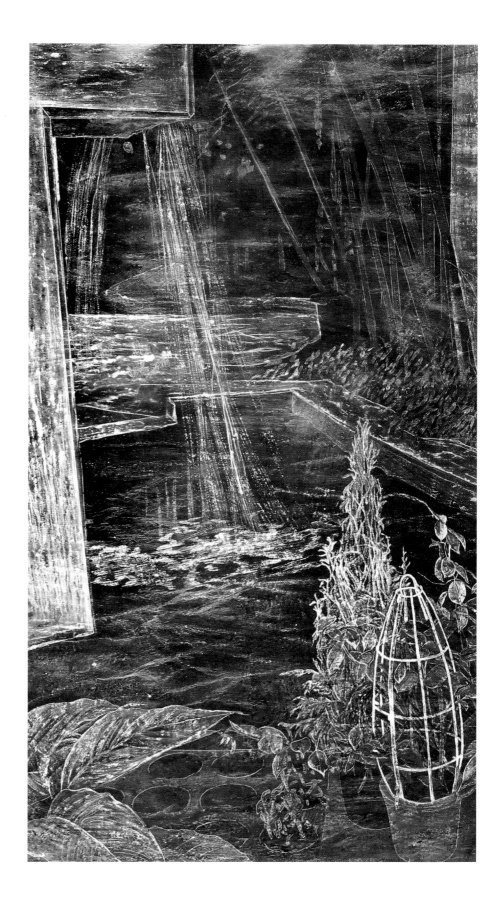

억압된 것들의 귀환

기혜경, 부산시립미술관 관장

김유정은 기다림을 작업 속에서 실천한다. 그녀의 작업은 절대적인 물리적 시간의 기다림과 육체적 노동을 담보한 후에야 작품으로서의 형태를 띤다. 오랜 세월을 견뎌낸 프레스코 벽화가 보여주는 시간의 흔적과 그러한 흔적이 불러일으키는 감성을 작업에 담고자 한 작가의 화면에는 작업과정에서 화면에 누적된 시간과 노동, 그리고 기다림이 담겨있다.

처음 작가가 프레스코기법을 작업에 이용하였을 때, 그는 프레스코라고 하는 전통적 기법과 그것의 효과에 천착하였던 것으로 보인다. 오래된 벽의 갈라진 틈, 그림자가 드리워진 벽의 한 편, 스쳐지나가는 바람이 남겨 놓은 풍화의 흔적 등을 모티브로 작업하고 있는 이 시기의 작품들은 오브제의 형태로 제시된다. 때로 그것은 캔버스와 같이 커다란 형태를 띠기도 하지만 평면의 캔버스로 다가오기 보다는 실재하는 벽의 한 부분을 잘라내어 제시한 듯 사물의 형태로 다가온다. 이후 초벌한 도기나 여성의 토르소 형태를 취하여 작업하면서 이러한 오브제성은 더욱 강화된다. 이 시기의 작품들은 용기로서의 기능이나 여성 토르소에 대해 우리가 가지고 있는 기본적 통념과는 다른 지점에 위치한다. 용기는 무엇인가를 담는 그릇으로서의 기능을 상실한 채, 테이블이 아닌 벽 위에 걸리고, 마치 우리 주변의 벽들이 주변을 반영하며 시간을 견디고 선 것처럼 그렇게 시간의 흔적과 주변의 풍경을 담아내고 있다. 여성 토르소 역시 오래된 회벽의 질감을 통해 기억이나 회상이라는 이름으로 잃어버린 욕망의 흔적을 뒤돌아보게 한다. 이처럼 작가의 초기 작업은 우리 곁에서 사라져 갔거나 혹은 존재하지만 곧 사라질 것들을 화면 위에 포치시키고, 거기에 프레스코화 특유의 세월을 견뎌 냄으로써 품게 된 회상의 힘과 기억에의 환기 능력을 덧붙여 작품으로 제시하고 있다.

한편, 김유정의 화면에 커다란 변화가 일어나는 시기는 2007~8년을 전후한 시기로 보인다. 이전시기 작품이 드러낸던 오브제적 성향은 이제 캔버스를 바탕으로 당당한 화면으로 제시되기 시작한다. 이러한 변화는 근본적으로 작가가 프레스코 기법의 마스터를 통해 그 운용이 자유로워짐으로써 가능해 진 것으로 여겨진다. 그 결과,

작가는 전통적인 프레스코 기법을 현대화하여 자신만의 조형언어를 완성하는가 하면, 더 나아가 대상을 바라보는 태도 역시 변화한다. 이전 시기 작가는 무엇인가에 투사 혹은 반영된 이미지, 즉 존재하지만 곧 사라질 그림자나 부재하지만 진한 잔영을 남기는 이미지를 통해 애잔함의 정서를 환기시키고자 하였다. 이는 프레스코화의 특징이라 할 수 있는 오래된 시간성이라는 특성을 시각화한 것이라 할 수 있다. 하지만 이즈음의 변화를 통해 작가는 이미지가 아닌 풍경을 직접 대상화함으로써 살아있는 생명을 갖는 식물과 풍경을 화면에 담는다. 이제 그의 화면은 강한 실재감과 존재감을 갖는 대상들이 주도하기 시작한다. 이는 작가가 오래된 빈티지 사진처럼 금방이라도 사라져 버릴 것만 같은 애틋함의 정서를 환기시키고자 하던 태도에서 벗어나 대상을 직시하고 그 특성을 살피기 시작하였으며, 그들의 이야기를 듣기 시작하였음을 의미한다.

이처럼 전환기를 맞은 작가의 화면에 일어난 가장 큰 변화는 전술하였듯이 풍경의 등장이라 할 수 있다. 이전시기 모티브로서의 풍경이 작품을 주도하였다면, 이제 그의 화면에는 풍경으로서의 담과 지붕, 그것에 기대어 혹은 그것을 에워싸고 살아가는 식물들로 구성된 풍경이 등장한다. 안료를 바탕위에 쌓아나가기 보다는 속으로 흡수하는 프레스코화의 특성상 건물의 일우와 그곳에 어우러져 살아가는 식물의 풍광은 담담하면서도 향수를 자극하는 평화로움으로 다가온다. 그러나 <Living together>, <Overwhelemed>, <Coexistence but...> 등의 작품 제목은 이 시기 작품이 담고 있는 자연물로서의 식물과 인공의 건축물 사이의 관계가 화면에 드러나는 평화로움과는 다른 문맥을 가지고 있음을 알 수 있게 한다. 화면 안에서 자연으로서의 식물과 인공으로서의 건물은 공존하고자 하지만 화면의 표면상의 평화로움과는 달리 그들의 관계는 공존하기 힘든 갈등의 상황을 품고 있다.

일반적으로 우리는 자연물과 인공물의 관계를 상정함에 있어 약자의 위치에 자연물을 놓는다. 김유정의 화면이 평화로워 보이는 것은 우리의 인식 체계가 인정하는 이러한 자연과 인공 사이의 균형이 유지되고 있는 것으로 비춰지기 때문이다. 그러나 정작 작가의 화면을 유심히 들여다보면

풍경 속 대상들의 관계가 우리가 상정한 것과는 다를 수 있음을 알게 된다. 연약하고 여리기에 피해자로만 인식되어 온 식물이 오히려 여린 듯 부드러움 속에 강인한 끈기와 생명력을 가지고 인공물을 에워싸, 결국 공존하는 듯 보이는 풍경 속에서 서서히 그리고 집요하게 인공과의 경계를 잠식하고 있음을 알 수 있다. 이러한 식물과 인간, 그리고 자연과 인공이 만들어 가는 관계는 이후 작가로 하여금 인공물 속에 존재하는 식물에 집중하며 그 관계를 살피게 한다. 그것은 화분에 심어져 실내에 놓인 화초나 온실의 식물을 대상화 하는 것으로 드러나는데, 이제 화면에 나타나는 식물들은 자연의 습성을 잃고 인간이 부여한 질서에 따라 화면에 등장하는가 하면, 일렬종대로 벽에 걸린 채 자연의 본성을 탈각하고 주어진 환경에 길들여져 간다.

통상적으로 온실 속에서 길들여진 식물은 인간에 의해 보호되기에 여리고 힘없는 존재로 인식된다. 하지만, 김유정의 화면 속 식물들은 아름답고 여린 존재라기보다는 관람자로 하여금 자신도 모르게 소름 돋는 아픔을 느끼게 할 만큼 날카롭고 뾰족한 상처를 통해 구현된 것들이다. 작가는 대상이 되는 식물을 안료를 사용하여 그려나가기 보다는 날카로운 조각도를 이용하여 각인한다. 조각도가 스쳐 지나간 신경질적이면서도 날카로운 상처들은 프레스코의 속살을 드러내며 식물의 잎맥을 형성하기도 하고 줄기가 되기도 하면서 하나의 식물을 완성한다. 이처럼 김유정이 구현한 온실 속 식물들은 그 몸에 각인된 자연의 본성과 속성을 떨쳐내는 과정에서 생겨난 상처를 보듬고 억압과 상처의 이중주를 통해 드러난 결과물이라 할 수 있다.

인공에 길들여져 가는 식물을 마치 접사하듯 표현하고 있는 최근작 <Taming the Plant> 시리즈의 화면은 흑색이 주도하며 어둡고 암울한 에너지로 가득 차있다. 마치 폭풍전야의 고요한 정적이 앞으로 다가올 엄청난 소용돌이의 에너지를 감추고 있듯, 이 시리즈의 화면에는 상처와 고통, 상실한 자연의 생명력에 대한 갈구, 잃어버린 자존감과 혼란한 정체성이 함께 어우러져 소용돌이 치고 있다. 표면적인 고요함 속에 내재한 암울함과 분노, 그리고 그것을 관통하는 어두운 에너지는 자연의 본성을 억압한데서 온 상처에서 연원하고 있는 것이다. 프로이트에 따르면 억압된 것은 지연된 만족을 실현하기 위해 끊임없이 표출되고자 하며, 억압의 기재는 끊임없이 억압된 것의 표출을 통제하고자 한다. 이와 같이 분출하려는 힘과

억압하려는 힘의 충돌은 억압된 것으로 하여금 우회적인 형태의 표출방식을 모색하게 한다. 이렇게 볼 때, 우회적인 방식을 통한 억압된 것의 귀환은 억압의 일부분이라 할 수 있으며, 더 나아가 이 둘은 하나이자 동일한 것이라 할 수 있다. 이러한 프로이트의 이론을 굳이 빌리지 않더라도 김유정의 화면 속 식물들은 끊임없이 억압하려는 힘과의 충돌을 통해 자신들의 억압된 생명력으로 회귀하고자 한다. 그 결과, <Taming the Plant>가 구현한 식물들은 그것을 식물이라 부르기엔 너무도 강한 에너지를 발산하며, 지금이라도 당장 살아 움직이는 촉수를 뻗을 것처럼 꿈틀대고 있다. 더 나아가 이들 꿈틀대는 에너지가 만들어내는 공간은 아프리카라는 야만의 땅에서 문명의 등불을 자처하지만 스스로 자신 속에 내재한 야만의 심연에 갇혀버리고 마는 주인공을 그린 『어둠의 심연 Heart of Darkness』을 떠오르게 한다. 인간과 자연의 공존이라는 이름으로 자연을 길들이고자 한 인간을 향해 이제 자연은 어둠의 심연과 같은 입을 벌린 채 김유정의 화면을 통해 어두운 촉수를 뻗으며 귀환하고 있다.

작품 속 대상들이 보여주는 돌고 도는 억압의 관계는 단순히 인간과 식물, 혹은 인공과 자연의 관계를 넘어, 우리가 주변과 맺고 있는 다양한 관계들을 생각하게 한다. 그것은 너와 내가 매일의 일상 속에서 맺고 있는 관계 속에 내재하는 억압과 폭력, 그리고 상처와 갈등을 드러내는 것이자, 사회 속 구성원들이 맺고 있는 관계를 반영하는 것이기에 우리를 불편하게 만든다. 한편, 억압된 것들의 귀환은 일상 속 사회적 관계에 균열을 가하며 당연한 것으로 받아들여지던 기존의 관계를 대체할 새로운 관계를 정립하는데, 이러한 바람을 담아 작가는 최근작 <녹색의 꿈>을 통해 인공의 환경 속에서 뒤로 밀어 두었던 자연의 생명력을 건져 올리기 시작한다. 채색이 극도로 절제된 김유정의 화면에 간헐적으로 등장하는 색채는 화면에 악센트를 주며, 강한 상징성을 드러내 왔다. <녹색의 꿈>에서 역시 화면 중앙에 유일하게 드러나는 초록색 식물은 생명력을 상실한 채 왜곡된 에너지로 가득한 온실 속 흑백의 자연과 대비되고 있다. 한편, 구도자와도 같이 화면 중앙에 생명 없는 인공의 땅에서 혹은 왜곡된 생명의 힘이 주도하는 인공의 정원에서 녹색의 생명을 건져 올리고 있는 여인의

등장은 김유정의 작업이 이전과는 다른 단계로 접어들고 있음을 암시한다. 이전 시기 작가의 작업이 인간과 식물, 보살핌과 억압, 주변과의 관계 정립의 문제를 상징적으로 드러내 보여주었다면, 이제 작가의 화면에 등장하는 인물은 직접적으로 작품에 내러티브를 도입하고 있다. 이러한 인물이 그의 전작이 벌려 놓은 관계의 틈을 비집고 새로운 관계를 정립하는 구도자가 될지, 혹은 그 틈을 메꿔 버리는 '데우스 엑스 마키나(deus ex machina)'가 될지는 좀더 지켜보아야 할 일이다.

Labyrinth
미로

2014
pigment print on tiles
30x30cm
private collection

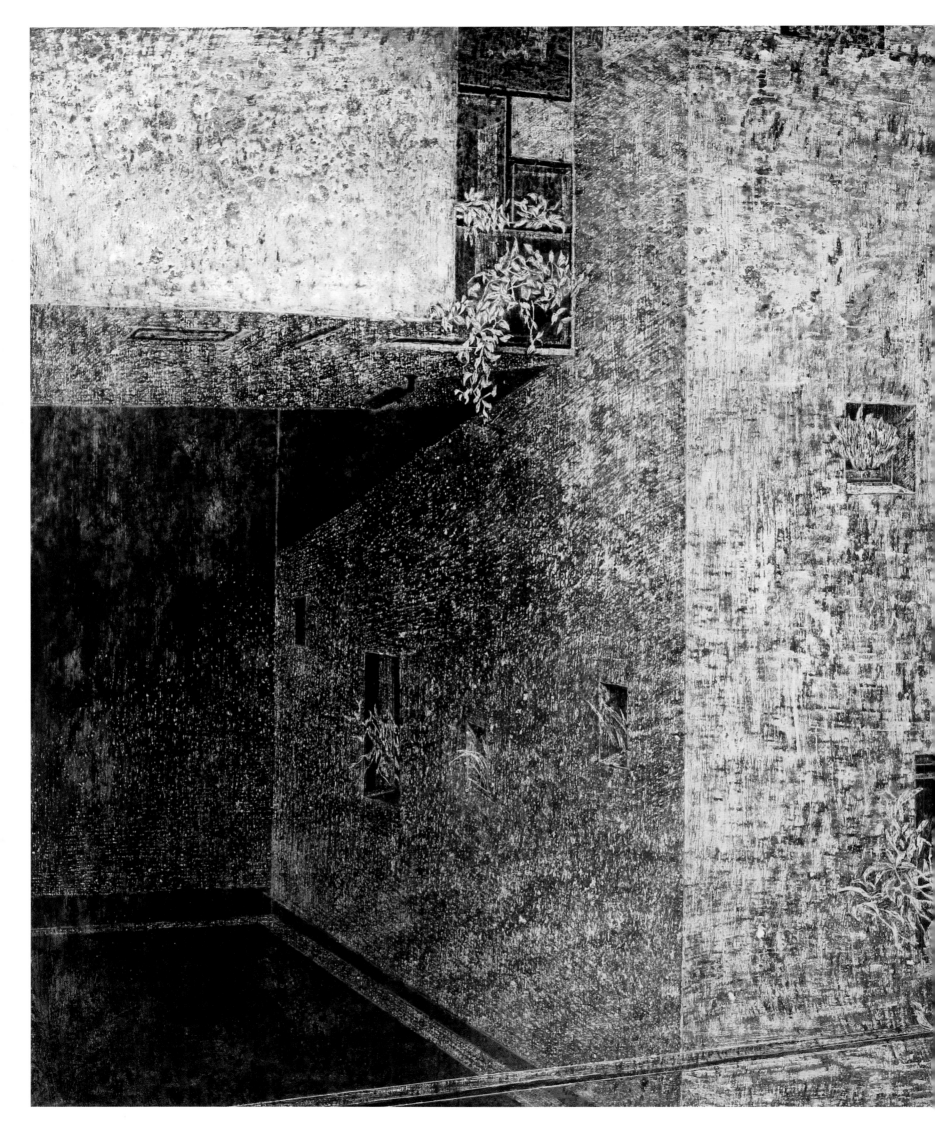

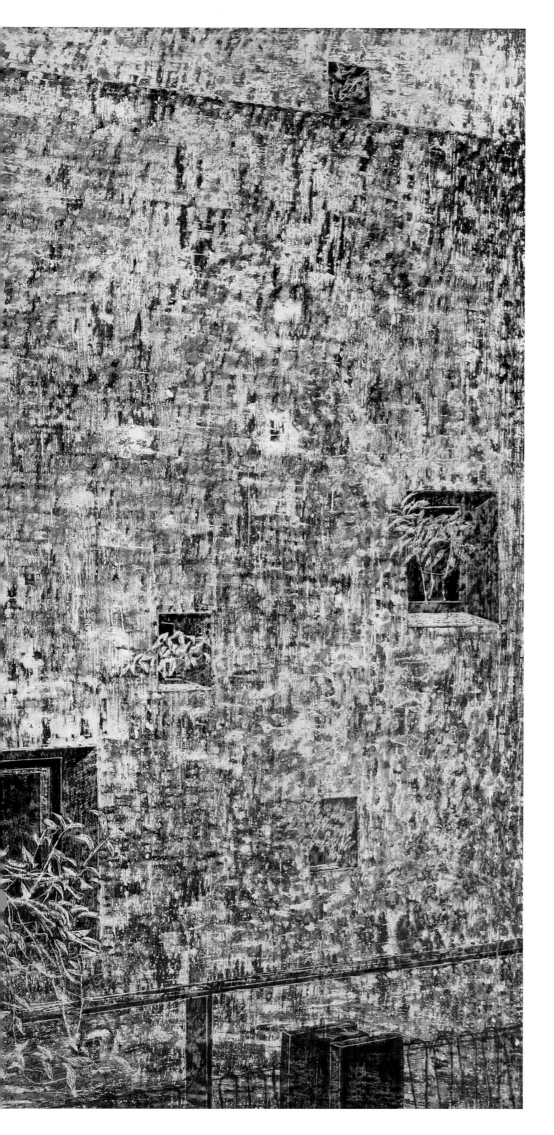

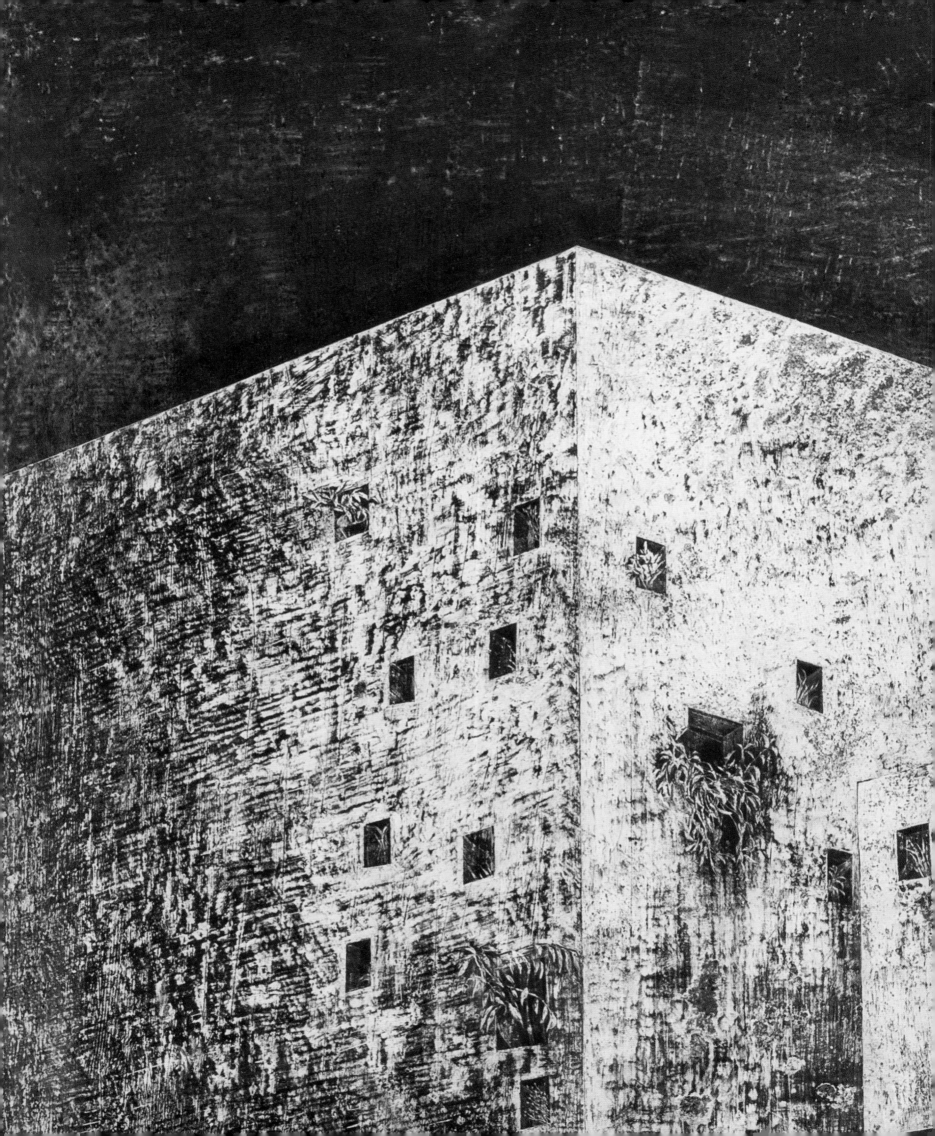

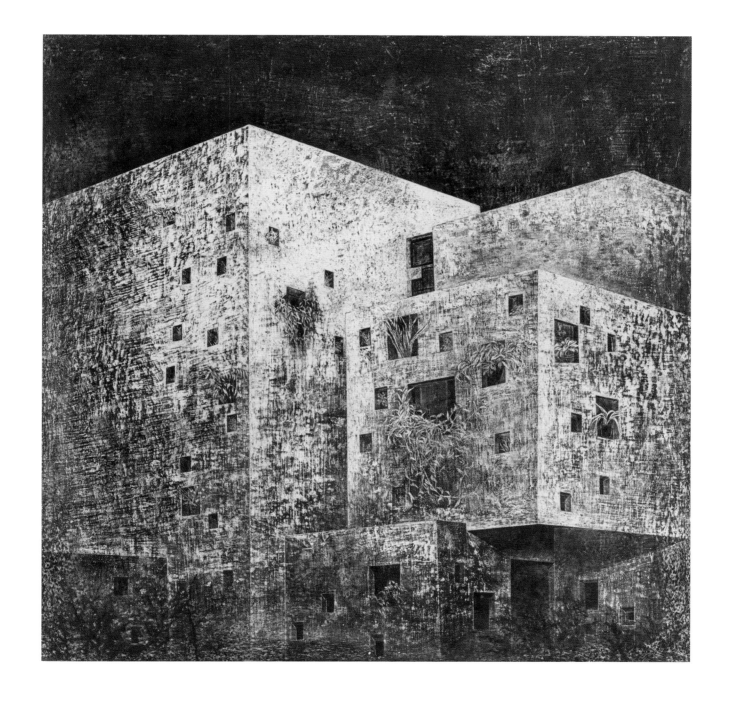

Yellow Position represents the self and relationality in the created environments that surround the self. Coexistence gives rise to conflict. The work captures a process of overcoming one's sense of loss and healing scars within the context of a particular relationship. The color that signifies mental energy and a representation for overcoming the last self.

<노란 자리>는 자신과 자신을 둘러싼 만들어진 환경에서의 관계성을 표명한다. 공존은 곧 갈등을 초래한다. 어떤 관계 안에서 자신의 상실감을 이기고 상처를 치유해가는 과정이 담긴다. 색채는 심적 에너지와 상실된 자아를 극복하기 위한 기표를 의미한다.

Yellow Position
노란 자리

2014
fresco, scratch on lime wall
120x120cm
Sophis gallery collection

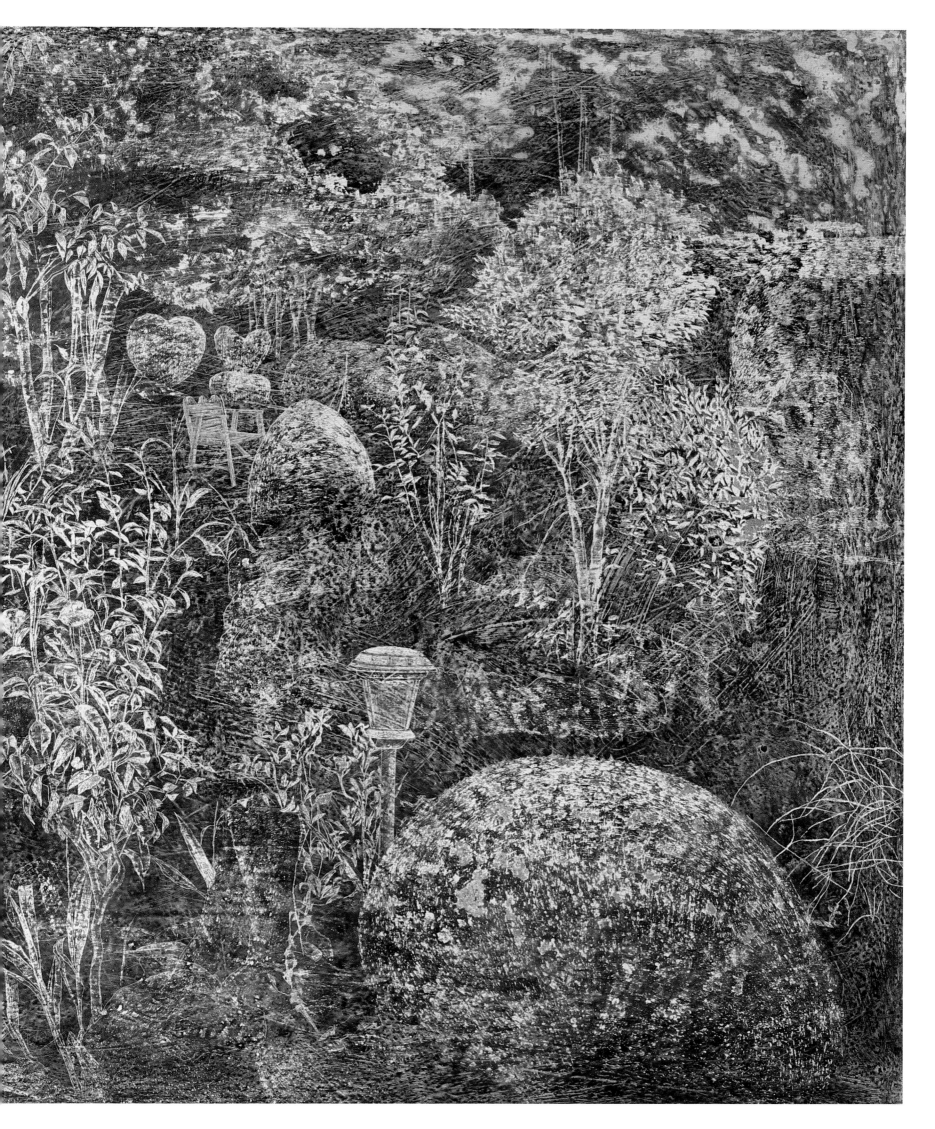

Yellow House

2014
fresco, scratch on lime wall
70x90cm
Incheon Dong-gu Office collection

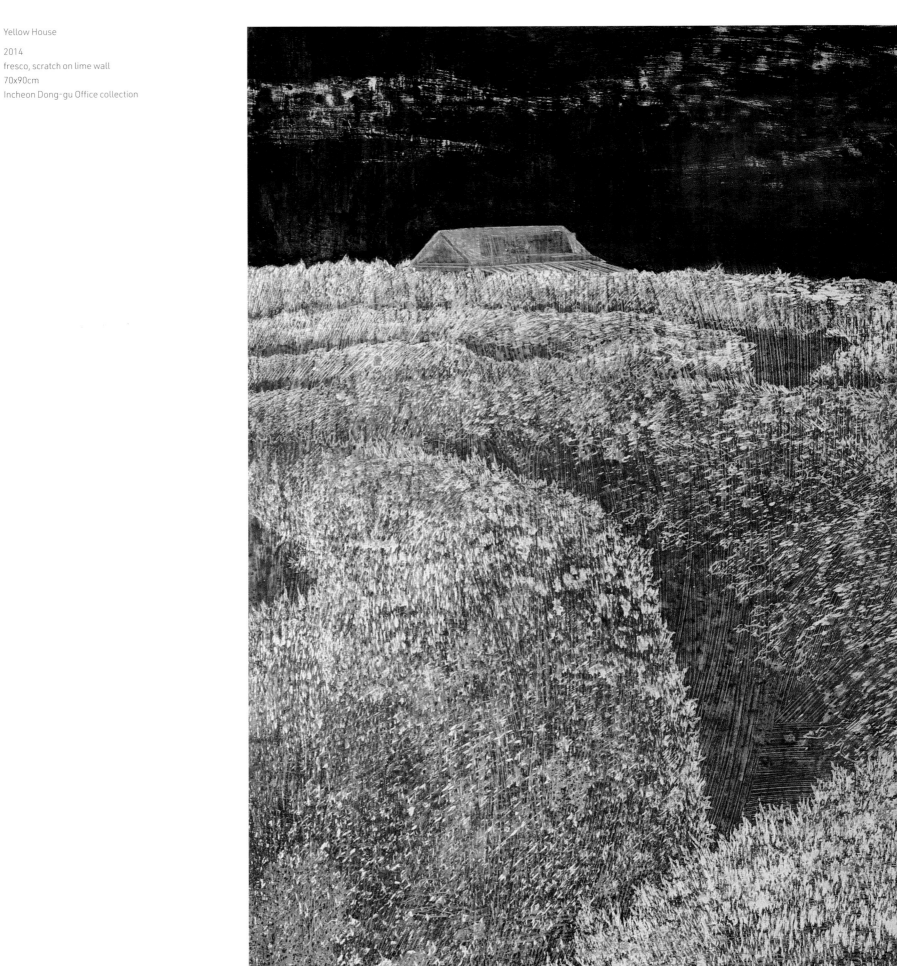

Silent Garden 2013–12

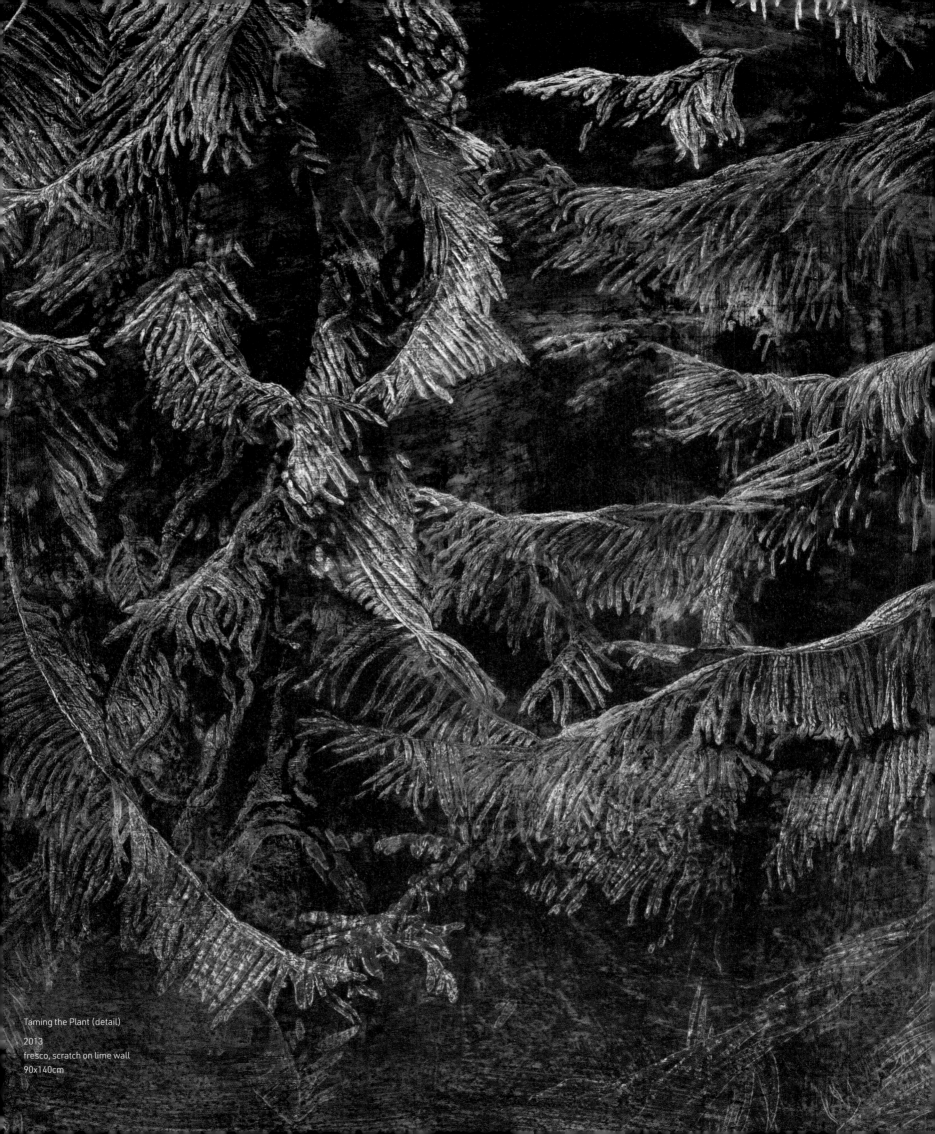

Taming the Plant (detail)
2013
fresco, scratch on lime wall
90x140cm

Taming the Plant began out of the question, "Is it really possible to tame a living plant?" It represents the iron inherent to the garden as a space. Within the gardens artificially designed by human beings, plants are intended for the most part for the purpose of appreciation. The plants present in the gardens tamed by human desire are transformed into an inverted garden, deviating from their original nature. When the values of a garden are inverted in this way, the original meaning possessed by the object is replaced with societal goals. A familiar landscape to human eyes, the garden is inverted here into a natural landscape. Rather than anything being externally added to the object presented before our mind, an approach of removal and omission is used, so that what is gained from familiar things sublimates internal characteristics that are not visible in the object itself.

<Taming the Plant>는 '살아있는 식물을 길들인다는 것이 과연 가능한 것인가?' 에 대한 물음에서 시작한 것이다. 정원의 공간이 내포하는 아이러니를 대변한다. 인간이 인공적으로 설정한 정원에 있는 식물은 관상용을 목적으로 설정된 것들이 대부분이다. 인간의 탐욕에 의해서 길들여진 정원에 있는 식물들은 식물이 원래 지닌 특성이 아닌 전도된 정원으로 바뀐 것이다. 가치 전도된 정원은 원래의 대상이 가진 의미가 사회적 목적으로 바뀌어 버린 현실이다. 인간의 눈에 익숙해진 정원의 풍경은 자연스러운 풍경으로 전도되어 버린 것이다. 심중에 다가왔던 대상을 향하여 무엇인가 외형적으로 첨가하는 것이 아니라 오히려 삭제와 생략의 방법을 동원하여 익숙한 것들을 통해서 얻은 것은 대상 자체에서 드러나지 않았던 내면적인 특성을 승화시킨다.

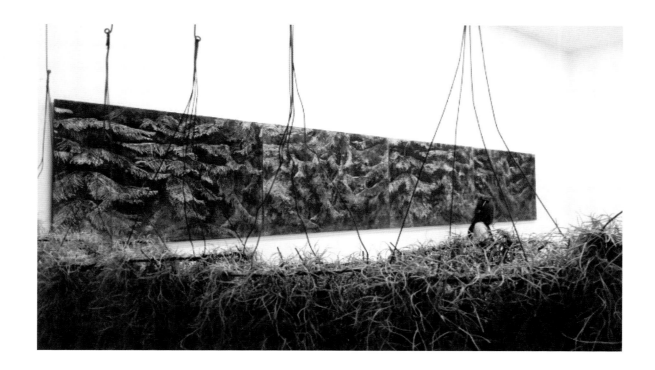

Incheon Art Platform Residency Studio
2015

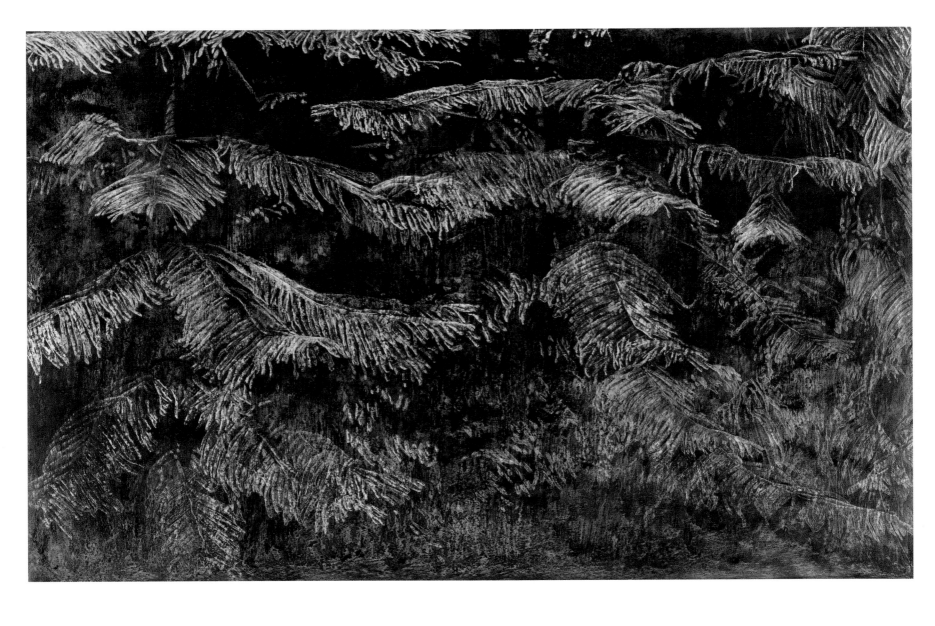

Taming the Plant

2013
fresco, scratch on lime wall
90x140cm

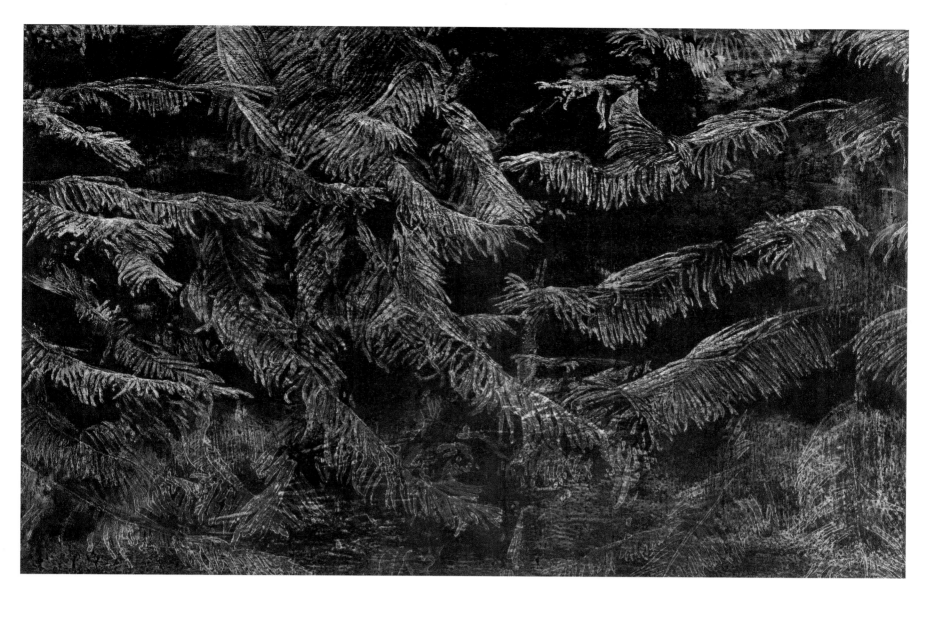

Taming the Plant

2013

fresco, scratch on lime wall

90x140cm

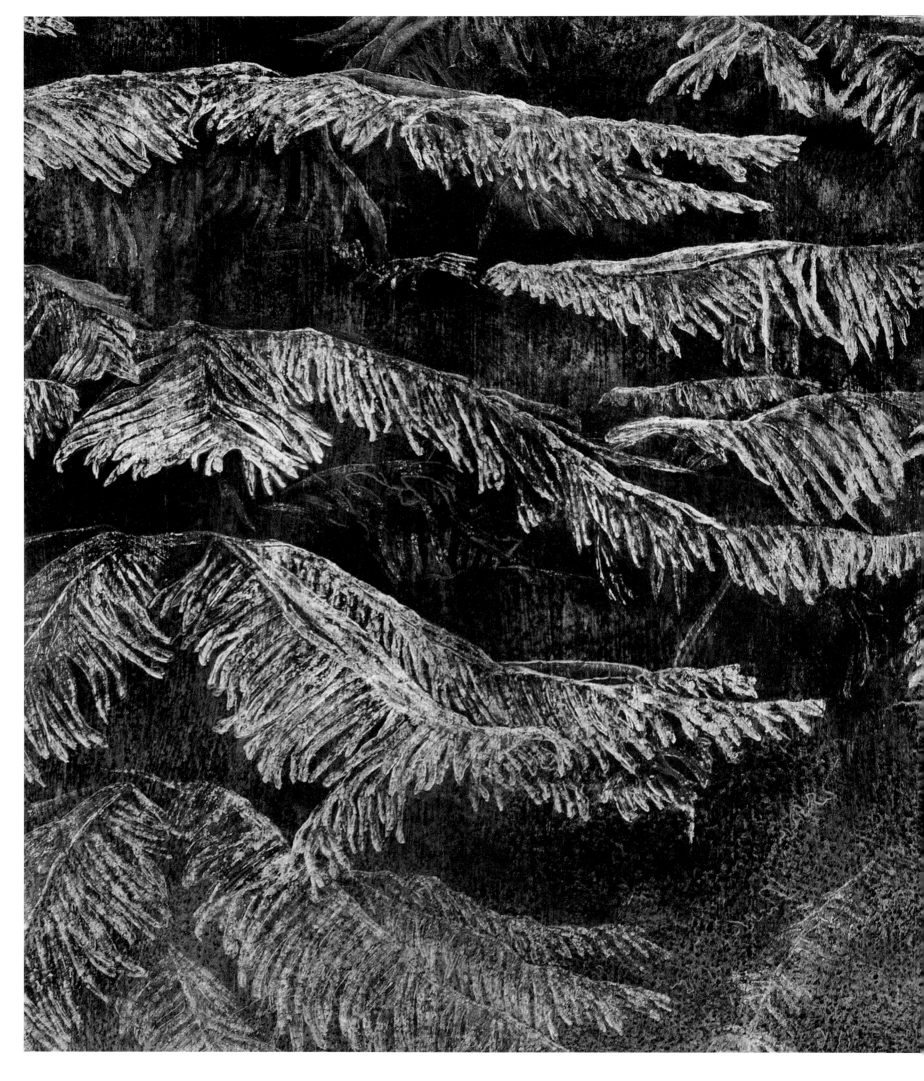

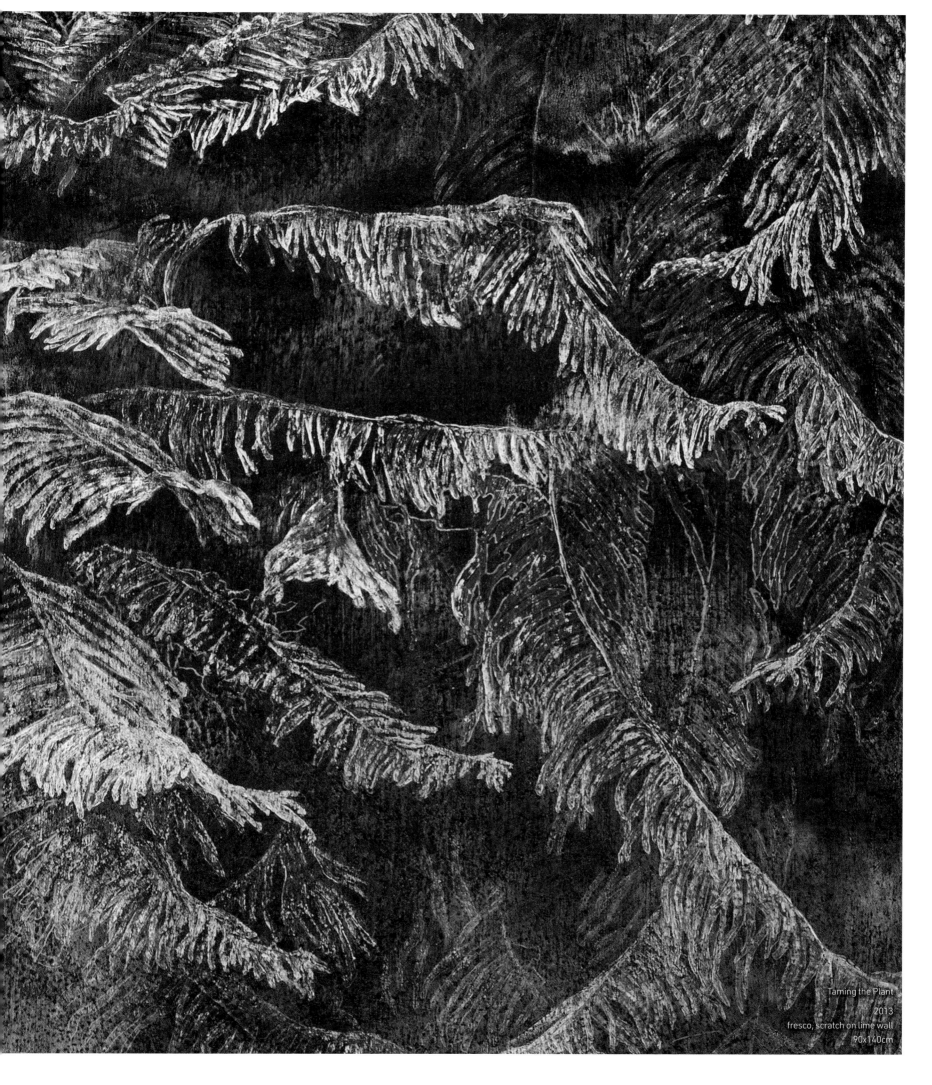

Taming the Plant
2013
fresco, scratch on lime wall
90x140cm

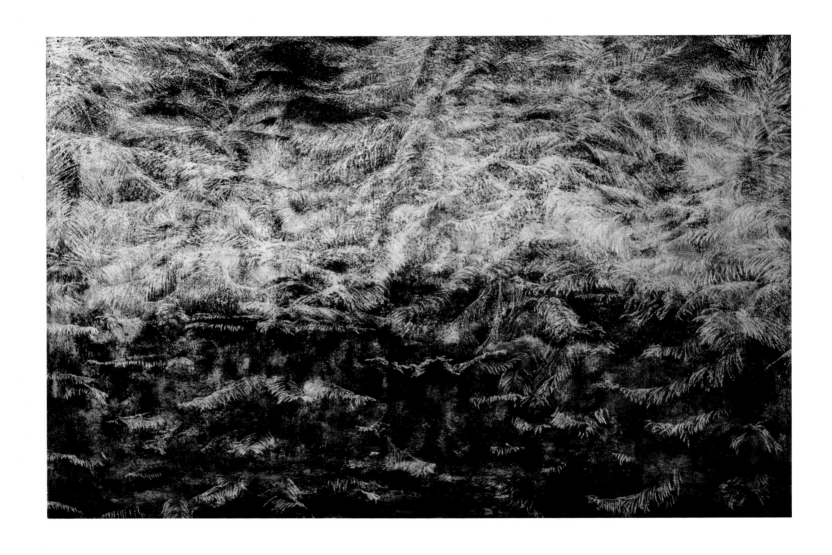

Taming the Plant

2013
fresco, scratch on lime wall
120x180cm

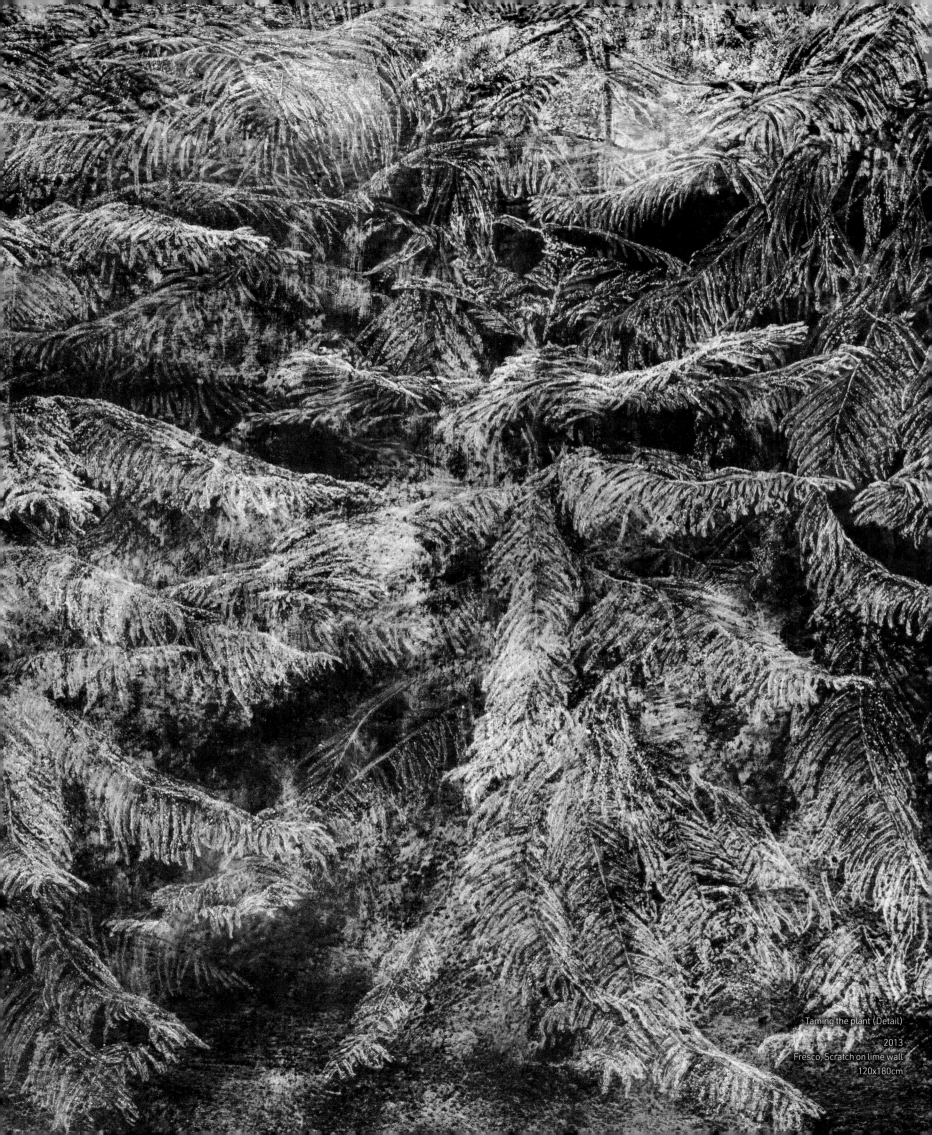

Taming the plant (Detail)
2013
Fresco, Scratch on lime wall
120x180cm

Gray Garden

2013
fresco, scratch on lime wall
113.5x162cm
OCI Museum of Art collection

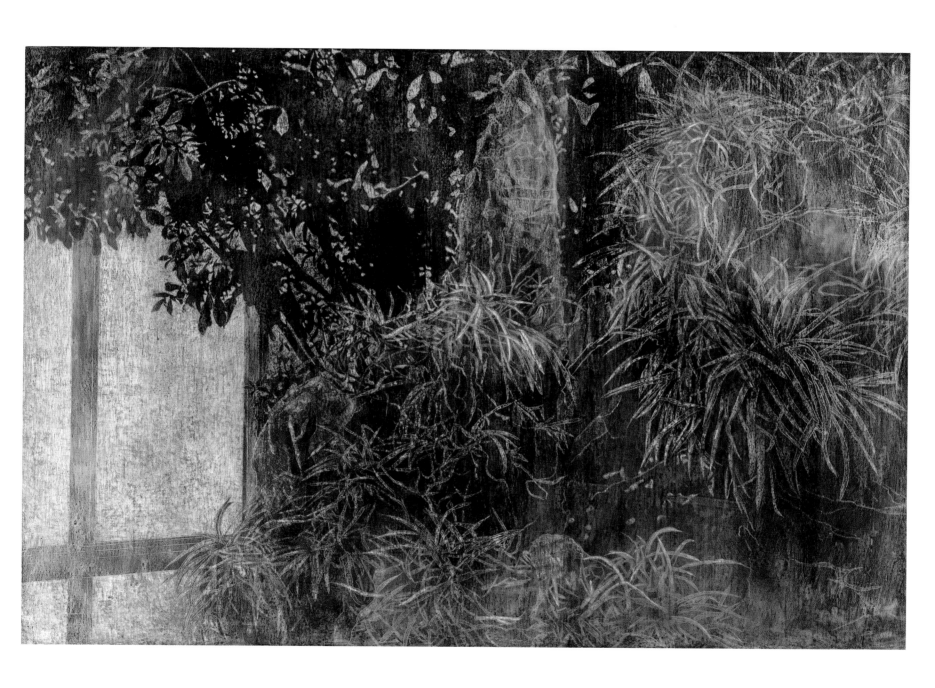

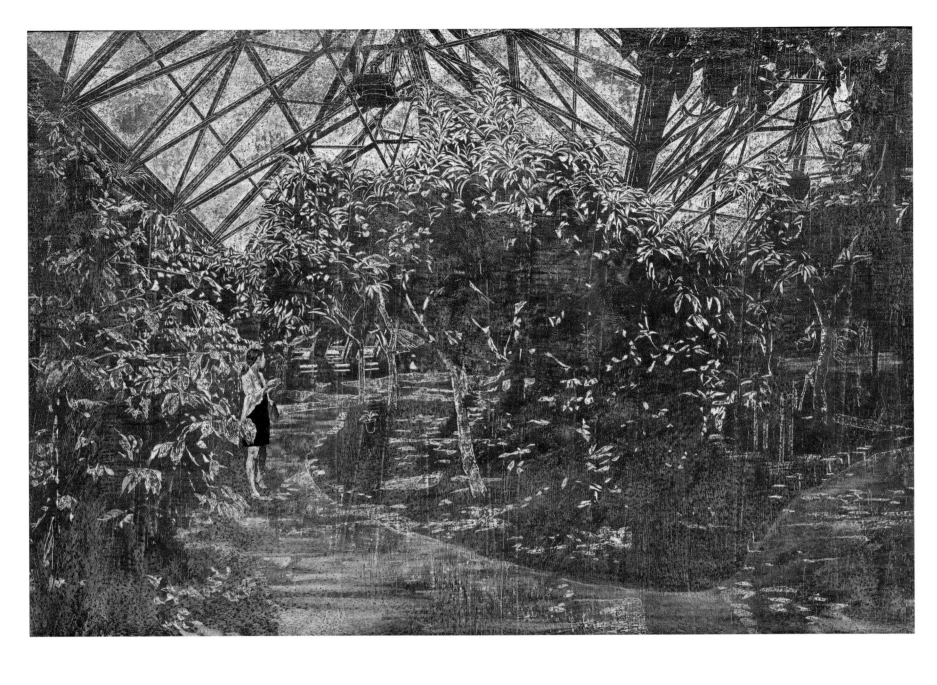

Dream of the Green

2013
fresco, scratch on lime wall
74.5x104.5cm

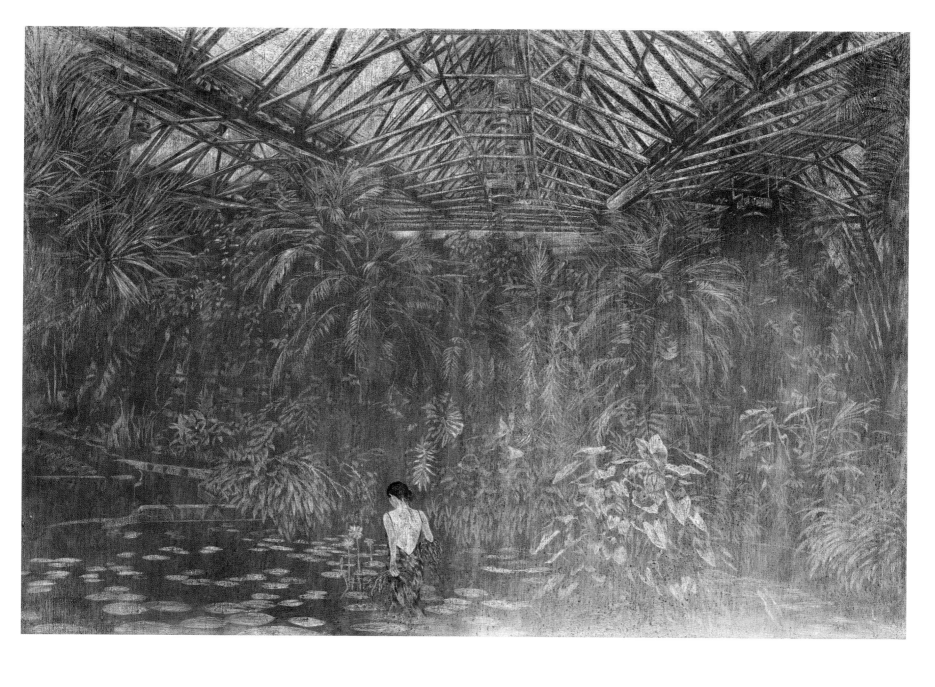

Dream of the Green

2013
fresco, scratch on lime wall
74.5x104.5cm
private collection

A house seems cozier and brighter when it is filled with plants toward the veranda, where the light comes in, or in the living room we see after opening the door. A person who is good at raising plants is a good person. Someone who learns about each plant's means of survival and provides the appropriate water and sunlight is someone who knows how to love. Sometimes plants decay after being given just a bit too much water; sometimes we are too busy and briefly forget to water them, and they dry up; sometimes, they suffer a lack of sunlight that leaves them large but scrawny. Flower pots are dumped in the bin outside the apartment along with the desiccated plant. A person who gives a potted plant as a gift may be a good person, but the gift of a potted plant may be a bad omen to someone who is not good at raising plants. Such was the relationship between us—fated to dry up in this way. Any other gift would have been fine; why did it have to be a potted plant? Failing to love and care for a plant is like picking up and punishing someone who failed to love another. It's depressing.

p. s. The plant you sent is growing nicely!

The plant growing in the pot symbolizes the relationship between men and you, or my attitude or etiquette toward love. I make sure to remember, looking after you regularly and with care. The pot is a symbol of utter passivity. Even when the rain falls outside, I dry up if you're not there. Forget about me and I will perish. My life is in your hands. Yet is that really the truth of the plant—that softness, passivity, frailty as it is moved about in its pot? Is it enough to use metaphors of "frailty," "docility," or "generosity" for plants, in contrast with the way "animal" signifies power and control? My image of the plant is not like that. I am attempting to get at the as yet unspoken "other-ness" on the other side of that plant metaphor/image of tameness, helplessness, and obedience. This is why my canvases are grotesque and powerful. My plants are trying to break free, cutting through the helplessness of being trapped in their pots. The pots themselves have been removed or minimized; the plants wage a frontal assault that unnerves the other who views them. In a word, the viewer cannot "meditate" in the face of my plants. Leaving behind the role of soft, submissive objects of contemplation, the plants thus possess tremendous strength. With plants having devolved into beautiful objects of interior decoration, I have attempted to restore their self-esteem as things that can survive quite well enough on their own.

문을 열고 들어선 아파트 저쪽 거실, 볕이 잘 드는 베란다 방향에 식물이 가득하면 집은 더욱 아늑하고 화사하다. 식물을 잘 키우는 사람은 좋은 사람이다. 식물 각각의 생존방식을 배우고 그에 맞춰 물을 주고 볕을 조절하는 사람은 사랑할 줄 아는 사람이다. 조금만 물이 많아도 썩어버리는 식물, 바쁜 일로 잠깐 물주기를 잊은 뒤 말라버린 식물, 햇볕이 부족해 키만 컸거나 앙상한 식물. 말라버린 식물과 함께 아파트 바깥 쓰레기장에 버려진 화분. 화분을 선물하는 사람은 좋은 사람일 테지만, 화분을 선물 받는 일은 식물을 잘 키우지 못하는 사람에게는 불행의 전조일 수 있다. 그와 나는 역시 이렇게 말라갈 관계였던 거지. 다른 걸 선물하지 하필 화분이 뭐람. 식물을 사랑하고 돌보는 데 실패하는 과정은 꼭 사람을 사랑하는데 실패한 사람을 골라내 처벌하는 일 같아서 우울해진다.

p. s. 보내주신 식물 잘 크고 있어요!

화분에서 자라는 식물은 나와 너의 관계를 상징하거나, 사랑에 대한 나의 예의 혹은 애티튜드를 상징한다. 나는 잊지 않고, 꾸준히, 관심을 갖고 너를 보살핀다. 화분은 절대적 수동성의 상징이다. 바깥에서 비가 오는 데도 나는 말라간다. 네가 없으면. 네가 나를 잊으면 나는 죽는다. 내 삶, 목숨을 네가 갖는다. 화분에 담겨져 여기저기로 옮겨 다니는 식물의 부드러움, 수동성, 연약함은 그런데 과연 식물의 실체일까? 식물은 지배, 권력을 의미하는 동물성과 다르게 약함, 순종적임, 포용의 은유로 충분할까? 나의 식물 이미지는 그렇지 않다. 나는 길들여진, 무력한, 복종하는 식물의 은유 혹은 이미지 너머 아직 말해지지 않은 식물의 '타자성'에 이르려 한다. 나의 화면은 그래서 그로테스크하고 강렬하다. 나의 식물은 화분에 붙들린 무력함을 뚫고 나오려고 한다. 화분은 지워졌거나 최소화되었고, 식물은 바라보는 타인의 시선을 불안하게 만들면서 정면으로 엄습한다. 말하자면 관람자들은 나의 식물 앞에서 '관조'할 수 없다. 관조를 위한 부드럽고 순종적인 오브제의 지위에서 벗어난 식물들은 그러므로 강렬한 힘을 갖는다. 마치 아름다운 실내 인테리어 장식을 위한 오브제로 전락한 식물들에게 나는 저 스스로의 힘으로도 충분히 생존할 수 있는 존재의 자존감을 회복해주려고 했다.

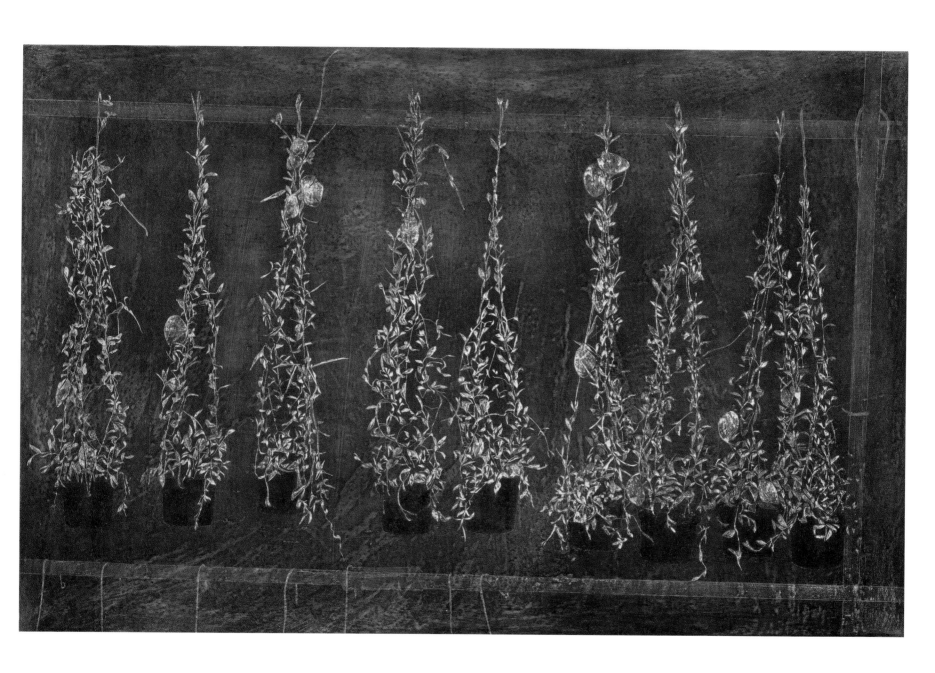

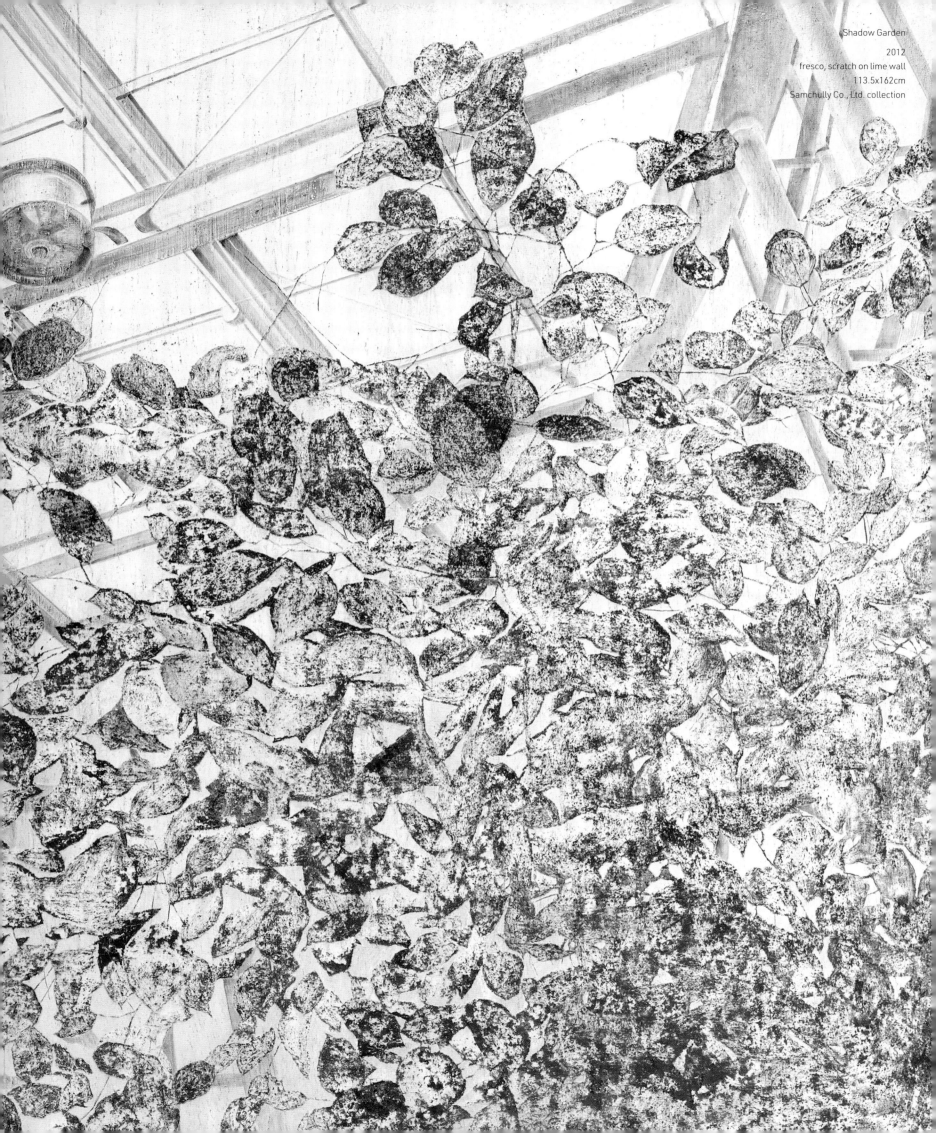

Shadow Garden
2012
fresco, scratch on lime wall
113.5x162cm
Samchully Co., Ltd. collection

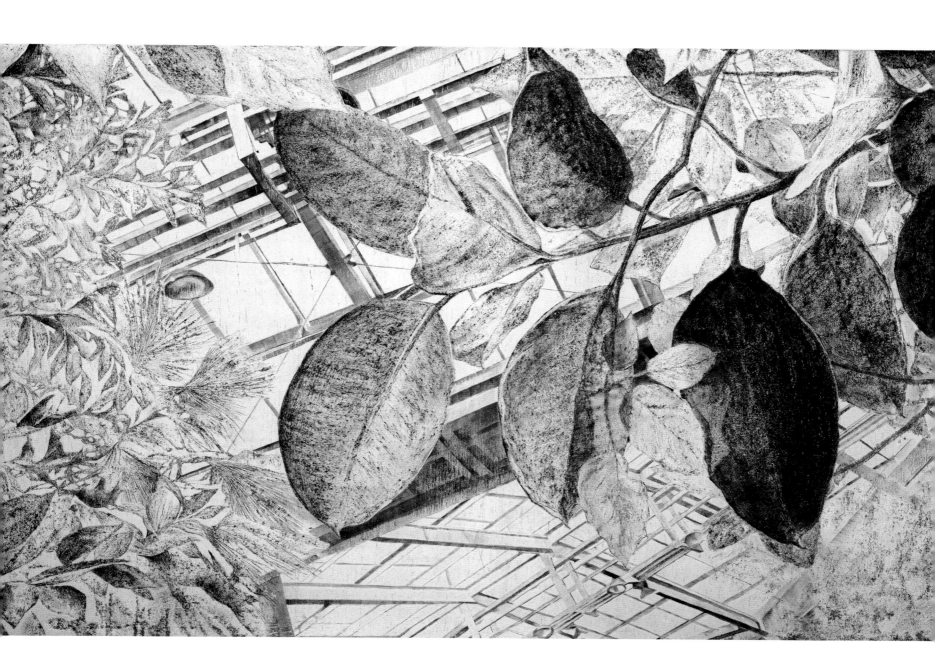

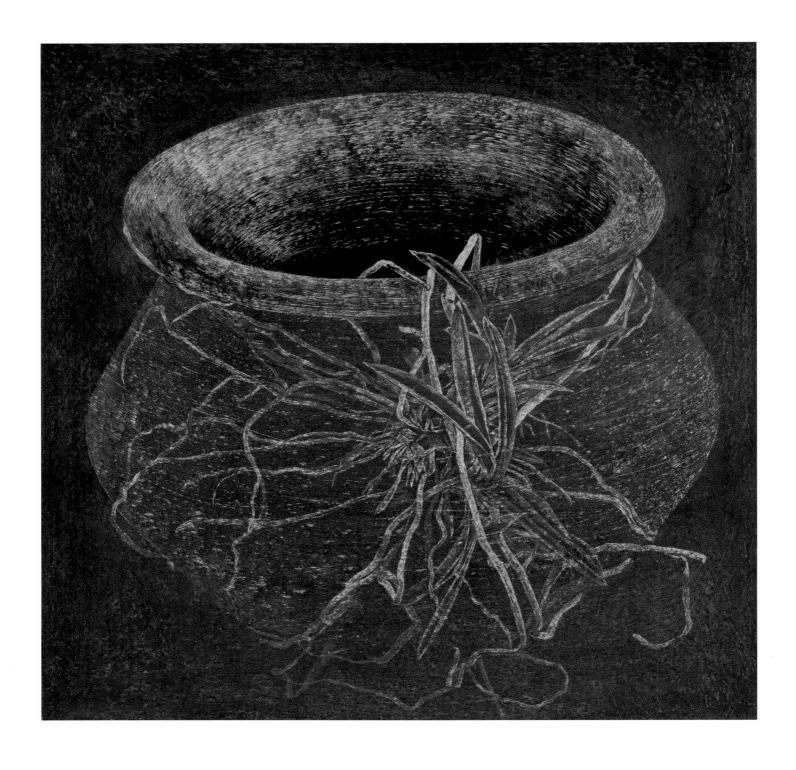

In a body
2012
fresco, scratch on lime wall
70x70cm

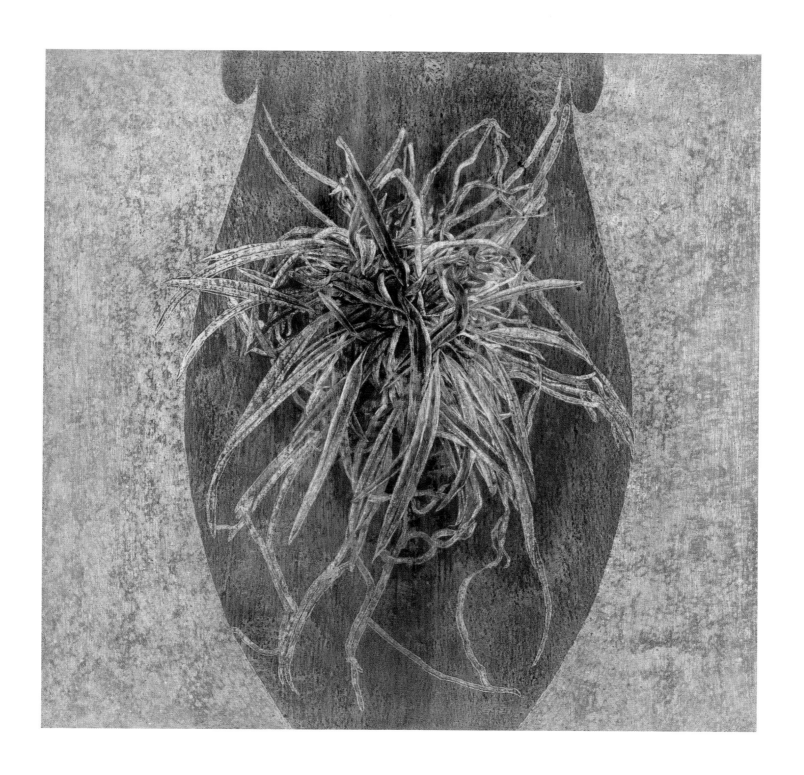

Boundary

2012
fresco, scratch on lime wall
80x80cm
private collection

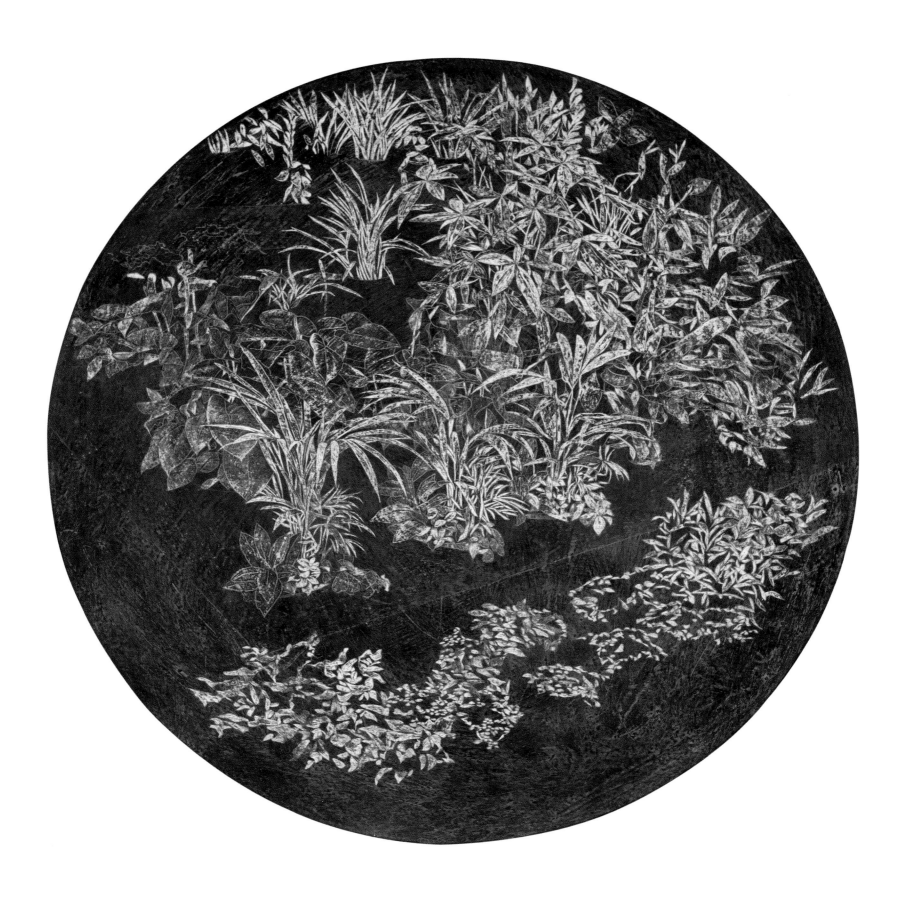

Landscape with Flower Pots 2011–

Intimate strange: Tamed Outside

Yang Hyosil, Ph.D., aesthetic

"You are nothing to me but countless other little children and you are same as them. And I don't need you and you don't need me. Because to you, I am only a fox like other foxes. However, if you tame me, we need each other. For me, you will be the only person. and for you, I'll be the only fox"

The Little Prince asks a fox he comes across while traveling around the earth about the meaning of the word, 'taming,' and the fox kindly explains him it is to come into a relation with someone: "You are nothing to me but countless other little children and you are same as them. And I don't need you and you don't need me. Because to you, I am only a fox like other foxes. However, if you tame me, we need each other. For me, you will be the only person. and for you, I'll be the only fox." The Little Prince grasps the meaning reminded of the only flower on his planet. With this new word, he is now able to articulate the relationship between him and the flower. He attained an enlightenment: "Yes, now I understand that the flower have tamed me!"

Taming, to come into a relation, to be the only one in the world. Once a flower turns into 'this/the' flower, I am subordinate to you, and we are taken hostages by each other. Then, you become something like insomnia, a trouble, or a ghost that ceaselessly haunts me, and you become my master, my eternal destination. At the end of the world, there always begins the narrative where you are situated. The glance and figuration of our own, the secret by-lane and landscape trodden and viewed by just the two of us are being born. The happy subordination opens the place that has never been before. When you open/close the door leaving the apathy and desolation behind, there is a world for two of us. We plead with each other for love, taming each other. We are enslaved by love. The interior, the secret, intimate, and private space.

The interior is the modern space. The interior emerged as a new space with the rising need of the individual life to be separated from the collective and communal life. The safe interior has been created and been constructed as a private place, keeping the fatigue, lassitude and anxiety Taf the public sphere away. It is in the city where the secrecy, intimacy,

repose, the ideas based on love, as it were, are (re) produced. The traditional community grounded on the big family gradually disappears in the process of modernization and urbanization. It is a (modern) fact that the city was, and is, being (re)developed on the basis of the bourgeois life. The marriage custom emphasized by the familial bonding has been replaced by the romantic marriage of love. The romantic love is the buttress of the bourgeois life, and the enunciation that 'I love you' is that of the genuine marriage. City is the space of the bourgeois life, which idealizes the concept of house with the name of love. We are enslaved or hijacked by love for good, as far as we live in the city, the chain of isolated houses. One who is not in love yet is guilty. Those urbanites who couldn't realize the fantasy of intimate interior unavoidably fall from grace as incompetents, even though they have succeeded in the public sphere. The synchronism of love as a psychological interior and the house as a physical interior. The success of our lives are ultimately assessed by the 'possession' of the love house.

Persons to stuff, the interior, you and I, or we, the space that packs the interior, rooms, living room, restroom, veranda, things to stuff the interior, TV, refrigerator, table, sofa, lapdog, flowerpot, animal companion or plant collections, etc — all these names/ nouns are modern neologisms.

Love is an unapproachable and unattainable fantasy to the apartment-born urbanite. Born isolated, and living as prisoners surrounded by cold and deaf walls, we almost never have chance to 'experience' what it is to live together. The house is to sleep in, you in that room and I in this room. Nowhere, and at no time, are we allowed to share our temperatures. We are under orders to love, though not being able to love. We obey the order of love without feeling what it is to love, while the Little Prince had already come into the relation with the flower without knowing that was taming and love. Love is overflowing in this world, but it stops before the walls on the way to us. Love is the only satisfaction and pleasure, but the walls prohibit us from getting out to the plaza to meet you.

Zoos, botanical gardens, and aquariums are the

sites or the stages of tragedy, agony, and sorrow. While the fox identifies taming with entering into a relationship, we are accustomed to taming without relationship. Zoos, botanical gardens, aquariums, and apartments. We all are great actors of fantasized love who frequently appear in happy dramas, in the interior void of love, temperature, and relationship.

We come back to the private space taking shelter from the coldness, dreariness, and lonesomeness, but the truth we get to face is that we repeat the fatigue of acting pretending that we are intimate with others. An amiable lapdog in an apartment can be the Little Prince tamed by the only flower or an untamable cat can be more appealing for the mysticism, but the image of an animal confined to the interior evokes dreariness overlapping with the human locked up in the urban space. We might, as a paradox of the city life, bear the metaphor of a wanderer who craves for but are incapable of love and who dies in a foreign land failing to reach you beyond the wall, as far as we live in the city. The settlement and the nomadic life coincide. We only drift, reaching nowhere.

Few people dream of escaping from the city, not to mention those who realize it. Nature, barbarism, and the innocence are consumed as products for those who cannot leave the city. While love is impossible, it tries to repress and tame us with saleable products, and too many fantasies and images. What did you purchase or what do you possess among new products available/furnished for the lonely people?

Kim Yujung renders the paradox of the city life with plants, the interior plants that grow in the flowerpot. All her frescos in this exhibition are about interior plants. The life of a plant growing in an artificial condition unconditionally depends on the human, the radical passivity. The plant swayed this and that way by the light, and by the master's sense of interior is the symbol of dependency (deprived of autonomy). The survival of this strange interior plant, for which the master's love is not necessarily beneficial and for

which indifference is not necessarily harmful, might be conceived as the representation of the overlapping of the tamed interior and the untamed exterior, which we can easily find in the mysterious characteristics of a cat. Plants die or survive somewhere between too much love and too much indifference. The interior plants are the peaceful green inner landscapes desired by people who struggle to be set free from the barrenness and the dryness/aridity of the outside world. The plants dying at any time regardless of the master's noticing nevertheless verify that the peaceful interior is a fantasy. There is no need to worry because the empty pot will soon be filled with a new plant with vivid colors. With the infinite possibility of replacement, the city, in that sense, realized the world of abundance where the life evolves into a product.

The landscape or still-life paintings starring plants are in general related to the observation, through which the gazer can reach mental stability and meditation. Ornamental plants take a role of soothing the fatigued hearts. That is the way the interior plants sold, survive, and are spoken of. The plants in Kim Yujung's screen do not represent the so-called feminine lyricism we all know as being vulnerable and tender. If any, only *Gray garden* maintains the conventional observation among others as if it is transferred to the interior from the genre of landscape paintings, thus dominating the screen through the stable gaze of the subject. Most of her other plants are brought to the fore as in close-up. This close-up of hers breaches the tacitly agreed distance necessary for the ordinary and conventional observation on the plants. If you say her screens are ominous, it must be due to her being too close to the plants. She does not treat the plants as (pictorial) objects. She reaches further than the convention of observation by getting too near to the plants. Observation allows us to love and enjoy the object, whereas getting extremely close to the objects reveals the pain and anxiety on the other side. The observation justifies the structure of domination and subordination sustained by the distance, while the confrontation which can even be called invasion erases the distance between you

and me by disturbing the eyes, and thus generates anxiety and fear. We are expelled, as it were, from the position of the stable subject, and cannot help being overwhelmed by the plants.

Kim Yujung seems to have felt the sound or voice in the silence of the interior plants. She forms the images of agony and anxiety of the prisoner locked up in the interior, deprived of his/her own specificity. Kim's screen shows powerful scratch-like expressions of fresco, painting on the plaster before it dries and letting it fix. Her works this time generate tension, anxiety, and fear on the screen, because of the protruding plants arranged as if they try to overwhelm us, not as healing images. Kim transfers the plants from the position of safely enjoyable object for the subject to the site of anxiety, tension, and strike. Some might say Kim's screen is grotesque and ominous, but it is because in her screen flow the energy and tension that refuse to be dominated by the observing eyes.

This is reinforced by concealing, minimizing, or even erasing the flowerpot that is the ground for the survival of interior plants. The plants (almost) without pots refuse the conventional gazing. The representation of the plant without its basis, as if it floats in the air, or as if rootless, reveals the author's desire to arrive at the verisimilitude of the plant that is beyond the idea of nature caught in the interior and outside the romantic, humane, and lyric nature, and that we do not know of at all. The author seems to be longing for the state of the difficult and even impossible relationship beyond the convenient, disinterested, amiable, familiar, and technical relationship. That is to say, Kim Yujung's plants are of the confrontation with the other, or of the other's unfamiliar and strange life that can only be encountered in the process of subtracting the plants we know. The metonymy of desire that feeds on the uncanniness of the familiarity among familiar people!

Saint-Exupéry believes love as taming which involves the break down of the individual and his/her

autonomy. The Little Prince is always here in that way. We are always either young or unhappy because of the dream, the fantasy of establishing relationships, being tamed, waiting and becoming special. The truth of life that we disregard in the expense of things which haven't arrived yet. It must be the matter of the place where the metaphors of subordination and taming take forms. We imagine tender and peaceful encounter surrounded by concrete walls that construct the interior, not in the meadow where the Little Prince and the fox meet. It results from that we are the creatures of hope who can never completely be subordinated by the meaningless life, and who can never be tamed. Kim Yujung's plants capture our contradiction, our paradox of still 'waiting' for something of which we already know much with affected ignorance.

친밀한 낯선: 길들인 바깥

양효실, 미학 박사

어린 왕자가 지구별을 여행하던 중 만난 여우는 길들인다는 단어의 의미를 묻는 왕자에게 그건 관계를 맺는다는 뜻이라며, "넌 아직 나에겐 수많은 다른 아이들과 다를 바 없어. 그냥 평범한 아이에 지나지 않아. 그래서 난 네가 필요 하지 않고. 너 역시 마찬가지일거야. 난 수많은 다른 여우와 같이 그냥 한 마리 여우에 지나지 않아. 하지만 네가 나를 길들인다면, 나는 너에게 이 세상에 오직 하나밖에 없는 존재가 될거야"라고 친절하게 설명한다. 어린 왕자는 자신의 유일한 꽃을 떠올리며 그 말을 이해한다. 어린왕자는 새 말로 자신과 꽃의 관계를 설명할 수 있게 된다. 꽃은 나를 길들인 거였구나!

길들인다, 관계를 맺는다, 이 세상에 하나 뿐인 존재가 된다. 꽃이 '이/그' 꽃으로 돌변하는 순간, 나는 너에게 종속되고 우리는 서로에게 볼모가 된다. 너는 내게서 떠나지 않는 불면, 두통, 근심, 유령 같고, 너는 나의 주인이고 영원한 목적지이다. 세상의 끝에는 언제나 네가 있는 서사가 쓰여지기 시작한다. 둘 만의 눈짓, 비유, 골목, 풍경이 탄생한다. 행복한 종속은 지금껏 없었던 장소를 개방한다. 바깥 세상의 무관심, 황량함을 뒤로 하고 문을 열면/닫으면 둘을 위한 세상이 있다. 우리는 그곳에서 자기를 사랑해달라고, 제발 길들여달라고 애원한다. 우리는 사랑의 노예이다. 은밀한, 친밀한, 사적인 공간, 인테리어.

인테리어는 근대적 공간이다. 실내는 개인의 삶이 집단적이고 공동체적인 삶과 분리되어야 할 필요가 대두하면서 새로운 공간으로 출현한다. 공적인 것의 피로와 권태, 불안과 분리된 안전한 실내가 창조되고, 사적인 것의 장소로 구조화된다. 은밀함, 친밀함, 휴식, 사랑에 근거한, 아니 그런 관념들을 (재)생산해내는 장소가 바로 도시이다. 대가족 중심의 전통적인 공동체는 근대화, 도시화 과정에서 점점 사라진다. 도시 (재)개발이 중산층 부르주아의 삶을 모델로 한다는 것은 (근대적)사실이다. 집안들의 유대에 토대한 결혼을 남녀 두 사람의 사랑에 근거한 결혼이 대체한다. 낭만적 사랑은 부르주아의 삶의 지지대이며, '나는 너를 사랑한다'는 참된 결혼의 지지대이다. 도시는 부르주아적 삶의 장소이고 부르주아적 삶은 사랑을 통해 집의 관념을 이상화한다. 고립된 집들의 연쇄인 도시에 사는 한, 우리는 영원히 사랑의 노예이고 사랑의 볼모이다. 아직 사랑하지 않는 자는 유죄이다. 친밀한 내부의 환상을 실현하지 못한 도시인은 공적인 장에서 아무리 성공했다고 해도 무능한 존재로 추락한다. 심리적 인테리어로서의 사랑과 물리적 인테리어로서의 집의 동시성. 우리의 삶의 궁극적 성공은 사랑의 집을 '소유'했는가에 있다.

인테리어를 채우는 사람, 나와 너, 혹은 우리, 인테리어를 채우는 공간, 방, 거실, 화장실, 베란다, 인테리어를 채우는

물건들, TV, 냉장고, 탁자, 소파, 혹은 애완견이나 화분들 등속. 혹은 반려견이나 반려식물들-이 모든 이름/명사는 근대의 신어(新語)이다.

아파트에서 태어난 도시인에게 사랑은 도달하기 어려운, 심지어 불가능한 환상이다. 우리는 고립되어 태어나, 차갑고 냉담한 벽 사이에 갇힌 수인(囚人)으로 살기에 함께 산다는 것을 '겪을' 기회가 거의 주어지지 않는다. 집은 잠을 자는 곳이고, 너는 그 방/그곳에서 나는 이 방/이곳에서 잔다. 우리의 온도는 나누어질 시간도, 장소도 허락받지 못했다. 우리는 사랑할 수 없으면서 사랑하라는 명령에 붙들린 노예들이다. 어린왕자는 그것이 길들임, 사랑인지도 모르면서 자신의 유일한 꽃과 이미 관계를 맺었지만, 우리는 사랑이 무엇인지 느낄 새도 없이 사랑의 명령에 복종한다. 세상에 사랑은 너무나 많지만, 사랑은 우리에게 오다가 벽에서 멈춘다. 사랑은 유일한 행복이고 기쁨이지만, 우리는 벽 때문에 너를 만나러 광장으로 나갈 수 없다. 동물원, 식물원, 수족관은 길들임의 비극, 고통, 슬픔의 장소이고 무대이다. 여우는 길들임과 관계맺음이 같다고 말하지만, 우리는 관계없는 길들임에 익숙하다. 동물원, 식물원, 수족관, 그리고 아파트. 사랑없는, 온도없는, 관계없는 인테리어들에서 우리는 사랑의 환상을 연기하는, 행복한 드라마에 자주 등장하는 배우들이다.

우리는 세상의 냉정함, 황량함, 쓸쓸함을 피해 사적인 공간으로 돌아가지만 거기서 우리는 사실은 잘 모르는 사람들끼리 친밀한 척 연기하는 피로를 반복한다. 아파트에 사는 사랑스런 강아지는 유일한 꽃에 길들여진 어린왕자 같을 수 있지만, 고양이는 개만큼 길들여지지 않는 신비 때문에 더 매력적이겠지만, 인테리어에 갇힌 동물들의 모습은 도시에 갇힌 인간과 중첩되면서 쓸쓸함을 자아낸다. 도시에 사는 한 우리는 도시적 삶의 역설로서 사랑에 목마르지만 사랑에 무능한, 벽 너머에 있는 너에게 이르지 못하고 객사하는 유랑인의 은유를 떠맡아야 할지 모른다. 정착과 유목이 겹친다. 우리는 흘러다닐 뿐 영영 이르지 못할 것이다.

도시 바깥으로의 도피를 꿈꾸고, 그것을 실현하는 이들은 극소수이다. 자연, 야만, 순수는 도시를 떠날 수 없는 사람들을 위한 상품으로 소비된다. 사랑은 불가능하지만 사랑은 너무나 쉽게 팔리는 상품으로, 너무 많은 환상이자 이미지로 우리를 억압하고 길들이려 든다. 외로운 사람들을 위해 마련된/비치된 신상 중 당신은 어떤 것을 샀고, 갖고 있는가?

김유정은 도시적 삶의 역설을 식물, 화분에 사는 인테리어 식물을 통해 드러낸다. 작가가 이번 전시에서 보여줄 프레스코화는 모두 실내 식물이 소재이다. 인공적인 조건에서 발육, 생장하는 식물의 생존은 절대적으로 사람에게 달려 있다. 철저한 수동성. 이리저리 빛을 따라, 주인의 인테리어 감각에 따라 옮겨지는 식물은 비자유(非自由)의 상징이다. 주인의 사랑이 꼭 식물에게 이롭지도, 무관심이 꼭 해가 되지도 않는 기이한 실내 식물의 생존은, 어찌 보면 고양이가 경계일 이미 길들여진 안과 아직 길들여지지 않은 바깥의 중첩을 재연하는 것 아닐까. 너무 많은 사랑과 너무 큰 무관심 사이에서 식물은 살거나 죽는다. 실내 식물은 바깥 세상의 황량함과 건조함에서 어떻게든 벗어나고픈 사람들이 욕망하는, 평화롭고 푸르른 내면(自然) 풍경이다. 그럼에도 언제든 주인이 알게 모르게 죽어가는 식물들은 안전하고 평화로운 내부가 환상임을 증명한다. 빈 화분은 언제든 새로운, 강렬한 색상의 싱싱한 식물로 또 채워질 것이니 걱정할 필요는 없다. 무한한 대체가능성, 그런 점에서 도시는 생명이 상품으로 진화한 풍요의 세계를 실현했다.

식물이 등장하는 풍경화나 정물은 일반적으로 바라봄을 통해 심적 안정과 명상에 도달하려는 관조와 연관된다. 관상용 식물은 지친 마음을 달래주는 일종의 치유 역할을 맡는다. 그것이 흔히 실내 식물이 팔리고, 생존하고, 이야기되는 방식이다. 그러나 김유정의 화면에 등장하는 식물은 우리가 익히 알고 있는 연약하고 부드러운 이른바 여성적 서정성을 대변하지 않는다. 풍경화 장르를 실내로 옮겨 온 듯한 <Gray Garden>이 그나마 관습적인 관조의 시선을 견지하고 있기는 하지만, 그래서 안정적인 주체의 시선이 화면을 장악하고 있다면, 대부분의 식물은 클로즈업으로 전경에 배치되어 있다. 김유정의 클로즈업은 식물에 대한 일상적이고 관습적인 바라보기에 필요한 거리를 위반한다. 그녀의 화면이 불길하다면, 이는 그녀가 식물에 너무 가까이 다가가기 때문이다. 그녀는 식물을 하나의 (회화적) 오브제로 처리/대우하지 않는다. 그녀는 식물에게 너무 가까이 다가감으로써 관조의 관습을 넘어간다. 관조는 대상을 사랑하게 즐기게 하지만, 극도의 다가감은 그 이면에 감춰진 대상의 고통, 불안을 드러낸다. 관조는 거리에 의해 유지되는 지배와 종속의 구조를 정당화하지만, 침입에 가까운 대면은 시선의 교란을 통해 나와 너의 거리를 지우고, 그 결과 불안과 공포를 발생시킨다. 우리는 말하자면 안전한 주체의 자리에서 밀려나고, 식물의 존재에 압도당한다.

김유정은 실내 식물의 침묵에서 (목)소리를 느낀 듯하다. 그녀는 자신의 삶의 고유함을 박탈당하고, 인테리어에 갇힌 수인의 고통과 불안을 이미지화한다. 김유정의 화면은 회벽이

마르기 전에 채색하여 고착하는 프레스코의 스크래치적
표현이기에 강렬하다. 특히 이번 작업은 순종적이고
평화로우며 치유적인 이미지로서의 식물 대신에 앞으로
튀어나와 우리를 압도할 것처럼 배치된 식물들로 인해 화면에
긴장, 불안, 공포를 발생시킨다. 김유정은 바라보는 주체가
안전하게 즐길만한 오브제의 지위에서 긴장과 불안, 엄습의
장소로 식물을 옮겨 놓는다. 그녀의 화면이 그로테스크한,
불길한 느낌을 주는 것은 화면이 시선의 지배를 거부하는
에너지와 긴장을 통해 움직이기 때문이다.

　　이는 그녀가 실내 식물의 생존에 토대가 되는 화분을 거의
지워버리고 감추고 최소화하는 데서 더 강화된다. 화분이
(거의) 사라진 식물들은 관습적인 시선에 의한 바라보기를
거부한다. 마치 공중을 부유하는 듯, 뿌리 없이 떠다니는 것
같은, 토대를 잃은 식물의 재현은 인테리어에 포획당한 자연의
관념 너머, 낭만적인 인간적인 서정적인 자연 바깥의, 우리가
전혀 알지 못하는 식물의 사실성에 이르려는 작가의 욕망을
드러낸다. 작가는 편안한, 무관심한, 사랑스러운, 익숙한,
기계적인 관계를 넘어서 관계의 어려움, 관계의 불가능성에
이르고 싶은 듯하다.
김유정의 식물은 우리가 '아는' 식물을 지워나가는, 즉
빼기의 과정에서야 만날 수 있는 낯설고 기이한 타자의 삶에
대한, 혹은 '타자성'과의 대면에 대한 것이다. 친밀한 타인들
사이에서 친밀함의 낯섬을 먹고 자라는 욕망의 환유!

　　생텍쥐베리(Antoine de Saint-Exupéry)는 사랑을 개인과
개인의 자유가 무너지는 길들임이라고 말한다. 어린왕자는
그렇게 늘 우리 곁에 있다. 관계를 맺고 길들여지고 기다리고
특별해지는 것에 대한 우리의 꿈, 환상 때문에 우리는 늘
젊거나 아니면 늘 불행하다. 아직 없는 것 때문에 우리가
외면하는 삶의 진실, 그건 종속과 길들여짐의 은유가 어느
장소에서 구체화되느냐의 문제일 것이다. 여우와 어린왕자가
만나는 들판이 아닌, 벽과 벽이 만나 실내를 이루는 콘크리트
이쪽에서 우리는 연약하고 부드럽고 평화로운 만남을
상상한다. 그것은 우리가 아직도 무의미한 삶에 완전히
복종하고 길들여지지 않는, 그럼에도 희망하는 존재들이라는
것에 기인한다. 김유정의 식물은 바로 그런 우리의 양면성,
너무 잘 알고 있지만 애써 모른 채 하며 여전히 '기다리는'
우리의 역설을 포착한다.

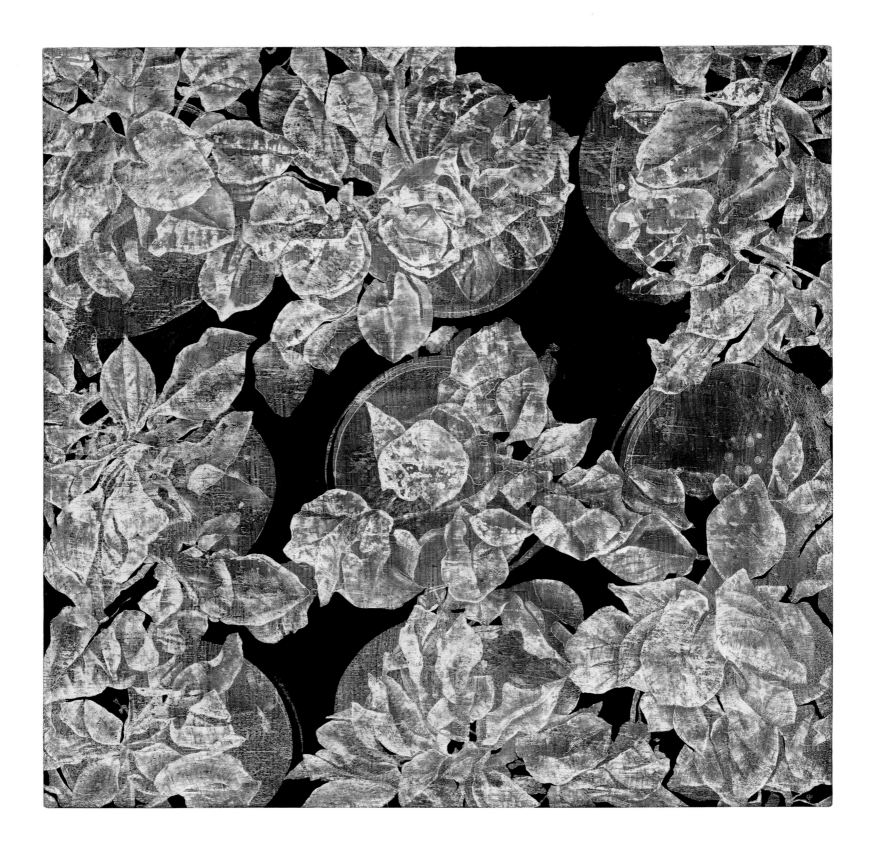

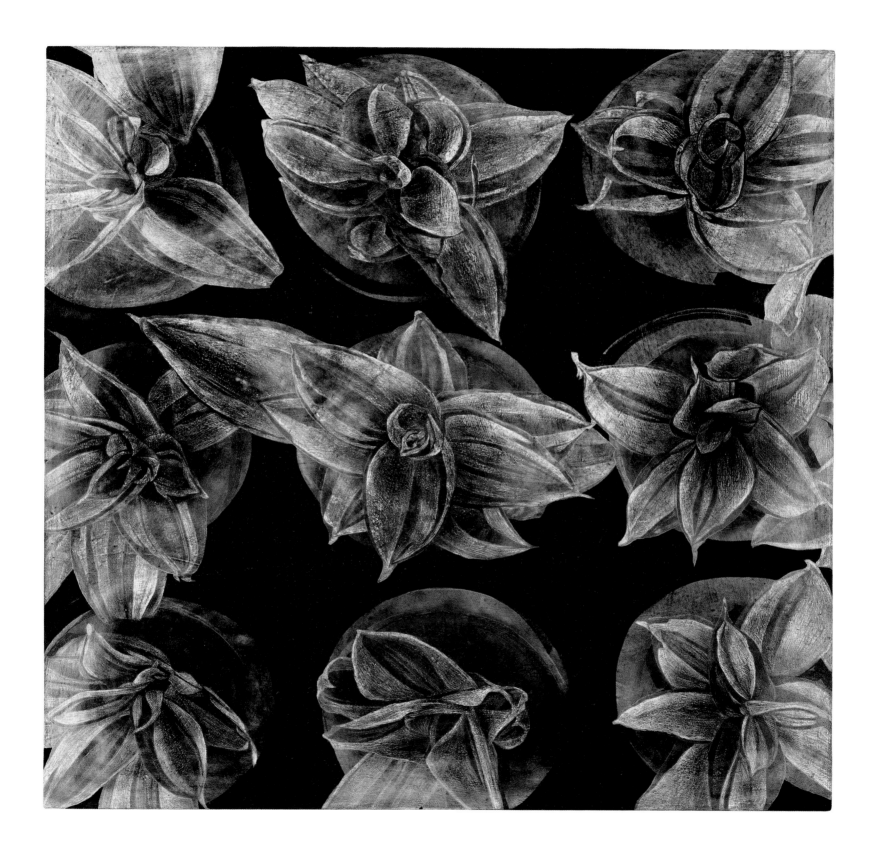

Frameworks

2011
fresco, scratch on lime wall
70x70cm

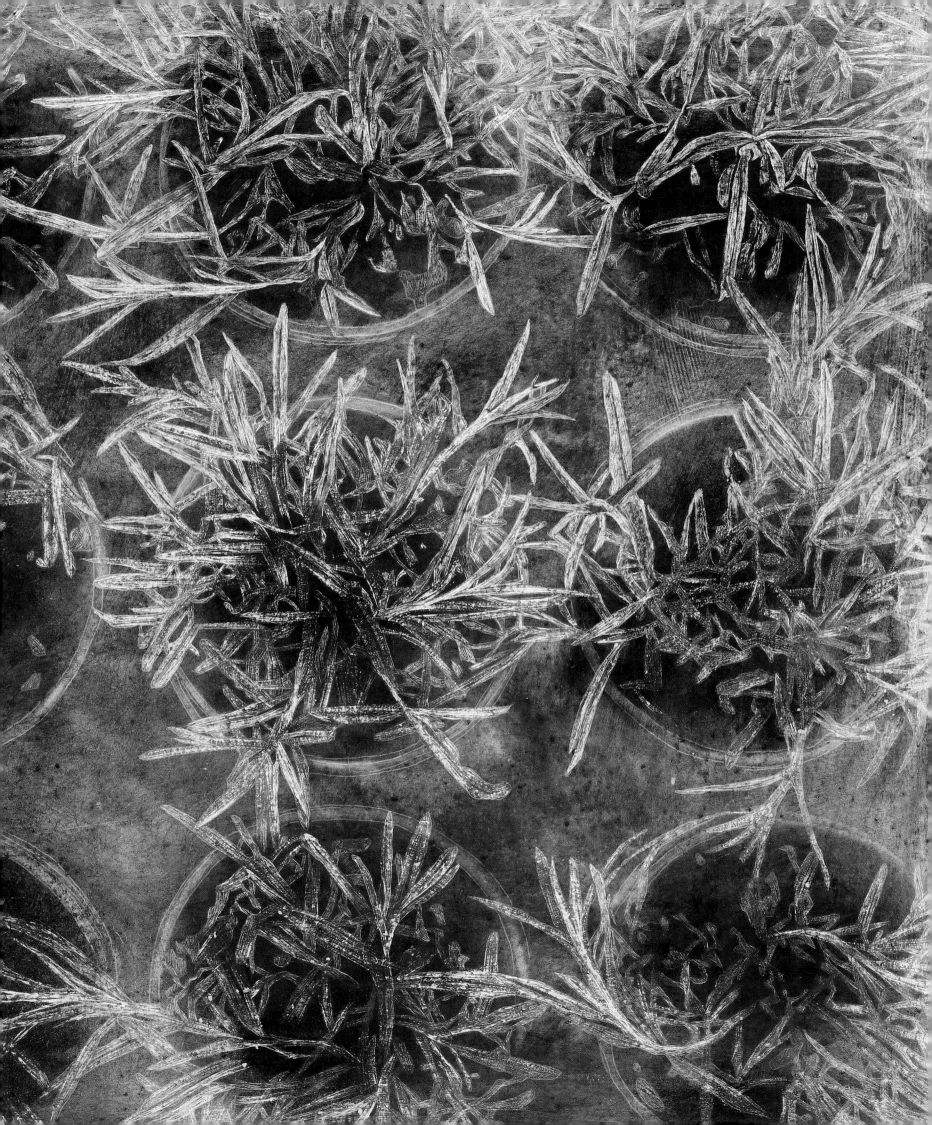

Gray Garden

2011

fresco, scratch on lime wall

113.5x162cm

private collection

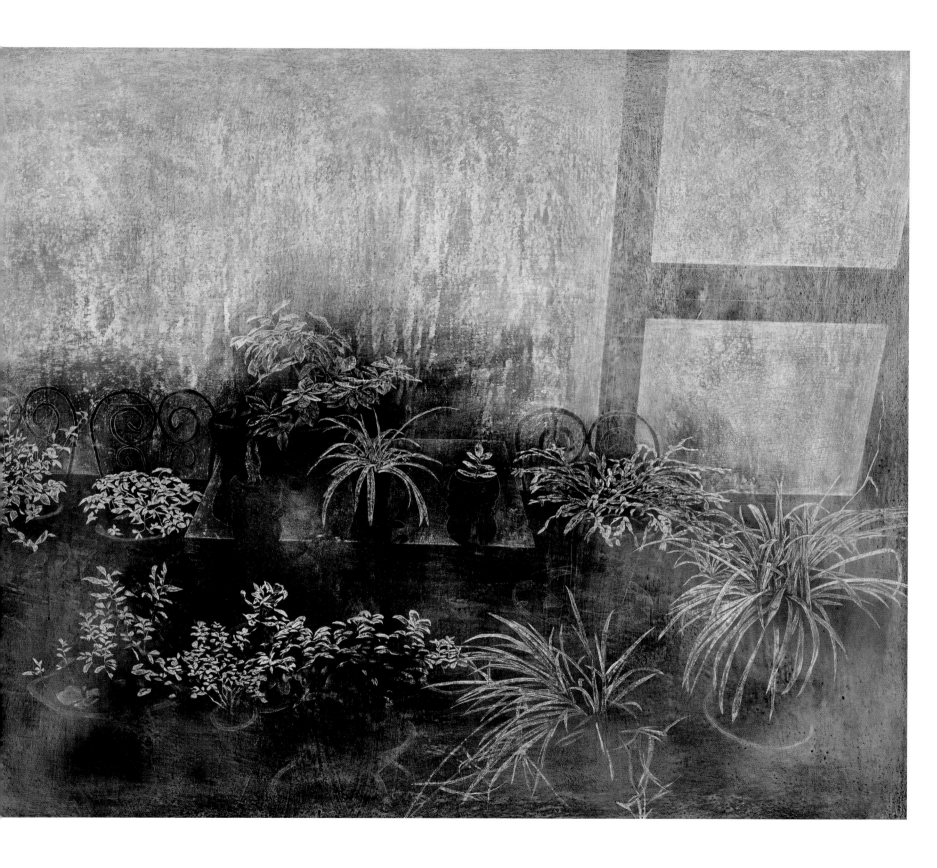

Gray Garden

2011
fresco, scratch on lime wall
80x80cm
private collection

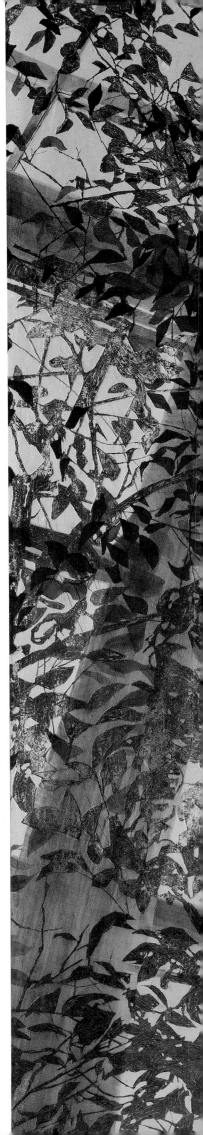

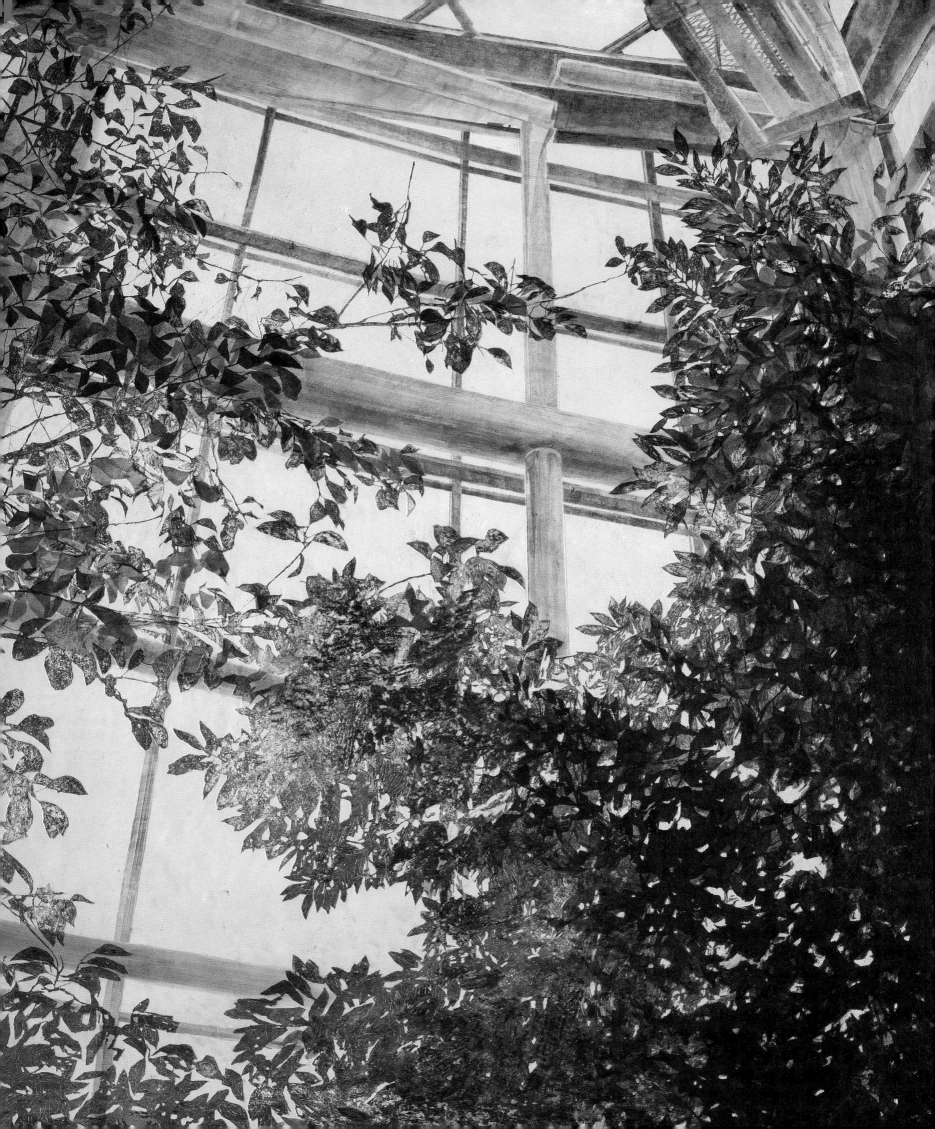

Floating Plants

2011
fresco, scratch on lime wall
85x85cm
Incheon Foundation for Arts and Culture collection

I am quite interested not only in visual representation, but also in representing the interior life and perceptions of the artist, as well as objects that are detected from an idiosyncratic perspective. So when I am creating an artwork, I'm not so much emphasizing the transferring of the object's external appearance as I am assigning new meaning to the object and reconfiguring it to represent the mental image within. In this sense, painting can be seen as taking place where a kind of meeting occurs between mental sensitivity and substance. This shows how subjective thought is expressed by means of the object that appears in the painting. As part of this approach, I assign symbolic meaning to the object, focusing my process on metaphorical representation to indirectly show what is inside. For most of us, a metaphor is a figurative expression that makes use of a semantic shift, where an object is likened to another object.

The images recreated in the work are reconstructed through a process of traumatic acts within the canvas, using metaphor to expand the strata of lives marked by injustice and contradiction. Within the work, the images operate as allusive allegories, transforming and deconstructing forms and effecting a différance of meaning. It is less a matter of transforming reality than imitation that substitutes for the reality, where the strategy of imitation is itself an allusive allegory for the purpose of decontextualization. The representation of image as both metaphor and metonymy in the work enables multiple readings. It is an allegory of lives that are unstable and sometimes precarious, a metaphorical representation of the threat posed to our existence by the "other" as well as a metaphorical representation of the anxiety we feel over being influenced by the other.

There is also a technique-based metaphor found within my fresco work. Traditional fresco technique involves applying colors with paints before the plaster dries. This technique is incorporated and expanded upon in a modern sense, where the engraved lines presented through fresco scratching are an external representation of internal scars. In other words, the scratches are the result of the violent act inflicted by the engraving itself, where the gouges can be explained as "wounds" or "traumas." The particles that make up the surface are turned to wounded flesh through a process of gouging, seeping, and scraping—which may be described as a "metaphor of technique." My work adopts an approach where I'm sincerely recording life as I perceive it while living in the contemporary era, while also using emotional thinking to interpret it, metaphorically inscribing and fixing my own (human) thoughts about these times on the wall's surface. By metaphorically representing internal psychology, I am confronting wounds, interpreting them in new ways, and overcoming them, so the process possesses multiple layers of meaning. In the end, this process circles into a tool for healing scars, opening up possibilities for the viewer to connect with the artist.

나는 시각적인 표현뿐만 아니라 예술가의 내면과 인식, 그리고 개성 있는 관점으로 감지된 사물을 재현하는 데 관심이 많다. 그리하여 사물의 외형을 옮기는 것에 가치를 두는 것이 아니라 그 내면의 심상표현을 위해 대상에 새로운 의미를 부여하고, 그것들을 재구성하여 작품을 완성한다. 이렇듯 그림을 그린다는 것은 일종의 정신적 감수성과 물질의 만남에서 이루어진다고 볼 수 있다. 이것은 주관적 사고가 회화 속에 나타난 대상을 통해 표출되고 있음을 나타낸다. 그 표현 방법의 일환으로 본인은 대상에 상징적인 의미를 부여하고 간접적으로 자신의 내면을 표현하는 은유적 표현에 관심을 갖고 작업하였다. 은유는 우리 대부분에게 의미론적 전이를 통해, 즉 하나의 대상을 또 다른 하나의 대상에 견주는 비유적 표현이다.

작품에서 재현되는 이미지들은 화면 속에 외상적 행위 과정을 통해 재구성함으로써 비의와 모순으로 점철된 삶의 지층을 은유를 통해 확장하는 것이다. 작품 속의 이미지들은 형식을 변형시키거나 해체하고 의미를 차연시키는 은유적 알레고리로 작용한다. 그것은 현실을 변형하기보다 현실을 대치하는 모방이며, 모조의 전략 역시 탈맥락화를 위한 은유적 알레고리이다. 작품에서 은유이자 환유인 이미지의 재현은 다의적인 해석을 가능케 한다. 불안정하고 때론 위태롭기도 한 삶의 알레고리, 자신의 존재가 타인으로부터 위협을 받는 것에 대한 은유적 표현이며 동시에 타인으로부터 영향을 받는 것에 대한 불안한 심리에 관한 은유적 표현이다.

나의 프레스코에는 기법적인 은유도 내재되어 있다. 전통적 프레스코 기법은 회벽이 마르기전 안료로 채색하여 고착하는 것이다. 이 기법을 차용하여 현대적으로 수용하여 확장한, 프레스코의 스크래치적인 표현으로 그려진 음각의 선들은 내면의 상처를 외부로 표출하는 것이다. 다시 말해 음각 자체가 폭력적 행위를 가하여 생긴 긁기이고 파인 그것은 바로 '상처', 즉 '외상'이라고 설명될 수 있다. 즉 표면을 구성하고 있는 입자들은 파이고, 스미고, 긁히는 일련의 과정을 통해 상처투성이의 피부로 둔갑하는데, 이는 기법적 은유라고 할 수 있다. 나의 작품은 동시대를 살아가면서 느끼는 삶에 대한 진지한 기록하기와 감성적 사유를 통해 읽어내는 방식으로써, 동시대에 대한 본인(인간)의 상념을 벽면에 은유적으로 각인하고 고착하는 것이다. 심리적인 내면을 은유화하는 것은 상처에 직면하고, 상처를 새롭게 해석해서, 상처를 극복하는 과정으로써 다의적 의미를 가진다. 결국 이러한 과정이 상처를 치료하는 '치유의 도구'로 순환되면서 관람자로 하여금 작가와의 소통의 가능성을 열어두는 것이다.

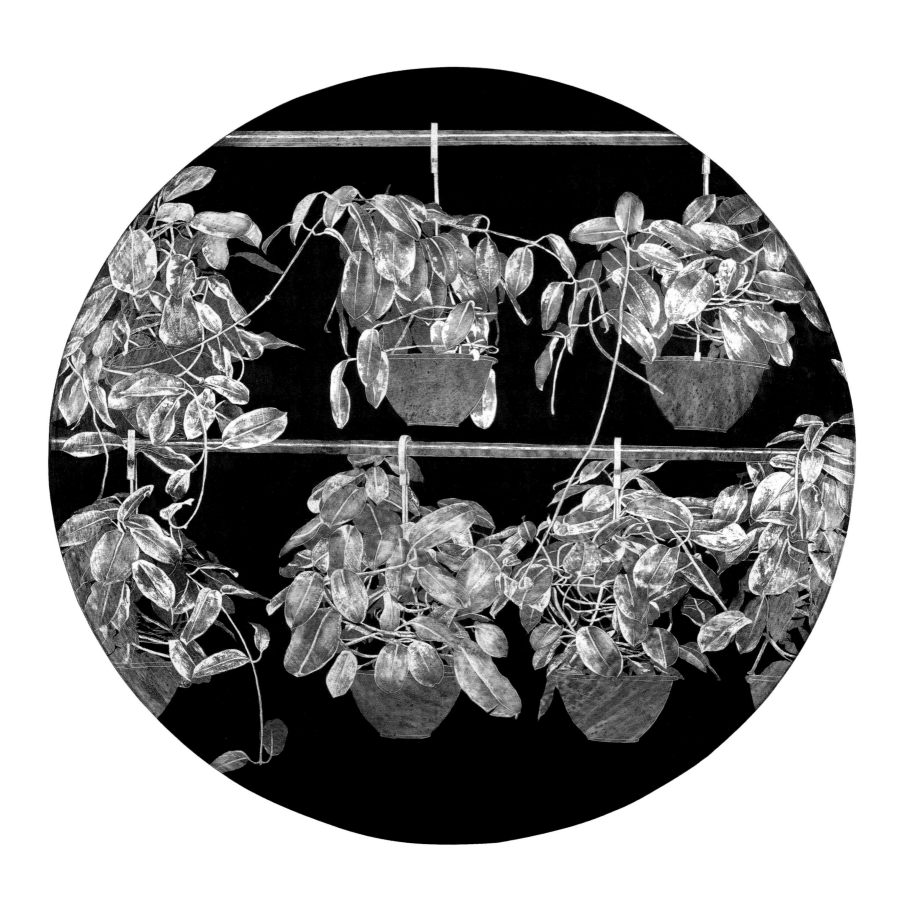

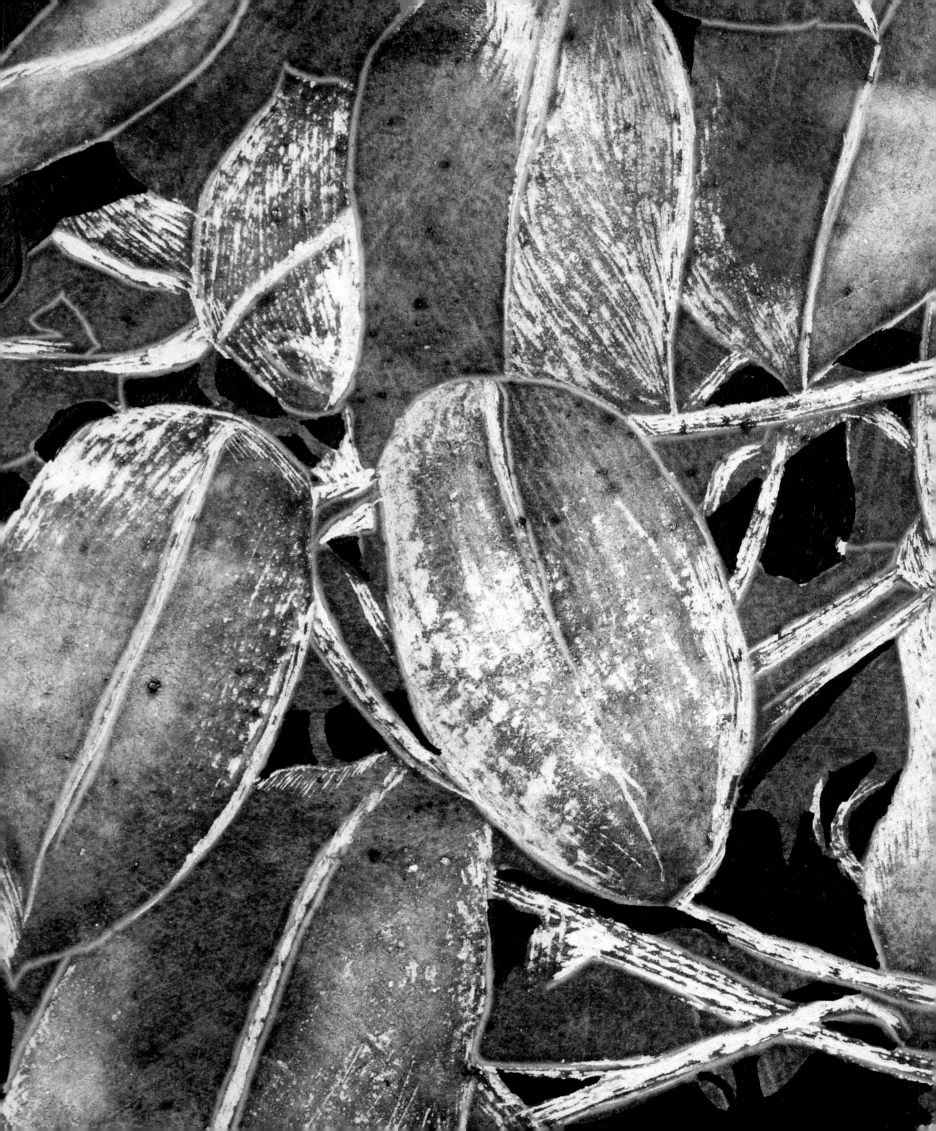

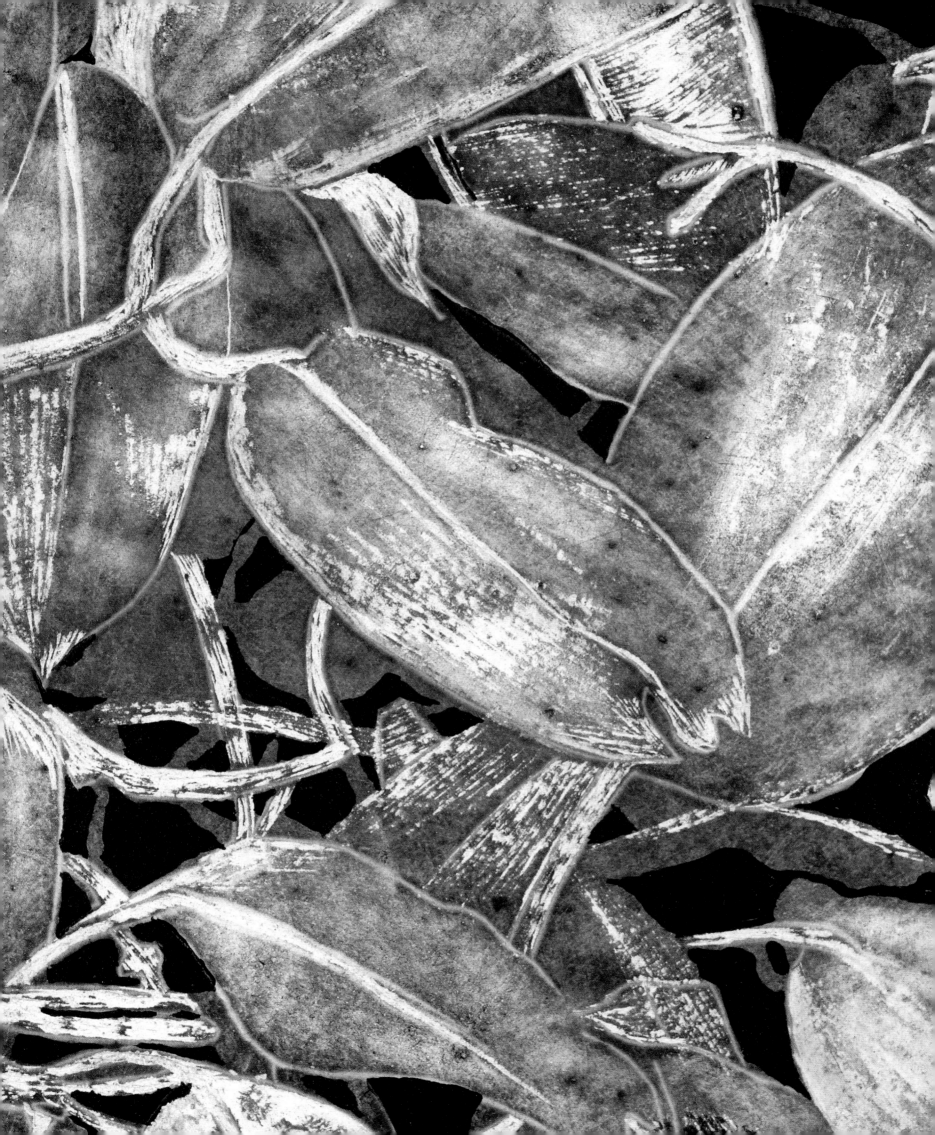

Overwhelmed

2008
fresco, scratch on lime wall
50x105cm
Sungmoon Book collection

Silhouette

2008
fresco, scratch on lime wall
50×105cm

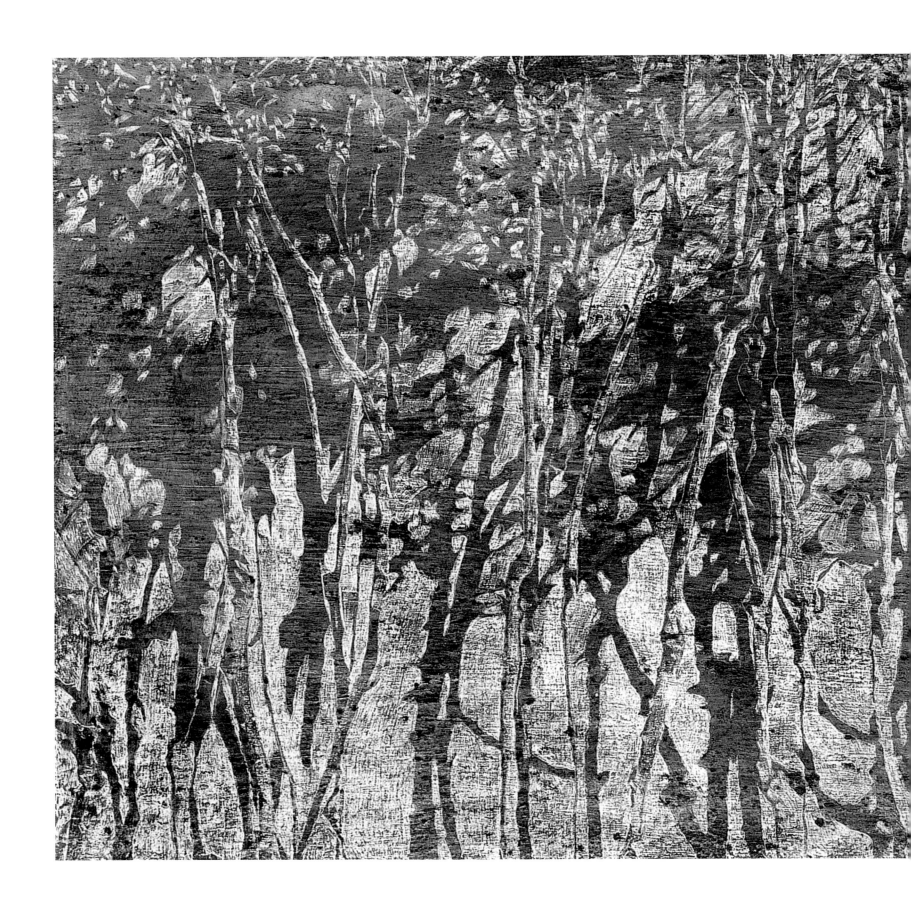

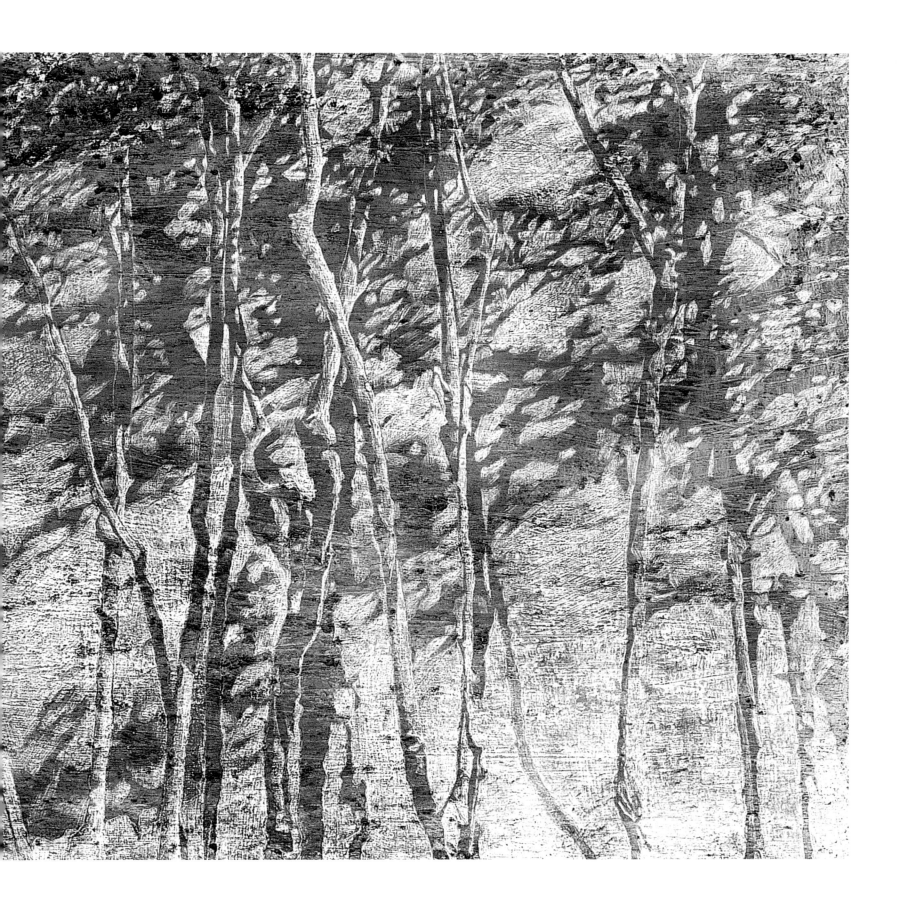

Silhouette

2009
fresco, scratch on lime wall
105x105cm
First Fire & Marine Insurance Co., Ltd. collection

Skin of the Leaf

2011
fresco, scratch on lime wall
50x50cm
private collection

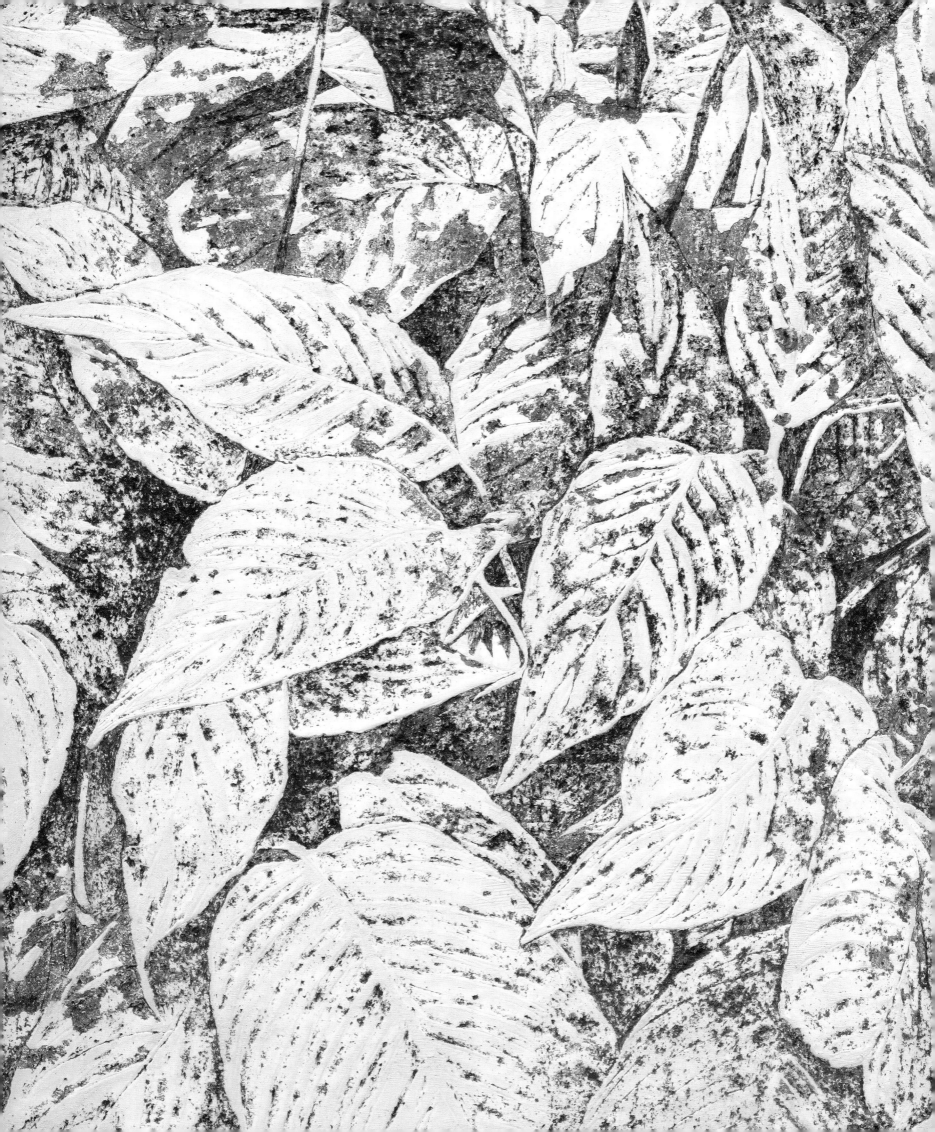

The Invisible Forest
보이지 않는 숲

2005
fresco, scratch on lime wall
120x183cm

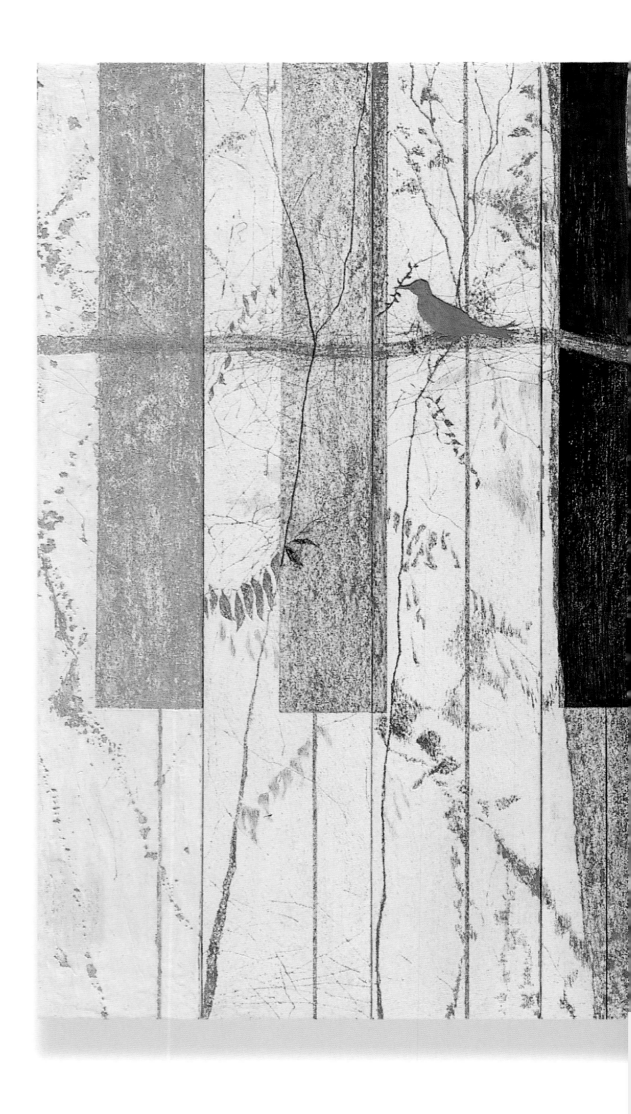

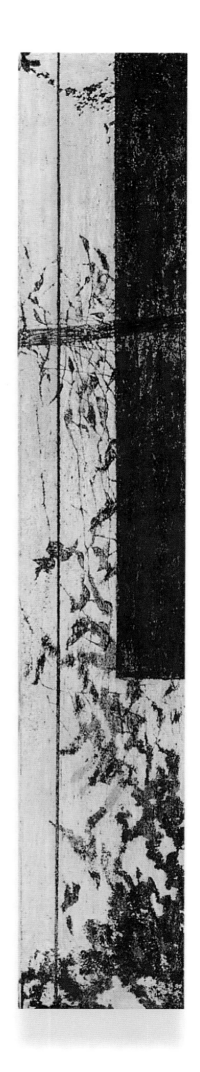

Appendix

Kim Yujung

Born in 1974

Education

Ph. D. in Painting, Dankook University

M. Ed in Art Education, Korea University

BFA in Painting, Dankook University

Solo Exhibitions

2021	*Red Air and Afterimage of the Edge,* Kumho Museum of Art, Seoul, Korea
2020	*Submerged Vessel*, Jeongseojin Art Cube, Incheon, Korea
2018	*Plants Also Have Power*, Sophis Gallery, Seoul, Korea
2017	*Breath Perspective*, Gallery Meme, Seoul, Korea
2016	*Caved Grove*, Incheon Art Platform, Incheon, Korea
	Grove, Sophis Gallery, Seoul, Korea
2015	*Survival Needs*, Gallery DOS, Seoul, Korea
2014	*Reversed Landscape*, Sunkwang Museum of Art, Incheon, Korea
2013	*Silent Garden*, E-Land Space, Seoul, Korea
2012	*Kim Yujung Fresco Exhibition*, Shinsegae Centum City, Busan, Korea
2011	*Landscape with Flower Pots*, Gallery Grimson, Seoul, Korea
	Upside-downed Inside, Shinsegae Gallery, Incheon, Korea
2008	*Skin of the Roof*, Insa Art Center, Seoul, Korea
2006	*China International Art Festival*, Shandong, China
	Kim Yujung Fresco Exhibition, JM Gallery, Shanghai, China
	Carving the Desire, Space Beam Gallary, Incheon, Korea
2005	*Shadow Unable to Behold,* Shinsegae Gallery, Incheon/Gallery Indeco, Seoul, Korea
	Unable to Hold a Shadow, Jung Gallery, Seoul, Korea
2003	*Reading the Wall and Shadow*, Kwanhoon Gallery, Seoul, Korea

Group Exhibitions

2022 *Differently, A little closer, 3 Person Exhibition,* Uijeongbu Art Library
Exhibition hall, Uijeongbu, Korea

Technique of Healing, MUSEUM 1, Busan, Korea

2021 *Holocene Future*, Chungmu Art Center Gallery, Seoul, Korea

Moka Palette, Mocha Garden Art Museum, Namyangju, Korea

a mark II-Unfamiliar Signal, Tilted Target, Samyuk Building, Seoul, Korea

The Time of Water and Wind, Daecheongho Museum of Art, Cheongju, Korea

The 6th Art Festa Jeju: The Biographies of San-zi, Sanjicheon Gallery, Jeju, Korea

ONOOOFF, Busan Museum of Art, Busan, Korea

Sounds of the *Blue Marble: Mourning the Anthropocene,*
Seoul National University Museum of Art, Seoul, Korea

The 21st-century Optimists, Art Centre Art Moment, Seoul, Korea

Republic of Fragrance, Jeongeup Museum of Art, Jeongeup, Korea

The 8th Amado Annualnale, Amado Art, Seoul, Korea

Blue Art Fair, Paradise Hotel, Busan, Korea

2021: INTO THE FOREST, Space 445, Seoul, Korea

Common Land, Kim Yujung×Koo Kijeong Duet Exhibition,
Cultural Space L.A.D, Seoul, Korea

2020 *Time Passing Through*, Incheon Art Platform, Incheon, Korea

*Society in the Individual Age_National Museum of Modern and Contemporary
Art Artbank Collection Exhibition,* Uijeongbu Art Library Exhibition hall,
Uijeongbu, Korea

Make Art, Palette Seoul, Seoul, Korea

2019 *Dear Plant, Loose Solidarity,* Soda Art Museum, Hwaseong, Korea

Unexpectedly Meet Green, Suwon Museum of Art Art Space Gwanggyo,
Suwon, Korea

Asia Art Connection, Eugene Gallery, Seoul, Korea

Re-classification: Night Leads to Night, Suwon Ipark Museum of Art,
Suwon, Korea

2018 *2018 Artmining Seoul*, DDP, Seoul, Korea

Wonderland, Gallery Geo, Incheon, Korea

HELP EARTH HELP US_Our House, The Earth, Goyang Aram Nuri
Aram Museum, Ilsan, Korea

Today Says Tomorrow: A Story about Life and Memories,
Insa Art Center, Seoul, Korea

Art Project Ulsan 2018 ICPU/18 WAVE, Gallery Raon, Ulsan, Korea

2018 Art Busan Art Fair, BEXCO, Busan, Korea

New Collection Exhibition, Busan Art Museum, Busan, Korea

2017 *FRACTAL,* Shinsegae Gallery, Seoul, Korea

Global Art Collaboration 2017, COEX, Seoul, Korea

Two Walkways, Art Space In, Inchoen, Korea

Yeosu International Art Festival-Tong, Yeosu Expo International
Exhibition Hall, Yeosu, Korea

Collection Thematic Exhibition-Breath, Seongnam Arts Center Cube
Art Museum, Seongnam, Korea

Alleyway Project by No Roof Gallery, Woori Art Museum, Inchoen, Korea

The 7th Incheon Art Platform Resident Artists Exhibition, Incheon Art
Platform, Incheon, Korea

5 Artists' HIGH NOON, Shinhan Gallery, Yeoksam, Seoul, Korea

2016 *Artist's Attitude Toward Labor-Wave Incubating,* Inchoen Art Platform,
Incheon, Korea

House Made by Wind, Shinsegae Gallery, Incheon, Korea

Secret Garden, Seoul Art Museum, Seoul, Korea

IN-spire, Art Space In, Incheon, Korea

Sensible Reality, Seoul Citizen Hall, Seoul, Korea

WET PAINT, Incheon Art Platform, Incheon, Korea

Breath of the Forest, Shinsegae Gallery, Incheon, Korea

Seoul Open Art Fair, COEX, Seoul, Korea

Gargen Tour Record, Daecheongho Museum of Art, Cheongju, Korea

Their Gaze, Gallery Grimson, Seoul, Korea

The 6th Incheon Art Platform of Art Residency, Incheon Art Platform,
Incheon, Korea

2015 *Garden of Healing*, KSD gallery, Korea Securities Depository, Seoul, Korea

The 4th, 5th, 6th Artists of Tomorrow, Gyeomjae Jeong Seon Museum,
Seoul, Korea

SOMA Drawing-Mindfull Mindless, SOMA Art Museum, Seoul, Korea

Korea Tomorrow 2015-I, Sungkok Art Museum, Seoul, Korea

Firefly Village, Gallery Geo, Incheon, Korea

*Finding the Origin of Jeonnam Province Culture-Lost in Jangheung,
Jeongnamjin,* Shinsegae Gallery, Gwangju, Korea

Paradise and Paradise Lost, Incheon Art Platform, Incheon, Korea

The 6th-term Incheon Art Platform Resident Artists Preview,
Incheon Art Platform, Incheon, Korea

6th Incheon Art Platform Resident Artist Preview Exhibition,
Incheon Art Platform, Incheon, Korea

Group Exhibitions

2015 *Resistance against Oblivion,* Ansan Culture and Arts Center, Ansan, Korea

Art Fair Tokyo, Tokyo International Forum Exhibition Hall, Tokyo, Japan

Incheon Art Festival, Gallery Geo, Incheon, Korea

Inert Gas, Typical Reality Alternative, Space Deum, Incheon, Korea

2014 *Environment and Art,* Gallery Geo, Incheon, Korea

SoAa, Gaon Gallery, Incheon, Korea

Gallery Geo Opening Exhibition, Gallery Geo, Incheon, Korea

ZIPPO Museum Inaugural Exhibition, ZIPPO Museum, Jeju, Korea

Individual Companions (別★同行), *OCI Museum of Art Traveling Art Exhibition,* Gwangyang, Pohang, Yeongju and Gunsan, Korea

Insight, Four-person Exhibition, Gallery 192, Seoul, Korea

Cre8tive Report, OCI Museum of Art Studio Resident Artists Exhibition, OCI Museum of Art, Seoul, Korea

2013 *Artist Tomorrow Selected Artist Exhibition,* Gyeomjae Jeongseon Museum, Seoul, Korea

True-view Landscapes Today Recommended by 11 Critics, Gyeomjae Jeongseon Museum, Seoul, Korea

KIAF, COEX, Seoul, Korea

Mr. Hulot's Holiday, Songwon Art Center, Seoul, Korea

Environmental Theme Firefly Relocation, Incheon Cultural Arts Center, Incheon, Korea

Pause, Shinhan Gallery Yeoksam, Seoul, Korea

Drawing, the Beginning of Thought, Pre-drawing Biennale, Art Factory, Paju, Korea

Eight Windows, OCI Museum of Art Resident Artists Exhibition, OCI Museum of Art, Seoul, Korea

2012 *Brand New Collection Exhibition,* Eugene Gallery, Seoul

The Cross, fn art Space, Seoul, Korea

Seoul Contemporary Art, Art Stars, Seoul Arts Center, Seoul, Korea

Environmental Theme Firefly Relocation, Namoo Gallery, Incheon, Korea

The Vestige of Existence, Gallery Grimson, Seoul, Korea

Push & Pull, Topohaus Gallery, Seoul, Korea

2011 *Incheon Women Artists Biennale Open Studio Project,* Incheon, Korea

Bridge to Bridge, Shinsegae Gallery, Incheon, Korea

The 37th Korea Galleries Art Fair, COEX, Seoul, Korea

2010 *Beyond the Labor, Four-person Exhibition,* Art Forum New Gate, Seoul, Korea

Return to Daily Life, Shinsegae Gallery, Incheon, Korea

2009 *Ganghwabyeolgok, Samrangsung History Culture Festival Special Exhibition, Echo of Remembrance,* Shinsegae Gallery/ Bupyeong History Museum, Incheon, Korea

Greencake Art Fair Exhibition, Shinsegae Gallery, Seoul, Korea

The 3rd Half n One, Kwanhoon Gallery, Seoul, Korea

Homecoming YAP, Jung Gallery, Seoul, Korea

Incheon Culture Foundation Art Bank Collection Exhibition, Incheon, Korea

The Scent of Orchids, Shinsegae Gallery, Incheon, Korea

The 2nd Reformation, Ewha Gallery, Seoul, Korea

2008 *Incheon Culture Foundation Art Bank Collection Exhibition,* Bupyeong History Museum, Incheon, Korea

Delayed Clouds, Yangpheong Project, Dr. Back Gallery, Yangpeong, Korea

Korea Museum Inaugural Exhibition, Korea Museum, Seoul, Korea

Young Flag Bearers, Bupyeong History Museum, Incheon, Korea

Phoart Gallery Inaugural Exhibition, Phoart Gallery, Seongnam, Korea

Northeast Asian Art Exhibition, Saga Prefectural Museum of Art, Saga, Japan

Flower-like Flower, Flower-like Garden, Shinsegae Gallery, Incheon, Korea

2007 *Asia Open Art Fair,* Busan Museum of Art, Busan, Korea

Moving Image Festival, Shinsegae Department Store, Jukjeon, Korea

Wild Flowers, Shinsegae Gallery, Incheon, Korea

Walk Around Flowers, Shinsegae Gallery, Gwangju, Korea

No Bounds, Gallery Sun Contemporary, Seoul, Korea

2006 *View Finder of YAP, Young Artist Project,* Gallery Jung, Seoul, Korea

Kyunghyang Housing Fair Art Festival, KINTEX, Ilsan, Korea

Haelap Art Exhibition, Incheon Culture and Arts Center, Incheon, Korea

The Shadow Catching the Light, Da Gallery, Seoul, Korea

Contemporary Art Spectrum Festival, Chosun Gallery, Seoul, Korea

Super Woman, Bae Art Center, Pyeongtaek, Korea

Korea Creation Art Exhibition, Insa Art Plaza, Seoul, Korea

Many Colors, Many Feelings, Style Cube Zandari, Seoul, Korea

Seeing & Showing, Kooalldam Gallery, Incheon/ Hyewon Gallery, Incheon, Korea

New Challenge in the 21st Century, Danwon Art Museum, Ansan, Korea

2005	*The Voice Waking Up the Dawn, Eulyu Year Thematic Exhibition,* Shinsegae Gallery, Incheon, Korea
	Wild Flowers, New Spring Art Exhibition, Shinsegae Gallery, Incheon, Korea
	Korea University Centennial Memorial Hall Fresco Project, Korea University, Seoul, Korea
	Prominent Korean Artists George Mason University Invitational Exhibition, Arlington Campus Art Gallery, Washington, USA
	It Is Symptomatic, Daedeok Cultural Arts Center, Daejeon, Korea
2004	*Youth's Breath,* Gallery Indeco, Seoul, Korea
2003	*Fresco Work Duet Exhibition,* Spring Gallery, Gwacheon, Korea
2001	*Paik Namjune & Jin Youngsun Fresco Mural Painting Project,* Joseon Royal Kiln Museum, Gwangju, Korea
2000	*No Name,* Gallery Doll, Seoul, Korea
	Paik Namjune & Jin Youngsun Fresco Mural Painting Project, Sungbo Museum, Haeinsa, Hapcheon, Korea
1999	*No Name,* Dansung Gallery, Seoul, Korea
1998	*Korea Youth Art Festival,* Incheon Culture and Arts Center, Incheon, Korea
	Fresco Work Exhibition, Johyung Gallery, Seoul, Korea
1997	*National Art Colleges Graduation Work Exhibition,* Johyung Gallery, Seoul
	New-Form, Yun Gallery, Seoul, Korea
	Environment and Art, Seoul Arts Center Gongpyeong Gallery, Seoul, Korea
	New Age New Image, Incheon Culture and Arts Center, Incheon, Korea
	No Name, Seokyong Gallery, Seoul, Korea
1996	*Gusang-jeon Art Competition,* Seoul Arts Center, Seoul, Korea
	Korea Mokwoohoe Fine Art Association Exhibition, National Museum of Contemporary Art, Gwacheon, Korea

Selected Awards / Supports

2022	Artists Support Program, Seoul Foundation for Arts and Culture, Seoul
2021	Artists Support Program, Seoul Foundation for Arts and Culture, Seoul
2020	Artists Support Program for Multi-year Work Grant for Incheon Artist, Incheon Foundation for Arts and Culture, Incheon
2018	The 2nd National Young Artist Competition, Namdo Culture Foundation, Gwangju
	Artists Support Program, Seoul Foundation for Arts and Culture, Seoul
2015	Artists Support Program, Seoul Foundation for Arts and Culture, Seoul
2014	Artists Support Program, Incheon Foundation for Arts and Culture, Incheon
2013	Awarded for Artist of Tomorrow, Gyeomjae Jeongseon Art Museum, Seoul
	Selected by Pre-Drawing Biennale, Paju
2012	Selected Artist, E-Land Foundation for Culture, Seoul
2010	Artists Support Program, Incheon Foundation for Arts and Culture, Incheon
2009	Registered Artist, SOMA Museum of Art Drawing Center Archive, Seoul
2006	Artists Support Program, Incheon Foundation for Arts and Culture, Incheon

Residency

2015-2017	The 6th and 7th Resident Artist, Incheon Art Platform
2012-2014	The 2nd and 3rd Resident Artist, OCI Museum of Creative Studio

Selected Collections

Government Art Collection	Sophis Gallery
National Museum of Modern and Contemporary Art Artbank	Eugene Gallery
	Shinsegae Gallery
Seoul Museum of Art	Jung Gallery
Suwon Ipark Museum of Art	Gallery Sun Contemporary
Seongnam Cube Art Museum	Dong-gu Office in Incheon
Busan Museum of Art	Sungmoon Book
OCI Museum of Art	Samchully Co., Ltd.
E-land Culture Foundation	Universe Motors Co., Ltd.
Namdo Culture Foundation	First Fire & Marine Insurance Co., Ltd.
Incheon Foundation for Arts and Culture	Korea University

김유정

1974년생

단국대학교 일반대학원 조형예술학과 서양화전공 박사
고려대학교 교육대학원 미술교육 석사
단국대학교 예술대학 서양화과 학사

개인전

2021 ≪붉은 공기와 모서리 잔상_Red Air and Afterimage of Edge≫
 금호미술관, 서울
2020 ≪잠식항_Submerged Vessel≫ 서구문화재단 정서진아트큐브, 인천
2018 ≪식물에도 세력이 있다_Plants Also Have Power≫ 소피스갤러리, 서울
2017 ≪숨의 광경_Breath Perspective≫ 갤러리 밈, 서울
2016 ≪조각난 숲_Carved Grove≫ 인천아트플랫폼, 인천
 ≪숲_Grove≫ 소피스갤러리, 서울
2015 ≪생존조건_Survival Needs≫ 갤러리 도스, 서울
2014 ≪전도된 풍경_Reversed Landscape≫ 선광미술관, 인천
2013 ≪침묵의 정원_Silent Garden≫ 이랜드스페이스, 서울
2012 ≪김유정 Fresco전≫ 신세계 센텀시티 윈도우갤러리&VIP라운지, 부산
2011 ≪화분이 있는 풍경≫ 갤러리 그림손, 서울
 ≪Upside-downed Inside≫ 신세계갤러리, 인천
2008 ≪Skin of the Roof≫ 인사아트센터, 서울
2006 ≪중국국제아트페스티벌 김유정 Fresco전≫ 산둥성, 중국
 ≪김유정 Fresco전≫ JM갤러리, 상하이, 중국
 ≪Caving the Desire≫ 스페이스빔, 인천
2005 ≪욕망의 그늘≫ 신세계갤러리, 인천/갤러리 인데코, 서울
 ≪담을 수 없는 그림자≫ 갤러리 정, 서울
2003 ≪벽과 그림자 읽기≫ 관훈갤러리, 서울

그룹전

2022 ≪다르게, 조금 더 가깝게 3인전≫ 의정부미술도서관 전시관, 의정부

≪치유의 기술≫ 뮤지엄 원, 부산

2021 ≪홀로세(Holocene)의 미래_중구문화재단 기획전≫ 충무아트센터 갤러리, 서울

≪모카 팔레트≫ 모카가든미술관, 남양주

≪a mark II_낯선 신호, 기울어진 대상≫ 삼육빌딩, 서울

≪물과 바람의 시간≫ 청주시립 대청호미술관, 청주

≪제6회 아트페스타제주: 산지열전≫ 산지천갤러리, 제주

≪오노프 ONOOOFF≫ 부산시립미술관, 부산

≪푸른 유리구슬 소리: 인류세 시대를 애도하기≫ 서울대미술관, 서울

≪낙관주의자들≫ 아트센터 예술의 시간, 서울

≪향기공화국≫ 정읍시립미술관, 정읍

≪제8회 아마도에뉴얼날레_목하진행중≫ 아마도예술공간, 서울

≪블루아트페어≫ 파라다이스호텔, 부산

≪아트마이닝 서울 2021: INTO THE FOREST 숲으로≫ 스페이스 445, 서울

≪공유지, 김유정x구기정 2인전≫ 복합문화공간 L.A.D, 서울

2020 ≪횡단하며 흐르는 시간≫ 인천아트플랫폼, 인천

≪개인 시대의 사회_국립현대미술관 미술은행 소장품 기획전≫
의정부미술도서관 전시관, 의정부

≪예술하라≫ 팔레트서울, 서울

2019 ≪Dear 식물_느슨한 연대≫ 소다미술관, 화성

≪뜻밖에 초록을 만나다≫ 수원시립미술관 아트스페이스 광교, 광교

≪Asia Art Connection≫ 유진갤러리, 서울

≪재-분류: 밤은 밤으로 이어진다≫ 수원시립아이파크미술관, 수원

2018 ≪2018 아트마이닝 서울≫ DDP, 서울

≪원더랜드≫ 갤러리지오, 인천

≪HELP EARTH HELP US_우리의 집, 지구 기획전≫ 고양아람누리 아람미술관, 일산

≪오늘이 내일에게_삶의 현장과 기억에 대한 이야기, 2nd 전국청년공모선정
작가전≫ 인사아트센터, 서울

≪아트프로젝트울산2018 ICAPU/18 WAVE기획전≫ 갤러리라온, 울산

≪아트부산 2018≫ 벡스코, 부산

≪부산시립미술관 신소장품전≫ 부산시립미술관, 부산

2017 ≪FRACTAL기획전≫ 신세계갤러리 본점 본관 아트월, 서울

≪글로벌 아트콜라보 2017≫ 코엑스, 서울

≪두 개의 통로≫ 아트스페이스 인, 인천

≪여수국제아트페스티발_통≫ 여수세계박람회장 전시홀, 여수

≪소장품 주제기획전 Breath≫ 성남아트센터 큐브미술관, 성남

≪우리미술관 골목길 프로젝트 지붕 없는 갤러리≫ 우리미술관, 인천

≪인천아트플랫폼 7기 입주작가 결과보고전 플랫폼아티스트≫ 인천아트플랫폼, 인천

≪5인의 HIGH NOON 신한갤러리 역삼 그룹공모 5주년 기획전≫
신한갤러리 역삼, 서울

2016 ≪협업프로젝트 예술가의 노동을 대하는 자세_Wave Incubating≫
인천아트플랫폼, 인천

≪바람이 짓는 집≫ 신세계갤러리, 인천

≪비밀의 화원≫ 서울미술관, 서울

≪IN-spire≫ 아트스페이스 인, 인천

≪창작공간페스티벌_감각적 현실≫ 서울시청 시민청, 서울

≪WET PAINT≫ 인천아트플랫폼, 인천

≪숲의 숨≫ 신세계갤러리, 인천

≪서울오픈아트페어≫ 코엑스, 서울

≪정원유람기≫ 청주시립 대청호미술관, 청주

≪그들만의 시선≫ 갤러리 그림손, 서울

≪6기 인천아트플랫폼 입주작가 보고전≫ 인천아트플랫폼, 인천

2015 ≪치유의 뜰≫ 한국예탁결제원 KSD갤러리, 서울

≪4, 5, 6회 내일의 작가 선정 작가전≫ 겸재정선미술관, 서울

≪소마 드로잉_무심전≫ 소마미술관, 서울

≪코리아 투마로우 2015-I≫ 성곡미술관, 서울

≪반딧불이 마을≫ 갤러리지오, 인천

≪남도문화의 원류를 찾아서_정남진 장흥에 취하다≫ 신세계갤러리, 광주

≪낙원과 실낙원≫ 인천아트플랫폼, 인천

≪6기 인천아트플랫폼 입주작가 프리뷰전≫ 인천아트플랫폼, 인천

≪망각에 저항하기≫ 안산문화예술의 전당, 안산

≪아트페어 도쿄≫ 도쿄국제포럼전시홀, 도쿄, 일본

≪인천 아트페스티벌≫ 갤러리지오, 인천

≪비-활성 기체, 비-정형 현실≫ 대안공간 듬, 인천

그룹전

2014 ≪환경과 예술≫ 갤러리지오, 인천
≪천애약비린 SoAa≫ 가온갤러리, 인천
≪갤러리지오 개관전≫ 갤러리지오, 인천
≪ZIPPO 뮤지엄 개관기념전 LOVE100≫ 지포뮤지엄, 제주
≪별별동행_OCI미술관 현대미술 순회전≫ 광양, 포항, 영주, 군산 예술의 전당
≪INSIGHT 4인전≫ 갤러리192, 서울
≪OCI미술관 창작스튜디오 입주작가 전_Cre8tive Report≫ OCI미술관, 서울

2013 ≪내일의 작가 선정전≫ 겸재정선기념관, 서울
≪11인의 평론가가 추천한 오늘의 진경2013전≫ 겸재정선기념관, 서울
≪KIAF≫ 코엑스, 서울
≪윌로씨의 휴가≫ 송원아트센터, 서울
≪환경테마 반딧불이전≫ 인천종합문화예술회관, 인천
≪PAUSE 정지된 시간, 움직이는 공간≫ 신한갤러리 역삼, 서울
≪프레드로잉비엔날레_공모전_드로잉, 생각의 시작≫ 아트팩토리, 파주
≪OCI미술관 창작스튜디오 입주작가 전 여덟 개의 창≫ OCI미술관, 인천

2012 ≪Brand New_소장가치전≫ 유진갤러리, 서울
≪The Cross≫ fn art Space, 서울
≪서울 컨템포러리 아트 스타전≫ 예술의 전당, 서울
≪환경테마 반딧불이전≫ 나무갤러리, 인천
≪존재의 흔적≫ 갤러리 그림손, 서울
≪Push & Pull≫ 토포하우스, 서울

2011 ≪인천국제여성비엔날레 오픈스튜디오 프로젝트≫ 인천
≪Bridge to Bridge≫ 신세계갤러리, 인천
≪제37회 화랑미술제≫ 코엑스, 서울

2010 ≪Beyond the Labor 4인전≫ 아트포럼뉴게이트, 서울
≪일상의 귀환≫ 신세계갤러리, 인천

2009 ≪삼랑성역사문화축제 특별전_강화별곡II 千劫, 기억의 울림≫ 신세계갤러리, 인천
≪그린케잌 아트페어≫ 신세계갤러리, 서울
≪제3회 Half n One≫ 관훈갤러리, 서울
≪Homecoming YAP≫ 정갤러리, 서울
≪인천문화재단 미술은행 소장작품전≫ 연수갤러리, 인천
≪난향에 머물고≫ 신세계갤러리, 인천
≪제2회 Reformation≫ 이화갤러리, 서울

2008 ≪인천문화재단 미술은행 소장작품전≫ 부평역사박물관, 인천
≪양평프로젝트_연기된 구름≫ 닥터박갤러리, 양평
≪한국미술관개관전 현대미술동행≫ 한국미술관, 서울
≪젊은 기수≫ 부평역사박물관, 인천
≪포아트 갤러리 개관 기념 초대전_한국 현대미술의 환영≫ 포아트 갤러리, 성남
≪동북아시아≫ 사가현립미술관, 사가, 일본
≪꽃 담은, 꽃 닮은 정원≫ 신세계갤러리, 인천

2007 ≪아시아 오픈아트페어≫ 부산시립미술관, 부산
≪무빙이미지 페스티벌≫ 신세계 백화점, 분당
≪야생화≫ 신세계갤러리, 인천
≪꽃길을 거닐다≫ 신세계갤러리, 광주
≪NO BOUNDS≫갤러리선컨템포러리, 서울

2006 ≪View Finder of YAP≫ 갤러리 정, 서울
≪경향하우징 페어 아트페스티벌≫ 킨텍스, 일산
≪해람전≫ 인천종합문화예술회관, 인천
≪빛을 낚는 그림자≫ 다갤러리, 서울
≪현대미술 스펙트럼 페스티벌≫ 조선일보미술관, 서울
≪슈퍼우먼≫ 베아트센타, 평택
≪대한민국 창작미술전≫ 인사아트프라자갤러리, 서울
≪다색다감≫ 스타일큐브잔다리, 서울
≪Seeing & Showing≫ 구올담갤러리/혜원갤러리, 인천
≪21세기 새로운 도전≫ 단원미술관, 안산

2005	≪을유년 테마전_새벽을 깨우는 소리≫ 신세계갤러리, 인천		

2005 ≪을유년 테마전_새벽을 깨우는 소리≫ 신세계갤러리, 인천

 ≪신춘기획 '야생화'≫ 신세계갤러리, 인천

 ≪고려대학교 100주년기념관 프레스코벽화≫ 프로젝트 참여, 서울

 ≪한국정예작가 초대전≫ 조지메이슨대학 갤러리, 워싱턴, 미국

 ≪징후이후≫ 대덕연구단지아트센터, 대전

2004 ≪Youth's Breath≫ 갤러리 인데코, 서울

2003 ≪프레스코 2인전≫ 봄갤러리, 과천

2001 ≪조선 관요박물관, 백남준·진영선 프레스코벽화≫ 프로젝트참여, 경기도 광주

2000 ≪노네임≫ 도올아트센터, 서울

 ≪해인사 성보박물관, 백남준·진영선 프레스코벽화≫ 프로젝트참여, 합천

1999 ≪노네임≫ 단성갤러리, 서울

1998 ≪대한민국 청년미술제≫ 인천종합문화예술회관, 인천

 ≪프레스코전≫ 조형갤러리, 서울

1997 ≪제3회 전국미술대학 우수졸업작품전≫ 조형갤러리, 서울

 ≪뉴-폼≫ 윤갤러리, 서울

 ≪환경과 예술≫ 공평아트센터, 서울

 ≪뉴에이지 뉴이미지≫ 인천종합문화예술회관, 인천

 ≪노네임≫ 서경갤러리, 서울

1996 ≪구상전 공모전≫ 예술의 전당, 서울

 ≪목우회 미술대전≫ 국립현대미술관, 서울

주요 수상 및 지원

2022 서울문화재단 예술지원사업 선정

2021 서울문화재단 예술지원사업 선정

2020 인천문화재단 인천형예술인지원사업 다년지원 선정

2018 제2회 남도문화재단 전국 청년작가 미술공모전 대상 수상

 서울문화재단 예술지원사업 선정

2015 서울문화재단 예술지원사업 선정

2014 인천문화재단 예술지원사업 선정

2013 겸재정선미술관 내일의 작가상 수상

 프레드로잉비엔날레 작가 선정

2012 이랜드 문화재단 3기 작가 선정

2010 인천문화재단 예술지원사업 선정

2009 제4회 소마미술관 드로잉센터 아카이브 등록작가 선정

2006 인천문화재단 예술지원사업 선정

레지던스 프로그램

2015 - 2017 인천아트플랫폼 6, 7기 입주작가

2012 - 2014 OCI미술관 창작스튜디오 2, 3기 입주작가

주요 작품 소장처

정부미술은행	소피스갤러리
국립현대미술관 미술은행	유진갤러리
서울시립미술관	신세계갤러리
수원아이파크시립미술관	정갤러리
성남아트센터 큐브미술관	갤러리선컨템포러리
부산시립미술관	인천 동구청
OCI미술관	성문영어사
이랜드문화재단	주식회사 삼천리
남도문화재단	주식회사 유너모터스
인천문화재단	제일화재
	고려대학교

14
Half Shade Encroached Land_Starting Point of Water I
반그늘 잠식지_물의 시원 I
2021
tillandsia, objects in the kitchen, net, wire
dimensions variable

17
Submerged Vessel 잠식 항(航)
2020
tillandsia, ship, various objects in the port, net, wire
dimensions variable

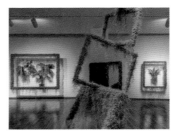

20-21
Installation View of *Red Air and Afterimage of Edge*
붉은 공기와 모서리 잔상
Kumho Museum of Art, Seoul, Korea
2021

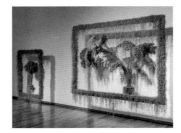

22-23
Flowing Tower 흐르는 탑
2021
tillandsia, collected frames, artificial flower pots, wire
dimensions variable

25
Edge of the Jungle 정글의 가장자리
2021
pigment print
40x30cm

27
President's Seat 높은 의자
2021
pigment print
162x130cm

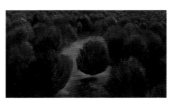

28-29
Hiding Crowd 숨어든 무리
2021
acrylic on canvas
112.3x194cm

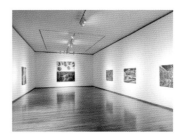

30-31
Installation View of *Red air and Afterimage of Edge*
붉은 공기와 모서리 잔상
Kumho Museum of Art installation view
2021

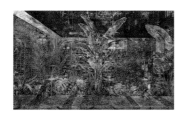

33
Middle Habitat of Life 중간 서식지
2021
fresco, scratch on lime wall
90x140cm

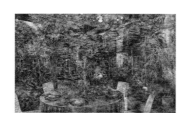

34
Middle Habitat of Life 중간 서식지
2021
fresco, scratch on lime wall
90x140cm

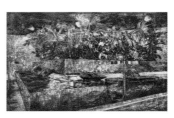

35
Middle Habitat of Life 중간 서식지
2021
fresco, scratch on lime wall
90x140cm

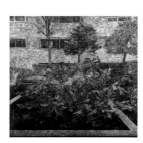

36
Pieces in Between 사이 섬
2021
fresco, scratch on lime wall
120x120cm

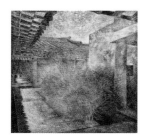

37
Middle Habitat of Life 중간 서식지
2021
fresco, scratch on lime wall
120x120cm

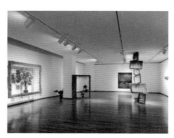

40-41
Installation View of *Red Air and Afterimage of Edge*
붉은 공기와 모서리 잔상
Kumho Museum of Art exhibition view
2021

42-43, 45
Installation View of *Holocene Future*
홀로세(holocene)의 미래
Chungmu Art Center Gallery, Seoul, Korea
2021

47
Flowing Tower 흐르는 탑
2021
tillandsia, collected frames, artificial flower pots, wire
dimensions variable

49
Installation View of *The Time of Water and Wind*
물과 바람의 시간
Daecheong ho Museum of Art
2021

50-57
Parasitic Air 기생하는 대기
2021
tillandsia, artificial flower pots, wire
dimensions variable

58-59
A Whitewashed Tree 회칠한 다락
2018
acrylic on the back of the canvas, birds sound art
100x1400cm
Daecheong ho Museum of Art installation view

60-61
A Whitewashed Tree 회칠한 다락
2018
acrylic on the back of the canvas
100x200cm

63
Installation View of *a mark* II_*Unfamiliar
Signal, Tilted Target*
a mark II_낯선 신호, 기울어진 대상
Sahmyook Building, Seoul, Korea
2021

64-65
Play Age 유희 시대
2021
tillandsia, collected frames, collected toys,
artificial flower pots, wire, net
dimensions variable

66-67
Play Age 유희 시대
2021
tillandsia, collected frames, collected toys with
sound, wire
dimensions variable

68-71
Landscape Still Life_Ornamental
풍경이 된 정물_보여지기 위한
2021
tillandsia, collected flower pots, collected
bookshelves, net, wire
dimensions variable

72-73
Installation View of *The 8th Amado Annualnale*
제 8회 아마도 에뉴얼날레
Amado Art, Seoul, Korea
2021

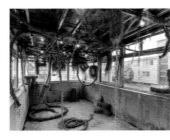

74-77
Through Channel 시간이 기억하는 통로
2021
tillandsia, collected channel signs, collected
hoses, net, wire, art neon sign
dimensions variable

78-79
Installation View of *The 8th Amado Annualnale*
제 8회 아마도 에뉴얼날레
Amado Art, Seoul, Korea
2021

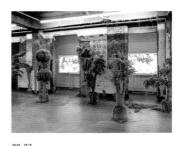

80-83
Floating Island 부유하는 섬
2021
tillandsia, artificial flower pots, wire
dimensions variable

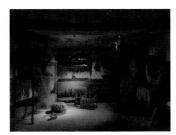

84-85
Installation View of *Common Land*
공유지
Cultural space L.A.D, Seoul, Korea
2021

87
Half Shade Encroached Land_Starting Point of Water I
반그늘 잠식지_물의 시원 I
2021
tillandsia, objects in the kitchen, net, wire
dimensions variable

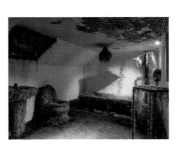

88-91
Half Shade Encroached Land_Starting Point of Water II
반그늘 잠식지_물의 시원 II
2021
tillandsia, objects in the bathroom, net, wire
dimensions variable

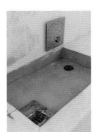

93
Concrete Jungle 콘크리트 정글
2021
pigment print
dimensions variable

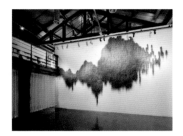

96-97
Installation View of *Time Passing Through*
횡단하며 흐르는 시간
Incheon Art Platform, Incheon, Korea
2020

98
Wild Garden 야생전도
2020
tillandsia, net, wire
dimensions variable

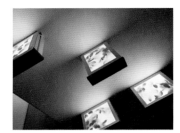

99
Recycle_Breath 재생_숨
2020
recycle living furniture drawer lightbox, recycle antique
furniture drawer lightbox, artificial plants, fabric
17x50x42cm, 3ea
10x34x42cm, 1ea

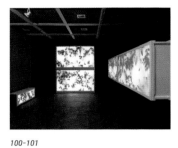

100-101
Recycle_Breath 재생_숨
2020
recycle living furniture drawer lightbox, recycle antique
furniture drawer lightbox, artificial plants, fabric
dimensions variable

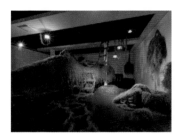

102-105
Installation View of *Submerged Vessel*
잠식 항(航)
Seogu Cultural Foundation Jeongseojin Art Cube,
Incheon, Korea
2020

107
Recycle_Breath (detail) 재생_숨
2020
collected wood bookcase furniture lightbox,
artificial plants, fabric

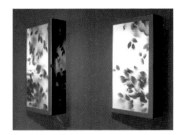

108
Recycle_Breath 재생_숨
2020
collected mother-of-pearl drawer lightbox,
artificial plants, fabric
93.5x48.7x16.5cm, 87x47x18cm

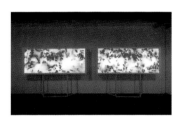

109
Recycle_Breath 재생_숨
2020
collected wood bookcase furniture lightbox,
steel frame, **artificial** plants, fabric
122x196.8x30cm, 2ea

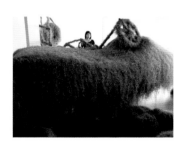

110-111
Submerged Vessel 잠식 항(航)
2020
tillandsia, ship, various objects in the port, net, wire
dimensions variable

114
Grove Structure 숲의 구조
2019
fresco, scratch on lime wall
60x60cm

115
Grove Structure 숲의 구조
2019
fresco, scratch on lime wall
60x60cm

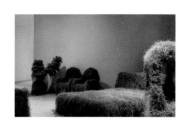

122-125
Plant Kingdom 세력도원
2018
tillandsia, artificial flower pots, artist's furniture
objects, net, wire
dimensions variable

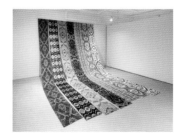

127
7 Prayers 7의 기원
2018
Uzbekistan national fabrics
500x257cm

128-129
K's Dream K의 꿈
2018
mashrabia pattern sheet, single channel video
120x500cm

130
Forced Plant 세력도감
2018
pigment print, dried fig peel
70x70cm

131
Forced Plant 세력도감
2018
pigment print, dried fig peel
70x70cm

132
Two Roads 두 개의 길
2018
fresco, scratch on lime wall
90x140cm

133
Incubator 인큐베이터
2018
fresco, scratch on lime wall
55x80cm

135
Grove 숲
2018
fresco, scratch on lime wall
60x60cm

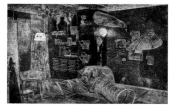

136
Imitated Room 복제된 방
2018
fresco, scratch on lime wall
90x140cm

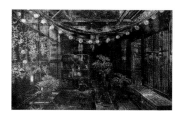

137
Imatated Garden 복제된 정원
2018
fresco, scratch on lime wall
90x140cm

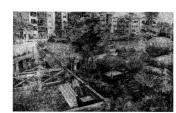

138-139
Imatated Garden 복제된 정원
2018
fresco, scratch on lime wall
90x140cm
National museum of modern and contemporary
Art, Art bank collection

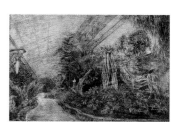

140-141
Warmth_Survival Mechanism 온기_생존기제
2018
fresco, scratch on lime wall
113.5x162cm
Namdo Culture Foundation collection

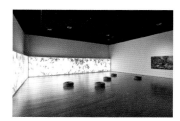

142-143
Breath_Rest and Waiting 숨_휴게와 대기
2018
lightbox, artificial plants, rattan cushions, fabric

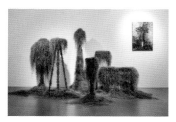

146-149
Dust-Free Grove_Topiary 먼지 없는 숲_토피어리
2017
tillandsia, standing wreath objects, net, wire
dimensions variable

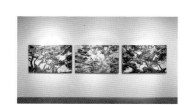

151
Survival Road 생존 통로
2017
fresco, scratch on lime wall
90x140cm

152-153
Survival Road 생존 통로
2017
fresco, scratch on lime wall
90x140cm

154-155
Survival Road 생존 통로
2017
fresco, scratch on lime wall
90x140cm

157
Survival Road 생존 통로
2017
fresco, scratch on lime wall
50x50cm

159
Tamed Future 길들여진 내일
2017
fresco, scratch on lime wall
55x80cm

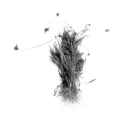

160
Möbius 뫼비우스
2017
pigment print
42x30cm

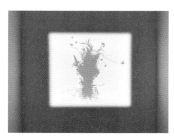

161
The Memory Of Plants 식물이 기억하는 시간
2017
projection
200x150cm

162
Forced Plant 세력 도감
2017
pigment print, dried grapes
70x70cm

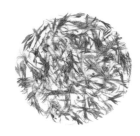

163
Forced Plant 세력 도감
2017
pigment print, dried weeds
70x70cm

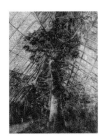

165
Optimal Symbiosis 완전한 공생
2017
fresco, scratch on lime wall
80x55cm
private collection

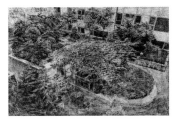

166-167
Infested Garden 잠식된 정원
2017
fresco, scratch on lime wall
113.5x162cm
Busan Museum of Art collection

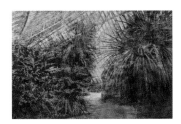

168-169
Warmth 온기
2017
fresco, scratch on lime wall
113.5x162cm

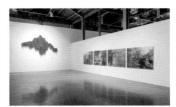

176-177
Installation View of *Caved Grove*
조각난 숲
Incheon Art Platform, Incheon, Korea
2016

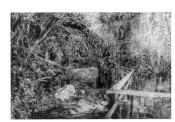

178
Warmth 온기
2016
fresco, scratch on lime wall
113.5x162cm

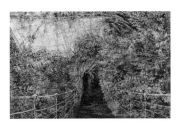

179
Warmth 온기
2016
fresco, scratch on lime wall
113.5x162cm

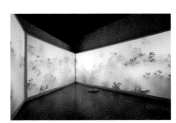

180-181
Breath 숨
2016
light box, artificial plant, rattan cushions
180x600x30cm

182-183
Labyrinth 미로
2014
pigment print on tiles
30x30cm
Incheon Art Platform of Art installation view

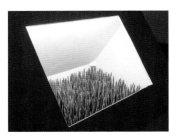

184-185
Grove 숲
2016
lime-painted house shape, stucky plants
176x180x152cm

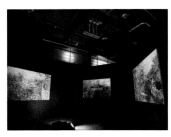

186-187
Installation View of *6th Incheon Art Platform of Art Residency*
6기 인천아트플랫폼 입주작가 보고전
Incheon Art Platform, Incheon, Korea
2016

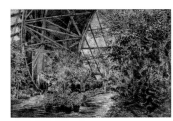

188-189
Warmth 온기
2016
fresco, scratch on lime wall
113.5x162cm
Seongnam Cube Art Museum collection

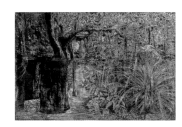

190-191
Warmth 온기
2016
fresco, scratch on lime wall
113.5x162cm
Suwon I-Park Museum of Art collection

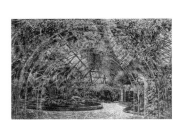

193
Warmth 온기
2016
fresco, scratch on lime wall
90x140cm

194-195
In stratum 축적
2016
acrylic box, lime powder left after work
13x100x7cm

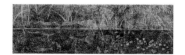

198-199
Symbiosis 공생
2015
fresco, scratch on lime wall
90x280cm

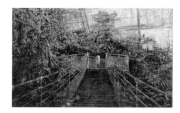

200-201
Warmth 온기
2015
fresco, scratch on lime wall
90x140cm
National museum of modern and contemporary
Art, Art bank collection

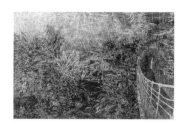

202
Warmth 온기
2015
fresco, scratch on lime wall
113.5x162cm

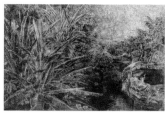

203
Warmth 온기
2015
fresco, scratch on lime wall
113.5x162cm
Korean Government Art Collection

204-205
B1
2015
fresco, scratch on lime wall
113.5x162cm

207
Alternative Plan 대체식물
2015
pigment print after wire drawing
70x80cm

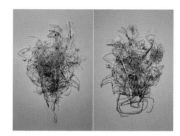

208-209
Alternative Plan 대체식물
2015
pigment print after wire drawing
70x80cm

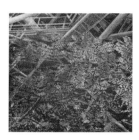

211
Gray Garden
2015
fresco, scratch on lime wall
50x50cm

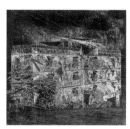

212-213
Incubator
2015
fresco, scratch on lime wall
120x120cm
Seoul Museum of Art collection

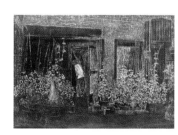

214-215
Incubator-Ownerless 주인 없는
2015
fresco, scratch on lime wall
74.5x104.5cm

216
Incubator-Ownerless 주인 없는
2015
fresco, scratch on lime wall
120x120cm

217
Incubator-Ownerless 주인 없는
2015
fresco, scratch on lime wall
104.5x74.5cm

224-225
Labyrinth 미로
2014
pigment print on tiles
30x30cm
private collection

226-227
Incubator
2014
fresco, scratch on lime wall
70x90cm

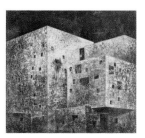

229
Incubator
2014
fresco, scratch on lime wall
120x120cm

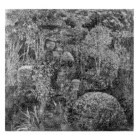

230-231
Yellow Position 노란 자리
2014
fresco, scratch on lime wall
120x120cm
Sophis gallery collection

232-233
Yellow House
2014
fresco, scratch on lime wall
70x90cm
Incheon Dong-gu Office collection

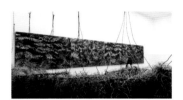

237
Incheon Art Platform Residency Studio
2015

238
Taming the Plant
2013
fresco, scratch on lime wall
90x140cm

239
Taming the Plant
2013
fresco, scratch on lime wall
90x140cm

240-241
Taming the Plant
2013
fresco, scratch on lime wall
90x140cm

242
Taming the Plant
2013
fresco, scratch on lime wall
120x180cm

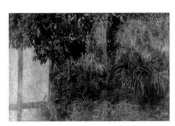

245
Gray Garden
2013
fresco, scratch on lime wall
113.5x162cm
OCI Museum of Art collection

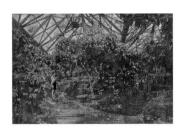

246
Dream of the Green
2013
fresco, scratch on lime wall
74.5x104.5cm

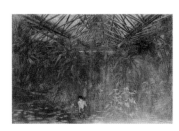

247
Dream of the Green
2013
fresco, scratch on lime wall
74.5x104.5cm
private collection

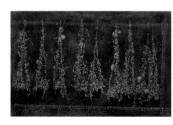

249
Floating the Plant
2013
fresco, scratch on lime wall
55x80cm

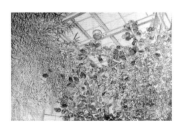

250-251
Shadow Garden
2012
fresco, scratch on lime wall
113.5x162cm
Samchully Co., Ltd. collection

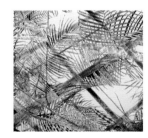

252
Shadow Garden
2012
fresco, scratch on lime wall
50x50cm
E-Land Culture Foundation collection

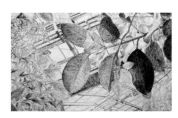

253
Shadow Garden
2012
fresco, scratch on lime wall
55x80cm
E-Land Culture Foundation collection

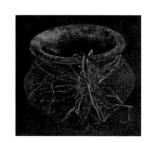

254
In a body
2012
fresco, scratch on lime wall
70x70cm

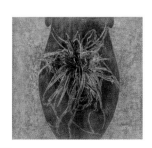

255
In a body
2012
fresco, scratch on lime wall
70x70cm

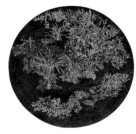

257
Boundary
2012
fresco, scratch on lime wall
80x80cm
private collection

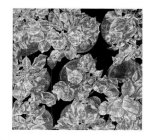

264
Frameworks
2011
fresco, scratch on lime wall
100x100cm

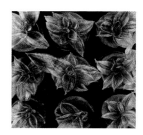

265
Frameworks
2011
fresco, scratch on lime wall
100x100cm

266-267
Frameworks
2011
fresco, scratch on lime wall
70x70cm

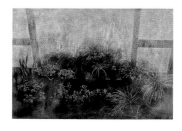

268-271
Gray Garden
2011
fresco, scratch on lime wall
113.5x162cm
private collection

272-273
Gray Garden
2011
fresco, scratch on lime wall
80x80cm
private collection

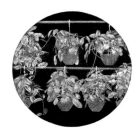

275-277
Floating Plants
2011
fresco, scratch on lime wall
85x85cm
Incheon Foundation for Arts and Culture collection

278-279
Overwhelmed
2008
fresco, scratch on lime wall
50x105cm
Sungmoon Book collection

280-281
Silhouette
2008
fresco, scratch on lime wall
50×105cm

282
Silhouette
2009
fresco, scratch on lime wall
105x105cm
First Fire & Marine Insurance Co., Ltd. collection

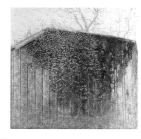

283
Skin
2009
fresco, scratch on lime wall
70x70cm
Universe Motors Co., Ltd. collection

284
Skin of the Leaf
2011
fresco, scratch on lime wall
50x50cm
private collection

284
Skin of the Leaf
2011
fresco, scratch on lime wall
50x50cm
private collection

285
Skin of the Leaf
2011
fresco, scratch on lime wall
50x50cm
private collection

286-287
The Invisible Forest 보이지 않는 숲
2005
fresco, scratch on lime wall
120x183cm

KIM YUJUNG
PLANTS ALSO HAVE POWER

김유정
식물에도 세력이 있다

Art Book Press
Seoul, South Korea

Image Kim Yujung
Photograph An Chunho, Cho Junyoung, Jeong Jinwoo, Jo Youngha, Kim Heechun
Photo retouch Cha gaheun

Editor Cho Sookhyun
Designer Kang Dahyun (uhdesignstudio.com)
English Translation and Revision artntext.com, Neil Scheihing

Editor in chief Cho Sookhyun
Publisher Art Book Press

This book was produced with support from the City of Incheon
and the Incheon Foundation for Arts and Culture.

Art Book Press publishes art books that matter in the global art scene.
artbookpress.co.kr
artbookpress@gmail.com

First hard cover edition
ISBN 979-11-969535-9-1 (03650)

값 66,000원
03650

9 791196 953591
ISBN 979-11-969535-9-1